Y

DATE DUE

APR 0 5 1993		AUG 0 2 1995	
MAR 2 5 1993		JAN 1 1 2000	
JUL 1 2 1993			
		JAN 1 2 2000	
OCT 0 1 1993		FEB 1 3 2005	
OCT 2 5 1993			
OCT 1 3 1994		FEB 1 6 2005	
NOV 0 3 1994			
DEC 2 2 1994			
GAYLORD			PRINTED IN U.S.A.

Motion Picture
and Video Lighting

Motion Picture and Video Lighting

Blain Brown

Focal Press
Boston London

Focal Press is an imprint of Butterworth-Heinemann.

 Recognizing the importance of preserving what has been written, it is the policy of Butterworth-Heinemann to have the books it publishes printed on acid-free paper, and we exert our best efforts to that end.

Library of Congress Cataloging-in-Publication Data
Brown, Blain.
 Motion picture and video lighting/by Blain Brown.
 p. cm.
 Includes bibliographical references and index.
 ISBN 0-240-80060-5
 1. Cinematography—Lighting. I. Title.
TR891.B76 1992
778.5'2343—dc20

British Library Catologing in Publication Data
Brown, Blain
 Motion picture and videao lighting.
 I. Title
 778.52343

ISBN 0-240-80060-5

Butterworth–Heinemann
80 Montvale Avenue
Stoneham, MA 02180

10 9 8 7 6 5 4 3 2 1

Printed in the United States of America

Contents

Preface

Filmmaking is not as easy as it looks and not as complicated as some people make it out to be.

William Burke

Lighting is at the heart of filmmaking. The image, the mood, and the visual impact of a film or video project are to a great extent determined by the skill and sensitivity of the cameraman and gaffer.

Learning about lighting, both as an art and as a technical craft, is a lifelong pursuit. For students, young people who are just breaking into the industry, and for working professionals seeking career advancement, it is an essential skill.

We have attempted to define an approach to lighting that will be equally useful to neophytes and established professionals: electricians who want to move up to gaffer, gaffers who want to be cameramen, assistant cameramen and operators who want to become lighting cameramen, and directors who want to better understand the technical side of production.

Lighting is an art, a craft, and a business. It is essential to understand all three aspects in order to be a successful practitioner. Without a thorough understanding of the theory of exposure and color control, and without a knowledge of the tools and techniques involved, it is very unlikely that the magic of art will ever happen.

The approach presented here is professionally oriented, but covers all levels of production from the most basic "no budget" practices, all the way up to big-budget "Hollywood" methods—from student work to large-scale feature film.

Lighting is lighting: the same basic principles apply whether you are part of a two-person video crew, shooting a 16mm industrial, or a theatrical feature. There is no clearly delineated set of techniques that apply exclusively to video, documentary industrials, commercials, or features. Rather, it is a continuum—while budgets, equipment orders, and crews naturally tend to get bigger as you work on the larger productions, there are no quantum leaps where you must forget everything you know and start in with an entirely new approach.

As for video, it is time to lay to rest the ancient myth that an entirely different style of lighting is called for in this medium. As we shall see in chapter 13, there are only minor differences between the lighting requirements of video and film. While they are important to understand and deal with, it is wrong to think of video lighting as a separate subject. What most people mean when they say video lighting is actually small-unit tactics: a two-person crew with only a few portable units in a single case. This way of working applies equally to 16mm film shooting for industrials and documentaries. We will look at some examples of these methods.

Further, it is not at all unusual to see the techniques associated with one arena being used in another. Circumstances frequently arise where a scene in a large-scale film production ends up being lit with a single hand-held portable unit. Conversely, single camera video productions often utilize the *big guns*—12K HMIs, xenons, and 10K fresnels. Only by being prepared to handle any kind of situation can you truly be considered a professional.

In the chapters that follow we will cover film lighting all the way from basic electrical theory to aesthetics and style. The emphasis throughout is on actual set practice: how to get the job done.

Acknowledgments

Special thanks to Ada, who helped me get it done, and to all the other directors, cameramen, lighting directors, gaffers, and grips with whom I have worked and learned lighting. Thanks also to Skip Roessel and Raffi Ferruci for reading the manuscript and to Roger Claman of Rosco Laboratories and Stephen Chamberlain of Arriflex Corporation and the many other manufacturers and suppliers who contributed material and offered consultation in researching this book.

All photographs are by the author except for historical photos, which are from the Film Stills Collection of the Museum of Modern Art, and where noted. Cover photo by the author.

Motion Picture
and Video Lighting

1. A Brief History of Lighting

Lighting is to film what music is to opera.

C.B. DeMille

Lighting creates the environment for storytelling. The first lighting for storytelling was the fire. For some purposes, it is still nearly perfect. Firelight is warm and glowing, associated in the mind with safety, heat, and protection from nature. It draws people toward it, they automatically arrange themselves into a circle at a comfortable conversational distance. It flickers gently and provides a visual focus that prevents one's attention from wandering. It starts out bright and blazing, then gradually dims as the mood turns inward and eyes grow heavy; it fades away to darkness just about the time the audience is ready to go home. For the hunter returned from the hunt, the village shaman, or an elder recounting the story of the tribe, it was ideal.

As theater became more formalized with written scripts and larger audiences, daylight performance became the norm: more light was necessary so that everyone could see clearly. Classical Greek plays were performed at festivals, which ordinarily began at dawn and continued through most of the day. With little emphasis on costumes (other than masks), staging, sets, or effects, the theater subsisted almost entirely on the power of the spoken word. Some purists feel it's all been downhill from there.

Even up to the time of Shakespeare and the Globe, daylight performances were the standard for the mass market. Increasingly, though, the works were also performed in the houses of nobility and for smaller audiences. These indoor and evening performances were lit with candles and torches, which doubtless had a simple and powerful effect.

Staging as we know it today came of age with the great spectacles of Inigo Jones, the seventeenth-century British architect who produced elaborate festival pieces with sumptuous costumes and sets.

1.1 The storyteller and the fire.

Controllable Light

Controllable, directional lighting for the theater is not a new idea. In fact, it dates back to the French chemist Lavoisier, who in 1781 suggested that movable reflectors be added to oil lanterns. With such innovations French theater led the way in lighting during this period, but there was always a division of opinion in European drama between those who wanted simple illumination of the elaborate sets and drops and those who wanted to develop a more theatrical and expressive lighting art.

The first technological advance came with the introduction of gaslight, which

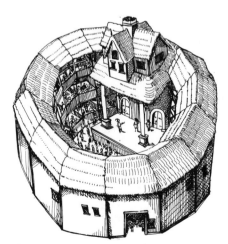

1.2 Shakespeare's Globe theater.

was more reliable and less smoky, but only slightly less hazardous. The next advance was the introduction of lime-light, which burned natural gas and oxygen in a filament of calcium oxide (limestone). This significant advancement which produced a beautiful warm light that complimented the actor's skin tone, is still commemorated in our everyday language with the phrase, "step into the limelight." At about the same time, this smaller, more concentrated source was combined with simple plano-convex lenses and spherical reflectors to provide the basis for one of the most important elements of modern lighting control: directional and focusable units.

The great theater pioneers Adophe Appia and David Belasco were revolutionary figures in the realm of expressionistic staging. Appia was perhaps the first to argue that shadows were as important as the light, and the first for whom the manipulation of light and shadow was *a means of expressing ideas*. In opposition to the "naturalism" of the time (which was in fact a very artificial broad, flat lighting), Appia created bold expressionist lighting full of *sturm und drang*.

Belasco's emphasis was on realistic effects to underscore the drama. He foreshadowed the private thoughts of many a modern cinematographer when he stated, in 1901, that the actors were secondary to the lighting.

His electrician Louis Hartmann is credited by some as inventing the first incandescent spotlight (Appia, Gordon Craig, and Max Reinhardt are also contenders), the forerunner of most of the lights we use today. To counteract the harsh theatrical hardness, Belasco and Hartmann also developed a row of over7head-reflected softlights, which were useful for naturalistic daylight scenes. (To this day there is no such thing as a true softlight in theater lighting.) Laudably, Belasco gave Hartmann credit on the billboards for the shows.

Carbon arcs that use electrodes to produce an intense flame, were also em-

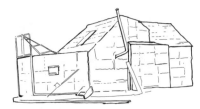

1.3 Edison's Black Maria.

ployed in theatrical applications beginning in 1849. They were widely used, particularly in high-intensity follow spots.

Early Film Production

With the advent of motion pictures in 1888, the earliest emulsions were so slow that nothing but daylight was powerful enough to get a decent exposure. Filmmaking was largely an outdoor activity until Thomas Edison unveiled his famous "Black Maria." Built in 1893 by Edison's associate William K.L. Dickson (cocreator of early motion picture technology), it was not only open to the sky but could be rotated on a base to maintain orientation to the sun.

As the motion picture industry developed, early studios in New York City and Ft. Lee, New Jersey, were open to the sky as well, usually with huge skylights. Some control was possible with large muslins stretched under the skylights to provide diffusion of the light and control contrast. Because these were

1.4 Mercury vapor tubes, the first film lights.

silent films and noise was not an issue, less space was needed in the studios since two or more production units could work within a few feet of each other.

The first artificial sources used in film production were Cooper-Hewitt mercury-vapor tubes which were suspended under the glass roof of the Biograph Studio on 14th Street in New York City around 1905. These were followed soon after by the introduction of arc lamps, which were adaptations of typical street lights of the time. The long exposure requirements, the lack of adequate equipment and the still slender economics of the business made anything but flat, overall lighting nearly impossible to attain.

As artificial sources were developed, the controlling factor was the spectral receptivity of the emulsions. Before 1927, black-and-white film was *orthochromatic*, that is, it was sensitive to blue and green light but not to red light. Tungsten lights, although available, were almost useless because of their large component of red.

Another adaptation of contemporary industrial equipment to motion picture use was the introduction in 1912 of white-flame carbon arcs , which had previously been used primarily in photoengraving. As with arcs today, these new units (called *broadsides*) were characterized by very high output and a spectral curve compatible with orthochromatic film. Carbon arc spotlights were purchased from theater lighting companies such as M.J. Wohl and Kliegl Brothers of New York (whose name still survives in the term *klieg lights*).

Another legacy of Belasco's illustrious career was carried on by a young man who worked as an actor for him, Cecil B. DeMille. DeMille rebelled against the flat illumination characteristic of the open-to-the-sky film stages. In the film *The Warrens of Virginia*, director DeMille and cameraman Alvin Wyckoff employed a startlingly modern concept: they enclosed the set in black

velvet to reduce bounce reflection and used sunlight reflected through windows as the sole source.

At the time, only a few American filmmakers, DeMille, Edwin Porter, and D.W. Griffith's cameraman Billy Bitzer, fought the stylistic preference for broad, flat lighting. Griffith and Bitzer had used firelight effects in *The Drunkard's Reformation* in 1908 and the next year *Pippa Passes* evoked the changing time of day with directional lighting simulating the passage of the sun. *The Thread of Destiny* contained scenes lit solely by slanting rays of sunlight and may be the first truly effective use of chiaroscuro (dubbed *Rembrandt lighting* by Wyckoff).

Introduction of Tungsten Lighting

For years, cameramen looked longingly at the compact, versatile tungsten lamps that were then available (called *Mazda lamps* at the time), but attempts to use them were foiled by the spectral sensitivity of the film stocks in use at the time; they were almost completely blind to red light—even slightly red objects would photograph as black. The tungsten incandescent bulbs were (as they are today) heavily weighted in the red end of the spectrum. In 1927, the intro-

1.5 Arc broadsides, an early adaptation from another industry.

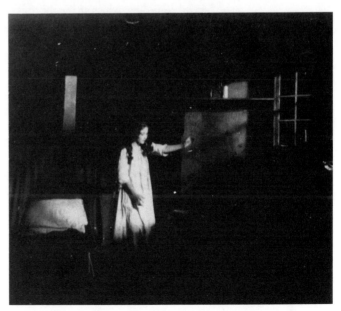

1.6 *Pippa Passes* (1909), one of the earliest uses of motivated light on a film set.

duction of a film stock sensitive to all visible wavelengths (hence its name, *panochromatic*) altered the lighting needs radically. The new stock was compatible with tungsten incandescent sources, which offered many advantages, including reduced cost. *Broadway*, produced in 1929 by Universal and shot by Hal Mohr, was the first film lit entirely with tungsten.

Studio management saw in the new technology an economical means by which set lighting could be accomplished by the push of a button. The "bean-counters" in the head office (they had them even then) responded enthusiastically to the economics of incandescent lighting, so much so that in some studios the use of arc lighting was banned except by special permission. With sound technology confining the cameras to immobile "ice boxes" and the resulting lack of the powerful arcs to create strong effects, the outcome was many a visually dull picture and one of the low points of studio cinematography.

The makers of carbon arcs responded to this challenge by developing carbons that were compatible with panchromatic film. Even with the new carbons, arcs remained (as they do to this day) more labor intensive and bulky. The death blow was dealt by the advent of sound recording, which made the noisy, sputtering carbon arcs even less useful.

The drawback of incandescent lights was and still is that they are inherently far less powerful than carbon arcs. The need to achieve maximum output from the incandescent lamps resulted in the introduction of an improved reflector made of highly polished, mirrored glass. Lights based on this technology were sometimes called *rifles*, for their ability to project sharp beams long distances. They were efficient but hard to control; they were hardly more than a raw source of light. What cinematographers yearned for was a light of even greater intensity, but with controllable beam spread and distribution. In 1934, the introduction of the fresnel lens led to the development of lighting units that are almost indistinguishable from those we use today.

Following the introduction of three-strip Technicolor with the film *Becky Sharp* in 1935, arcs came back into favor. Technicolor required a spectral distribution close to that of natural daylight, which made tungsten lighting difficult. In the intervening years, manufacturers had managed to make arcs quieter and so white flame carbons which produce daylight blue with very high output were just the ticket for the new process. The addition of the fresnel lens also made them more controllable.

This was the heyday of the carbon arc. Not only did they have the correct color balance but the fact that Technicolor is a process where the image formed by the lens is split by prisms to three different film strips meant that enormous quantities of light were needed. Some early Technicolor films were lit to such intensity that piano lids warped and child performers (most notably Shirley Temple) were barely able to withstand the heat on the set.

In order to use tungsten lights with color, it was necessary to lose almost half of the light to filtration, so their use on color sets was very limited; they still found wide use in black-and-white filmmaking and later in television.

The Technicolor Era
As with the advent of sound, Technicolor imposed severe restrictions on cinematographers. Until color came along, the use of light meters was almost unknown: cameramen used film test, experience, and guesswork to establish exposure. The precise engineering needs of the three-strip process made it necessary to impose rigid standards. In the early days, cameramen were not trusted to handle the job alone. The licensing of the Technicolor process carried with it the obligation to employ one of their own advisory cameramen to oversee color balance and exposure. Films of this period are distinguished by having two cameramen listed in the credits.

The constant supervision of the Technicolor cameramen, along with the employment of *color advisors* gave rise to the still current myth of the "Technicolor look." Contrary to popular belief, the Technicolor process and the film stock then available did not necessarily lead to bright, intense color completely lacking in subtlety. What we think of as the Technicolor look is in fact a reflection of the desire to show off the new technology, coupled with the somewhat primitive artistic tastes of the studio chiefs of the period. Since the process gave engineers and advisors as much input into the look of the film as the cameramen and directors, the dictates of the head office could be implemented in an orderly, bureaucratic way, thereby bypassing the age-old film tradition according to which directors and cameramen would agree to ridiculous demands in the conference room, then follow the dictates of conscience and art while on the set.

The pendulum swung back to tungsten with the introduction of *high speed* Technicolor film balanced for incandescent in 1951. Other companies such as Kodak and Ansco also made tungsten balance films available. This established the standard that prevails: color films balanced for tungsten light but usable in daylight with filtration. Only recently has Kodak introduced its excellent line of daylight balance negative films.

In 1955, *yellow flame carbons* (tungsten balance) were invented, which made arcs usable with the new tungsten-balanced films without the use of color correction.

One major obstacle remained for incandescent lamps: the vaporized tungsten metal that *burned off* the filament tended to condense on the relatively cooler glass envelope of the bulb. As a result the output of the lamp steadily decreased as the lamp burned; in addition, the color balance shifted as the bulb blackened. One solution was to put small pellets inside the bulb. When it had turned black enough to be a problem, the bulb was removed from the light, held upside down, and swished around so that the pellets could clean off the inside of the glass.

A far more practical solution was the invention of the tungsten-halogen regenerative-cycle sources in the early 1960s. Employing a gas cycle to return the boiled-off metal to the filament, the design resulted in lamps with longer lifespans and more efficient output.

Another advantage of the smaller

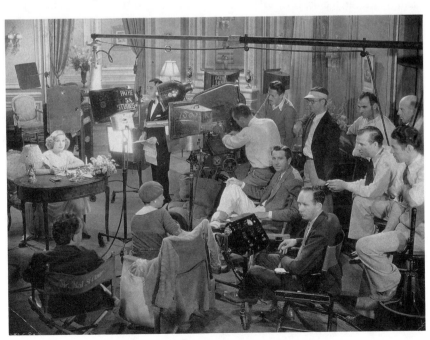

1.7 Shooting crew at work on *Goldie*, a 1932 film.

quartz lamps is their ability to fit into smaller housings than could a conventional tungsten incandescent. The result has been more compact lights (baby babies, baby deuces) and smaller lights, such as the popular Tweenie 650-watt size.

The Introduction of the HMI

The next revolution in lighting came in the late 1960s when enclosed metal arcs (HMIs) were developed for German television. Their main features are the tremendous advantage in lumens-per-watt output over conventional sources and the fact that they are daylight color balanced without the need for filtration.

HMIs have changed the lighting business by allowing more powerful sources with less electrical input, which translates into smaller generators and smaller cables. The largest sources (12Ks and 18Ks) have output that equals and exceeds the output of the power-hungry carbon arcs but don't require direct current (DC) or a full-time operator.

Although originally developed for television, filmmakers were quick to recognize the advantages of these stable, efficient sources. When the first film was shot using the new lights, they were horrified when the exposure varied constantly. Research quickly revealed the cause of the notorious flicker effect: HMIs are arc sources just like the old Brutes, but while Brutes were DC, HMIs are alternating current (AC). The light output varies as the AC cycle goes up and down, as a result the output of the light varies as well.

For video this is no problem, since both are synchronized to the same AC cycle. In film, however, there are many conditions where the two are not synchronized. We now know the conditions that must be met for HMIs to be used successfully, but the problem has

added new considerations to filming and imposed limitations on many types of filming, particularly high-speed photography and working with live monitors.

Meanwhile, 1982's *Blade Runner*, with its stunning cinematography by Jordan Cronenweth, ushered in a new player—xenons.

A gas discharge arc, the *xenon* is a cousin to the HMI and big brother to xenon gas projector lamps used in theaters. A highly efficient source coupled with a polished parabolic reflector gives xenon the capability of extraordinary output in an extremely narrow, focused beam. Although very specific in application, xenon has proved a useful and powerful tool for the image maker.

Only now becoming widely available, the latest development is flicker-free HMIs that feature electronic rather than magnetic ballasts. They promise to make the HMI a useful tool in all lighting situations. Other developments include the creation of fluorescent tubes with color rendition good enough for color filming applications.

Today's image maker has a wide variety of powerful and flexible tools available for lighting in film and video. Extraordinary advances in emulsion technology by Kodak and others, as well as progress with video tubes and image processing and the potential introduction of high definition television (HDTV), all provide opportunities for richer and more expressive lighting and shooting.

The history of lighting is the story of adapting new technology and new techniques to the demands of art and visual storytelling. The same concerns still face us every day on the set and we can draw on the rich experience of those who have gone before us.

2. Physical Light and Perception

To understand how we can use light for our purposes, we must know something about its characteristics and how it works. It is a physical, a sensory, and a psychological phenomenon.

The Physics of Light

Light is unique in nature. It is both particle (photon) and wave, mass and energy. Its family is all types of electromagnetic radiation, extending from cosmic rays to the longest audio waves with frequencies extending from just a few cycles per minute to 1×10^{22} cycles per second (1×10^6 is a million).

The waves of the electromagnetic spectrum are measured in two ways, wavelength and frequency. *Frequency* is defined as the number of complete waves, or cycles, per second. Cycles per second is also referred to as hertz (Hz). *Wavelength* is defined as the linear distance occupied by a complete wave or cycle, measured horizontally. The two are not independent, however; they vary inversely in proportion to each other. The smaller the distance between

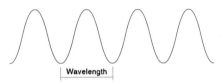

2.1 A typical sine wave.

two wave crests, the more of them will fit into a one-second span of time.

Visible light is only a small part of the electromagnetic spectrum. The wavelength of light is measured in nanometers (nm), a unit equal to one one-millionth of a millimeter (10^{-9} meter), and has a frequency of 10^5 to 10^6 gigahertz (GHz) or billion cycles per second. Visible light extends from approximately 400 nm to 700 nm. On either side of the visible spectrum are infrared and ultraviolet wavelengths, which are invisible to the human eye but perceptible to photographic emulsions and light meters.

Variations in wavelength in the visible spectrum are perceived by the brain

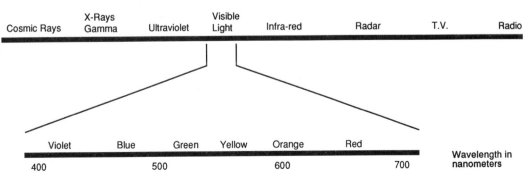

2.2 The electromagnetic spectrum.

as differences in color, varying from violet at the 400 nm end to red at the 700 nm end. Later when we discuss color, gels, and filters, the arrangement of this spectrum will be shown.

It is impossible to consider light as a merely electromagnetic phenomenon. More than any other force of nature, what light is and does is inextricably linked with how our eye processes it and how our brain perceives it.

Fundamentals of How We See: The Brain and The Eye

The eye focuses the image of a viewed object on a small area at the back of the eye: the retina. The retina is composed of two types of receptors: rods and cones. The rods are far more sensitive to light, but poor at perceiving fine detail. They are insensitive to color except at the blue end of the spectrum. Cones are concentrated in a small area of the retina called the *fovea*. They are less numerous than the rods and less sensitive to light, but they are far better at discriminating fine detail, color, shape, and position.

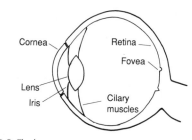

2.3 The human eye.

2.4 Human eye sensitivity.

Cones are further divided into three types according to color sensitivity: some respond to blue/violet, some to green/yellow, and some to red/orange, with their respective ranges roughly centered on 440 nm, 550 nm, and 610 nm. As we will see later, this is quite similar to the way color film works.

For example, yellow light of about 580 nm generates a roughly equal response in the red and green sensitive cones, with a much smaller response in the blue cones. As we shall see in Chapter 4, mixing red and green light produces yellow. The eye works in an analogous way: if two different wavelengths reach the cones, say 550 nm (green) and 640 nm (red), this produces the same response as light of 580 nm (yellow).

Perception by the rods is called scotopic vision and by the cones, photopic. The differences between rods and cones account for many aspects of color perception including the ancient mystery of why all cats are gray in the moonlight. The rods, being more sensitive but color blind, are the primary source of an image in low-light situations, where there is not enough spectral energy to stimulate the cones. In essence, we see in black and white in low-light situations.

The mystery of our perception of the color of moonlight is also explained by this arrangement of rods and cones. Moonlight is perceived by most people as slightly blue. In theater and film the convention is for moonlight to be blue in varying intensities. In fact, moonlight is sunlight reflected off the neutral gray surface of the moon. It is the same color as sunlight. Why does it seem blue? The answer is something called the Purkinje effect. The intensity of moonlight puts it in what is called the *twilight zone*, which is the level at which the eye starts to shift over from photopic to scotopic vision. As this shift occurs the eye loses the red/orange sensitivity of the cones and gains in the blue/green sensitivity of the rods. The result is that we experience moonlight as blue. Lighting is art,

not science, it is therefore legitimate to make moonlight blue, even though it is not.

Logarithmic Perception

In 1890, the German physiologist E.H. Weber discovered that changes in any physical sensation (sound, brightness, pain, heat) become less noticeable as the stimulus increases. The change in level of stimulus that will produce a noticeable difference is proportional to the overall level. If three units of light create a perception of brightness that is just noticeably brighter than two units, then the smallest perceptible increase from 20 units of light will require 30 units.

To produce a scale of steps that *appear* to be uniform, it is necessary to multiply each step by a constant factor. In fact, the perception of brightness is logarithmic.

Logarithms are a simple way of expressing large changes in any numbering system. If, for example, we wanted to make a chart of something that increases by multiplying by 10 (1, 10, 100, 1,000, 10,000, 100,000), we very quickly reach numbers so large as to be unwieldy. It would be extremely difficult to make a graph that could handle both ends of the range.

In log base 10, the most common system, the log of a number represents the number of times 1 must be multiplied by 10 to produce the number. One must be multiplied by 10 once to make 10, so the log of 10 is 1. To arrive at 100, you multiply 1 by 10 twice, so the log of 100 is 2.

Number	Log
1	0.0
2	0.3
4	0.6
8	0.9
10	1.0
16	1.2
32	1.5
64	1.8
100	2.0

2.5 Examples of the logs of smaller numbers.

The log of a number is the exponent of 10, $10^2 = 100$, so the log of 100 is 2; 10^4 is 10,000, so the log of 10,000 is 4. This means that we can chart very large changes in quantity with a fairly small range of numbers.

As we will see, logs are used throughout lighting, photography and video.

Brightness Perception

Our perception of brightness is logarithmic, and we shall see that this has far-ranging consequences in all aspects of lighting for film and video. If we chart the human perception of brightness in steps that appear smooth to the eye we can follow its logarithmic nature. It is apparent that each step up in a seemingly even scale of gray tones is, in terms of its measured reflectance, spaced logarithmically.

Perception	% Reflectance
White	100%
	70%
	50%
	35%
	25%
Middle grey	17.5%
	12.5%
	9%
	6%
	4.5%
Black	3.5%

2.6 Perception Reflectance Chart

As we shall see later, this chart is in fact fundamental to the entire process of lighting and image reproduction.

Color Adaptation

Technically, *white light* is a mixture of all the colors of the spectrum. In fact, there is enormous variation in what we call white light. Midday sun, the light of an ordinary light bulb, and the light of a fluorescent tube are in every measurable way different colors of light, and yet we experience them all as white light. It is only when we view them side by side that the differences are apparent.

The reason for this is adaptation, a

Daylight sources

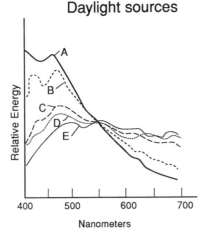

A: Clear noon sky
B: Clear north sky
C: Sun plus sky
D: Overcast sky
E: Direct sun

Sun direction

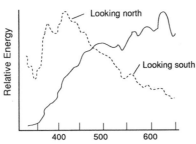

2.7 Spectral distribution of daylight looking north and south.

perceptual and psychological phenomenon by which the brain compensates for color variations. To a large extent, the light appears white because we *believe* it is white as a result of environmental conditioning.

Two other phenomena are associated with this general color adaptation, local and lateral adaptation. Local adaptation occurs when we look at a strong color for a few minutes. The color perceptors become overloaded and will retain a color image for a few seconds even as we look away. This image is a negative, however, and appears in the complementary color.

Lateral adaptation occurs between a colored area and its background. A highly colored object will appear to in-

duce a complementary hue in its neutral background. Also, colors appear lighter when we see them against a black background and darker against a white background.

Brightness Adaptation
Just as the brain adjusts for deviation in color, it also compensates for variations in brightness level. Part of this is, of course, physical. The iris of the eye expands and contracts in exactly the same way as the iris of a photographic lens, admitting more or less light. (The eye is basically an f/2 optic, with a top end of only f/10.) Also, the photochemical sensitivity of the retina changes, not unlike changing from a slow to a fast film.

Another factor is psychological adaptation, which is called brightness constancy. Ansel Adams, in his book *The Negative,* makes an excellent example that you can try yourself. In a room lit only by one window, place several pieces of white paper at varying distances from the window, say 4, 8, 12, and 16 feet from the window. Clearly those nearest the window are receiving a great deal more light than those farther away (in fact, due to the inverse square law their actual luminances are 1, 1/4, 1/9, and 1/16). To a light meter and to a photographic emulsion they vary from white to gray, with those nearest the window being the lightest and those farthest away being the darkest. But our brain knows them to be pieces of white paper, and therefore we perceive them as white.

Other Types of Constancy
In addition to brightness constancy, there is color constancy, which affects mostly familiar objects. We "know" that apples are red so we see them as such even under varying colors of light. We "know" that shadows are black even though they may in fact be any color.

We are also affected by size constancy, which helps us understand that a telephone pole which is 100 yards away is not actually smaller than the

2.8 Size constancy is an important factor in perceiving distance and perspective.

one nearest us. Shape constancy helps us recognize objects even when they are distorted by perspective.

Perception of Space

There are several ways in which we perceive the relative spatial distribution of objects.

Binocular. The most fundamental way is stereoscopic or binocular vision. The brain calculates the difference in the views of the two eyes and interprets from this the distance of the object.

Behind/in front. Obviously, things that are seen as behind are interpreted as being farther away than things in front.

Size constancy. Size constancy, as in Figure 2.8, helps us determine distance.

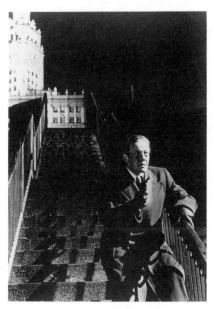

2.9 In this scene from *The Third Man* the shadow pattern on the steps creates a tense, staccato rhythm, which contributes to the mood of the scene.

Spatial induction. Light toned objects are perceived by the brain as being larger and closer than darker objects.

Resolution. The discrimination of fine detail affects perception of distance.

Haze. Related to discrimination of detail is atmospheric haze. A mountain whose details are obscured by haze is seen as farther away than one that is clearly resolved.

Above/below. Absent other clues, things that are above are perceived as being distant and things below as near. The clearest example of this is in medieval painting before the discovery of optical perspective by Brunelleschi and Alberti.

How Light Shapes Our Perception

- Light is the most important influence on our visual perception of the world; we see far more than we touch or smell.
- Light reveals *form* to us. In conjunction with perspective and the constancy effects, we understand the shape of the physical world by how light and shadow falls upon it.
- Short of actually touching an object, its *texture* is known to us by the way it takes the light, in its relative reflectance and degree of smoothness or roughness.
- Perception of *distance* and perspective are affected by the quality of light.
- *Color* works on so many levels that we will devote an entire chapter to it,

2.10 Texture revealed by light.

but in this context we must mention the psychological power of color, which is becoming a science in itself. Cultural values (darkness associated with evil, lightness with good), psychological effects (red is hot, blue is cool), and memory (glowing magenta for sunsets, flickering amber for firelight) all play a crucial role in shaping our perception. For those who want to use light for a purpose, these associations should be a source of constant study.

- Light directs our *focus* by emphasizing or de-emphasizing objects or spaces and by guiding the eye.
- Light is the key factor in establishing *mood,* time, and atmosphere.
- Light can be visually *unifying* or *divisive,* delineating compositional relationships and groups.

3. Exposure

Technically, *exposure* refers to the act of exposing the film or video tube to light, but it has come to have a larger meaning as well. Exposure is more than merely setting the aperture on the lens: the basic concepts of exposure control are fundamental to everything we do in lighting and camerawork.

On the surface, exposure is a simple technical matter, the technician determines the light level of the scene and sets the lens accordingly. But as Ansel Adams notes in *The Negative,* "...our aesthetic and emotional reactions may not be ruled by simple numbers, we must learn how to evaluate each subject and understand it in relation to the materials used."

We must begin at the beginning with some definitions of basic terms.

Exposure Definitions

Exposure involves a number of factors. They are
1. light levels in the scene
2. reflectances of materials in the scene
3. sensitivity of the film or video tube
4. latitude of the film or video tube
5. aperture setting of the lens
6. camera frame rate
7. filters, exposure factors, etc.
8. shutter angle,
9. a final, less tangible factor, the photographic effect or mood desired

In order to discuss exposure we have to go over a few basic definitions. Although this discussion will be presented primarily in terms of film emulsions, in most cases it applies equally to video tubes. (For simplicity in this chapter we will use the term *film* generically for the imaging medium. Chapter 13 contains a more specific and technical discussion of video exposure.)

Exposure. Image reproduction materials are all based on a change in tone or density of the emulsion or video tube that varies in relation to how much light strikes it. The amount of light can vary in two ways: the intensity of the light and the amount of time that the light falls on the reproduction material. Within limits, the density change from both is essentially the same. Exposure, then, is the amount of light and the time it is allowed to fall on the exposure plane

$$exposure = intensity \times time$$

F/Stop. The f/stop is a mathematical measure of the ability of a lens to pass light. The variable opening inside the lens is the aperture or iris. The maximum f/stop of a lens is a measure of its light passing ability with the aperture fully open. A lens with a maximum of f/1 would theoretically allow all light passing through it to reach the film. Beyond this maximum, the scale of f/stops (or more commonly *stops*) is a doubling of the *amount of light.* In other words, by *opening up* the lens one stop, you are allowing *twice* as much light to pass. Conversely, by *closing down* a stop, you are decreasing the amount of light by 50%.

Strictly speaking, the term *f/stop* refers only to a lens aperture, but it has gained a more general usage to include any in light value or change in exposure. More technically, an f/stop on a lens is the number that is derived by dividing the focal length of the lens by its *effective aperture,* that is the diameter of

the beam of light which can pass through the lens at a given setting.

$$C = \frac{F}{d}$$

where F is the focal length and d is the diameter of the lens with the iris fully open.

The actual f number series is

f/1	f/1.4	f/2	f/2.8	f/4
f/5.6	f/8	f/11	f/16	f/22
f/32	f/45	f/64	f/90	

The series is based on the square root of 2 (approximately 1.4), and every other f number represents a doubling of 1.4 (2.8, 5.6, 11, etc.).Notice that above f/8 there is some rounding.

An increase of 2 stops indicates a *quadrupling* of the amount of light (a factor of four), 3 stops represents an *eightfold* increase in light (a factor of eight), and so on.

Why so complicated? This is a question many cameramen ask as they are trying to calculate the aperture based on a reading of "1/3 under f/11 minus 1/4 stop for frame rate and 1/2 of a stop for filter factor." The simple answer is that it could be a lot less complex (f/numbers are, to a large extent, based on certain arbitrary factors), but no one has ever bothered to make it easy.

There are some reasons for it being the way it is, however. A simple numerical series would not be adequate. For example, think of a simple black-and-white photograph. Say we expose the photograph for 2 seconds and then find that the negative is underexposed. If we increase the exposure to 3 seconds we have increased the amount of light by 50%, but if we were to change the exposure time from 10 to 11 seconds we would be making only about a 10% change. In other words, there is no consistent relationship between increments of time and the percentage change in exposure time. F/stops are a way of dealing with geometric steps that are more consistent with the way imaging mediums react to light.

Since doubling the amount of light reaching most films only results in a modest change in the reproduction scale, any numerical series would involve large numbers and be clumsy to work with.

The entire series, including 1/2 and 1/3rd stops is shown in Table 3.1

Table 3.1

Full Stops	1/3 Stops	1/2 Stops
1		
	1.1	
		1.2
	1.3	
1.4		
	1.6	
		1.7
	1.8	
2		
	2.2	
		2.4
	2.5	
2.8		
	3.2	
		3.4
	3.5	
4		
	4.5	
		4.8
	5	
5.6		
	6.3	
		6.8
	7	
8		
	9	
		9.6
	10	
11		
	13	
		13.6
	14	
16		
	18	
		19
	20	
22		
	25	
		27
	28	
32		
	35	
		38
	40	
45		
	50	
		54
	57	
64		
	72	
		77
	80	
90		

T/stop. A t/stop is an *adjusted f/ stop.* The f/stop of a lens is a purely mathematical calculation. In reality some lens designs are more efficient than others. Zoom lenses in particular are extremely inefficient in allowing light to pass and exposures based on theoretical values might be quite wrong. To remedy the situation, manufacturers test the lenses on an optical bench and calibrate them in "true" f/ stops or *t/stops.* While most lenses have both scales printed on them, always use the t/stop scale. In general, the white scale is f/stops and the red scale is t/stops.

Luminance. Measurements of the intensity of light are based on a *standard candle,* which was the amount of light produced by a certain type of candle. This has been replaced by the *candela* (cd), which is a more high-tech version of the same thing. The luminous intensity of a lamp is often quoted in *candlepower.*

Light that is falling on a surface is quantified in terms of *footcandles,* which is equal to the luminous flux of light from one candela falling on a surface that is one foot from the source. (In the metric system it is the *metercandle* or *lux.*) One footcandle equals 10.764 lux. Lumens-per-square-foot is the same as foot-candles. Most incident-type light meters are calibrated in footcandles or lux.

Two important factors affect the illumination of a surface. First is the *inverse square law.* Crudely put, the amount of light falling on a surface falls off drastically with fairly small movement away from the source. In other words, a surface that is twice the distance away does not receive 1/2 of the amount of light. In reality it is far less. The inverse square law states that intensity change is inversely proportional to the square of the distance.

$$I = \frac{1}{d^2}$$

Thus, doubling the distance in fact cuts the light to 1/4 of its former intensity. In practice the design of the lighting unit alters this ratio.

Second is the *angle of incidence.* Common sense tells us that the amount of light decreases as the surface is tilted away from the source. In fact, it is proportional to the cosine of the angle of incidence. This is called the *cosine law.*

Luminance of a surface is measured in candles-per-square-foot or foot-lamberts. A foot-lambert is the amount of light reflected by diffuse surface with 100% reflectance when the surface is re-

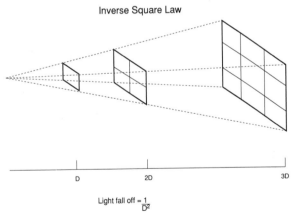

Inverse Square Law

Light fall off = $\frac{1}{D^2}$

3.2 The inverse square law.

1 foot

3.1 A footcandle.

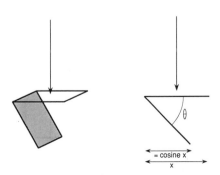

= cosine x

3.3 The cosine law.

ceiving one footcandle and is at right angles to the source.

A candle-per-square-foot is obtained by dividing the foot-lambert value by π, which compensates for the spherical nature of diffuse reflection. Spot meters are sometimes calibrated in candles-per-square-foot.

Film Response to Light

When light falls on the film stock, a chemical reaction occurs in the crystals of silver halide that will cause them to be reduced to particles of black metallic silver during development. In effect, photography is a tarnishing of the silver in the emulsion; in video, the light falling on the image plane induces a proportional change in electrical change. The effect is proportional to the amount

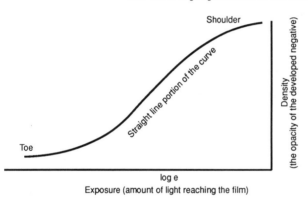

3.4 The basic D Log E curve.

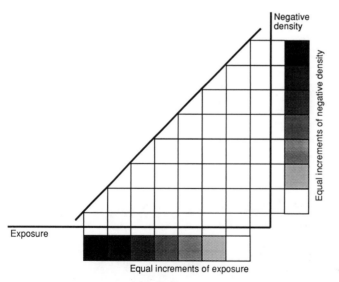

3.5 A theoretical ideal film would record every change in exposure as an equal change in negative density.

of light which falls on any area of the film or video tube.

Well, *almost* proportional, and therein lies the rub. It is the lack of strict proportionality that causes cameramen endless torment, but also makes the magic possible.

The human eye is capable of processing an image with a brightness ratio of roughly 256:1 (seven stops, which is an average; it varies according to light level). In real life, brightness ratios may run as high as 10,000:1. It is the nonlinearity of reproduction which makes it possible to compress much of the visual data which we record.

The H & D Curve

To understand film response we must look at its curve. This classical approach to densitometry (the scientific analysis of exposure) was devised by Hurter and Driffield and so is called the H & D curve or sometimes the *D Log E curve.*

It plots the amount of exposure (E) in logarithmic units along the horizontal axis and the amount of density change in the negative (D) along the vertical axis.

Let's look at a theoretical *linear* film. For every additional unit of exposure, the density of the negative changes exactly one unit (Figure 3.5). The slope of this line (in this case 45°) is a measure of the amount of contrast of the film. In a film where large changes in exposure only change the negative density a little (low-contrast reproduction), the slope is very shallow. Where a film is very high-contrast, the slope is very high. In other words, small changes in the amount of light cause the film density to change drastically.

No film acts in the perfectly linear manner of this first example. In Figure 3.6, we see a film that only changes 1/2 unit of density for each additional unit of light. This is a *low-contrast* film.

In Figure 3.7 we see a *high-contrast* emulsion: for each additional unit of exposure, it changes 2 units of negative density. Looking at the brightness

range of the exposure against the brightness range of the negative density, we see that it will show more contrast in the negative than actually exists in the scene. The slope of this line is called the gamma of the film, it is a measure of its amount of contrast.

Gamma is measured in several different ways as defined by scientific organizations or manufacturers. Basically the slope of the straight-line portion of the curve is calculated by more or less ignoring the shoulder and the toe portions of the curve (Figure 3.8).

But there is another wrinkle. In the lowest range of exposure, as well as in the highest range, the emulsion's response changes. In the lowest range, the film does not respond at all as it "sees" the first few units of light (until it reaches the inertia point where the amount of light first begins to create a photochemical change in film or an electrical change on a video tube), and then it begins to respond sluggishly. Negative density changes only slightly for each additional unit of light. This region is called the *toe* of the curve. In this area, the changes in light value are compressed.

At the upper end of the film's sensitivity range is the "shoulder". Here also, the reproduction is compressed.

The end result is that film does not record changes in light value in the scene in a linear and proportional way. Both the shadows and the highlights are somewhat crushed together.

The Log E Axis

Let's think about the Log E axis for a moment. It is not just an abstract scale of exposure units. Remember that it represents the various luminances of the scene. All scenes are different, and thus all scenes have different luminance ratios. What we are really plotting on the horizontal axis is the *range* of luminances in the scene, from the darkest to the lightest. (See Figure 3.17). Remember that these are not fixed values (the darkest point on the Log E axis is not a certain number of candles-per-square-

foot, for example), because we open or close the aperture of the camera to adjust how much light reaches the film and we use faster or slower film, and so on. What really counts is the ratio between the darkest and lightest, and that is what we are plotting on the Log E axis.

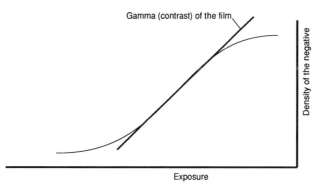

3.7 A high-contrast film.

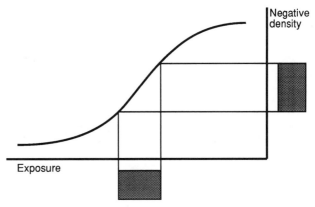

3.6 A low-contrast film.

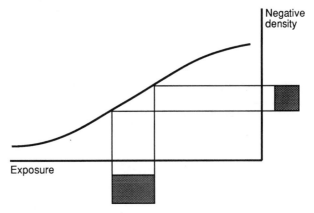

3.8 The gamma of a film.

Each unit on the log E axis represents one stop more light. If the brightest point in the scene has 128 times more luminance than the darkest point (seven stops), then we say it has a seven-stop *scene brightness ratio.*

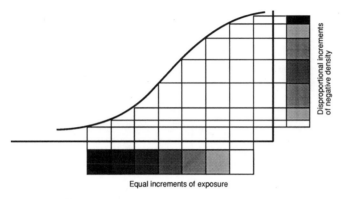

3.9 Gray scale compression.

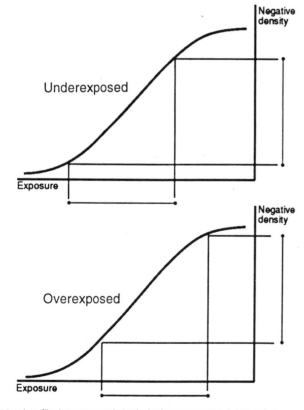

3.10 When film has generous latitude, both an overexposed shot and an underexposed shot produce usable negatives.

Correct Exposure

Correct exposure, then, is essentially the aperture setting that will best suit the scene brightness range (the horizontal axis, Log E) to the characteristic curve of the imaging medium. What is needed is to slip the scene values comfortably in between the toe and the shoulder. A typical scene with a seven-stop range of light values fits nicely on the curve *if* we place the exposure exactly in the middle.

Graphically, overexposure appears as a shift of the subject brightness range (Log E) to the right. (In effect we are making the scene values "brighter" by opening up the aperture.) Here we see that this overexposure places the scene values too much in the shoulder. Some information is lost in the flat part of the shoulder; lost because the differences of scene brightness values result in no change in the density of the negative. Further, because everything is shifted to the right none of the scene values fall in the toe of the curve. There will be no deep black values at all in the final print, even though they existed in the original scene.

Underexposure is shown as a shift of the Log E values to the left. Here every subtle nuance of the high tones will be recorded because they fall in the straight line portion of the curve. But at the dark end of the scale—trouble. All of the dark values of the scene are mushed together in the toe. There is little differentiation of the medium gray values, the dark gray values, and the black shadows. In the final print they will all be a black hole.

The relationship of the gamma (the angle of the straight line portion of the film: its amount of contrast), the toe, and the shoulder is what determines a film's "latitude." Latitude can be viewed as two characteristics: the emulsion's room for error in exposure or the ability of the film to accept a certain brightness range. In these diagrams, a film with great latitude will produce an acceptable negative with either of the two exposures.

The problem is exacerbated if we consider a scene that has more than seven stops of brightness. Here there is no aperture setting that will place all of the values on the useful part of the curve. If we expose for the shadows (open up the aperture) we get good rendition of the dark gray areas, but the light values are hopelessly off the scale.

If we "expose for highlights" (by closing down to a smaller f/stop) we record all the variations of the light tones, but the dark values are pushed completely off the edge.

How do we deal with this situation? Later we will discuss some rather abstruse solutions to the problem (flashing, Lightflex, etc.) but there is one solution that is really what we are all about: we change the brightness range of the scene so that it will fit the curve of the film; it's why we get the big bucks.

This, then, is one of the most essential jobs of lighting—to render the scene in a scale of brightness values that can be accommodated by the optics and emulsion of a film camera or by the optics and electronics of video.

Modern films have consistently improved in latitude even as they have increased in speed and reduced grain. The new high-speed emulsions in particular are amazing in their ability to record subtleties even in heavily overexposed highlights and in very dark shadows. Although there has been some improvement, the ability to handle brightness ratios is still one of the most crucial differences between film and video.

Determining Exposure

So we have two basic tasks:

- to manipulate the brightness ratio of the scene so that it can be properly reproduced on film or video
- to set the aperture so that the scene values fall on the appropriate part of the curve

In practice these often turn out to be two sides of the same coin. The first task is essentially the work of lighting

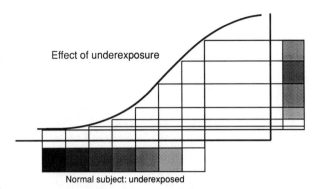

Effect of underexposure

Normal subject: underexposed

3.11 Underexposure means that no part of the negative reaches maximum density. As a result, there will be no completely white areas in the print.

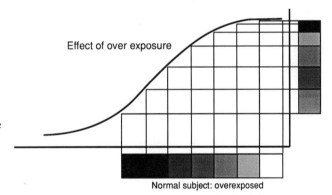

Effect of over exposure

Normal subject: overexposed

3.12 Overexposure means that no part of the negative reaches minimum density. The final print will contain no areas that reflect the deep black areas of the original subject.

and lighting control: the second task involves measuring the scene and making a judgement about the best setting for the lens.

The Tools

The two most basic tools of the trade are the incident meter and the spot meter. There is a third type of meter, the wide angle reflectance meter (what most photographers would simply call a *light meter*), but it has extremely limited use on professional sets.

Let's take a look at them.

The Incident Meter

The incident meter measures scene illumination only. In other words, the amount of light falling on the scene. To

Stops	Ratio
2/3	1.5:1
1	2:1
1-1/3	2.5:1
1-2/3	3:1
2	4:1
2-1/3	5:1
2-2/3	6:1
3	8:1
3-1/3	10:1
3-2/3	13:1
4	16:1
5	32:1
3-2/3	13:1
4	16:1
5	32:1

3.13 Although they are not as commonly used as they once were, you will still hear the phrase, *lighting ratio*. This chart covers most ratios.

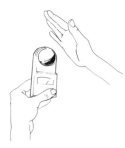

3.14 Incident meter.

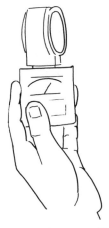

3.15 Incident meter with
flat plate.

3.16 Spot meter.

accomplish this purpose, most incident meters use a hemispherical white plastic dome that covers the actual sensing cell.

The diffusing dome accomplishes several purposes. It diffuses and hence "averages" the light that is falling on it. It also approximates the geometry of a typical three-dimensional subject. Unshielded, the dome will read all of the front lights and even some of the side-back and backlight that might be falling on the subject. Left to itself, the hemisphere would provide a reasonable average of all the sources falling on the subject. In practice, many people use their opposite hand to shield the back-light off the reading, and use a combination of hand shielding and turning the meter to read the backlight and sometimes the key, fill, side, lights and backlights separately.

The classical practice, however, is to point the hemisphere directly at the lens, eliminating only the backlights, and then take a reading exactly at the subject position. Reading key, fill, and backlight separately is in fact only a way of determining the ratios and looking for out-of-balance sources. The actual reading that will determine the aperture setting is the averaging one. Later we will look at applications that go beyond the simple classical approach and are useful in dealing with unusual situations.

Most meters that are used with the diffusing dome also come with a flat diffusing plate that has a much smaller acceptance angle (about 45° to 55°) and has a cosine response rather than an averaging one. This means that the angle of the light falling on the plate has an effect on the reading, just as it does in illuminating a subject. The flat plate makes readings for individual lights simpler and is also useful for measuring illumination on flat surfaces, such as in copy work, animation plates, etc.

Incident meters are generally also supplied with a lenticular glass plate that converts them to wide acceptance reflectance meters. These see little use

on most sets as they have very wide acceptance angles and it is difficult to exclude extraneous sources from the reading.

For the most part, incident meters are set for the film speed and shutter speed (either electronically or by using slide-in plates) and then read out directly in f/numbers. The Spectra and Sekonic, among others, have an alternate mode that reads footcandles directly; the user is then able to calculate exposure separately. This is useful if there is no slide for the exposure index (EI) being used.

The Spot Meter

Reflectance meters read the actual luminance of the subject, which is itself an integration of two factors: the light level and the reflectivity of the subject. On the face of it, this would seem to be the most logical method of reading the scene, but there is a catch. Simply put, a spot meter will tell us how much light a subject is reflecting but this leaves one very big question: how much light do you *want* it to reflect? In other words, incident meters provide *absolute* readouts (f/stops) while spot meters provide *relative* readouts that require interpretation.

While most spot meters were formerly calibrated in exposure value (EV) units, some of the new electronic spot meters provide direct readout in f/stops, but it would probably be better if they didn't as they are a source of much confusion. Think of it this way: you are using such a meter and photographing a very fair skinned woman holding a box of detergent in front of a sunset. You read the woman's face, f/5.6, the box reads f/4, the sky is f/22. So where are you? Not only do we not know where to set the aperture, we don't even know if the situation is good or bad.

Let's step back a moment and think about what it is that light meters are telling us. To do this we have to understand the cycle of tone reproduction and lay down a basic system of thinking about it.

The Gray Tone Reproduction Cycle

We must remember that the exposure values of a scene are not represented by one simple number. Most scenes contain a wide range of light values and reflectances. In evaluating exposure we must look at a subject in terms of its light and dark values, the subject range of brightness. For purposes of simplicity we will ignore its color values for the moment and analyze the subject in terms of its monochromatic values.

Let's visualize a continuous scale of gray values from completely black to completely white. Each point on the gray scale represents a certain value that is equivalent to a tonal value in the scene. In everyday language we have only vague adjectives with which to describe the tones—dark gray, medium gray, blinding white, and so on. We need more precise descriptions.

Using Ansel Adams' classic terminology we will call the most completely black section Zone 0 and each tone which is one f/stop lighter is one zone "higher." For example, a subject area that reflects three stops more light than the darkest area in the scene would be designated Zone III. Still photographers might be accustomed to thinking of ten zones in all, but if there is a great contrast range in the scene, there might well be zones XII, XIII, or more. (Zone system purists will no doubt object to such an extreme simplification of the method, but it is sufficient for the present discussion since few cinematographers do their own darkroom work.)

What we are measuring is subject brightness (luminance), which can vary in two ways: its inherent reflectance and the amount of light that falls on it. Reflectance is a property of the material itself. Black velvet reflects about 2% of

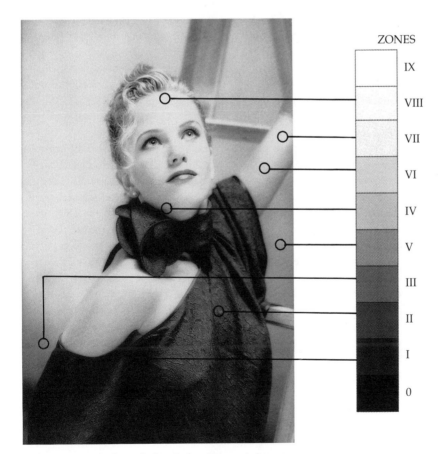

3.17 A zone scale. Each tone in the print matches a particular zone.

the light that falls on it. A very shiny surface can reflect up to 98% of the light that falls on it. This is a reflectance range of 1:48. However, this is the reflectance ratio if the *same amount* of light falls on both objects. In reality, different amounts of light fall on different areas in the same frame (indeed, we make our living making sure they do).

In natural light situations the reflectance ratio can be as much as 3,200:1. Picture the most extreme example possible: a piece of extremely absorbent velvet in deep shadow in the same scene with a mirror reflecting the sun.

The brightness range of a typical outdoor subject is about 1000:1. This is 15 stops and here's the rub: imaging systems cannot reproduce this range of subject brightness, just as the human eye cannot accommodate such a range.

The Zones

Examine a typical scene with the spot meter. If you assign the darkest black value to Zone 0 you can then find areas that are 1, 2 ,3, 4, 5, 6, 7, and perhaps 8 stops brighter than the darkest area (see Figure 3.7). These are Zones I through IX. This is an important exercise and is vital to understanding exposure control. Ignoring the effect of color contrast can be cumbersome. It can be helped by viewing the scene through a viewing glass, which is basically a neutral density filter.

Now picture each of these tonal values arranged in ascending order. What you have is a gray scale, and fortunately it is a commonly available item. Most gray scales are made to reasonably rigorous densitometric standards and are useful calibration tools. Let's take a look at what it really is.

The Gray Scale

There are a great many gray scales but they all have one thing in common: they vary from black to white. Most are divided into six to ten steps but they certainly don't have to be. Many are 20 steps or more. How white the white is

Table 3.2

Zone	%
Zone X	100%
Zone IX	70%
Zone VIII	50%
Zone VII	35%
Zone VI	25%
Zone V	17.5%
Zone IV	12.5%
Zone III	9%
Zone II	6%
Zone I	4.5%
Zone 0	3.5%

and how black the black is varies somewhat depending on the printing quality and the materials involved. Some scales include a piece of black velvet since black paper can never be truly black. For our purposes, we will consider only gray scales where each step represents one full stop increment over the previous; that is, where each step is $\sqrt{2}$ times the reflectance of the previous one.

The Gray Card

There is one special condition of the gray scale that concerns us most directly in practical work—Zone V. In practice it has become the universal calibration standard for all types of photography. What is it that makes this particular zone so important?

Zone V is the middle zone of a ten-zone scale and we would therefore assume it to be 50% reflectance. It isn't, it is 18% reflectance. The reason for this, as we recall from the discussion of perception, is that *the eye perceives changes in tone logarithmically* rather than arithmetically. If each zone were, for example, 10% more reflective than the previous, the eye would not read it as a smooth spectrum.

In fact it works out as shown in Table 3.2

Each step is greater than the previous by $\sqrt{2}$, a familiar number, no? What appears middle gray (Zone V) to the eye is actually 17.5% reflectance, which is universally rounded off to 18%. But wait, there's more. It turns out that if you take dozens of spot readings of typical scenes, most will have an average reflectance of about 18%. Simply put, 18% is the average reflectance of the normal world. Clearly it is not the average reflectance in a coal mine or at the North Pole, but in most of the world it is a reasonable working average.

This gives us a solid ground on which to build. In fact, *it is the standard on which incident meters are built.* As you recall, in the introduction to incident meters we noted that most inci-

dent meters, when set for film speed and shutter speed, read out directly in f/ stops.

How do they do this? How can they know if we are photographing diamonds on a white background or a chimney-sweep in the basement? They don't know, they just assume that we are photographing a scene of normal reflectances, and the diffusing dome averages the light and the meter calculates the f/stop needed to photograph the scene for good exposure.

More simply, if we are photographing a card that is exactly 18% reflectance (a photographic gray card) and we read the light with an incident meter and then set the aperture to the stop the meter indicates, the print will in fact come out to be Zone V. Check it for yourself. Set a photographic gray card in uniform light evenly lit from both sides at roughly 45° front. Read it with a spot meter and note the f/stop the meter indicates. Then read the light with an incident meter. The readings should be exactly the same. If they're not, have your meters checked.

Now try a reverse experiment. Read a uniformly lit scene with an incident meter and notice the indicated stop. Now take the spot meter and read various parts of the scene until you find something that the spot meter indicates as the same f/stop. You have just found a Zone V subject brightness. Now photograph the scene with a black-and-white Polaroid or with black-and-white film. Compare the Zone V subject with the gray card— they should be roughly the same.

This is the simple key which unlocks the world of exposure control:
• an incident reading
• an average 18% reflectance
• a spot meter reading of a gray card, and
• Zone V
are *all the same thing* looked at from different perspectives.

The result of this is that there are many different ways to read the exposure of a uniformly lit scene and arrive at the same result.
• You can read it with an incident meter.
• You can place a gray card in the scene and read it with a spot meter.
• You can find something in the scene that is Zone V and read it with the spot meter.

Let's think about that last one, because it really points us in a whole new direction. It depends on you making a certain judgment. You have to look at a scene in the real world of color and decide that it is about Zone V or middle gray. (It takes some practice to do this, but it is an incredibly important exercise; I urge you to do it often.)

What about the next logical step: what if there isn't anything in the scene that is middle gray? What do we do then?

Let's remember that each step on the gray scale is one stop different from its neighbor. So if Zone V equals f/4 (given a particular film and shutter speed) then Zone VI must be f/5.6 and Zone IV must be f/2.8, right?

So if there is nothing in the scene that equals Zone V, but there is something in the scene that equals Zone VI, we're still in business. If we read it and it equals f/5.6 then we know that Zone V would be f/4. We also know that Zone V (f/4 in this example) is the same as an incident or average reading and is therefore the correct f/stop to set on the lens.

So what is there that we can count on to be roughly Zone VI under most conditions? Easy one—Caucasian skin. Average Caucasian skin is around Zone VI; it is in fact one of the few constants we can count on. Get out your light meter and check it out. If you are ever stuck without an incident meter, or worse, even without a spot meter you can always use the old palm trick. Use your spot meter or any reflecting meter to read the palm of your hand. This equals Zone VI. Then open up one stop to get Zone V and you have your reading. (There is a greater variation in

black people's skin and so there is no one standard; however many cameramen take Zone V as a starting point.)

Or how about this worst case. Let's say your meter case was lost by the airline and there is not a single light meter on the set. What to do? Look around and see if anyone has a single lens reflex camera. Almost universally, they have averaging light meters in them. Read your hand through the camera and there it is, Zone VI.

I think you can see where this leads us. We don't have to confine ourselves to just reading things that equal Zone V and Zone VI; in fact we can do it with any zone. It all depends on your judgment of what gray tone a subject brightness should be. In real life, it takes years of practice and mental discipline to accurately determine subject brightnesses in terms of gray scale values, but in the long run it is a useful skill.

If you can visualize what gray scale value you want a particular subject to be in the final print, you then have the power to "place" it where you want it in the exposure range. This turns out to be a powerful analytical and design tool.

Place and Fall

What do we mean by *placement*? We just saw its simplest form. We placed the skin-tone value of the hand on Zone VI.

We can, if we want, place any value in the scene. Say we have a gray background in the scene that the director wants to be light gray. We decide that by light grey, he means Zone VII (two stops above middle gray). We then read the background with a spot meter and it indicates f/4. We then count down two stops and get f/2. If we set the lens at f/2, that gray background will photograph as light gray or Zone VII.

Let's try the reverse as a thought experiment. Say we had the same background under exactly the same lighting conditions, but the director decided he

wanted it to be dark gray, which we take to mean Zone III. We read it with the spot meter and of course nothing has changed; the spot meter still indicates f/4, only now we want the gray background to appear much darker, so we place it on Zone III, which we do by counting up two stops to get f/8. Common sense tells us that if we photograph the same scene at f/8 instead of f/2, it is going to come out much darker in the final print; that is, the gray background will not be Zone III (dark gray) instead of Zone VII (light gray). Nothing has changed in the actual set; we have changed the value of the final print by placing the value of the background differently.

But what's the fly in this ointment? There is more in the scene than just a gray background, and whatever else is there is going to be photographing lighter or darker at the same time. This brings us to the second half of the process, "fall."

If you place a certain value in a scene on a certain zone, other values in that scene are going to fall on the gray scale according to how much different they are in illumination and reflectance. For our example, let's assume we are using a spot meter that has a zone dial attached to it. Typical white skin tone is a Zone VI. You read an actor's face and find that it reads EV 10. Turn the dial so that 10 aligns with Zone VI. Now read the exposure indicated opposite Zone V. This is the exposure to set the lens at.

Let's try an example. We are lighting a set with a window. We set a 10K to simulate sunlight streaming in through the window. We then read the curtains and the spot meter indicates f/11. We have decided that we want the curtains to be very "hot" but not burned out. On the film stock we are using today, we know that white starts to burn out at about three stops hotter than Zone V. So we want to place the curtains on Zone VIII (three stops hotter than the average exposure). By placing the cur-

tains on Zone VIII, we have determined the f/stop of the camera: it will be f/4, right?

We then take an incident reading in the room where the people will be standing. The incident reading is f/2.8. This means that people standing in that position will photograph one zone too dark. In other words Zone VI falls at f/4 (one stop above the incident reading, which equals Zone V). Their skin tone will come out as Zone V instead of Zone VI. To correct the situation we have to change the balance. If we just open up the lens, we are shifting the placement of the curtains and they will burn out. We must change the ratio of the illumination, not just shift the aperture of the camera.

We can either tone down the 10K hitting the window with a double scrim (reducing it one stop) or we can raise the exposure of the subject area by increasing the light level there one stop. Either way manipulates the subject values of the foreground to fall where we want them, based on our placement of the curtains on Zone VIII.

We could have just as easily approached it from another direction, of course. We could place the foreground values where we want them and then see where the curtains fall. It's the same thing. By reading the scene in different ways you can place the values of the negative where you like. Placement is important in determining subject brightness ranges and contrast ratios and in reading subjects that you can't get to for an incident reading. In order to expose by placement you must visualize which zone you want a subject value to reproduce.

Exposure and the Camera

Nearly all film cameras have rotating reflex shutters, which control exposure by alternately rotating closed and open sections past the film plane. While the closed section is in front of the film gate, the film moves; while the open section is in front of the gate, the film is exposed. Some video cameras, particularly high-speed video units, also have shutters (either mechanical or electronic) and thus variable exposure times.

The exposure time of the camera is determined by two factors, the speed at which the shutter is operating and the size of the open section. The speed is determined by the frame rate at which the camera is operating. The U.S. standard is 24 frames per second (fps) for synch sound filming, and the European standard is 25 fps (based on the 50 cycles-per-second power supply).

The open section of the rotating shutter assembly is referred to as the *shutter angle* and is measured in degrees. Sensibly, most shutters are half open and half closed, which makes the shutter angle 180°. Some shutters are 165° and many are adjustable, but the 180° shutter is something of a standard.

With the camera operating at 24 fps and a 180° shutter, the exposure time is 1/48 of a second (1/50 at European 25 fps). This is commonly rounded off to 1/50 of a second and is considered the standard motion picture exposure time. Light meters that use different slides for various ASAs (such as the venerable Spectra or Studio Sekonic), just assume a 1/50 of a second exposure; indeed it is cumbersome to use them at any other exposure.

Exposure time can then vary in two ways: by changing the frame rate (which is common) and by varying the shutter angle (which is less common).

Exposure is determined by this formula:

$$\text{Shutter speed for } 180° = \frac{1}{2 \times \text{fps}}$$

$$\text{Exposure in seconds} = \frac{\text{shutter opening (degrees)}}{360 \text{ fps}}$$

Tables 3.3-3.7 covers most situations.

The simplified version of Table 3.3 (and the numbers used in actual practice) are shown in Table 3.4

Table 3.3

Shutter Angle	Exposure 24fps
180	1/48
175	1/49
172.8	1/50
170	1/51
160	1/54
150	1/58
144	1/60
150	1/62
130	1/66
90	1/96
80	1/108
70	1/123
60	1/144
50	1/173
40	1/216
30	1/288
20	1/432
10	1/844
5	1/1728

Table 3.4 Exposure with 180° shutter

FPS	8	12	16	24	25	32	48	96	120
	1/16	1/24	1/32	1/50	1/50	1/60	1/100	1/200	1/250

Table 3.5 Exposure Variation with Shutter Angle

180° Shutter	*Exposure(in stops)*	*165° Shutter*	*120° Shutter*
180	No change	165	120
140	- 1/3	130	100
110	2/3	100	80
90	1	80	60
70	1 1/3	65	50
55	1 2/3	50	40
45	2	40	30
35	2 1/3	30	
30	2 2/3	25	
22	3	20	
18	3 1/3	15	

Table 3.6 Exposure Adjustment at Various Frame Rates (High Speed)

FPS	24	25	30	32	38	48	60	76	96	120	150	190	240	300	380	480
Stops	Normal		1/3	1/2	2/3	2	1 1/3	1 2/3	2	2 1/3	2 2/3	3	3 1/3	3 2/3	4	4 1/3

Table 3.7 Exposure Adjustment at Various Frame Rates (Low Speed)

FPS	6	7.5	9.5	12	15	19	24	25
Stops	2	1 2/3	1 1/3	1	2/3	1/3	Normal	

4. Color

Color is one of the most important and most difficult issues we deal with in lighting. Oddly, a grasp of color theory is essential even in black-and-white shooting. Let's first look at a bit of the history of color theory.

Violet	Blue	Green	Yellow	Orange	Red

400 500 600 700

Wavelength In Nanonmeters

4.2 The visible spectrum.

Color Theory

Color was considered to be a property of materials, until 1666, when Issac Newton proved that color is a property of light. His experiment of passing a beam of white light through a prism is well known. Newton's genius is indisputable, but was everyone else really so dumb that they had never held a prism in a beam of light before?

Of course not, but before then the mini-rainbow was believed to be the result of imperfections in the glass. Newton took it one step further and passed the separated light through a second prism, which reconstituted the rainbow back into white light, thus proving that white light was composed of separate color components. He did this at the same time he was discovering gravity, formulating the basic laws of the universe, and inventing the calculus—we do have to keep busy, don't we?

The color of light is a result of its wavelength. Light waves themselves have no color; it is the physiological effect that they have on the cones of the eye. Longer wavelengths are perceived as warm colors, shorter wavelengths as cool in color. The difference between the longest and shortest visible wavelengths is only about .00012 of an inch, but within this tiny variation there are over 1000 distinguishable hues.

Within the electromagnetic spectrum, light visible to the human eye is the band extending from 430 nm to about 800 nm (a nanometer is 1/1000 of a millimeter, 10 nm equals 1 angstrom). Photographic emulsions and light meters have a slightly broader receptivity, from around 300 nm to over 800 nm.

$$1 \text{ nm} = 0.0000001 \text{ mm}$$

Table 4.1

Color	Wavelength (nanometers)	Frequency
Red	800-650	400-470
Orange	640-590	470-520
Yellow	580-550	520-590
Green	530-490	590-650
Blue	480-460	650-700
Indigo	450-440	700-760
Violet	430-390	760-800

Infrared is the area just below 650 nm and ultraviolet is just above 390 nm.

White Light → [prism] → Red / Orange / Yellow / Green / Blue / Blue-Violet / Violet

4.1 The spectrum revealed by a prism.

4.3 The sensation of color is created by the reflective properties of the surface.

a: Illuminant "a", tungsten light
c: Illuminant "c", daylight 6774K
d: Illuminant "d", daylight 6504

4.4 Color placement on the CIE diagram.

4.5 Layout of the CIE diagram.

The color of a surface is due to the fact that it absorbs some colors and reflects others. For example, an apple "appears" red because it absorbs all colors except red, which it reflects. In physical terms, light is both wave and particle (photons). The color of an object is a result of this dual personality. Light is absorbed by a surface, because certain photons are captured by molecules in the object. Most colors are the mixture of many wavelengths; what we see is the sensation that mixture produces on our brain.

Color film does not work in precisely the same way. Direct recording of color is too difficult for photographic process; instead, it depends on mixing the primary or secondary colors, which produces exactly the same effect on the perception of color.

Color Definitions
Color is described along three axes: hue, saturation, and brightness.

Hue
Hue is the color (red, orange, yellow, green, blue-green, blue, violet, magenta). These correspond to narrow bands of the visible wavelength. A pure hue, then, is a source heavily concentrated in a particular area of the spectrum.

Saturation
Saturation is the variation between the strong color of single wavelengths and a neutral or achromatic condition. Saturation is also thought of as intensity, purity, or chroma: the extent of "dilution" by the addition of white light.

Spectral colors (narrow bands of the spectrum) have 100% saturation, while black, white, and gray have 0% saturation.

For example, red is pure hue while pink is a lower saturation of red. Low saturation hues are often called *tints* (where white has been added), *tones* (a grayed hue) and *shade* (a hue diluted with black): *Chromaticity* is a term that refers to both hue and saturation, such

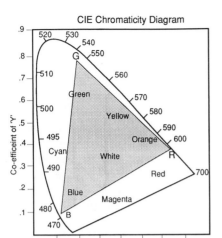

4.6 The CIE chromaticity diagram.

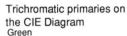

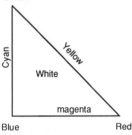

4.7 Standard reference colors.

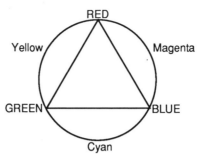

4.8 The color wheel.

ors. All colors that are combinations of two primaries are known as the *complementary* or *secondary* colors:

red + blue = magenta
blue + green = cyan
red + green = yellow

magenta + cyan = blue
cyan + yellow = green
yellow + magenta = red

red + cyan = neutral gray
blue + yellow = neutral gray
green + magenta = neutral gray

The Subtractive System

We can approach this from another direction by starting with white light. If we *subtract* yellow from white light we have blue. If we subtract magenta from white light we are left with green. For this reason, the complementary colors are also known as the *subtractive primaries*. The combination of all three subtractive colors produces black: all light is absorbed.

yellow (red + green) = white - blue
magenta (red + blue) = white - green
cyan (green + blue) = white - red

There are several advantages to using the subtractive system in color photographic film, the most basic being efficiency. To obtain white in the additive method, we need three filters (red + blue + green), each of which absorbs a great deal of light. In the subtractive system we need nothing to produce white. We don't put a filter in front of the white light at all.

as on the Chromaticity Diagram (Figure 4.6).

Brightness
Brightness is an indicator of the "amount" of light. It is also referred to as *luminance* or *value*.

Color Systems

The Additive System

The electromagnetic spectrum is divided into the major hues: violet, indigo, blue, green, yellow, orange, and red. But not all hues are created equal. It turns out that red, blue, and green have special properties. By mixing various combinations of these three, any known color can be produced. For this reason, they are known as *primary* col-

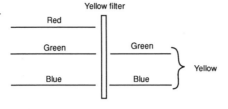

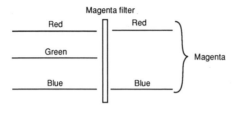

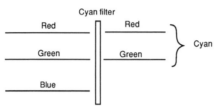

4.9 Subtractive color filters.

Similarly, to obtain yellow in the additive system we need two filters (red + green), which absorb two-thirds of the spectrum, while in the subtractive system we need only one filter (blue) which absorbs only one-third of the spectrum.

Some early color film systems used the additive system, but it proved to be too inefficient. Today all color films use the subtractive system: they are composed of layers sensitive to yellow, magenta, and cyan.

Considerable confusion arises from the seeming difference between color systems in light and paint. Artists who work in paint are taught that the primary colors are red, yellow, and blue. This is not a difference in the characteristics of the two mediums but is, in fact, a deviation in nomenclature. The painter's colors red, yellow, and blue are in fact basically magenta, yellow, and cyan. Paints act as filters, thus yellow and blue (cyan) mix to form green, in the same way that combined yellow and cyan filters produce green.

What Is White?

The eye will accept a wide range of light as white, depending on external clues and adaptation. The phenomenon is both psychological (adaptation) and environmental. The color meter (and color film, which is very objective about these things) will tell us that there are enormous differences in the color of light in a room lit with tungsten light, one lit with ordinary fluorescents, and one flooded with noon daylight. Our perception tells us that all three are white light, mostly because we are psychologically conditioned to think of them as white. Without a side-by-side comparison, the eye is an unreliable indicator of what is neutral light. Unfortunately, color film emulsions are extremely sensitive and unforgiving. An absolute reference is essential.

Color Temperature

In film production, the most common system used in describing the color of light is color temperature. This scale is derived from the color of a theoretical black body (a metal object having no inherent color of its own, technically known as a Planckian radiator). When heated to incandescence, the black body glows at varying colors depending on the temperature. Color temperature is a quantification of the terms red hot, white hot, etc. Developed by Lord Kelvin, the nineteenth-century British scientific pioneer, it is expressed in degrees Kelvin in his honor. On the Celsius scale, the freezing point of water equals 0°. The Kelvin scale takes absolute zero as the zero point. Absolute zero is -273° Celsius on the Kelvin scale, thus 5,500° Kelvin is actually 5,227° Celsius. Degrees Kelvin is abbreviated K and the degree symbol is omitted.

Because a tungsten filment heated to incandescence is very similar to a Planckian radiator, the color temperature equivalence is very close for incandescent and tungsten halogen lamps, but not for HMIs, CIDs, and fluorescents.

Here are some typical color temperatures for common light sources:

Table 4.2

Candle	2000K
Sunlight at dawn	2000K
Low wattage tungsten bulb	2900K
Tungsten-halogen bulb	3200K
Photo bulbs	3400K
Morning/afternoon sun	4400K
Arc with White Flame carbon	5000K
Midday sun	5500K
HMIs	5600–5800K
Midday sunlight + skylight	6500K
Cloudy sky	6800K
Clear blue sky	10,000-20,000 K

A graphic representation of the generation of various wavelengths is called an SED (spectral energy distribution) or SPD (spectral power distribution).

When a metal object (such as the tungsten filament of a light bulb) is heated to incandescence, its SED is quite similar to that of a Planckian radiator and is fairly smooth across all wavelengths, even if some are stronger than others. This is not necessarily true for all light sources. Fluorescent lights, for example, have very "spiky" outputs, which tend to be very heavy in green.

Color temperatures can be very misleading: for many sources (especially those which exhibit discontinuous SEDs) it is only an approximation and is referred to as *correlated color temperature*. As noted, color temperature tells us a great deal about the blue/orange component of light and very little about the magenta/green component, which can produce extremely unpleasant casts in the film even if the meter indicates a correct reading for the color temperature.

An approximate measure of how close a source is to a pure black body radiator is the Color Rendering Index (CRI), a scale of 1 to 100, which gives some indication of the ability of a source to render color accurately. For photographic purposes, only sources with a CRI of 90 or above are generally considered acceptable.

Color Meters

Since many colors are combinations of various colored sources, there is no one number that can describe the color accurately. Rather, it is defined on two scales: red/blue and magenta/green.

As a result, most meters give two readouts (they are called three-color meters, since they measure red, blue, and green); one for the warm/cool scale and one for the magenta/green scale. In the case of the Minolta color meter, the magenta/green readout is not in absolute numbers, but directly in amount of filtration needed to correct the color to "normal" on the magenta/green scale.

Mireds

Another problem with color temperature is that equal changes in color temperature are not necessarily perceived as equal changes in color. A change of 50K from 2,000K to 2,050K will be a noticeable difference in color. For an equivalent change in color perception at 5,500K, the color temperature would need to shift 150K and about 500K at 10,000K.

For this reason, the mired system has been devised. *Mired* stands for micro-reciprocal degrees. Mireds are derived by dividing 1,000,000 by the Kelvin value. For example, 3,200K equals 1,000,000/3,200 = 312 mireds.

To compute how much color correc-

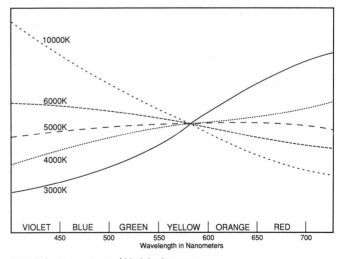

4.10 Color temperatures of black body sources.

85 (Full CTO)	+131
1/2 CTO	+81
1/4 CTO	+42
1/8 CTO	+20
CTB	-131
1/2 CTB	-68
1/3 Blue	-49
1/4 Blue	-30
1/8 Blue	-12

tion is required, you use the mired values of the source and the final desired color. If you have source at 5,500K and wish to convert it to 3,200K subtract the mired value of the desired color from that of the source: 5,000K = 200 mireds; 3,200K = 312 mireds; 312–200 = 112 mireds; 85 orange has a mired value of +112.

On the mired scale, a plus shift value means the filter is yellowish, a minus value means the filter will give a blue shift. When combining filters, add the mired values.

Color Balance of Film

No color film can accurately render color under all lighting conditions. In manufacture, the film is adjusted to render color accurately under a particular condition, the two most common being average daylight (type D film), which is set for 5,500K, and average tungsten illumination (type B film) designed for 3,200K. There is a third, which is based on the now disused photo bulbs, which were 3,400K (type A film), rather than 3,200K, but very few films are available in this balance.

Given the fact that providing tungsten light is costly and electricity intensive, while sunlight is usually far more abundant, most motion picture films are type B, balanced for tungsten. The idea is that we put a correcting filter on when we can most afford to lose light to a filter factor—in the sunlight. Kodak does have several daylight-balanced films available.

Color balance with camera filters

There are three basic reasons to change the color of lights:

- to correct the color of the lights to match the film type (instead of using a camera filter)

- to match various lighting sources
- for effect or mood

To shoot with type B film under *blue* light (in the 5,500° degree area) an 85 orange filter is used. The 80A or 80B blue filters for shooting daylight film with warm light are rarely used, and in most cases should be combined with an ultraviolet (UV) filter because tungsten film cannot tolerate the high proportion of UV in daylight and HMIs. There is some light loss when using a correction filter and the filter factor must be used to adjust the t/stop. For convenience, most manufacturers list an adjusted exposure index (EI) that allows for the filter loss. When using this adjusted EI, do not also use the filter factor.

You will also notice two different EIs on cans of black-and-white film as well. This is not related to correction filters, since none are needed. It has to do with the fact that black-and-white films vary in their sensitivity to colors. In most cases the EI for tungsten light will be one-third stop lower.

Smaller color mismatches can also be corrected with color filters. If the scene lighting is 2,800K, for example (too warm), then an 82C filter will correct the light reaching the film to 3,200K.

The most basic filter families are shown in Table 4.4.

Conversion Filters

Conversion filters work in the blue-orange axis and deal with fundamental color balance in relation to the color sensitivity of the emulsion. Conversion filters affect all parts of the SED for smooth color rendition.

Light Balancing Filters

Light balancing filters are warming and cooling filters; they work on the entire SED as with the conversion filters, but

Table 4.4

85:	Conversion	Correcting daylight to tungsten light.
80:	Conversion	Correcting tungsten to daylight.
82:	Light balancing	Cooling filters
81:	Light balancing	Warming filters
CCs	Color Compensating	Primary and secondary colors

they are used to make smaller shifts in the blue-orange axis.

Color Compensating Filters

Color compensating (CC) filters are manufactured in the primary and secondary colors. They are used to make corrections in a specific area of the spectrum or for special effects. They affect only their own narrow band of the SED. Don't make the mistake of trying to correct color balance with CC filters. Primary filters work in a limited band of the spectrum and correct only one wavelength.

However, since CC filters are not confined to the blue-orange axis, they can be used to correct imbalances in the magenta-green axis, such as those that occur with fluorescent lamps, where a CC-30M is often a part of the basic filter package for standard tubes.

The 80 Series
The 80 series, which are blue conversion filters, are listed in Table 4.5

The 81 Series
The 81 series of warming filters (81, 81A, 81B, 81C, 81O, 81EF) increase the warmth of the light by lowering the color temperature in 200K increments. The 81 shifts the color temperature by the minimum amount required for the eye to perceive any change, -200K. For cooling, the 82 series works in the same fashion, starting with the 82, which shifts the overall color temperature by +200K. As with most color temperature correction filters, excess magenta or green is not dealt with and must be handled separately.

Correcting Color Balance
Daylight to Tungsten
Daylight sources include
- daylight itself (daylight is a combination of direct sun and open sky)
- HMIs
- cool-white or daylight type fluorescents
- dichroic sources such as FAYs (650 watt PAR 36)
- arcs with white-flame carbons

Table 4.5

Number	Conversion	Mired Shift	Compensation
80A	3200 > 5500	-131	2 stops
80B	3400 > 5500	-112	1 2/3 stops
80C	3800 > 5500	-81	1 stop
80D	4200 > 5500	-56	1/3 stop

Table 4.6 No. 81 and No. 82 Kodak Wratten Gelatine Filters

	Number	Exposure Increase	Mired Shift	To Obtain 3200K from
	82C + 82C	1 1/3	-89	2490K
	82C + 82B	1 1/3	-77	2570K
	82C+82A	1	-65	2650K
Cooling	82C+82	1	-55	2720K
	82C	2/3	-45	2800K
	82B	2/3	-32	2900K
	82A	1/3	-21	3000K
	82	1/3	-10	3100K
	81	1/3	+9	3300K
	81A	1/3	+18	3400K
	81B	1/3	+27	3500K
Warming	81C	1/3	+35	3600K
	81D	2/3	+42	3700K
	81EF	2/3	+52	3850K

Table 4.7 Color Compensating Filters: Secondary Colors

COLOR	Designation	Exposure Compensation
	CC.025Y	-
	CC05Y	-
	CC10Y	1/3
YELLOW	CC20Y	1/3
(Absorbs Blue)	CC30Y	1/3
	CC40Y	1/3
	CC50Y	2/3
	CC.025M	-
	CC05M	1/3
	CC10M	1/3
MAGENTA	CC20M	1/3
(Absorbs Green)	CC30M	2/3
	CC40M	2/3
	CC50M	2/3
	CC.025 C	-
	CC05C	1/3
	CC10C	1/3
CYAN	CC20C	1/3
(Absorbs Red)	CC30C	2/3
	CC40C	2/3
	CC50C	1

In general, daylight sources are in the range of 5,400K to 6,000K, although they can range much higher.

Correction is achieved with either 85 or *Color Temperature Orange* (CTO), both of which are orange filters. The Rosco product Roscosun 85 (85 refers to

Table 4.8 Color Compensating Filters: Primary Colors

	Name	Value
	CC.025R	-
	CC05R	1/3
	CC10R	1/3
RED	CC20R	1/3
(Absorbs Blue and Green)	CC30R	2/3
	CC40R	2/3
	CC50R	1
	CC.025G	-
	CC05G	1/3
	CC10G	1/3
GREEN	CC20G	1/3
(Absorbs Blue and Red)	CC30G	2/3
	CC40G	2/3
	CC50G	1
	CC.025B	-
	CC05B	1/3
	CC10B	1/3
BLUE	CC20B	2/3
(Absorbs Green and Red)	CC30B	2/3
	CC40B	1
	CC50B	1 1/3

Table 4.9 CTO Filters

Name	Typical Conversion	Mired Value	Light Loss
85	5500K >3200K	+131	3/4 stop
Full CTO	5500K > 2900K, 6500K > 3125K	+167	2/3 stop
1/2 CTO	5500K > 3800K, 4400K > 3200K	+81	1/2
1/4 CTO	5500K > 4500K, 3800K > 3200K	+42	1/3
1/8 CTO	5500K > 4900K, 3400K > 3200K	+20	1/3

Table 4.10

Name	Conversion	Light Loss
85N3	Daylight to tungsten	1 2/3
85N6	Daylight to tungsten	2 2/3
85N9	Daylight to tungsten	3 2/3

Table 4.11 CTB Filters

Name	Typical Conversion	Mired Value	Stop Loss
CTB, Full Blue	3200K > 5500K	-131	1-1/2
1/2 CTB, Half Blue	3200K > 4100K	-68	1
1/3 CTB, 1/3rd Blue	3200K > 3800K	-49	2/3
1/4 CTB, 1/4 Blue	3200K > 3500K	-30	1/2
1/8 CTB, 1/8 Blue	3200K > 3300K	-12	1/3

the Wratten number equivalent), has a mired shift value of 131, which will convert 5500K to 3200K. (Technically, this is equivalent to a Wratten 85B, Wratten 85 has mired shift value of 112, which converts 5,500 to 3,400, which is slightly cool for tungsten balance.)

Color Temperature Orange is warmer than 85 and has a higher mired shift value, 159. This means that it will convert 6500K to 3200K, which is excellent when correcting cooler sources such as HMIs that are running blue or heavily skylit situations. It is also useful when going for a warmer look, as it will convert 5,500K to 2,940K. (5,500K = mired 181, shift value of 159. Warmer equals positive. 181 + 159 = 340 mired. Divide 1,000,000 by 340 = 2,940K.) The difference is basically American versus European—probably due to the fact that European skylight is generally bluer than American skylight.

85 ND
An important variation of 85 is the combination of color correction and neutral density. The purpose of this is to avoid having to put two separate gels on a window, which might increase the possibility for gel noise and reflections, not to mention the additional cost (which is substantial). The variations are shown in Table 4.10.

Unfortunately, no one makes a 1/2 85 plus ND filter, which would be useful to preserve a natural blueness in the windows. Gel manufacturers take note.

Tungsten to Daylight
Filters for converting warm tungsten sources to nominal daylight are called *full blue, tough blue,* or CTB (*Color Temperature Blue*).

The problem with "blueing the lights" is that CTB has a transmission of 36% while 85 has a transmission of 58%. This means that while you lose almost a stop and a half with CTB, you lose only about two-thirds of a stop with CTO. CTB is very inefficient; its most common use is to balance tung-

sten lights inside a room with the day-light blue window light that is coming in. This is a losing situation from the start—the window light is liable to be far more powerful than the tungsten lights to begin with. If we then lose two stops off the tungsten by adding CTB we are really in trouble (not to mention the fact that we also have to put an 80B filter on the lens with tungsten-balance film and we lose heavily there too). In practice most people try to avoid this solution. The alternatives are

- Put 85 on the windows and shoot at tungsten balance. By doing this we avoid killing the tungsten lights, we don't have to use an 80B on the camera, and we lose two-thirds of a stop off the windows, which may keep them more in balance with the inside exposure.
- Put 1/2 85 on the windows and 1/2 blue on the lights.
- Put 1/2 CTB on the lights and let the windows go slightly blue. This is actually a more realistic color effect and is much preferred these days.
- Use daylight balance lights (FAYs or HMIs) inside.

Fluorescents

One of the most common color problems we face today is shooting in loca-

4.11 Daylight and tungsten.

4.12 Cool white fluorescent.

Table 4.12

Existing Source	Your Lights	Strategy	Comments
Any fluorescents	None or fluorescents	Shoot fluorescent balance	Use fluorescents only (adding fluorescent fill if necessary) and let the lab time the green out of the print.
Any fluorescents	Tungsten or HMI	Replace the lamps	Remove existing fluorescent lamps and replace with **full spectrum** fluorescent bulbs, which provide photographic daylight or tungsten balance.
Cool white fluorescents	HMIs	Gel the fluorescents (daylight balance)	Add **minusgreen** gel to the existing fluorescents, which removes the green. With cool white fluorescents this will result in daylight balance. Tungsten lights can be blued or HMIs used.
Warm white fluorescents	Tungsten	Gel the fluorescents (tungsten balance)	Add **minusgreen** gel. With warm white fluorescents this will result in a tungsten balance. Tungsten lights may be used or HMIs with 85.
Cool white fluorescents	HMIs	Gel the HMIs	Add **plusgreen** to the HMIs, which matches them to the heavy green output of the fluorescents. Then use a camera filter to remove the green or have the lab time it out.
Cool white fluorescents	Tungsten	Gel the tungsten and convert to daylight	Add **plusgreen 50** to your lights, which adds green and blue for daylight balance.
Cool white fluorescents	Tungsten	Gel the fluorescents and convert them to 3200K	Add **fluorofilter** to the fluorescent, which reduces green and converts them to tungsten balance.

tions where the dominant source is fluo-rescent. The problem with fluor-escents is that they are not a continuous spec-trum source; in most cases they are very heavy in green.

In many instances, it is not practical to turn off the fluorescents and replace them with our own lights. Fortunately, there are several approaches that make sense. For effect of these filters see Fig-ures C.22 to C.27.

The filter materials available for deal-ing with these situations and the two combination filters are shown in Tables 4.13-4.15.

Table 4.13

To Reduce Green	Nominal CC Equivilent	For use when CC Index is Approx
Minusgreen	30	-12
1/2 Minusgreen	15	-5
1/4 Minusgreen	075	-2

Table 4.14

To Add Green	Nominal CC Equivilent	For use when CC Index is Approx
Plusgreen (Windowgreen)	30	+13
1/2 Plusgreen	15	+5
1/4 plusgreen	075	+3

Table 4.15

Fluorofilter	Reduces green and corrects cool white flourescents to nominal 3200K
Plusgreen 50	Increases green and corrects 3200K sources to balance cool white fluorescents

Lee makes some filters to suit differ-ent types of fluorescents. See Table 4.16.

Table 4.16

Fluorescent 5700	Converts tungsten to match 5700K cool white/daylight tubes
Fluorescent 4300	Converts tungsten to match white tubes (4300K)
Fluorescent 3600	Converts tungsten to match warm white tubes (3600K)

There are matching camera filters to use with these lamp filters.

Additional Tips on Shoot Fluorescents

- In the field, it may be necessary to use a combination of these tech-niques. Whatever you do, shoot a gray scale to give the lab a starting point for correction.
- Shooting with ordinary fluorescents alone and letting the lab remove the green results in a very flat color rendi-tion. Adding some lights (such as tungsten with plusgreen) gives a much fuller color feeling to the image.
- Several high-output units are avail-able that use color corrected (full spectrum) fluorescents and can be used in conjunction with HMI or tungsten lighting (with either daylight or 3,200K fluorescents tubes) and provide perfect color. They are ex-tremely efficient in power usage and give a soft, even light.
- Full minusgreen is equivalent to CC30M (30 magenta). In an emer-gency, it is possible to use a piece of CC30M.
- Don't forget that most backlighted advertising signs (such as those in bus shelters) have fluorescent tubes in them. The scene may look fine but the fluorescent cast of the lighted signs will be very ugly.
- If you are shooting a large area, such as a supermarket, factory, or office, it is far more efficient to add green to your lights than to have the crew spend hours on ladders gelling or changing bulbs.
- When you add plusgreen or fluorofilter to lights they give a very strongly colored light that looks very wrong and doesn't appear to visually match either HMI or tungsten light. It looks absolutely awful. You will often find it difficult or impossible to convince a director or cameraman that it works. Try taking a color Polaroid or shooting a film test.

Correcting Off Balance Lighting
Arcs

Carbon arcs give off heavy ultraviolet. Rosco Y-1 or Lee LCT. Yellow reduces the UV output.

To correct white flame carbon arcs to tungsten balance use Rosco MT2 (together with Y-1) or Lee 232. Rosco MTY is a combination of MT2 and Y-1.

HMIS

HMIs generally run a little too blue and are voltage dependent. Unlike tungsten, their color temperature goes up as voltage decreases. It is important to check each lamp with a color temperature meter or color Polaroid and write the actual color temperature on a piece of tape attached to the side. For slight correction, Y-1 or Rosco MT 54 can be used. For more correction, use 1/8 or 1/4 CTO.

Many HMIs also run green. Have 1/8 and 1/4 minus green available for correction.

Tungsten

Tungsten bulbs and lamp reflectors yellow with age. For critical color balance use 1/8 or 1/4 CTB. Soft lights always run a little yellow because of the reflector. Putting a light through diffusion will usually warm it a bit.

Other Sources
Industrial lamps

Various types of high-efficiency lamps are found in industrial and public space situations. They fall into three general categories: sodium vapor, metal halide, and mercury vapor. All of these lights have discontinuous spectrums and are

Table 4.17 Lamp Correction Filters

Gel	Description	Use	Mired Shift
Y-1 LCT Yellow	Pale straw	On HMI and white flame carbon arc to absorb UV and reduce Kelvin to daylight balance	+45
WF (White Flame)	Similar to Y-1 but less color warming	HMIs and white flame carbons to absorb UV and reduce Kelvin to daylight balance	+20
MT2	Similar to CTO	Used with Y1 to convert white flame arcs to 3200K, also used as amber conversion on HMIs and CIDs	+110
MTY	Combination of MT2 and Y-1	Converts white flame carbons to 3200K and reduces UV	+131
1/2 MT2	Amber	Partial conversion of white flame arcs and HMIs	+38
1/4 MT2	Pale amber	Partial conversion of white flame arcs and HMIs	+20
MT54 UV Filter	Pale straw Very pale straw	Correction of white flame arcs and HMIs Absorbs 90% of UV below 390 nm	+35 +8

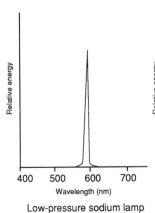

Low-pressure sodium lamp

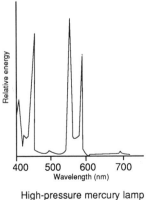

High-pressure mercury lamp

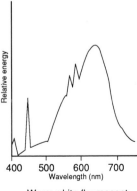

Warm white flourescent

4.13 SEDs for typical industrial sources.

dominant in one color. They all have very low color-rendering indexes. It is possible to shoot with them if some corrections are made.

High-pressure sodium lamps are very orange and contain a great deal of green. Low-pressure sodium is a monochromatic light: they are impossible to correct.

Camera Filtration

The following are recommended starting points for using camera filtration to correct off-balance industrial sources. They are approximations only and should be confirmed with metering and testing. *Never* fail to shoot a gray scale and some skin tone for a timer's guide.

Table 4.18 Industrial Sources

Existing Source	Your lights	Filtration on your lights
High Pressure Sodium	Tungsten	Double Plusgreen
	HMI or other daylight source	Double Plusgreen + Full CTO
Metal Halide	Tungsten	Plusgreen + Full CTB
	HMI or other daylight source	Plusgreen (and possibly some blue)
Mercury Vapor	Tungsten	Full CTB + half CTB + double Plusgreen
	HMI or other daylight source	Full CTB + double plusgreen

Table 4.19

Film Type	Existing Source	Camera Filters
Tungsten	High Pressure Sodium	80B + CC 30M
	Metal Halide	85 + CC50M
	Mercury Vapor	85 + CC50M
Daylight	High Pressure Sodium	80B + CC50B
	Metal Halide	81A + CC30M
	Mercury Vapor	81A + CC 50M

Table 4.20 Effect of Diffusion Material on Color Temperature

SOURCE	3200K
Tough Spun	3180K
Light Tough Spun	3180K
Quarter Tough Spun	3200K
Tough Frost	3000K
Lt. Tough Frost	3060K
Opal Tough Frost	3100K
Tough White (216)	3120K
Tough 1/2 White	3150K
Tough 1/4 White	3150K
Grid Cloth	2960K
Tough Silk	3160K
Soft Frost	2840K
Half Soft Frost	3180K
Hilite	3050K
Hamburg Frost	3200K

(Data courtesy of Rosco Laboratories.)

5. Lighting Sources

Lighting Sources

Lighting instruments are the tools of our trade. Just as a mechanic must know what his tools are capable of, it is important to understand the capacity of our resources in order to use them to their potential. Here we will examine them classified in their major groups: tungsten fresnels, HMIs, carbon arcs, open-faced units, PARs, softs, broads, and miscellaneous.

Tungsten Fresnels

All tungsten fresnel lights are designated by their bulb size (2K, 5K, etc.) and come in two basic flavors: studio and baby. The studio light is the full size unit, the baby is a smaller housing and lens. As a rule the baby version is the housing of the next smaller size (for

example, the 5K is similar to a studio 2K) with a box that extends further from the bottom to house the socket in a position to keep the bulb centered on the reflector and lens. The baby lights are much favored for location work.

The 10K

For many years the 10K was the big gun inside the studio. Still a popular unit, it comes in three versions:

5.1 The Big Eye 10K.

- The baby 10K provides high-intensity output with a fairly compact, easily transportable unit with a 14-inch fresnel lens.
- The basic 10K, known as a *tenner* or *studio 10K,* has a 20-inch fresnel.
- The big daddy of the group is the *big eye* tenner which has a 24-inch lens. The Big Eye is a special light with

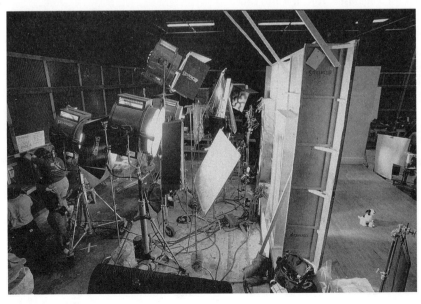

5.2 Big Eyes on the set.

5.3 Baby 5K.

5.4 Baby deuce.

5.5 Baby-baby.

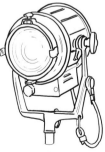

5.6 Tweenie.

quality all its own. The 10,000 watt DTY bulb provides a fairly small source, while the extremely large fresnel is a large radiator. The result is a sharp, hard light with real bite but with a wrap-around quality that gives it a soft-light quality on subjects close to the light. This is a characteristic of all big lights (the 12K HMI and the brute arc as well) which gives them a distinctive quality impossible to imitate.

There is such an animal as the 20K, but they are rare: Disisti now makes a 240-volt unit with a 24-inch lens and built-in dimmer.

Note on large lights: Never burn a 10K or a 5K pointing straight up. The lens blocks proper ventilation and the unit will overheat. Also, the filament will not be properly supported and will sag and possibly touch the glass. Either condition will cause the bulb to fail and overheating may crack the lens. The failure will cost somebody hundreds of dollars and put the light out of commission.

The 5K

Available in studio and baby versions, the 5K has enough oomph to serve as the key on medium size sets. It can work as a general purpose *big light* and a fill used against a 10K. It's also called a *senior*. The baby 5K is similar in size and configuration to a studio 2K, but has an enlarged box on the bottom to allow the larger 5K bulb to sit with the filament properly positioned in front of the reflector.

Deuces

The 2K fresnel (also known as a *deuce* or a *junior)* is the "jeep" of lights. In the old Hollywood studio days, the grid was crammed with 2Ks, each with its own particular job. Although not a big light, it has enough power to bring a single subject or actor up to a reasonable exposure, even with light diffusion. Deuces are also useful as backlights, rims, and kickers. Baby deuces are the

more compact 2K fresnel unit, they have the body of a 1K with a larger tray on the bottom to accommodate the FEY bulb. They are also called *baby juniors* or *BJs*.

1K

Known as a *baby*, an *ace,* or a *750*, the 1K sees action as an accent light, a splash on the wall, a small backlight, a hard fill, and dozens of other uses. The baby can use either a 750-watt bulb (EGR) or a 1000-watt bulb (EGT). The widely used name, of 750, comes from the days before quartz halogen when the 750 tungsten bulb was the most common. Most are now used with the 1K quartz bulb, but are still called 750s. The baby 1K, also called a *baby baby*, is the small size version. Because of its smaller lens and box, it has a wider spread than the studio 750, and this can be a useful feature when hiding small units in nooks and crannies.

Tweenie

The tweenie is a relative newcomer. Its name comes from its position between the 1K and the inkie. With the new high-speed films, the tweenie is often just the right light for the small jobs a baby used to do. Its compact size is a tremendous asset.

Inkie

The inkie has long been the smallest light available. At 200 or 250 watts, it is not a powerful unit, but up close it can deliver a surprising amount of light. The inkie is great for a tiny spritz of light on the set, as an eyelight, a small fill, or for an emergency light to just raise the exposure a bit on a small area. When you finish lighting a scene, an inkie or two should always be standing by for last minute touchups. Because they are so light, inkies can easily be mounted to a film or video camera, handheld, hung on broomsticks, hung from suspended ceilings, and rigged in all sorts of ways to accommodate strange situations.

Photometric Data for Representative Units

Tables 5.1-5.6 provide data for output in footcandles and beam spread in feet for representative units. (Note: These are averages for lights from several manufacturers and so are only approximations for rough calculation.)

Table 5.1

UNIT	Inky		
BULB	FEV		
	5'	10'	15'
Flood	90	25	10
Beam	4.8	9.3	14
Spot	780	195	90
Beam	0.6	1.1	1.7

Table 5.2

UNIT	Tweenie			
BULB	FRK			
	5'	10'	15'	20'
Flood	450	150	55	30
Beam	6	11	17	23
Spot	2000	500	220	110
Beam	1	1.5	2	3

Table 5.3

UNIT	Baby				
BULB	EGT				
	5'	10'	15'	20'	30'
Flood	700	180	80	45	20
Beam	4.3	8.5	12.8	17.1	25.6
Spot	5100	1720	710	390	160
Beam	0.8	1.5	2.2	3	4.5

Table 5.4

UNIT	Junior				
BULB	CYX				
	10'	15'	20'	30'	45'
Flood	400	200	100	50	20
Beam	9	13	17	26	40
Spot	2100	920	590	300	150
Beam	1.6	2.5	3.4	5	8

Table 5.5

UNIT	Senior				
BULB	DPY				
	10'	15'	20'	30'	50'
Flood	810	415	200	110	30
Beam	9	14	19	28	46
Spot	4500	1800	1400	600	200
Beam	2	3	4	5.5	9

Table 5.6

UNIT	Tenner					
BULB	DTY					
	10'	20'	30'	40'	50'	100'
Flood	3,600	1,040	460	260	165	40
Beam	6.5	12	18	24	30	49
Spot	16320	5280	2465	1390	890	220
Beam	2	3.5	5	7	9	17

HMIS

12K and 18K

The 12K and the 18K HMIs are the most powerful fresnel lights available. They have tremendous output and, like all HMIs, are extremely efficient in footcandle output per watt. Like the arc lights that they are replacing in general use, they produce a very sharp, clean light that is the result of having a very small source (the gas arc), which is focused through a very large lens. Camera-men characterize these lights as having a lot of "bite." For some jobs these large lights are practically indispensable. Anytime a sunlight effect is needed (such as sunbeams through a window) one of these is a natural choice, although a 6K might handle it in some cases.

For daytime exteriors, the big lights are among the few sources that will balance daylight and fill in the shadows sufficiently to permit shooting in the bare sun without silks or reflectors. The fact that they burn approximately *daylight blue* (5,500° K) is a tremendous advantage in these situations: no light is lost to filters.

The ballasts generally don't have plugs but are tied directly into the feeder cable with Siamese connectors. This is advantageous in balancing a load. Often when a 12K is used to fill in sunlight it is the only unit operating on a generator. If it was drawing on only one leg, the load would be extremely difficult to balance and might damage the generator. Most 12Ks and 18Ks are 220-volt lights but some are 110-volt units, which can make load balancing difficult. As with any large light, coordinate with the genny operator before firing it up or shutting it down. Be sure to

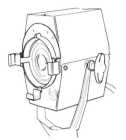

5.7 Inkie.

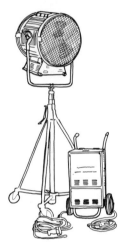

5.8 12K HMI.

clarify with the rental house what type of power connectors are used on the lights you are ordering.

The most significant new development in HMIs is the new flicker-free ballasts that use square-wave technology to provide flickerless shooting at any frame rate. With some units there is a penalty paid for flicker-free shooting at frame rates other than synch-sound speed—when the high-speed flicker-free button is selected on these units they operate at a significantly higher noise level. If the ballasts can be placed outside or shooting is without sound (MOS), this is not a problem.

The other good news about large HMIs is the1 substantial reduction of the size of the ballasts, due to the change from magnetic to electronic ballasts. This is a great relief for electricians who have had to move the old ballasts that were the size of small refrigerators.

Header cables are the power connection from the ballast to the light head itself. Most large HMIs can only take two header cables; a third header will usually result in a "no joy" situation.

6K and 8K

The 6K HMI (and the newer 8K) is a real workhorse. On jobs where the budget will not permit a 12K, it performs much of the same work. Although it generally has a smaller lens it still produces a sharp, clean beam with good spread. In most applications it performs admirably as the main light, serving as key, window light, or sun balance.

Some 6Ks are 110 volts and some are 220 volts, depending on the manufacturer and the rental house. They may require a stage box, a twist-lock connector or a set of Siameese connectors. When ordering a 6K, it is crucial to ask these questions and be sure the rental house will provide the appropriate distribution equipment. Failure to do so may result in the light not being functional.

Some makes of HMIs (such as Arriflex) provide for head balancing. This is accomplished by sliding the yoke support backwards or forwards on the head. This is a useful feature when adding or subtracting barndoors, frames, or other items that radically alter the balance of the light.

4K & 2.5K

The smaller HMIs, the 4K and 2.5K, are general purpose lights, doing all of the work that used to be assigned to 5K and 10K tungsten lights. Slightly smaller than the bigger HMIs they can be easily flown and rigged and will fit in some fairly tight spots.

Smaller HMIs

The smallest units, the 1.2K and 575 HMI, are versatile units. Lightweight and fairly compact, they can be used in a variety of situations. The electronic ballasts for the small units have become portable enough to be hidden on the set or flown in the grid. Photometric data for units from several manufacturers is shown in Tables 5.7-5.12

Table 5.7

UNIT	575 HMI fresnel				
	10'	15'	20'	25'	30'
Flood	300	86	64	30	19
Beam	6.5	10	12.5	18	21
Spot	1150	780	706	325	228
Beam	1.5	2.5	2.75	3	3.15

Table 5.8

UNIT	1200 HMI fresnel				
	10'	15'	20'	25'	30'
Flood	490	215	168	84	54
Beam	10	16	18	26	36
Spot	7150	2700	2230	1000	670
Beam	1.3	2.5	3	4	5

Table 5.9

UNIT	2500 HMI fresnel				
	10'	15'	20'	25'	30'
Flood	1800	580	410	240	150
Beam	9	19	22	27	36
Spot	13200	4800	3450	2000	1200
Beam	1.6	2.3	3	4	4.5

5.9 1.2K HMI.

Table 5.10

UNIT	4K HMI fresnel				
	10'	15'	20'	25'	30'
Flood	2000	740	510	300	195
Beam	8.5	14.5	18	26	31
Spot	28000	10000	7150	3900	2500
Beam	2	3.6	4.3	4.9	6

Table 5.11

UNIT	6K HMI fresnel				
	10'	15'	20'	25'	30'
Flood	4100	1500	1000	575	370
Beam	8.5	14	18	26	31
Spot	49000	17000	12250	6800	4400
Beam	2	3.6	4.3	5	6

Table 5.12

UNIT	12K HMI fresnel				
	10'	15'	20'	25'	30'
Flood	5800	2900	1650	1050	730
Beam	9	12	17	21	25
Spot	45000	27000	16000	10500	7300
Beam	1.5	2	2.5	3	3.5

Care and Feeding of HMIs

- Always ground the light and the ballast with appropriate grounding equipment.
- Check the stand and ballast with a volt ohm meter (VOM) for leakage by measuring the voltage between the stand and any ground. There will usually be a few volts, but anything above 10 or 15 volts indicates a potential problem.
- Keep the ballast dry. On wet ground, get it up on boxes or rubber mats.
- Avoid getting dirt or finger marks on the lamps. Oil from the skin will degrade the glass and create a potential failure point. Many lamps come with a special cleaning cloth.
- Ensure that there is good contact between the lamp base and the holder. Contamination will increase resistance and impair proper cooling.
- The filling tip (nipple) should always be above the discharge; otherwise there is a risk of a cold spot developing inside the dis-charge chamber where the filler sub-stances may con-

dense and change the photometric properties.
- Prolonged running at a higher rated voltage may result in premature failure.
- Extended cable runs may reduce the voltage to a point that affects the output and may result in the lamp not firing.
- Excessive cooling or direct airflow on the lamp may cool the lamp below its operating temperature, which can result in a light with a high-color temperature and inferior CRI.
- All bulbs are rated for certain burning positions, which vary from plus or minus 15° to plus or minus 45°. In general, bulbs 4K and above have a 15° tolerance while smaller bulbs have a greater range.

5.10 575-watt HMI.

When an HMI Fails to Fire

On every job there will be at least one HMI that will fail to function properly. Some rental houses will provide a backup head, ballast, or both. Be sure to have a few extra header cables on hand. They are the second most common cause of malfunctions, the most common being the safety switch on the lens.
- Check that the breakers are on. Most HMIs have more than one breaker.
- After killing the power, open the lens and check the micro-switch that contacts the lens housing. Make sure it is operating properly and making contact. Wiggle it, but don't be violent— the light won't operate without it.
- If that fails, try another header cable. If you are running more than one header to a light, disconnect and try each one individually. Look for broken pins, garbage in the receptacle, etc.
- Check the power. HMIs won't fire if the voltage is low. Generally they need at least 108 volts to fire. Some have a voltage switch (110, 120, 220); be sure it's in the right position.
- Try the head with a different ballast and vice-versa.
- Let the light cool. Many lights won't do a hot restrike.

5.11 Xenon and ballast.

Xenons

Xenons are a relative newcomer to the film and video industry. Related to the HMI (they are a gas arc with a ballast) they feature a polished parabolic reflector that gives them amazing throw and almost laser-like beam collimation. At full spot they can project a tight beam several blocks. They are tremendously efficient with the highest lumens-per-watt output of any light (part of the secret is that there isn't much spread, of course). They currently come in four sizes, 1K, 2K, 4K, and 7K. There is also a 75-watt sungun unit. The 1K and 2K units come in 110-volt and 220-volt models, some of whicht can be wall-plugged. The advantage is obvious: you have a choice between a high-output light that can be plugged into a wall outlet or a small put-put generator. Be sure to check with the rental house, as some units are Camlock or Tweco 220 volt.

The 4K and 7K xenons are *extremely* powerful, and must be used with a bit of caution. At full spot they can crack a window. Just one example of their power: with ASA 320 and full spot, a 4K delivers f/64 at forty feet from the light!

Because the current at the bulb is pulsed DC, flicker is not a problem for xenons. They can be used for high-speed filming up to 10,000 fps.

There are, however, some disadvantages. All xenons are very expensive to rent and have a cooling fan that makes them very difficult to use in sound filming. Also, because of the bulb placement and reflector design, there is always a hole in the middle of the round beam, which can be minimized but never entirely eliminated.

Because of the parabolic reflectors, flagging and cutting are difficult close to the light. Flags cast bizarre symmetrical shadows. Also, the extremely high and concentrated output means that they burn through gel very quickly. Many people try to compensate by placing the gel as far as possible from the light. This is a mis-take. The safest place to gel is actually right on the face of the light which is the coolest spot.

The 75-watt sungun is excellent for flashlight effects. It is a small hand-held unit that was developed for the Navy, and comes in both AC (110 volt) and DC configurations. The newer models have motorized flood-spots that can be operated during the shot. They have a narrow beam with the extremely long throw of xenons. There is, however, a hole or a hot spot in the center of the

Table 5.13

Type	Peak Beam Candle Power	Voltage	Amperage
75 watt		110 VAC or battery	
1000 watt	115 million	117 volts	25 amps
2000 watt	195 million	208 – 230 Single phase	25 amps
4000 watt	395 million	208 – 230 Three phase	28 amps
7000 watt	795 million	208 –230 Three phase	40 amps

Table 5.14 1K Xenon

	Distance(Feet)	Beam Diameter	Beam Angle	Footcandles
Full spot	50	12"	Collimated	14500
	100	14"	Collimated	3625
	200	18"	Collimated	900
Medium	50	14"	1.5°	9500
	100	24"	1.5°	2375
	200	36"	1.5°	600
Wide	50	5'	10°	1750
	100	10'	10°	438
	200	25'	10°	110

Table 5.15 2K Xenon

45

Lighting Sources

	Distance (Feet)	Beam Diameter	Beam Angle	Footcandles
Full spot	50	14"	Collimated	55000
	100	14"	Collimated	13750
	200	14"	Collimated	3400
Medium	50	14"	1.5°	36000
	100	24"	1.5°	9000
	200	36"	1.5°	2260
Wide	50	5'	10°	3500
	100	10'	10°	875
	200	25'	10°	220

Table 5.16 4K Xenon

	Distance (Feet)	Beam Diameter	Beam Angle	Footcandles
Full spot	50	20"	Collimated	70000
	10'	20"	Collimated	17500
	200	20"	Collimated	4500
Medium	50	14"	1.5°	54000
	100	24"	1.5°	13500
	200	36"	1.5°	3400
Wide	50	5'	10°	11250
	100	10'	10°	2810
	200	25'	10°	700

beam (depending on the focus) that cannot be eliminated.

Xenon bulbs do not shift in temperature as they age or as voltage shifts.

Brute Arc

The DC carbon arc fresnel is falling into disuse since the advent of the HMI. For many years, the brute arc was the "big mama," the heaviest hitter. With many times the output of the 10K, it was the standard for fill to balance sunlight, the major workhorse for night exteriors, and sun effects through windows.

Invented by Sir Humphrey Davy in 1801, the arc was the first high-intensity electric light. It was used in theaters and then adopted by the film industry as the only source bright enough to use with the extremely slow emulsions then available. It was the only artificial alternative to the all glass or all skylight studios that were necessary.

The arc produces light by creating an actual arc between two carbon electrodes. As the arc burns, the negative and positive electrode are consumed and so have to be continuously ad-

vanced to keep them in the correct position. In modern arcs this is done with feed motors. In the early days, the electrode feed mechanisms had to be turned by hand. This called for considerable experience on the part of the technician, and the term *lamp operator* was applied to the most skilled electricians. Even today the name is used on some older studio budget forms to describe set electricians.

Even with feed motors and complex geared mechanisms, arcs require an operator to monitor them constantly and adjust the speed of the motors to maintain precise flame size. This need for a skilled electrician with each light is one reason for the demise of the arc as popular source.

The other reason is the gigantic power consumption of arcs (225 amps for the standard brute, which calls for a #00 cable run for *each* light) and the fact that it must be DC, which dictates either a studio with DC or a large DC generator. The bottom line is that even with a very cheap daily rental, the arcs are more expensive to operate than an HMI. This is too bad, since the brute

5.12 Brute arc.

arc has a lighting quality that is distinctive and quite beautiful. Because the plasma arc that creates the light output is quite small, the arc is almost a point source. The small source, combined with the large lens produces a sharp, specular light that has a very clean, "wrapping" quality. A 12K HMI comes close, but it is not clear that anything can really replace the arc look. This combined with ability to change the color of the arc makes it unfortunate that they are no longer economically feasible.

The arc was particularly useful in that it could be daylight- or tungsten-balanced without gels, something that no other light can do. This is accomplished by using either *white-flame* carbons (daylight balance) or *yellow-flame* carbons (tungsten balance).

For daylight-balanced use, the white-flame carbons run high in ultraviolet, and a Y-1 filter is usually added to counteract this. MT-2 converts the white-flame carbons to tungsten color balance.

All arcs have an ancillary piece of

Table 5.17

Unit	Amperage	Availability
Titan	350 amps	Only a few exist
Baby Brute	also 225 amps	Most common
150	150 amps	Also rare

Table 5.18

UNIT	Brute Arc					
SOURCE	White flame or yellow flame carbon					
	10'	20'	30'	40'	50'	100'
Flood	10000	2650	1190	670	430	110
Beam	5.5	10.5	15.8	21	26	53
Spot	62300	19500	9000	5060	3240	810
Beam	1	1.8	2.8	3.7	4.6	9.2

Table 5.19 Daylight Balance Filming

Carbon	Filter	Light Loss
White flame	Y-1	10%

Table 5.20 Tungsten Balance Filming

Carbon	Filter	Light Loss
Yellow flame	YF-101	15%
White flame	MT-2 plus Y-1	40%

equipment called a grid or ballast (and sometimes referred to as the heater: it can be a very popular place to sit on cold winter night locations, another thing we lost with HMIs). The grid serves two purposes. It is a giant resistor that limits current flow across the arc and reduces the voltage to the optimal 73 volts without reducing the amperage. Voltage that is too high or too low can cause the electrodes to burn improperly and inefficiently.

While the 225-amp Litewate brute is by far the most common type of DC arc, other sizes are available as shown in Table 5.17 and 5.18.

Filters for Arcs
Arcs create a good deal of ultraviolet. To correct this warming gels are used. See Tables 5.19 and 5.20

Arc Operation
Arc operation is not difficult, but it is not something to be attempted by the uninitiated. Injury and damage to the equipment are very possible. Hands-on training from an experienced set electrician is a must. We can, however, provide some basics that will assist the electrician in preparation.

Make sure you have the right carbons. White-flame carbons (daylight-balanced shooting) are marked with a white dot. Yellow-flame carbons (tungsten-balance shooting) have a yellow dot.

Negative carbons are copper clad and about ten inches long with a conical nose. Positives are twenty inches long with a crater at one end: this is the business end of the carbon.

The necessary tools are screwdriver, pair of pliers and good leather work-gloves. You will also need positive and negative electrodes and a can of arc lubricant. A dousing can full of water or sand is also useful if you are removing the glowing hot electrodes from a recently operating arc.

If DC is not available, it is possible to use a rectifier to convert AC. Special units are available for this.

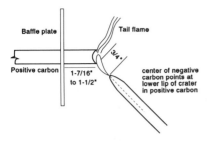

5.13 Correct trim of a carbon arc.

Operating Steps

1. Make sure the power is off.

2. Release the latch and tilt the guts out for access.

3. Press the dimpled negative carriage release lever. The carriage will drop to its lowest position. Always use the pliers or screwdriver to operate anything inside the arc. If it has been operating, these parts will be hot enough to burn right through workgloves.

4. Depress one side of the negative holder. This lifts the roller and allows you to place the carbon in the V-block holder.

5. Rotate the positive electrode camming lever clockwise to release the positive electrode. If there is a used positive, remove it. You can then slide a new one in with its cratered end forward, protruding from the carrier about 1-1/2 inches.

6. Depress the striker lever (outside lower rear of the housing) to bring the negative up to its striking position. Push the positive gently forward until it touches the negative.

7. The ideal positioning is for the tip of the negative to just contact the lower lip of the positive. Adjust the manual positive handcrank if necessary

8. Rotate the positive carbon camming lever counterclockwise to lock the rod in.

9. Tilt the guts back into the housing and lock in place.

10. Attach the power lines to the grid and then run cables from the grid to the light.

11. Check polarity. Correct polarity—the negative side of the DC source connected to the negative electrode is essential to arc operating. Switch the power on at the head and look at the polarity light; if it is ON, then the polarity is wrong. Reverse the cables to correct.

12. To strike the arc, gently depress the striking lever to bring the two electrodes into contact. Immediately release it. The arc should be working. If it's not, check your electrode positioning and try again.

13. Trimming during operation is a skill that can only come from practice. There are three basic trim functions: the external rheostat that controls the speed of the feed motors, the positive handcrank advance, and the negative handcrank advance. It is the job of the arc operator to view the flame through the viewing ports (never look at the flame with the naked eye; the intensity and ultraviolet will cause immediate eye damage) and make adjustments to maintain the optimal 3/4-inch gap and proper relationship of the carbons.

Cautions

1. Never use cracked carbons. The sound when lightly tapped against metal will reveal their condition.

2. Strike arcs one at a time. Striking too many arcs at a time creates a huge strain on the generator.

3. Warn the gaffer or cameraman when carbons are burning low. It is your job to make sure they don't burn out in the middle of a shot.

4. Never burn an arc at more than 45° tilt either way.

5. Get lots of help when mounting a light on the stand.

6. Do not lubricate a hot head.

7. Not all arc guts require lubricating. Some companies run their brutes as "dry guts," which means they never lubricate them. Check with the rental house. Oiling a dry guts arc can cause trouble.

Open Faced Lights
Skypan

The skypan is the biggest open-faced light now available. Originally designed as a raw, broad source for illuminating

5.14 Skypan.

cycs, it is now used for any applications where brute power is needed and control is not important—cyc lights, backlighting translights, blue screen backdrops and large bounce sources. One of the most common ways to use the skypan is to hang it from the grid over a 12' x 12' or 20' x 20' silk as a large scale soft toplight. This is one of the simplest and most efficient methods of getting a soft, even illumination over a large area.

The skypan is simple in design. It consists of a reflective white pan with a heavy duty lamp socket positioned to keep the bulb at the center of the reflector. Most have a switch on the back. There is only one flavor of skypan but either a 5K bulb (DPY) or a 2K bulb

5.15 Skypans as an overall ambient fill.

(CYX) bulb can be used in it. When ordering, don't forget to specify bulb size and remember that this will affect your cable order and your power considerations.

Only two basic accessories are available for the skypan: a skirt that does control some of the side spill (and is useful for keeping direct hits out of the lens) and a gel frame. You usually won't get them unless you specify in the order.

Mighty/Blonde
The 2K open face is a real workhorse. Mole's version is the Mighty-Mole, Ianiro's is the Blonde, and Colortran also has a version. Its open-faced design provides far greater output per watt than a 2K fresnel, making it the light of choice for bounce sources. If going through diffusion, it can also be a direct source. Mightys are used in book lights, frog lights, and as backlight illumination for tissued windows, tented products, etc.. Most versions have a collar that clamps on the front of the light and provides the support for the barndoors, gel frames, or scrims.

Mickey/Redhead 600/650 watt open face
Mickey-Moles (Mole-Richardson) and the Redhead (Ianiro) are the little brothers of the 2K open face and differ only in bulb (1K) and size. Although they don't have much oomph, they are great as small bounce sources (such as an umbrella light for portraits), small-fill bounces and for just sprinkling a little light on background objects. Their small size (especially the Redhead which is remarkably compact) makes them easy to hide in the set. The 650- and 600-watt baby sisters are even smaller and find use in Electronic News Gathering (ENG) and small unit video production. With a bit of diffusion they are often attached to the top of the video camera as a traveling fill light.

Lowell makes the lightweight, highly portable DP Lite that is a mainstay of

the small video and ENG production. Like all Lowell lights, it has a wide variety of clever and well-designed accessories: snoots, barndoors, snap-on flags, gel holders, dichroic filters, etc.

Lowell's Omni Light is a smaller version of the DP and has the same range of accessories. It is an inexpensive unit and provides basic open-faced light or can be used as a self-contained umbrella bounce.

Table 5.21

UNIT	650 watt openface			
BULB	FAD			
	10'	15'	20'	25'
	40	100	26	16
Beam	14'	21'	28'	37'
Spot	450	175	112	68
Beam	5	7	9	12

Table 5.22

UNIT	1000 watt openface				
BULB	DWX				
	10'	15'	20'	25'	30'
Flood	150	56	39	22	14
Beam	9.3'	21'	25'	33'	41'
Spot	715	265	180	110	65
Beam	4.4'	6.5'	180'	100'	66'

Table 5.23

UNIT	2000 watt openface				
BULB	FEY				
	10'	15'	20'	30'	45'
Flood	464	170	116	65	44
Beam	10'	16'	21'	30'	34'
Spot	2500	950	625	355	225
Beam	3.5'	5.5'	630'	9'	10'

Table 5.24

UNIT	5K Skypan				
BULB	DPY				
	10'	15'	20'	30'	50'
	500	245	145	65	25
Beam	14	20	25	37	60

Table 5.25

UNIT	Lowell DP Light				
BULB	FEL (1000 watt)				
	5'	10'	15'	20'	25'
Flood	297	88	40	23	16
Spot	3066	711	307	166	109

PARS

Par 64

PARs are raw light power in its most basic form. Cousins to auto headlights, they are a sealed beam light (combined bulb, reflector, and lens) available in a wide variety of sizes and beam spreads. One of the most commonly used is the PAR 64 1000 watt. Eight inches across (64/8 of an inch), they employ a highly efficient parabolic reflector that is capable of projecting the beam with very little spread.

The detachable lens is the variable that affects beam spread. A completely clear lens for a PAR is called a very narrow spot (VNSP) and with a light texture it is a narrow spot (NSP). This makes them useful for hitting distant background objects that cannot be reached otherwise. With a stippling effect on the lens, the light becomes a medium flood (MFL) and spreads the same amount of light over a broader beam. With a more pronounced stippling, the light is a wideflood (WFL) with an even greater beam spread. Because PARs have a long, thin filament inside the reflector, the beam of a PAR is oval rather than circular. This can be a useful feature as the beam can be oriented to "fit" the subject.

PARs are remarkable in their efficiency. A narrow spot 1K PAR, measured at the center of its beam, generates an output comparable to a 10K measured at the center of its beam. The trick, of course, is that it covers only a very small area, but it may be sufficient for many purposes such as high-speed table top, punching of light through heavy diffusion, etc..

PARs come in two basic varieties. Film versions come in a solid rotary housing such as a MolePar or CineQueen (Colortran) that feature barndoors and scrim holders and in a flimsier theatrical version called a PAR can. Most versions allow for the bulb to be rotated freely to orient the oval beam.

PARs (especially NSPs) can quickly

5.16 2K open face.

5.17 Redhead.

5.18 1K PAR.

5.19 PAR lamp.

5.20 Maxi-brute: 9 1K PARs.

burn through even the toughest gels, melt beadboard, and set foamcore on fire. PARs are also available with a dichroic coating that makes them usable as a daylight-balanced source. Small PAR 48s and 36s are also available at lower voltages and these are commonly referred to as aircraft landing lights.

PAR Groups

PARs are also made in groups, the best known being the maxi-brute, a heavy hitter with tremendous punch and throw. They are used in large night exteriors and in large-scale interior applications, aircraft hangers, arenas, etc..

The bulbs are housed in banks that are individually oriented for some control. All the bulbs are individually switchable, which makes for very simple intensity control. All PAR group lights allow for spot, medium, and flood bulbs to be interchanged for different coverages. See Tables 5.26-5.28

FAYs

The smaller cousins of the maxi-brute are the FAY lights, also called 5-lites, 9-

5.21 9-lite FAY.

lites or 12-lites, depending on how many bulbs are incorporated. They use PAR 36 bulbs (650 watts). The FAY bulbs are dichroic daylight bulbs. Before the advent of HMIs they were widely used as daylight fill in combination with or in place of white-carbon arcs.

Most people refer to any PAR 36 dichroic bulb as a FAY, but in fact there are several types. FAY is the ANSI code for a 650-watt PAR 36 dichroic daylight bulb with ferrule contacts. If the bulb has screw terminals it is an FBE/FGK.

As with the larger maxi-brutes, the bulbs are in three adjustable banks and they generally do come with barndoors.

Twelve-lites, 9-lites and 5-lites are far more flexible than one might imagine. With heavy diffusion over the barndoors they can have a large-source soft light quality with real power. Used raw they are a quick and adaptable bounce source with individual switching control and straight on they can cover the entire side of a building for a night shot.

HMI PARs

The newest addition to the PAR family is the HMI PAR, which is available as 4K, 2.5K, 1.2K, and 575. These are extremely popular as bounce units, to create shafts, and for raw power. Moreover, the PAR can be moved easily, where moving a scaffold and heavy light is a major operation.

Table 5.26

UNIT	1K Molepar						
BULB	PAR 64						
	10'	20'	30'	40'	50'	75'	100'
VNSP	5040	1260	560	315	200	90	50
NSP	3600	900	400	225	145	65	35
MF	1350	340	150	85	55	25	-
WF	470	120	52	30	20	-	-

Table 5.27

UNIT	Maxi-Brute						
BULB	9 PAR 64s						
	20'	30'	40'	50'	75'	100'	150'
VNSP	10000	4500	2530	1620	720	405	180
NSP	8100	3600	2025	1300	575	325	145
MF	3040	1350	760	485	215	120	55
WF	1010	450	255	160	70	40	20

Table 5.28

UNIT	9 Lite						
BULB	9 PAR 36						
	10'	20'	30'	40'	50'	75'	100'
Med	2160	540	200	135	85	-	-
Wide	990	250	110	60	40	-	-

Table 5.29 System Efficiency

	HMI 1200 W fresnel	HMI 1200 W PAR
medium flood	20%	48%
spot	10%	54%

(Source: OSRAM.)

Table 5.30

UNIT	575W HMI PAR		
	15'	25'	35'
VNSP	2000	720	360
NS	1775	640	325
MF	667	240	125
WF	110	40	20

Table 5.31

UNIT	1.2K HMI PAR		
	20'	40'	60'
VNSP	4500	1125	500
NS	3250	815	360
MF	1500	375	165
WF	425	105	47

HMI PARs are different from tungsten units in that they have changeable lenses. The basic unit is a VNSP (very narrow spot). The auxiliary lenses can be added to make it a narrow spot, a medium flood, wide flood, and an extra wide flood. As with tungsten PARs, the beam is oval and the unit can be rotated within its housing to orient the pattern. See Tables 5.29-5.31.

Softs

Studio Softs (8K, 4K, and 2K)

Studio soft lights consist of one or more FCM 1000-watt bulbs directed into a "clamshell" white-painted reflector that bounces light in a random pattern, making a light that is soft in relation to the size of the reflector. They vary from the 1K studio soft (baby soft, also known as a 750 soft) up to the powerful 8K studio soft, which has eight individually switchable bulbs.

All soft lights have certain basic problems:

- They are extremely inefficient in light output.
- They are bulky and hard to transport.
- Like all soft lights, they are difficult to control.
- While the large reflector does make the light soft, the random bounce pattern makes the light still somewhat raw and unpleasant.

As a result of this rawness, some people put some diffusion (either Opal or 216) over the soft light for any close-up work. Big studio softs through a large frame of 216 is probably the easiest and quickest way to create a large soft source in the studio. The main accessory of all soft lights is the eggcrate, which minimizes side spill and makes the beam a bit more controllable.

Zips

Some compact versions of the studio soft lights are called *zip lights*, particularly the 1K and 2K zips. They are the same width but half the height of a normal soft. Because of their compactness,

5.23 8K soft.

5.22 1.2K HMI PAR.

5.24 Baby Soft.

5.25 2K zip.

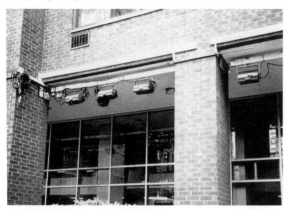

5.26 2K zips pre-rigged for night exterior.

Table 5.32

UNIT	Baby Soft					
BULB	FCM					
	4'	6'	8'	10'	12'	50'
	200	90	50	30	20	—

Table 5.33

UNIT	2K Studio Soft					
BULB	FCM					
	4'	6'	8'	10'	12'	14'
	295	135	75	50	35	25

Table 5.34

UNIT	2K Zip					
BULB	FCM					
	4'	6'	8'	10'	12'	14'
	540	135	150	70	40	25

Table 5.35

UNIT	4K Baby Soft						
BULB	FCM						
4'	6'	8'	10'	12'	14'	20'	24'
1030	500	270	180	125	85	45	30

Table 5.36

UNIT	4K Studio Soft						
BULB	FCM						
4'	6'	8'	10'	12'	16'	20'	24'
1440	660	360	2700	165	95	60	40

Table 5.37

UNIT	8K Studio Soft						
BULB	FCM						
4'	6'	8'	10'	12'	16'	20'	24'
3000	13000	750	4800	325	180	120	80

zips are great for slipping into tight spaces. On a set with a low ceiling a 2K zip with eggcrate can be flown in on a 2 × 4 for a nice soft backlight over the actors.

Cone Lights

A variation of the soft light is the *cone light*. It differs in that the reflector is a cone and it uses a single-ended bulb instead of a double-ended FCM. Because the bounced beam is more collimated, the cone light is much smoother and prettier than a studio soft. With a showcard collar and some dense diffusion, the cone light is one of the most attractive beauty and product lights, and the smaller ones are quickly flown for a soft backlight. Unfortunately, the cone light is not used much these days.

Cone lights come with *dots* that shield the bulb from the hard direct light and double shadows characteristic of open-faced lights. For extra punch when going through diffusion, the dot can be pulled.

Fluorescent Rigs

Portable fluorescent arrays are available from several sources. The Lowell unit, for example, uses six 120-volt, 4-foot, 2-pin tubes, and the flicker-free ballast serves as a counterbalance for the head. The unit draws only 3 amps and folds down to a compact, highly portable package.

Fluorescent rigs are most often used as a front fill when shooting in a fluorescent-lit industrial situation. This makes for very quick shooting as they are color balanced to the existing lighting, which is usually an overall soft ambient; with a little fill for the eyes, the lighting is often usable as is. Then it is just a matter of adding a fluorescent filter, letting the lab take the green out, or white-balancing the video.

Table 5.38

UNIT	8 Tube Fluorescent Rig				
BULB	FCM				
4'	6'	8'	10'	12'	14'
125	55	30	20	15	10

Cycs, Strips, Nooks, and Broads

When just plain output is needed, broad lights are strictly no-frills, utilitarian lights. They are just a box with a a double-ended bulb. As simple as it is, the broad light has an important place in film history. In classical Hollywood hard lighting, the fill near the camera was generally a broad light with a diffuser.

The distinctive feature of the broad light is its rectangular beam pattern, which makes blending them on a flat wall or cyc much easier. Imagine how difficult it would be to smoothly combine the round, spotty beams of mighties or fresnel lights.

The smallest version of the broad is the nook, which, as its name implies, is designed for fitting into nooks and crannies. The nook light is a compact, raw-light unit, usually fitted with an FCM or FHM-1000 watt bulb. The nook is just a bulb holder with a reflector. Although barndoors are usually available, nooks aren't generally called on for much subtlety, but they are an efficient and versatile source for box light rigs, large silk overhead lights, and

for large arrays to punch through frames.

A number of units are specifically designed for illuminating cycs and large backdrops. For the most part they are open-faced 1K and 1.5K units in small boxes. Their primary characteristic is the asymmetrical throw that puts more output at the top or bottom, depending on the orientation of the unit. The reason for this is that cyc lights must be either placed at the top or bottom of the cyc but the coverage must be even.

Strip lights are gangs of PARs or broad lights, originally used as theatrical footlights and cyc lights. They are often circuited in groups of three. With each circuit gelled a different color and on a dimmer, a wide range of colors can be obtained by mixing. This can be a quick way to alter background colors and intensities.

The Lowell Tota Lite deserves special mention. Small, cheap and fundamental, its no-nonsense reflector design and 750- or 1000-watt double-ended bulb provide tremendous bang for the buck. Practically a backpocket light, the Tota can be used as an umbrella bounce, hid-

5.27 1K broad.

5.28 Nook lights rigged for a broad backlight. A diffusion frame will be flown in front of this row.

5.29 Lowell Tota Lite

5.30 Cyc lights.

den in odd places or used in groups for a frog light or cyc illumination.

Two Totas can be ganged by simply inserting the male end of the stand clamp into the female side of the other Tota. Adding more lights to the stack is a problem, they are too close together to allow the doors to open fully. To make a stack of three or more, a special adaptor is available.

Miscellaneous
Chinese Lanterns

Chinese lanterns are the ordinary paper globe lamps available at houseware stores. A socket is suspended inside that holds either a medium base bulb (household, ECA, ECT, BBA, BCA,

Table 5.39

UNIT	1K Broad			
BULB	FCM			
4'	8'	12'	20'	24'
960	240	107	38	27

Table 5.40

UNIT	2K Broad			
BULB	FCM			
4'	8'	12'	16'	20'
1920	480	213	120	77

Table 5.41

UNIT	650 Nook			
BULB	FCM			
4'	8'	12'	16'	20'
340	85	40	25	12

Table 5.42

UNIT	1K Nook		
BULB	FCM		
4'	8'	12'	16'
935	245	110	60

Table 5.43

UNIT	2K Nook			
BULB	FCM			
5'	10'	15'	20'	25'
1000	250	110	60	40

Table 5.44

UNIT	Tota-light			
BULB	EMD (750 watt)			
5'	10'	15'	20'	25'
146	41	21	13	9

etc.) or a 1K or 2K bipost. Just about any rig is possible if the globe is large enough to keep the paper a safe distance from the hot bulb. Control is accomplished by painting the paper or taping gel or diffusion to it.

Musco Lites

The Musco is the most powerful wide coverage light available. It consists of 6K HMI heads permanently mounted on a crane/truck. It can provide workable illumination up to a half mile away and is used for moonlight effects and broad illumination of large areas. Musco lights are available only from Musco. The unit comes with its own 1000-amp generator, either an onboard or a tow rig.

The 6K heads are individually aimable by a hand-held remote control that operates up to 1000 feet away from the truck. The boom allows placement of the heads up to 100 feet in the air.

Table 5.45 Musco Lights

Direct throw	1/2 mile	20 footcandles
	1/4 mile	80 footcandles
General flood	400' x 400'	20 footcandles

Largest effective coverage area: 1/4 mile

Lekos

The ellipsoidal reflector spot (Leko) is a theatrical light, but is used occasionally as a small effects light because of its precise beam control by the blades. Because the blades and gobo holder are located at the focal point of the lens, the leko can be focused sharply and patterned gobos can be inserted to give sharply detailed shadow effects. A wide variety of patterns are available: leaf, venetian blinds, trees, buildings, etc.. Not all lekos have gobo holder slots and if you need one you must specify when ordering. In addition to the gobo holder and the shutter blades, some units incorporate a mechanical iris that can reduce the size of the beam to a tiny spot; this also must be specified in ordering.

Also tell the equipment house that you are using it for film work—they are

5.31 Chinese lanterns working on a barroom set

5.32 Overhead clusters are also used for ambient light in large areas.

normally shipped with a pipe clamp, and an adaptor will be needed to put it on a normal stand. Matthews makes the TVMP adaptor that handles the job neatly.

Lekos come in a size defined by their lens size and focal length. See Table 5.46.

Photometric data for some typical ellipsoidals are shown in Tables 5.47–5.49.

The longer the focal length the longer the throw of the light, that is, the narrower the beam. For example the 4 1/2-inch unit has a field angle of 45° while the 8 × 16 throws a beam of only 6°.

The Moleipso is a sturdier and more powerful version (1,000 and 2,000 watts) of the leko. For smaller uses, there are focal-spot attachments for the 1K and inky. They provide sharp focus and leaf shutter beam control. They have interchangeable lenses for variable beam width.

Handling Big Lights
- Don't be a hero; get help with big lights.
- Always protect the lens by keeping the barndoors closed when moving.

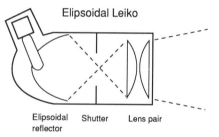

Elipsoidal Leiko

Elipsoidal reflector Shutter Lens pair

5.33 Lekos work with a double condenser lens system and an ellipsoidal reflector.

5.34 A 6 x 12 inch ellipsoidal leko.

Table 5.46

3″ x 10″	250w, 400 w, 500 w
3″ x 12″	250w, 400 w, 500 w
41/2″x 6 1/2″	500w, 750w
6″ x 9″	750w, 1000w
6″ x 12″	750w, 1000w
6″ x 16″	750w, 1000w
6″ x 22″	750w, 1000w
8″ x 8″	1000w
8″ x 10″	1000w
8″ x 14″	1000w
8″ x 16″	1000w

5.35 1K stand. (Courtesy Mathews Studio Equipment

5.36 2K stand with pop-up 1K stud.

5.37 Wind machine stand (lo-boy 2K).

5.38 Lo-boy crankovator, a geared stand for large units.

Table 5.47 6" x 9"

Distance	Field Diameter	Footcandles
30'	11'	250
40'	14'	140
50'	18'	90
60'	21'	60

Table 5.48 6" x 12"

Distance	Field Diameter	Footcandles
50'	11'	140
60'	13'	96
70'	15'	70
80'	17'	55

Table 5.49 8" x 14"

Distance	Field Diameter	Footcandles
55'	10'	185
70'	12'	115
85'	15'	78
100'	17'	55

- Always remove the bulb when loading, unloading, and trucking the light.
- Detach the power cable and header cables when trucking.
- Make sure the switch is off before plugging in.
- Don't switch on with the light pointing into people's eyes or with the barndoors closed.

The appropriate procedure (two or more people) for mounting a big light is as follows:

- Check that the tie-down screw is loosened.
- With the light on the ground, rotate the yoke to full up and lock.
- Lift the light up to the stand and rest the bottom of the light on the top of the stand.
- With two people stabilizing the light, the person on the bail side loosens the yoke (announcing it as he does).
- The yoke is rotated to full down position and locked.
- The light is lifted and the yoke pin dropped into the stand.
- The tie-down screw is secured.

A variation is to use the lift gate of the truck as a hoist to get the light near to its position. The stand is set up and locked as close to the lift gate as pos-sible. With two people on the lift gate and one or more standing below, the yoke is rotated down, locked, and the light dropped into the stand. It may be possible to tilt the light onto its face to facilitate locking the yoke in the down position.

A variation is to "Iwo Jima" a light by mounting the unit with the stand lying on the ground, then lifting as someone foots it. Don't try this one without a little practice first.

Sunguns

Sungun is a generic term for any portable, battery-powered light. There are two basic types, tungsten and HMI.

Tungsten sunguns are usually either 12-volt or 30-volt and powered from battery belts. Some are specifically designed as sunguns, but some are 120-volt lights converted by changing the bulb and power cable. The most popular units for this type of conversion are Lowell Omni and DP lights. Typically, a tungsten sungun will run for about fifteen to twenty minutes.

HMI sunguns are daylight-balanced and more efficient than tungsten units; also the batteries run considerably longer before running out. With either type of light, it is important to order plenty of extra batteries and to switch them off whenever possible.

5.39 The sungun: a handheld, battery-powered portable unit. sungun.

6. The Elements of Lighting

Light is what we work with. Infinite and subtle in its variety, the quality of light is a life-long study. In order to shape it to our purposes, it is essential to understand the basic jobs it can do for us. Let's review the fundamental building blocks of lighting, the basic elements with which we shape a scene.

The Fundamental Elements
Key
The keylight is the main or predominant light on a subject. Not necessarily the brightest (the backlight is usually hotter in intensity), it is the light that gives shape, form, and definition to the subject. If a person has only one light on her, that is by definition the key. Al-though we generally think of the key as coming from somewhere in the front, there are many variations: side key, side-back key, cross key, and so on.

One way of thinking of the key is that it is usually the light that creates a shadow of the subject. There may be a key for the whole scene or a key for each object in it, or any combination of these. In a moving shot, an actor may have several keys and move from one to the other.

Fill
The key as a single defining source may exist alone (which is not uncommon in low-key or "European-look" shooting), but in most cases the contrast between

6.1 Key.

the lit areas and the shadows will be too great or the *single-source* look may not be appropriate for the shot. Any light that balances the keylight is referred to as the *fill*. Fill lights come in all varieties. Many glossaries will tell you that fill light is a soft light or usually is placed near the camera on the opposite side from the key. Although these may apply for the most simplistic type of formula lighting, they simply aren't true in all cases. The fill might be anything from an inkie with a snoot up to a 20' × 20' silk, and it might come from almost any angle.

Backlight

Backlight is any light that comes from behind the subject. When backlight comes from almost directly overhead and high enough to get over the head and onto the face and nose, it is called a toplight. In most cases, a backlight that is too toppy will be avoided.

Backlight is a definite stylistic choice. Since it is usually an obviously artificial light, motivated light purists seldom use it except where it occurs naturally. It is also called a *hairlight*.

Kickers and Rims

A kicker is often confused with a backlight. A kicker is a light from behind the subject, but enough to the side so that it skims along the side of the face. Kickers are sometimes called 3/4 backlights. A rim is similar to a kicker but doesn't come around onto the side of the face so much. It is more for creating a shape-defining outline. In general, the term *kicker* is used when lighting a face, and the term *rim* occurs more often when lighting an object.

Eyelight

A very specialized type of fill is the eyelight. Because eye sockets are recessed in the facial structure, the combination of key and fill that works best for the overall face may not reach deeply enough to give illumination to the eyes themselves. Since it is extremely rare that we are willing to let the eyes go dark, no matter how shadowy and low key the rest of the shot, it is often necessary to add some light for the eyes themselves.

There are two main varieties of eyelight. The first is very minimal, usu-

6.2 Key and fill.

ally just a snooted inkie, which has only one purpose: to provide a little twinkle in the eyes, basically a reflection of the light in the eyeball. The other type is an actual fill light and is used to fill in the eyes and provide sufficient illumination so that we can see them.

An "Obie" light is any small lighting unit that is attached to the camera directly over the lens. Its name is derived from the beautiful actress Merle Oberon. It was discovered early in her career that this type of lighting was most complimentary to her facial structure. An Obie might be the key, the fill, or an eyelight, depending on the relative intensities of the other units working, if any.

Ambient

Ambient is just as the name implies, overall ambient. Ambient is either an overall base on which we build or a general, directionless fill. Outdoors the ambient might be the daylight reflected from the sky and the surroundings. In a location room ambient might be an overall fill provided by bouncing a light onto a white ceiling.

Quality of Light

The variations in the quality and mood of lighting are nearly endless. Just think of the many adjectives that we apply to it:

indirect/direct
harsh/soft
specular/diffuse
ambient/sourcey
punchy/wrapping
splashing/slamming
contouring/frontal
flat/chiaroscuro
strong/gentle
shadowy/high key
modulated/plain
skimming/direct
focused/general
snappy/mushy

....and so on. Not all are precise and easily defined, but they all convey a sense of mood, quality, and atmosphere.

All of that leads to one conclusion—there is far more to light than can be defined by subdividing it into hard and soft, key and fill. Perform this simple experiment for yourself. For one full day, look around you, everywhere you

6.3 Key and fill and kicker and background light.

go at the quality of light in the place you are in. See how it defines the space, shapes the objects, and falls on the faces of the people around you.

Every quality of light that you see can be reproduced on a set or location. Ask yourself, how would I light a scene to achieve this look? What units would I use, where would I put them, how would I modify and shape the light to achieve this?

Let's look at the major variables that we deal with. First we must realize that there are actually two factors involved in what is traditionally called *hard/soft*.

Hard/Soft

Relative Size of Source
The most important factor in the relative hardness/softness of a light is the size of the radiating source relative to the subject. The larger the radiating source in relation to the subject, the more the light tends to "wrap" around the contours of the subject. Where a hard light (small source) would create shadows, the large source will reach in and fill them. *Hard light* is characterized by the opposite effect; the transitional shadow area is relatively sharp and abrupt. (See Fig. C1.)

What this means is that no light is inherently hard or soft. Even a soft-light unit might under certain conditions be a hard light, while something we would normally think of as a hard light, such as a bare lens fresnel light,

Specular light

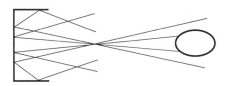

Diffusion

6.5 Relative size of source as affected by diffusion.

Relative distance to source

6.6 Distance of subject from the source.

might be a soft light. The deciding factors are actual size of the source (such as the size of the lens of a fresnel light), the actual size of the subject, and their distance apart. The major determinant of this wrapping is the size of the source relative to the subject. If a very large light source is illuminating a smaller subject, the light will be able to get further around the curves and edges. This will decrease the shadow areas and tend to fill in its own shadows.

Why distance? It's simple geometry: a studio soft light is soft because the radiating source is the size of the opening. In the case of a Mole-Richardson 4K studio soft light the aperture is 36" × 30". If a subject is 1 foot high and 2 feet away from the light, it is obvious that the source is huge in relation to the subject.

Even with a large source and a small object placed far apart, only the light rays that are traveling parallel to each other reach the object. Any rays that

6.4 Size of the source in relation to the subject.

would have the ability to wrap miss the subject; only the parallel rays illuminate it and the result is a relatively hard light.

Specular/Diffuse

The other aspect of the hard/soft character of light is whether it is specular or diffuse. Specular light is light in which the rays are relatively parallel. Light from the sun, a point source 93 million miles away, is specular. Specular light is highly directional and collimated. In terms of reflective surfaces, a specular reflection is one where the *outgoing* light closely resembles the *incoming* light, in other words, a fairly mirror-like surface. In this case the angle of reflection equals the angle of incidence. A diffuse reflector is one in which the reflection does not resemble the incoming light. The diffuse surface scatters the light in many directions, the angle of reflection is more or less random. This covers reflecting surfaces, but what about direct light?

Diffuse is a condition where the light rays are traveling in random, disorganized directions. Light bounced off a rough white surface is diffuse. Light traveling through thick white translucent material is diffuse.

Diffusion

Traditionally, diffuse light is thought of as soft and specular light is thought of as hard. As we have just seen, this isn't always true, but generally, diffuse light will tend to be softer than specular light. Diffusion material can be any semi-transparent or tranzlucent material: white plastic, silk, nylon, bleached or unbleached muslin, or shower curtain. They all serve the same purposes:

1. They reduce the specularity of the light. Relatively specular (collimated) light that falls on one side of the diffusion material emerges on the other side more diffuse (randomized); the degree of change depends on the opacity and thickness of the material.

2. They increase the size of the radiator. The size of the source of a fresnel light is the size of its lens. If a 12-inch light illuminates a dense diffusion material 24 inches in diameter, it becomes a 24-inch radiating source; this also makes the light more diffuse and wrapping. This effect depends on the thickness and density of the material. The thicker and more dense it is, the more the source becomes a pure area of diffuse radiation. If the diffusion material is very thin and light, the area of diffuse

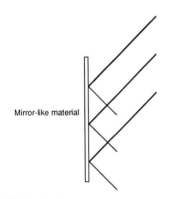

6.7 Specular bounce.

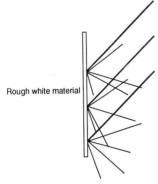

6.8 Diffuse bounce.

6.9 Single diffusion.

6.10 Double diffusion.

radiation increases, but there is also direct specular radiation still coming through.

3. Light from a radiating source is highly directional (specular). Also, the source is usually a mixture of two types of light, direct radiation from the filament or arc and *bounce off* from the reflector. The fresnel lens cannot smoothly combine these two types of light, and untreated direct light from one of these units is always just a little bit "raw." Diffusers homogenize the light. Both the direct, specular light of the filament and the indirect bounce from the reflector are combined and smoothed by the diffusion.

For effects of various diffusion materials see Figures C.1–C.21.

Traditional Hollywood lighting up until the 1960s was almost entirely direct hard light without bounce light or heavy diffusion in front of the lamps. One reason for this is the slow emulsions used at the time; in order to maintain exposure, they needed everything they could get out of a light. With the high-speed films and video tubes we use today, together with the far more efficient sources we have available, it is possible to modify, diffuse, bounce, and double bounce as much as we like.

It is important to remember that there is a loss of exposure when using

Table 6.1 Diffusion Frame at Source (In F/stops)

Diffusion Material	Exposure at Beam Center	2' from Center	5' from Center
Source	**f/38**	**f/4.8**	**f/3.4**
Tough Spun	f/16	f/6.3	f/4.5
Light Tough Spun	f/20	f/6.3	f/4.5
1/4 Tough Spun	f/28	f/6.3	f/4
Tough Frost	f/20	f/6.7	f/4
Lt. Tough Frost	f/22	f/6.3	f/4
Opal Tough Frost	f/27	f/5.6	f/3.5
Tough White (216)	f/14	f/6.7	f/4.5
Tough 1/2 White	f/20	f/6.7	f/4
Grid Cloth	f/7	f/5.6	f/4.5
Tough Silk	f/25	f/9	f/5
Soft Frost	f/19	f/6.3	f/4.5
Half Soft Frost	f/28	f/5.6	f/3.5
Hilite	f/25	f/6.3	f/4
Hamburg Frost	f/35	f/4.8	f/3.4

(Courtesy of Rosco Laboratories.)

Table 6.2 Diffusionin Frame 2' from Source (In F/stops)

Diffusion Material	Exposure at Beam Center	2' from Center	5' from Center
Source	**f/38**	**f/4.8**	**f/3.4**
Tough Spun	f/22	f/6.7	f/4.5
Light Tough Spun	f/27	f/6.7	f/4.5
1/4 Tough Spun	f/35	f/6.7	f/45
Tough Frost	f/27	f/5.6	f/4
Lt. Tough Frost	f/25	f/5.6	f/4
Opal Tough Frost	f/32	f/5.6	f/3.5
Tough White (216)	f/20	f/7	f/4.8
Tough 1/2 White			
Grid Cloth	f/11	f/6.3	f/4.5
Tough Silk	f/28	f/8	f/4.5
Soft Frost	f/25	6.7	f/4.5
Half Soft Frost	f/32	f/5.6	f/3.5
Hilite	f/28	f/6.3	f/3.5
Hamburg Frost	f/38	f/4.8	f/3.4

(Courtesy of Rosco Laboratories.)

6.11 Wrapping light.

diffusion material. The light is not simply lost, however; it is useful to think about where it goes. Some is bounced back to the back surface of the diffusion and wasted and some is lost as heat in the diffuser, but most of it is not lost at all; it simply spreads out to cover more area.

For example, reading a bare light at the center of the beam, you may find that you have 100 footcandles. After placing diffusion in front of the light, you have only 50 footcandles, but you now have exposure over a larger area. Tables 6.1 and 6.2 illustrate the effect of diffusion material on exposure.

Natural Diffusion

Environmental factors also play a role. Smoke, fog, and haze can have much the same effect as diffusion with one important distinction: the smoke or fog is on the shadow side of the subject as well; it can serve as a reflector, bouncing small amounts of light back onto the subject.

Other Qualities of Light
High Key/Low Key (Fill Ratio)

Scenes that have an overall sense of being brightly lit are said to be *high-key*, which translates to lots of fill in relation to the key, not many shadows, and fairly high levels overall. The opposite of high-key is *low-key* lighting, which is dark, shadowy, and has little or no fill. Historically, comedies, household product commercials, and other light-hearted material is lit high-key while mysteries, romance, and stylish upscale commercials tend to be low-key.

Sourcey/Ambient

Specular light is by nature directional. It originates at a source and follows a fairly straight path. When a light is

A

B

6.12 Direction of source (A, B, C, D.)

C

D

6.13 A frog light is a
foamcore bounce with
heavy diffusion attached.

placed in a scene so that we can clearly perceive its origin, we call it *sourcey*, which may or may not be desirable, depending on the look we are going for. Specular hard light just outside the frame will usually be sourcey. Soft light, such as bounce light or highly diffused light will tend not to be sourcey. Highly diffuse light that covers all of the set is called *ambient* light. It is undefined, directionless light.

Direction Relative to Subject

Light that is flat frontal will be less directional since it will be seen by the lens to cover all subjects equally. Sidelight and backlight will always be perceived as more directional, since the shadow areas it defines are far more recognizable to origin. (See Fig. 6.12)

Relative Size of Radiating Source and Lens

A more subtle factor, and one that applies only to lights with lenses, is the relative size of the radiating source and the lens. This particularly applies to large units.

For example, many lighting people still miss the unique quality of the old brute arcs, which are not used much anymore. The electrical arc that generates the light is a very small, almost point source and there is no reflector behind it. The lens of the light is quite large creating a good deal of wrapping while the small arc creates a light that is highly specular and sharp. The wrapping gives it certain soft light characteristics while the small source keeps it clean and hard, very *snappy*.

Although 12K HMIs have just as large a lens, their slightly larger radiating source keeps them from having the kind of "bite" of a brute. Some 12Ks

are available with different reflectors, small and hard or slightly larger and diffuse.

Modulation

Raw light from any source, be it hard or soft, directed or reflected, can be further modified by modulation. Also known as *breakup*, subtle gradations can be introduced into the light pattern by *cookies, celos, dingles,* or other diffusion materials (such as from a translucent window curtain, for example).

Subject /Texture

We can never consider light apart from the subject it is illuminating and the conditions in which it is working. The item being lit plays as important a role as the source itself. There are dozens of variables, but some of the most important are

1. Reflectivity versus absorbency. There can be tremendous variation here, even between different people's skin.

2. Surface texture: diffuse versus specular.

3. Angularity versus roundness.

4. Transparency. For example, large blocks of ice not only reflect some light off of their wet surface but internally transmit light.

5. Color. Affects not only our visual perception of color, but what colors of light will be absorbed or reflected.

6. Subject contrast. How dark or light the object is in terms of the gray scale. Also the contrast between the subject and background or between different parts of the subject.

These are the basic building blocks we work with on the set. In the next chapter we will examine how they are deployed to light different types of scenes.

7. The Lighting Process

Let's look at the actual process of lighting a set. In other chapters we cover the tools, technical details, and aesthetic options that play a role in lighting, but it also important to understand the day-to-day workings of a lighting professional in order to see how all the tools and techniques come together.

As an illustration of the process we will look at a fairly typical lighting situation, a small set for a feature film. A fairly simple task, as lighting challenges go, but one that illustrates the possibilities and problems we face in lighting, even in the most basic situations.

The basic principles apply, for the most part, to all sets and it will not be necessary to reiterate them in subsequent chapters on other types of lighting situations.

Preproduction
Reading the Script

Lighting the set is a complex process that begins in the preproduction phase. Like any other phase of film production it depends on a number of closely interrelated factors that come together to form the "look and feel" of the production. As with all else, it begins with that most fundamental of steps, reading the script.

A motion picture script is a specialized document that is highly standardized in the industry. If read carefully, it can provide a wealth of information that is useful to the cameraman and gaffer. Figure 7.1A indicates the key elements.

This is a feature film script, of course, and not a format that is used in other types of production.

On commercials, and to a large extent on industrials, the predominant form is a story board, which not only lists dialogue and effects, but shows rough sketches of the scene, camera angle and moves. It can be a useful tool, but learn to read it with a healthy dose of skepticism. There never has been and probably never will be (Francis Ford Coppola's interesting experiments notwithstanding) a substitute for being on the set, looking through the camera as a shot is put together. It is only under these live conditions that the director and cameraman can really make the decisions that others take their cue from.

As you read the script you will be making mental and written notes about the various settings involved, however it is not necessary to make a highly structured database of each scene: that work will have already been done for you by the production company and will be available in the form of a breakdown. While less commonly used in the world of commercials and industrials, the breakdown is universal in features.

Like the script that it summarizes, the breakdown provides information that is vital to your planning, the most essential of which is summarized on the call sheet. The call sheet is usually distributed at the end of each day as an important means of communicating to every member of the production who is working the next day, what their call times are, where they will meet, what equipment is involved, and so on.

Scene number in both margins are one of the primary identifiers

Identifies the scene as interior or
exterior: vital information for your planning

Which set you will be lighting

Whether it's a day or night shot

```
15      INT. LEVEL FOUR CONTROL ROOM - NIGHT

        We PAN over the wall of an office.  Diplomas and citations cover
        the wood-paneled surface.

        We PAN down from the pictures to a CHESSBOARD.  A hand reaches
        over and snatches up a black PAWN.  But instead of making a
        chess move, the hand rubs the piece between its fingers like
        it's a talisman.

        McGinnis, fidgeting in his chair, addresses Dr. Kurtz, who's
        huddled behind the chess board.

                              MCGINNIS
                Dr. Kurtz--Gordon kept asking about
                Smith.  He could be trouble.

        Kurtz' face is underlit by a nearby lamp making him look
        sinister and invulnerable.
```

The characters
involved

A certain lighting effect is mentioned. Make special note
of these and consider what it means for your lighting, your
equiement order and for the mood of the scene. Clearly, a
mention of this sort indicates that the rest of the set is
dark and sinister.

Keep in mind, however, that this is the screenwriter's
conception of the lighting of the scene. The director may or
may not want the scene done in this way.

7.1A A typical script page.

DOLLY SHOT AS MODEL
TURNS TOWARD CAMERA—
PLANET SWINGS BEHIND
ON PENDULUM.

7.1B A typical commercial storyboard.

7.2 The set design drawings provide essential information for your planning.

Remember that many specifics might change. The script may list a scene as being in a railroad station, but production may be unable to procure the appropriate setting and the scene will be done elsewhere. Similarly, any aspect of the script may change at any time it is the production department's job to ensure that you are informed of such impending changes at the earliest possible moment.

As you read the script, be alert for problems to warn production about. Are the sets listed problematical in terms of your ability to light them adequately on budget and schedule? If not, you must discuss them immediately with the production manager. Keep them in mind for your meetings with the director and other department heads.

The characters listed in each scene are important insofar as they might involve special techniques or equipment. You won't know much about this until you meet the actors, the wardrobe person, and the make-up artist, but keep them in mind so you will know the relative frequency of each character's appearance.

The specific actions involved are essential to your planning. Are they walking up a staircase? Sprinting across an airport runway? Fighting? Every action—sitting, walking, opening a door, examining an x-ray—involves lighting considerations. It is very easy to fall into the trap of "lighting the set," without taking into account special problems that might arise due to the action.

Your reading of the script is not merely a technical exercise. Lighting is a major creative element. Unless you are able to understand the intentions of the scene and its place in the overall scheme of the creative enterprise, your lighting will be unlikely to live up to the director's expectations.

At this stage of the game, your understanding of the mood of the scene is critical to your lighting plan. The mood will be a key determinant in the most basic choices of overall approach and technique. Keep in mind that it is dangerous to form overly firm ideas until you have talked to the director, who may see the scene differently from the script writer or may have a specific visual approach in mind.

Depending on the screenwriter, any

special effects mentioned in the script will usually be in all capital letters to facilitate the breakdown. Not only do you need to ensure that the appropriate lighting and grip equipment is provided (for a lightning or fire effect, for example) but you must be ready to provide support for any effect that is the responsibility of another department.

For example, the script may mention that a character "turns on a VCR and slides the cassette in." On the face of it, this has nothing to do with lighting. But if you happened to be on a remote location that has no electricity and you had planned to light the set with carbon arcs (and as a result have ordered a DC generator), there may be no AC 110-volt electricity on the set for the prop department to plug the VCR into. Advance discussions are required to determine whether you might order an AC/DC generator, provide a small "putt-putt" portable AC genny, find a small nearby tie-in, or try to convince the prop man to get a DC-powered VCR.

For the most part, crews assume that AC will be available. Many departments use it: props need to be plugged in, carpenters use power equipment, wardrobe people have irons, hairdressers have hot curlers, and video playback is usually AC powered; even the production assistants will need power for their coffee pots. Unless you tell them otherwise, everyone will expect you to provide sufficient power. If not, they must be warned a day or more ahead of time through the assistant director.

Clearly, the time of day listed for each scene is one of your most critical pieces of information. A day scene generally calls for a very different equipment package than the same scene at night. The same applies to interior or exterior. The critical nature of these two parameters dictates their appearance in the scene identifier line.

Screenwriters vary in their specificity beyond simply calling a scene "day" or "night." Some will wax poetic, differentiating "golden hour," "dusk," "pre-dawn darkness," etc. Try to get a sense of whether or not these are merely the screenwriter's way of making the script more vivid and readable or if they are essential parts of the story and crucial to the action.

Be cautious in readily accepting the scene's classification as interior or exterior. Many scenes identified as interior are as difficult and require the same power needs as exteriors. For example, an interior scene played out in front of huge glass windows with sun streaming in will most likely require lighting units and grip equipment nearly equal to a full exterior. These are subtleties that can be determined only by a location scout, however, and for the moment, they are on the back burner.

Meetings With Your Collaborators
The Director

Equally important to studying the script is meeting with the director.

From him you will learn his intentions for the scene and whether he has a specific visualization that he wants you to fulfill.

Also to be discussed are any ideas he may have about lighting as a character in the scene, the overall mood, his initial thoughts on the action (beyond what is listed in the script, or perhaps, in place of what is mentioned there), any special situations, and whether he wants to add rain, wet-downs, fog, smoke, wind, or other environmental effects.

If it is at all possible, try to see other work that the director has done. In most cases a director will mention certain references: films that serve as good examples or that relate to a particular aesthetic goal. Frequently, the director will ask you to screen certain films and discuss them.

At these meetings, your input on overall lighting style and visual approach will usually be sought. The discussions will most likely be general at this point, with specifics to wait until everyone is at the location. Beyond this general discussion, you may want to

make specific suggestions about lighting as a character in the film, as a motivator of action, and as a story point.

The Production Designer

If you are hired early enough you may be able to meet with the production designer. If sets are going to be built, this may be your last chance to make your input on the color palette, use of *practicals* (working lights that appear in frame) on the set, and placement of any openings (doors, windows, skylights, etc.) that you might light with or through.

Other situations that you should be aware of are the color and light absorbing quality of the set materials (in particular, any very dark and absorbent set materials will have their own special problems, as will any mirrored or highly reflective surfaces).

Don't forget to discuss the number and placement of rigging positions. If you end up on set and find that there are no reasonable places to set your lights, the problem is at that point yours, not anybody else's.

Wild walls and removable pieces may also facilitate your work. *Teasers* (set pieces that hide the lights from camera) can often be worked into the set design at these early stages and are far easier to deal with during set construction than in the desperate minutes just before the camera rolls.

Often overlooked but sometimes deadly is the placement of a set on the stage. Reasonable and well-designed sets can be a nightmare to work on if they butt up against a cyc wall or another set or, at the opposite extreme, are moved so far out onto the stage that there is little room to maneuver equipment behind the camera. Think ahead about what lighting needs space or distance from the set. Certainly, sunlight or moonlight effects, which depend on a long throw of a lensed unit, are impossible if there is not a fairly generous distance from the area that they fall on. Don't just look at a model or drawings of a set, go to the stage and look at it

with the designer. The career you save may be your own.

The Production Team

Your discussions with the production manager will center largely on the budget. Not in terms of actual dollars and cents, but in the more general sense of what kind of crew you can have and what kind of equipment you can order. You may well be in the film business your whole life without ever hearing the phrase "the sky's the limit, order anything you want." Production types just don't talk that way.

The production style will play a role in your considerations as well, be it "run and gun" with just you and a camera, or heavy-duty production where every base has to be covered and the equipment complement ready to handle any exigency.

To a certain extent a film production team is a system of checks and balances. It is the job of the director and department heads (including you) to push for as much as they can get to do their jobs as well as possible. Conversely, it is up to the producer, production manager, and assistant director to keep the requests within the boundaries delineated by the budget and schedule.

As always, a balance must be struck. On the one hand is the danger of being caught short of people or equipment that are vital to do the job properly; on the other hand is the danger of being known as "one of those guys who always asks for the moon and doesn't care about the budget."

Your discussions with the AD will cover the schedule, transportation, and the marshalling of resources. Hopefully, you will be asked to participate in the scheduling sessions that will determine how much time is allotted to the lighting and shooting of each scene. You will also need to be aware of the order of the scenes so that you can start thinking about any possibilities of prelighting, rigging crews, etc.

As the shoot day approaches, the AD will be your primary source of informa-

tion concerning weather forecasts, staging areas, schedule changes, and so on. A good AD will also serve as a conduit of communication between departments.

The Lighting Team

Another key meeting will be between the director of photography, the gaffer, and key grip. The cinematographer will pass along everything he has learned so far and will give the keys as much information as possible about his intentions and the lighting requirements as he understands them.

The gaffer will discuss any potential problems concerning power, cabling or mounting the lighting units. The grip will cover any problems he sees concerning rigging, moving equipment, lighting control, transportation, weather rigging and so on.

The Location Scout

The location scout is the most crucial phase of preproduction. More than anything else, a basic lighting plan is determined by the set. Insist on a location scout before you plan your requests for equipment and crew. The most effective scout will result when the cameraman, the gaffer, key grip, director, AD, and production designer all visit the set together.

During the scout you will be looking for the opportunities that the set offers: existing practicals, windows, skylights, neon signs, etc. You will take note of potential rigging positions (with the gaffer paying attention to how lights in those positions will be cabled and adjusted).

Other characteristics of the set are also critical. For example, is the ceiling white or colored? A white ceiling is a ready-made soft reflector, while a colored ceiling or one that is too high will force you to provide your own overhead reflectors. The same thinking applies to other surfaces in the room. Dark absorbent materials will "eat up" the light and will often require additional units to light. Mirrored or highly reflective walls will dictate an entirely different lighting solution.

At this point you will probably begin forming some general ideas about the basic strategy you will pursue on this set. You will be alert to any interesting possibilities while at the same time weighing the relative time and cost of various approaches. Foremost in your mind will be the basic choice from among the three types of approaches: should it be an overall ambient lighting, a localized/specific approach, or a combination of the two?

Consideration of the director's intentions for the scene, the physical layout of the place, the time/cost factors and the look you are going for will all factor into this decision.

You will be asking yourself a number of questions: Are there convenient mounting positions or will you need to put up *spreaders* or *pogo sticks*? Will you need to ask the grips to build a grid, or are floor mount units the way to go? Can you light from outside through the windows, or are you on an upper floor that is too high for scaffolding.

These considerations may lead to discussions with the production manager about what is possible within the budget and schedule. For example, if the set is on a second floor and you would like to light from outside, it may be necessary to convince her that the rental of the scaffolding, the possible extra grip or two, and the time involved will be necessary for the lighting to be right.

As with studio sets, you may need to ask the production designer for teasers, additional practicals, mounting positions and so on. Don't be afraid to ask, even if the solution doesn't seem obvious. Good designers and prop people are usually aware of the gaffer's needs and can be remarkably inventive in providing solutions.

Finally, the location scout should include the director "blocking out" the basic action of the scene. Observe this closely. The smallest changes in action can frequently entail major lighting

changes. Few other departments seem to recognize that a seemingly simple change in blocking (for example, "he comes in from that door over there instead of this one") can sometimes lead to major rerigging of lights, rerouting of cables, and so on. So make careful mental and written notes about the placement and movement of action in the scenes, but take anything that the director says with a grain of salt; such rough blocking will almost always change. This is the director's right and privilege, and it is your job to ensure the greatest possible flexibility under the circumstances of the production.

As you watch the director walk through the scenes, a rough lighting plan will most likely start forming in your mind. Try to be a bit psychic. Anticipate possible alternatives and allow some slack in your plans so that you are not completely locked in to a particular set-up.

If the lighting that you and the director are planning involves a particular action to be unalterably set for the lighting to work, be sure to tell the director this so that she will understand the situation. Also be sure to tell the AD about this. It is his job to be aware of potential bottlenecks and problems and, quite frankly, it is often useful to have a witness who will also remember that the director said "no problem, I know exactly what I want."

The next step will be to meet with the actors. In the golden age of Hollywood, every great star knew where her "light" should be, and would occasionally refuse to do a scene if she felt that it was not set properly. Extensive testing was often done at the beginning of a star's career to determine the exact height and angle of key and fill that was most attractive to her particular face.

Marlene Dietrich's "butterfly" lighting is the best known of these, but many other glamorous stars knew when their light was right and when it wasn't. They frequently wielded the power to demand particular cameramen who knew not only how to place their keylight, but also what combination of filters to use to maximize the star's beauty. The filtration consisted not only of the often jarringly heavy diffusion for closeups, but also arcane combinations of colored filters that were necessary to optimize the response of the black and white emulsions to create the most glamorous skin tones.

Although these specific practices are seldom used, the factors that they address have not changed and will most likely remain important so long as motion pictures are fundamentally about the human face and figure.

The most important characteristics to observe in your actors are the depth of their eye sockets, the size and shape of their noses, their overall skin and hair coloring, and how they wear their hair. These, in conjunction with a look at the coloring of their costumes and the size and style of hats they might wear, will be important determinants of your lighting and, indeed, for the scenes as a whole.

Deeply set eyes will usually necessitate some kind of eyelight (unless you use a very low angle key), whereas your primary lighting will often work well enough for an actor with shallow eye sockets.

Similar problems arise when an actor wears a hat. The larger the brim the bigger the problem. A key low enough to reach under the hat will often be so low and frontal as to become flat and undistinguished. Historically, the most popular solution has been to set the keylight for the overall scene, then add a special "hat light" for the actors face.

This leads to the familiar double shadow line that you will see on almost every actor's face in older films with daylight exterior scenes (back in the days when everybody wore hats). The upper and darker shadow is the shadow of the hat brim from the hat light that falls off to true black. The lower one falls approximately where a hat shadow would actually fall in reality. It is the shadow of the primary key for the scene and falls on the face in a natural way

that sustains the illusion of realistic lighting while perhaps adding the drama of a half-hidden face. Since it is largely filled in by the hat light it is a very open, low-contrast shadow, generally only a fraction of a stop down from the keylight as it hits the face unshaded by the hat. It is, in fact, a suggested shadow more than a real one.

The necessity of adding light to fill the faces of actors wearing hats illustrates the difficulty of thinking of all lights in terms of *key* and *fill*, the traditional terms. Which one is it?

The key light that is imitating the sun or other strong source is clearly the more domonant light in the scene, so it might be logical to call this light the fill. On the other hand, the smaller unit is the primary illumination for the actor's face (indeed the only illumination for most of her face), and could thus be properly called her key. For purposes of clarity, lights of this kind are referred to as *secondary keys*.

The make-up artist may ask for your help in reducing the size of a nose, hiding pouches under the eyes, making blemishes disappear, and so on. Based on what you anticipate your lighting will be able to handle, you will give the make-up artist an honest appraisal about what you will be able to solve and what needs more corrective makeup.

Be diplomatic at all times. Many actors may be accustomed to having their physical characteristics discussed by fellow professionals, but their faces are their livelihoods and they are understandably quite sensitive and emotionally exposed in such a position. Be tactful and, when possible, keep the conversation out of the actor's presence.

The Order

Based on everything you have learned so far from the script, the meetings with key personnel, the location scout and seeing the actors, you will now come to one of the most important phases of the lighting process: placing the order for crew and equipment.

It is your responsibility to make sure that you arrive on set with all of the basic tools to do your job. It is the production manager's job to see that you spend as little money as possible achieving this goal. The eternal push/pull negotiating with the production manager is an essential part of your job. Consider carefully what you absolutely must have to do the scene, what you would like to have to do the best job possible, what would really make it a pleasure to do, and finally, what you could barely scrape by with in the worst of all possible cases. Have these categories in mind if it becomes necessary to negotiate with the production manager or producer.

Most people start by thinking about what *big lights* they will use as the primary keys for the scene: A 12K HMI for sun through a window? A big eye 10K for a dramatic shaft of light down a staircase? Ten skypans for an overall ambient? Or maybe just a couple of mighties for a bounce soft key?

Having decided on the keys, make some guesses about fill units and the secondary equipment involved, mighty moles for bounce fill, deuces for backlights, babies to create some patterns on the walls, and so on.

Next, consider the smaller units: inkies for eyelights and small jobs, an extra baby for a slate light, several small softs to provide worklights for makeup, props, and others.

Finally comes the *slack*: the spares and extras that are impossible to anticipate and that may or may not be used, but when they do, they will often save your life. Don't overlook this essential category, and keep Murphy's laws in mind as you make up your order.

Generally, the cameraman will specify the major units that he feels will be necessary to execute his design and then turn the process over to the the gaffer and the key grip. The gaffer will fill in the additional units, whether minor lights, spares or slack, and also specify any needed stands, specialty equipment (chicken coops, soft boxes,

lightning machines), electrical distribution, spare bulbs, etc.

At this time, a decision will be made about the source of power and the gaffer will specify his tie-in equipment and/or the size and type of generator to be ordered. Of course, the prudent gaffer will nearly always order tie-in equipment even if a generator is on call. This has made many a hero when generators get lost en route, break down, or run out of fuel.

It is in placing the order that one is reminded of a basic reality of film production: the biggest, most elaborately equipped film shoots can be brought to a grinding halt by the smallest, most seemingly insignificant items. It is the gaffer's responsibility to make sure that it's all there for the lighting department.

While reeling off a complete and accurate equipment list on a moment's notice from memory is something almost any experienced gaffer can do, a preprinted order form is helpful in guaranteeing that all bases get covered. Beyond that, it is useful to submit a written document to production to help prevent any glitches in the ordering process. Much of the terminology of lighting equipment may be unfamiliar to the person who phones in the order and being able to read it from a printed list will help prevent mistakes. If your handwriting is not so good or if it was raining when you wrote out the list, this will help prevent a production assistant from ordering ten "Mighty Mouses," when what you really wanted was ten Mighty Moles.

The order form illustrated in Figure 7.3 is typical. It lists all types of equipment commonly used in production and leaves blanks available for oddball additions for unusual situations.

In addition to equipment, the gaffer must submit his request for crew. Here the gaffer must evaluate the lighting situations to be dealt with, problems to be surmounted, budget and schedule carefully to be sure that the team is adequate but not excessive. All factors must be considered carefully: it may be

an extensive set-up but a prelight day indicates the need for a slightly smaller set crew. On the other hand, it may be a simple set-up but must be executed quickly, so a larger crew may be called for. The general rule of thumb is that the number of electrics and grips should be equal. Obviously, unusual situations will force a departure from this rule, but in general it seems to work well.

The grip will list mounting equipment, control equipment (flags, nets, silks), and requirements for grip stands, high-boys, sand bags, clips and clamps, apple boxes, etc. If the gaffer anticipates the need to use grip equipment, such as a high-boy as a light stand for maximum height, it is important to alert the grip so that extras can be ordered beyond the grip department needs.

On the Set
Once you're on the set, the real action begins. Although you will probably have prepared a rough sketch of your lighting plan, actual lighting is almost always built, one light at a time. No matter how careful the planning, there is no substitute for seeing the lights actually working on the sets with the actors. How you start to build the lighting will be a matter of personal preference and the individual situation, but certain techniques seem to be common to gaffers and cinematographers.

Traditional Set Operating
It is frequently useful to stick to the traditional Hollywood method of operating a set. Typically it goes like this:

1. Basic rough-in of major units and electrical distribution is based on the director's rough blocking of action and the cameraman's general scheme.

2. The director blocks the scene and the cameraman and gaffer watch to observe the action they will be lighting.

3. Actors clear the set and the cameraman directs the lighting crew in setting the lighting for the scene.

4. The crew turns the set back over to the director and actors for final rehearsal. If possible, the cinematogra-

Job Name: _____ Date: _____ Rental House: _____

Arc	Carbons	Cinevator	216	Clothes pins
12K HMI	Headers	Crankovator	Opal	Gaffers tape
6K HMI		Senior Stand	Spun	2" black
4K HMI		Junior Stand	1/2 Spun	1" black
2.5K HMI		Baby Stand	Velum (1000H)	Double stick
1.2K HMI		Reflector Stand	Tracing paper	#10 sash
575K HMI		Wind mac. Stand	Grid cloth	#8 sash
HMI PAR 1.2K	Batteries		Soft frost	J-Lar
HMI PAR 2.5K		#1 Tricos	Hampshire	Balling wire
Big Eye 10K	Snoots	#2 Tricos		Black Wrap
10K		Siameese	ND 3	Streaks & Tips
5K		301 1/2	ND 6	Dulling spray
2K		Stage boxes	ND 9	Black dulling spray
1K		Hollywood box		Trick line
Tweenie	w/snoots	Tweco adapters	CTO	3 to 2's
Inkie	w/snoots	#0000	1/2 CTO	Cube taps
*(Stands for all lights)		#00	1/4 CTO	
Skypans	Collar	#2 (4 wire)	1/8 CTO	Polaroid 667
Mighties		#1	Blue	Polaroid 669
Mickies		#4	1/2 Blue	Polaroid 107
Nooklights		#6	1/3 Blue	Mat silver card
Totas		Bullswitch	1/4 Blue	Shiny silver card
DP Lights			1/8 Blue	Mat gold card
Lowel kit		100 a DP porc	Y-1	Shiny gold card
Stick-Ups		100 a SP porc	MT2	Black flock paper
Gator lite		60 a SP porc	MTY	Seamless
1K Xenon		4 way > Hub	UV Filter	Silver mylar
2K Xenon		4 way short>Hub		
4K Xenon		4 way > SP	Minus Green	Showcard
7K Xenon	Batteries	4 way short>SP	1/2 Minus Green	4x8 foamcore
PAR narrow	Bulbs	Singles	1/4 Minus Green	4x8 b/w f.c.
PAR med			Plus Green	30x40 f.c.
PAR wide		Generator (ac/dc)	1/2 Plus Green	Beadboard
9-Lite		Put-put	1/4 Plus Green	FEL rigs
5-Lite		Car batteries	Flourofilter	Chineese lanterns
Maxi-Brute	Egg crates	Inverter		Porcelain sockets
A.C. lites		750 Varlac	Straw	Zip cord
1K zip		2K Varlac	Theatrical gel	Male quick taps
2K zip		5K dimmer		Female quick taps
1K soft		10K dimmer		
2K soft		6K dimmer		ECT-500 T
4K soft		Dimmer board		ECA-250 T
8K soft		2K riser		EBV-500 34
1K cone		1k Offset arm	Cyc meter	EAL-500 32
2K cone	hoods	2K Offset	White plexi	BBA-250 34
	bulbs	1K Sidearm	Black plexi	BCA-250 48
Space lights		2K Sidearm	3/8" glass	EBW-500 48
Bay lights		Mafers	Mirror	R-40
Chicken coop		1K pidgeon	Front mirror	R-20
Flourescent		2K pidegeon		Flourescent tubes
4 x 5 Leiko			Turtle	200 W
6 x 8 Leiko		Sus. ceiling clamp	Set Claw	150 W
6x 12 Leiko		T.S. clamp	Bazooka	100 W
6 x16 Leiko			Crowder clamp	75 W
6 x 22 Leiko			1K pipe clamps	60 W
			2K pipe clamps	25 W
Molelipso			Comet boom	Fairy lights
Inky focal sp			Western dolly	
1K focal sp			Doorway dolly	MR 16/TP-40
Xenon Sungun				
Sungun				

7.3 A typical lighting order.

pher; gaffer and key grip observe, alert for details, problems and changes.

5. The lighting is fine-tuned for problems and changes.

6. The scene is shot.

Amateur directors and production types will often suggest that "we're just one big happy family here; we'll all work on the set at the same time." Avoid this if at all possible since chaos, frayed nerves, and injuries are the most common results and in the end little, if any, time is saved. Time and again, the old Hollywood methods, worked out over fifty years of trial and error, prove to be the most efficient techniques.

Planning Ahead

As you start to rough-in the scene, there is more to think about than just making this shot look good. Now you must plan the coverage for this scene, the next shot, and the next set.

As you set the lights and run the cable, be alert for anything that might save time in the future. Can a light be set now that will merely need to be switched on for the next shot? Will a little more cable on the fill unit enable it to be easily repositioned for the closeup? Will a piece of blue gel clothespinned to the stand of a backlight make the changeover to a night scene quicker?

The range of issues involved in anticipating future moves extends from the overall concept down to the smallest details. For example, one of the most fundamental decisions to be made in lighting a set is whether to light from units on stands on the floor or whether to hang all the lights from a grid, wall stretches, or other "up in the air" mounts. As always, there are tradeoffs: lighting from the grid takes longer, but when you go for a *turnaround* (reverse angle), little if anything has to be moved to see in frame the side of the room that was formerly behind the camera.

On the other hand, lighting from floor units is usually quicker, but turning around for the reverse may involve moving every single unit, recabling, and refocusing. To quote an old gaffer's reply to an AD's question about why a reverse would take so long: "the lights may be on wheels, babe, but the cables ain't."

As always, politics may play a role in the decision. Even though the first set-up may take longer if the entire day's shoot is planned for and anticipated, it will generally more than pay for itself in time. But the time elapsed for the first day's set up is the most visible and most nervously watched indicator of how the crew is doing. This is an institutionalized measurement; there is even a slot on the AD's daily production report that records when the first shot is made.

Production types who have no background for knowing how the slightly longer route may be the shortest path to the goal, will often grow restless and irritable. Regrettably, it may sometimes be necessary to make an impression. Occasionally the director, AD or cameraman will ask that the quick way be taken, knowing full well that it is less efficient. This is done based on a well-known psychological fact: once that clapboard snaps down on "take one," everybody relaxes into a vague sort of "hey, we're making movies" semi-euphoria and the tension of waiting for the lighting disappears for a while.

Future changes that you may need to anticipate include

1. Changing time of day. For example, the same set will frequently have a daylight scene and, after a costume change, a night scene. Lighting for both scenes at the same time is often possible by having additional units standing by, moonlight gels already cut and clipped to the lights, power cables already laid out and standing by in a new position for a light in use elsewhere. Dimmers have become increasingly popular as a quick means of moving from one set-up to another. It is not unusual to see sets where every unit is controlled by dimmers of one type or another.

2. The same applies to weather

changes. If rain is called for in the next scene, it makes sense to provide protection for the lights while they are first being installed, rather than just before the rain effect is first tested. A general rule of thumb is to ask yourself: if I have to bring a ladder back to rerig a unit, could I have done this when the ladder was here originally?

3. Anticipate environmental problems. It is surprising how quickly the sun moves through the sky when the shadows are in frame. Check the site with a compass, consult sunrise and sunset tables, look at nearby trees and buildings, try to look ahead to how the direct sun and shadows will change throughout the day. Most likely this will not only affect your original decisions but will motivate you to ask the grips to have a silk and cutters standing by to keep errant sun beams from intruding onto the set.

One problem that has crept up on otherwise well-prepared crews is the reflection of direct sun off glass buildings. The reflections are very hot and hard and move very quickly. They are very obvious in the scene and because of the high angle they come from, are not easy to deal with. Be warned!

4. Keep up with the latest weather reports. They affect more than just the soft/hard quality of the skylight. Rain also means ordering extra rubber mats and plastic to keep connectors and lights dry, as well as apple boxes to keep them up off the ground. It means having the grips prepare rain protectors to keep hot fresnel lenses from cracking. It means having additional units standing by to keep the t/stop constant if the clouds get thick.

5. Finally, establish a lighting you can live with. If other scenes are going to be shot on the same set in continuity and with no need for a lighting change, your decisions in lighting the first scene may end up locking you into a lighting situation that is difficult or impossible for later scenes. While a certain amount of "cheating" is almost always involved

in lighting coverage, turnarounds, and subsequent scenes, the more you can anticipate and provide for these situations, the less you will have to relight and compromise.

Lighting a Small Commercial Set

In order to illustrate the decision making process that goes on before the camera rolls on the first shot, we will look at a fairly common lighting situation, a small set for a dramatic scene. The set is a room in a cabin with a large window *camera left*, a wood burning stove, a bed *camera right*, and some hanging laundry. The action moves around quite a bit and involves a woman sitting at the stove, men entering the door, and characters sitting on the bed. The time of day for the shot will be late afternoon. See Figure 7.4.

Getting Started: Rough-In

Now the moment of truth, the time has come to set the first light. All eyes are on you. Your electrician on the set turns to you and asks the dreaded question, "What do we need, chief?"

There it is. One of the most important and far-reaching decisions of the entire day and you haven't even had time to get to the craft services table for a cup of coffee.

Placing the first light is different from planning your lighting, and to understand why, we must understand the lighting process: both physically and as it develops in the lightingperson's mind.

Lighting is often planned, whether in an elaborate diagram, a rough sketch, or just a few mental notes. Planning consists partly of careful consideration of all the factors we have just discussed, partly of intuition, and partly of experience, resulting in some general idea of the overall concept of the lighting and of the placement and size of specific units.

Lighting a set is never a cut and dried mechanical process, although it may appear to be to most bystanders. Lighting that has subtlety, beauty, and a strong

concept, is not a simple matter of hanging a few lights and turning them on. It is the result of a complex interaction of all the physical aspects of the set, actors, and mood and character of the scene. Every light has a job to do, every light must fit and balance within the overall shot, every light interacts with others and with the action. They all work together in a web of complexity and subtlety that is impossible to predict on a diagram.

As a result, the lighting process is one of *building*. Lights are added singly or a few at a time; the cumulative effect is observed, measured, and judged, then adjustments are made and the next units are added. Building may take many forms, units may actually be brought to the set one at a time or may be *roughed in* and then turned on and adjusted individually. Clearly, the schedule and budget have a great deal to do with how this procedure is performed.

This building process is a highly fluid one and is different in nearly every situation but as with many things in life, where you start has a lot to do with where you end up.

Setting the first light breaks down into a few fundamental groups of thinking. You have several choices.

1. Build on existing *clues* in the set: practicals, windows, doors, skylights, fireplaces, etc. On a practical level, this usually translates to roughing in your set lighting first. For example, among the most frequent choices for setting the first light is a shaft of sunlight through the window, whether it be an HMI, a tenner, a 5K, or the softer look of a skypan bounced into foamcore. This provides a good deal of the ambient for the scene and shows immediately what is lit by this effect and what still needs treatment. Often this will be the actor's key as well, at least for part of the scene.

2. Set the actor's primary key first. This method will often be preferred when the scene is a closeup or the es-sence of the scene is a particular actor, or when the set offers few clues or points of departure.

3. Set a general ambient base. This base might be skypans through an overhead silk, a couple of open-faced units bounced into a white ceiling, or some similar technique. This technique is the obvious starting point of the general ambient lighting type (see Chapter 5). It is unlikely that you would start another way when using this lighting type, as the base exposure level is the reference against which all other units must be balanced, therefore it is essential to set before moving on.

For the moment, we will assume that you have decided to start by building on the set's natural qualities. For our example, we will look at a simple room set where a large window is a primary element.

So you have decided *where* the unit will be set; now you must decide *what* it will be. There are two aspects to consider, the *quality* of light and the *quantity* of light. The decision about quantity of light will be based on the footcandle level you are trying to achieve and your general plan of how the whole scheme will fit together. This decision will be a result of a number of factors:

1. The rated film speed of the emulsion you are using. Keep in mind that you may not be rating the film at the manufacturer's listed speed.

2. The t-stop you are trying to achieve. This is dictated by the maximum stop of the lens (that is, whether the lens is a slow zoom, a normal prime, or a high-speed prime), and how much depth of field is desirable for the scene.

3. The distance from the light to the subject as determined by limitations of the set, the hard/soft quality you are trying to achieve, and possible action or camera movements.

4. Whether or not there will be light modifiers in front of the light. Heavy diffusion will usually cost a stop or

more, but the real culprit is colored gels that, for the deeper colors in particular, can cut the light by several stops.

Window Lighting

We have a general idea of the acting area (the entire set in this case) and that it is a daylight scene. It's late afternoon, sunlight will be coming through the window, and we need a light that is somewhat hard, but still flattering to the actress.

Clearly the sun coming through the windows camera left will be the major motivated source for the scene. Most of the key lighting for the scene must either come through these windows or seem to be coming through these windows. This sets the major constraints of most of our keylights for the scene.

We could angle the sunlight so that it comes in at a right angle (parallel to the back wall of the set) or even at a steeper angle so that the shaft is angling toward the camera. But there are problems with both solutions. First of all, sunlight at a right angle becomes more of a sidelight than a keylight. The director wants the scene moody and shadowy but not quite that shadowy. It's a long dialogue scene and we need to see more of the faces. The same applies to the steeper angle—it would be a backlight. Both of these are more dramatic visually and can be terrific, but they just don't happen to suit the purposes of this scene.

Additionally, neither of these angles gets any light on the walls. Remember, you are lighting both the actors and the set. Those shafts of light angling across the walls will be an important part of making this otherwise dull room come alive.

These other solutions are, however, well worth storing in the back of your head for later. The scene we're shooting now is a character establishing scene early in the film. Is there a really dramatic, climactic scene later in the film where stronger, more violent lighting would be appropriate? If there is, these alternates might be the perfect way to

build a progression of lighting that reinforces the story line. Discuss it with the director but don't forget to mention it to the script clerk who is the person most responsible for making sure that the script makes sense in terms of times of day, weather conditions, and other continuity problems. If the time arrives to shoot this later climactic scene and it turns out that they have just walked inside from a scene at high noon, your idea will be worthless. Now is the time to make sure it all fits together.

So, everything points toward bringing the light in as if the sun was over the camera's left shoulder.

One problem becomes apparent from the outset: the window is fairly deep in the set, back by the corner. Shafts of sunlight coming through this window will do a fine job of covering the area by the stove and the door but won't give much coverage for the downstage area or the downstage end of the bed. We know that there will be some action in this area. And since the camera is here, action in this area will pretty much be closeups, which demand more light on the faces.

We opt for a straightforward solution: we assume the existence of another window just off-camera to the left. This will cover the main acting area and give us some flexibility in the adjustment of the light. Since it will be *sunlight*, a 10K is the appropriate unit. We will cheat a little bit and diffuse it to make it a little softer on the actor's faces.

Our first light, then, is a studio 10K through a heavy diffusion on a frame. It is set and turned on and we survey the effect (Figure 7.4A.) It seems to do its job, but let's face it, it's nothing spectacular. That's ok. This is just basic acting area lighting; what matters is what it does for the actor's faces, not how it looks by itself.

The next logical step is to bring the sunlight through the window. This should do a great deal for the set and start to define the space and set the mood. Since we are trying for a sunlight effect and this is a dramatic scene we

A

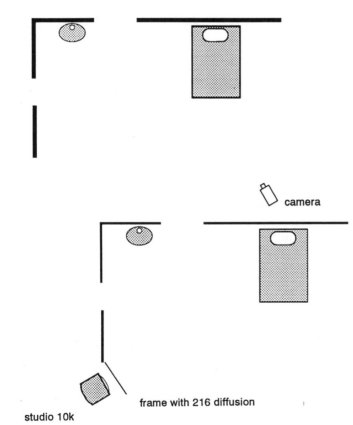

camera

frame with 216 diffusion

studio 10k

B

7.4 A and **B** The first decision: a 10K through a 216 frame.

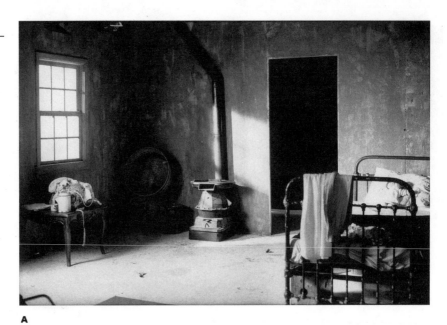

A

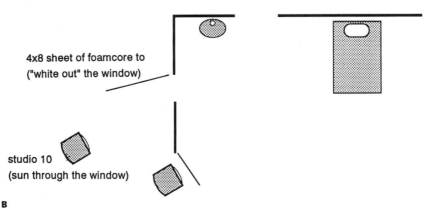

4x8 sheet of foamcore to
("white out" the window)

studio 10
(sun through the window)

B

7.5A and **B** A 10K sunlight is added.

know several things. First of all, we want this light to be hotter than most of the other lights in the scene since, psychologically, sunlight will overpower any other source.

Secondly, we know that sunlight is a sharp focus light because it is an almost point source from 93 million miles away. We know that we will need to keep the instrument as far back as possible so that the shadows will be sharp and the beams will not spread out and look unnatural. Finally, it is unlikely that we will put any diffusion over it.

Since our first *window light* was a 10K (and 10Ks are the biggest light we have available), this will have to be the

same. It will be backed off as far as possible and flooded all the way to provide the sharpest possible shadows. In this case it works out fine, since our first 10K was much closer; it goes through a layer of heavy diffusion, thereby losing about 1 stop of exposure. As a result, the two lights balance out pretty well.

We switch on and right away the scene has some life, some depth to it, as well as a much more convincing, realistic look. But there are problems. Notice the nice prop details in the corner: the old wash tub on top of a nail keg. They are lost in shadow. While shadows are fine, it would be nice to sprinkle some light on these. We could maneuver our

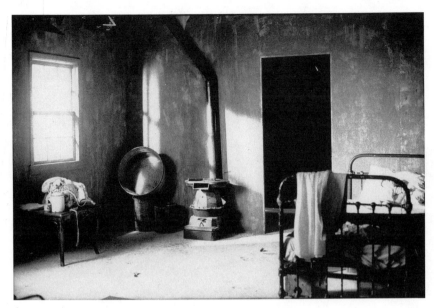

A

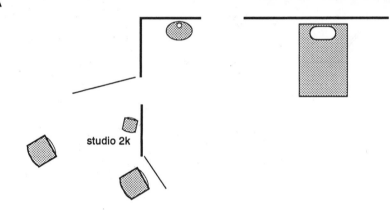

studio 2k

B

7.6A and **B** Studio 2K for the corner.

sunlight 10K around, but then we would lose the beautiful splash of sun on the stovepipe that spills over into the door and almost reaches the bed.

It's time to *cheat*.

A second unit will be added to extend the sunlight and carry it into the corner. No more 5Ks left, but a studio 2K at full spot should do it. It is pressed up against the wall as far as possible and it does get in where we need it—a nice little sprinkle that adds depth and spatial sculpturing to the scene. But that isn't what the sun would really do, now, is it? This is really the effect you would get from two separate sources at different distances from the window.

True. That's why they call it cheating. Even when the lighting style is pure realism and motivated sources, it is not necessary to be slave to the laws of physics. The fine art of cheating is in understanding the level of perception of the audience. This is true not only of lighting, but of camera angles, editing, and story continuity. The human mind is wonderfully forgiving of these inconsistencies; the trick is to know what that level is.

Key Lighting

You are ready to set the key. Let's remember what jobs it has to do.

1. Reinforce the actor's character.

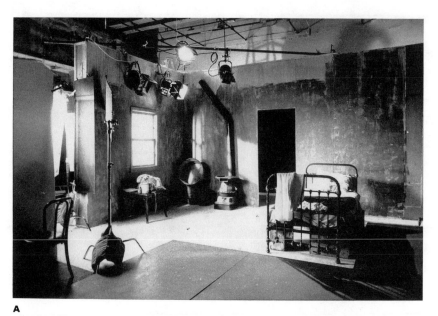

A

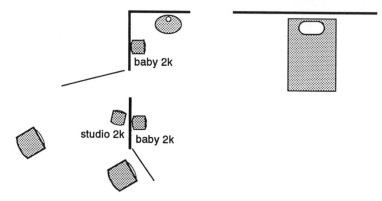

B

7.7A and **B** Baby 2Ks for bed area key.

Make the starlet look beautiful, the bad guy look sinister, the product look sparkling, etc.

2. Reinforce the mood of the scene. This may involve some cheating. For example, the rest of the scene may be dark, moody and ominous, almost completely in shadow. This might be fine for a quick pass of a minor character, but if a key character is doing a long dialogue scene, the director may deem it unacceptable for the face to be in shadow for a long ime. In this case, the key light will have to look dark and shadowy, while still adequately illuminating the actor's face. (See Chapter 6)

3. Maintain continuity.

4. Cover moves.

5. Provide proper exposure and bal-

ance for the subject in relation to the rest of the scene.

6. Achieve proper color balance for what you are trying to do.

Many questions will run through your mind as you decide on the key, hard or soft? What kind of footcandle level is needed to balance with the scene I've established so far? What kind of lighting is best for this facial structure? Do I need one key for each actor, or can one light work for a whole group? Will one unit cover the move or will the actor need several keys to pass through?

Additional Lighting

We know that the actor's blocking is to start seated near the stove and move to the bed. The first 10K we set is doing a

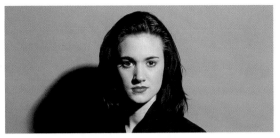

C.1 A bare studio 2K without fill. The following 21 photographs illustrate the effect of various diffusion materials on this basic source.

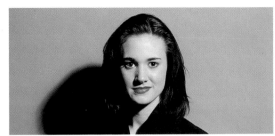

C.2 1/4 Tough Spun.

C.3 Hampshire.

C.4 Opal Tough Frost.

C.5 Light Tough Spun.

C.6 Tough Spun.

C.7 Tough Frost.

C.8 Light Grid Cloth.

C.9 1/2 Tough White Diffusion.

C.10 Tough White Diffusion (216).

C.11 Tough Rolux.

C.12 Double Tough White Diffusion.

C.13 Soft Frost.

C.14 Unbleached Muslin.

C.15 Bleached Muslin.

C.16 Double Bleached Muslin.

C.17 Foamcore Bounce.

C.18 Beadboard Bounce.

C.19 Froglight.

C.20 Hilite.

C.21 Grid cloth.

C.22 Uncorrected cool white fluorescent and 5500K daylight.

C.23 Minusgreen correction gel added to the fluorescent.

C.24 Cool White fluorescent on one side, tungsten 3200K on the other. Plusgreen 50 is added to the fluorescent to balance them, then the lab will take the green out for correct color balance.

C.25 Fluorofilter added to the fluorescents to bring them into balance with the tungsten lights.

C.26 Warm White fluorescents corrected to tungsten by adding Minusgreen and 1/4 CTO.

C.27 Color correct Optima 32s in balance with tungsten lights.

7.8 Studio 2K above the corner for a hair light.

pretty job of general illumination, but it lacks punch. We need something a little harder and more localized for when the actors are sitting on the bed. We need something to carry the sunlight effect to the far side of the room, and to do it with a little kick, hard and focused.

In this case we will use two baby 2Ks just out of frame above the windows. A little *opal tough frost* (the lightest diffusions available) just "takes the curse off" enough to make them flattering to the actors without losing the punch. These will act as backlights for parts of the move and then as a hard key, when the actors are sitting on the bed facing the window. See Figure 7.7A.

Traditional Hollywood *stand ins* were the same height and coloring and facial characteristics as the stars they represented. It is crucial to focus the keylight and backlight to proper altitude (particularly in the case of setting a backight, which often involves the time consuming process of maneuvering a ladder onto the set). The height of the actor on a really tight set can affect what is in the frameline, thus lights might show up in the frame.

Lights that are discovered to be in the frame are most commonly the result of setting the lights without the frame line being absolutley locked in. To prevent a panicky scramble to move or hide them at the last second, it is up to you to insist that the shot be locked before you start final lighting. Even if everyone says they are too busy and rushed to rehearse the shot and set the

camera and give you the go-ahead to start lighting, a panic situation like this will only make you look bad: no one will step forward to share the blame. So remember rule number one: set the shot before lighting!

For this scene the shot is locked so we know that we are clear on these 2Ks. A studio 2K is added on top of the set in the corner to provide separation for the actors. Also, a quick check with the spot meter shows that the foamcore that provides our *burned out* exterior as viewed through the window is not hot enough. We need it to be about 2–2 1/3 stops hotter than the aperture we will set on the camera.

If it is not that hot, it will just be a white surface with visible texture, or even worse, a shade of gray. Any hotter than this and the window will *bloom*, causing flare and distortion. To handle this problem, a 5K is added that covers the foamcore. It's a little too hot, so a double scrim (one stop light reduction) is dropped in to bring it into balance. A little tweaking on the barndoors and we're ready for a rehearsal.

How to Be Fast
For cinematographers and gaffers, being *fast* is one of the most essential attributes. Some issues to consider:

1. Don't light in your head. This does not mean don't plan ahead or don't think about your lighting, but it is critical to distinguish between what are ideas and plans and what constitutes getting ahead of yourself. It is easy to

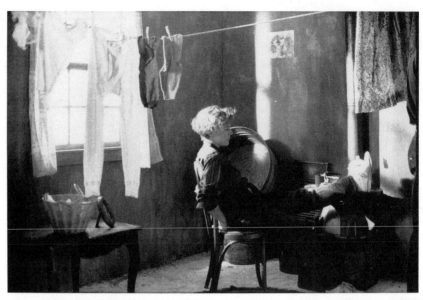

7.9 The area near the bed.

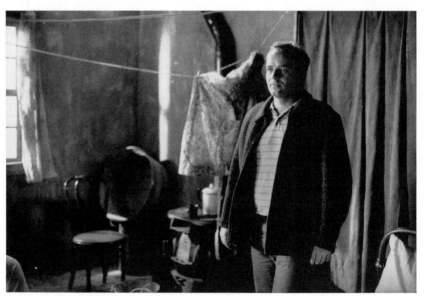

7.1 0 Near the window.

trap yourself into thinking that a certain approach will work, then have the crew work on it for several hours before discovering that it doesn't work at all.

2. Build one light at a time. The illusion of having a lot of things going on at once may put on a good show for the producer, but it can be extremely counterproductive at times, if, in fact, some people are working on rigs that are pursuant to a basic idea that won't

fly. It is far better to wait a few minutes until you are sure people are working on something that will actually pan out than to make a lot of busy work that has to be undone.

3. Light from the back. Set levels on cycs—background and windows first—then you can adjust your keys and fills to suit that level.

4. Cinematographers and video lighting directors often get frustated waiting for something to be done and will try to

pitch in and help with the lighting. This is usually a mistake. Don't try to be your own gaffer or electrician: work with the chain of command, not against it.

5. Keep your team with you. It is the responsibility of each electric and grip to be easy to find and within earshot at all times. "Don't make me come look for you," is the familiar refrain; a professional crew will seldom make that necessary without good cause. Get walkie-talkies whenever you can.

6. Don't jump in and call for a light until you are sure you really need it. As in real life, the problem with wanting things is that you sometimes get them. Make sure it's really the right idea. It is easy to lose sight of the manpower and resources that go into setting one light: bringing it around, setting it on a stand, running power, bringing a ladder, clearing other items, etc. A good crew makes it look easy but it's still resources being spent, which might be better used elsewhere. Look at what you have before you call for one more light: Many beginning DPs resort to the call of "I need another light" in every moment of doubt. Sometimes what is needed is just a little tweaking of what is already there, a bit of spotting up, a different diffusion, a refocus, etc.

7. Don't panic! Even when you are losing the sun or the director is going crazy and wants to shoot immediately, don't let chaos break loose. Work steadily and play by the rules; in the end a lot more will get done than if everyone runs around screaming. When in a hurry, slow down!

8. Don't get involved in long discussions about "how can we move faster?" Enormous amounts of time are wasted on sets discussing this and other arcane philosophical issues, time that could have been spent lighting.

9. Try to stay out of the grid whenever you can. It takes far longer to rig a light from the ceiling than to set it on a stand. It's not just setting the light; it's running the power, tying up the cable, maneuvering the ladder, running up to the greens, etc.—they all take time. There are, of course, many exceptions to this.

10. Learn from your experience. Think about set-ups you have done: In what situations is it more efficient to bomb the 12K through the window? In what situations is it quicker to go with small units?

11. There is an old saying in the movie business: "Good, fast, cheap, pick any two". Nothing could be more fundamentally true. To shoot something good, fast and cheap is extremely rare. Be realistic in your expectations and try to get the director, producer and assistant director to be reasonable as well.

8. Basic Scene Lighting

In this chapter we will look at a number of examples of scene lighting, looking not only how the lighting problems were resolved, but also to see how resources are deployed for the requirements of the action, and the constraints of time and budget.

One of the most interesting aspects of lighting is that no two scenes are ever exactly alike. There are constantly new problems to solve, new variations to try, and new looks to establish. But the basics remain fairly constant. We will be able to see the variety of looks that can be built with these simple elements and different lighting approaches.

When we set out to light a scene there are a number of questions we must ask:
- What is the dramatic intent and atmosphere of the scene?
- What time of day is it?
- Where does the action within the scene take place?
- How many people in the scene? Do they move around?
- Do we see the ceiling? Do we see the floor?
- Are there any practical effects?—such as turning on a light, a radio, a TV, etc.
- Is there anything that we have to bal-

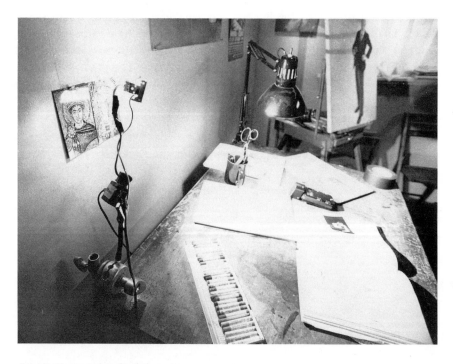

8.1 MR-16 mounted on the desk.

8.2 The desk lamp by itself.

8.4 Some sprinkles on the background.

8.3 MR-16 on her face plus a tweenie bounce.

ance such as a TV set, outdoors scenes, neon lights, computer monitors?

- Do we need to establish lighting continuity for future scenes, cutaways, or product shots?
- What is the ASA of the film?
- What is the slowest lens (usually the zoom) we might use ?
- Any high-speed or macro work?

Night Artist

This scene is an artist at her drawing table. The time is night and we won't see outside the window. She stays seated for the scene.

Our first decision concerns our basic approach: we decide to use the desk lamp as the motivating source. The electricians have made it hot through a dimmer—standard procedure for any practical lamp in the scene—a 60 watt bulb is in.

A

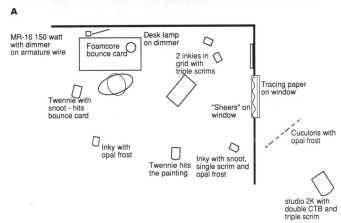

B

8.5A and **B** The final result.

Sometimes we can use the practical itself as the actual source. We try a simple test. Turning it on we find many of the usual problems; while it throws a beautiful light on her face, it makes the desk very hot. We can't tone down the desk without reducing the key. The other problem is that it isn't hot enough to give us the depth-of-field that we need.

We tone it down to give a nice glow on the table and bring in something to recreate the desk lamp effect. The problem in this scene is that the table is up against the wall and we need the full width of it for the shot. This leaves us very little room for a unit. There are two choices: fit in something very small or go with a bounce card. Neither of these solutions really gives us the quality we are looking for, so we use both.

An inkie might fit, but by the time we add barndoors, it would crowd the frameline. We go to the smallest unit around, an MR-16.

8.6 In the hydraulic control room.

MR-16s are actually projector lamps, that have small bulbs with self-contained reflectors. They come in 120 volt and 12 volt and are very punchy and efficient. The bulb we will use is an FMG 120 volt, 150 watt on a handheld dimmer. It is mounted on an Arriflex arm (used mostly for dots and fingers) that is held by a grip head that is mounted on a mafer clamp with baby stud. See Figure 8.1.

The FMG gives us good punch and modeling to the face, but it doesn't have the slight wrapping quality as the desk lamp. For this we add a small foamcore bounce card just below the MR-16 (Figure 8.3). Hitting the bounce card is a snooted tweenie from camera right. Moving on to the background, we add two splashes from inkies in the grid. One hits the painting on the wall and the other rakes across the window and the wall. We also hit the painting on the easel to bring it out.

Finally we add some outdoor "presence," just a sprinkle of moonlight on the curtains. Here it is a studio deuce scrimmed down with a triple and some opal frost. It goes through a cookie that breaks it up like a branch would. In some cases we might use a real branch and direct a small fan at it to give it a gentle rustling motion, which adds some life to the scene as well as a small touch of realism.

Looking at the painting on the easel we realize it is too hot and distracts from the face. A double scrim tones it down and we are ready to go.

L1011

This scene shot inside a hydraulic control room in the belly of an L1011 presented some unusual location problems. Because it was adjacent to the open (although drained) fuel tanks and other potentially explosive fumes, no HMIs or tungsten lights were permitted. Only specially sealed fluorescent tubes and hand-held units were allowed.

The shot itself presented difficulties, as it was to be a 360° pan that might include the ceiling, There were no

Hydraulic room floor

Fluorescent units

8.7 Fluorescents set into the floor.

8.8 Country bus.

8.9 The Stick-up.

places to hide units. The solution turned out to be the floor, which was a series of aluminum beams with the deck set below it. By laying the double fluorescent tubes in the recesses, they were hidden from the lens and permitted full freedom of movement for the camera. It created an unearthly bottom light that was appropriate for the sci-fi mood of the shot.

Country Bus

This rolling bus shot had some interesting problems to solve. It was a sound shot and the bus would be rolling for miles around the countryside. To provide power, a 300-amp tow away genny was rigged to the rear of the bus. From the genny, two porcelains (heavy duty extension cables) were laid through a rear window.

An overall ambient for the country singers came from a bounce rig above the driver. Two nook lights were bounced off a piece of foamcore taped to the luggage rack. The key was a mighty-through double 216 diffusion to camera right.

The shot was made with an 18mm lens from right beside the driver. The nook bounce and the mighty took care

of the foreground, but the back fell off substantially and there was no sparkle. A couple of inkies were hidden in the luggage rack at the back of the bus and they created a hot glow on the ceiling.

The key singer could be backlit by a snooted inky just above frameline, but the back singers needed some definition, as well as something to simulate a bus nightlight to motivate and add some accent. The solution turned out to be Stick-Ups. The Stick-Up is an extremely compact nook type rig with a 100 watt bulb that is so lightweight it can be stuck to a wall or ceiling with tape.

Stick-Ups were put in the railing of the luggage rack. They are small enough to look like reading lights, but powerful enough to provide some backlight. They were put on household dimmers to adjust to the right level.

Young Inventor

Showing a practical in a scene can be a problem. The temptation is always to let it light the scene itself. Although it sometimes works, there are a number of reasons why it may not, the primary one being that if a source is hot enough to illuminate the subject, it will undoubtedly be hot enough to flare the lens.

8.10 The practical lamp alone.

8.11 The practical lamp dimmed to a workable level.

8.12 The key alone.

8.13 Some window presence, along with a slight kicker for the actor.

8.14 The final shot: the young inventor at work.

8.15 An overview of the young inventor set.

While we might use "Streaks 'n Tips" (a hair coloring spray) to control the flare, this shot presented another problem. Since the bulb itself is a "hero," it was important to see the filament. However, when we turned it down low enough to see the filament, it no longer provided sufficient illumination for his face.

Clearly, we were going to have to *carry* the light bulb. The source will need to be low to match the direction, but we can't let it spill all over the objects on the table, which would give the gag away by revealing the source. It needs to be reasonably hard and clean, as it was from the bare bulb.

The rig used was a long foamcore snoot with a piece of 216 halfway. The snoot is to control the spill and keep it only on the actor's face. The source is a MolePAR, chosen because it is punchy, efficient, and compact. It is set on a pigeon on an apple box. The snoot box has a pigeon taped to it and is supported by a C-stand, which gives it the kind of fine-tuning height and attitude adjustment needed for this kind of shot.

For the items on the table we added an inkie almost straight down. To get it into the right position we armed it in on a C-stand long arm. In most cases, it is better to avoid rigging lights in the grid unless necessary; they are harder to get to, take longer to cable, and are difficult to move and adjust.

Rigging a small light (up to a tweenie or a baby-baby) is easy on a C-stand. Simply reverse the grip arm so that the blank end of the arm is where you need it. The arm is the same size as a baby stud (5/8 inch) and so the unit fits right on. Be sure to *safety* the light to the arm.

Don't forget the *right hand rule* (see Chapter 12), as this puts a strain on the grip head, especially for anything larger than an inkie or small pepper. In some cases you may want to add a counterweight, such as a small sandbag.

The same gag positions an inkie as a backlight for the actor. Not too much, just a hint that simulates a splash of moonlight hitting him from the window and to give his back definition against the dark background. Rigging a light on a C-stand like this gives us the added advantage of a taller stand; grip stands are generally about two feet taller than the average light stand. In this case, it gets us up and over the set wall, so we can get the light right behind him without being inside the frame line.

Next we need some outdoor presence, to keep the window behind him from becoming a black hole. A studio

deuce and full CTB throw a mullion shadow on the background, thus giving us some sense of the location (a rough workshop with no curtains), the time (late night), and also picks up the tools on the wall, adding to the sense of time and place (Figure 8.13).

The moonlight works fine, but it leaves the rest of the wall inky black. For some shots and some looks this might be fine, but in this case, we need just a little presence. An inky in the grid adds just enough of a splash to define the wall. To cool it down a little and take the edge off, one layer of light spun is placed at the lens.

Of the lights working in this scene, the key (PAR in snoot box), the overhead inky for the table and the practical

8.16 Restaurant overall set-up.

8.17 Overall set-up for the living room set.

bulb, itself, all are on dimmers. This greatly simplifies the delicate task of adjusting the balances for a shot like this.

Restaurant Set
In lighting large areas we generally have three choices:
- large single source such as a 10K or 12K.
- overall omnidirectional source, such as a 20 × 20-foot silk over the whole set.
- many units covering specific areas.

For a scene that needs an intimate, nighttime look, the latter will usually be the choice. Set-ups of this type need a great deal of rigging and cabling and a prelight day is almost always necessary.

There are four types of lighting going on here. For each table there are three studio deuces, one straight down on the table and one each as a key for actors on each side of the table (Figure 8.16).

Coming up over the set walls are two studio 10Ks and two studio 5Ks, which are hard backlights for the entire scene.

Rigged in the grid are three 5K skypans that hit 4 × 8-foot sheets of foamcore. This rig provides an overall soft glow that is appropriate for a warm restaurant scene.

Finally there is foreground fill, provided by a studio 8K softlight with eggcrate and a 2K conelight rigged on a 2 × 4, which is the key for the hero table. The conelight has a layer of 216 that homogenizes and softens the light.

The overall effect is a soft backlight glow of a dimly lit restaurant, but with a little hard punch to keep it from being too mushy.

Living Room Set
This living room set for an insurance company commercial needed to be pretty, sunfilled, and clean. A basic two wall set has a double door that opens up onto a back room with bay window.

A studio 10K punches sun through the sheer curtains on the bay window. Added to it is a 5K skypan into a vertical 4 × 8-foot foamcore, which provides the white surface that the camera will

see and ensures that the window will burn out to pure white with no discernible detail outside the window.

A similar rig, but with a 5K, takes care of the foreground window. Since this is a different direction than the sun key, it simulates less directional skylight and the window is covered with tracing paper for a softer, less directional light quality.

In the backroom, a 2K and a baby-baby backlight house plants and set pieces, while a 2K conelight provides an overall soft fill. A 5K high on a crankovator simulates another window out of frame in the back room.

In the foreground, the keylight is two mightys through a 4 × 4-foot open frame covered with two layers of 1000H velum tracing paper. Because this light doesn't carry quite far back enough, an additional piece of 1000H is hung next to the frame and a baby-baby carries the soft key into the open double doors.

Because there is quite a bit of fill coming through the foreground window, only a 4 × 4-foot foamcore on a C-stand is necessary for some camera fill. Another baby 2K adds a plant light for the foreground.

AT&T Monitor Room
This location had low ceilings and the shot was a very long dolly move covering the entire room. The look needed was low-key, dimly lit, and intimate. There were several practical monitors in the scene and it was essential to keep the level low enough so that an exposure balance could be maintained.

The solution presented itself when it was decided that the frameline would never get as high as the top of the cabinets over the desks. Apple boxes and pancakes were placed on top of each cabinet. Pigeons were screwed onto the boxes that supported either triple headers or short arm assemblies. These provided the mounting points for inkies that were set to pick out individual scene elements in the long dolly move: actors, computers, monitors, etc. Other

snooted inkies were mounted to studded gaffer grips attached to the recessed ceiling lights (Figure 8.18).

Illumination for the key actors' walk through the scene came from bounce rigs hidden behind each cabinet. Broad lights on short arm rigs hit coved show cards in the recesses. Practical desk lamps added sparkle to the scene and picked up some desk areas.

A xenon was raked across the back wall for a hot stripe to really punch up the contrast.

Casa de Moneda
This shot was staged inside the gold pouring room at the old Mexican mint, in operation in an old convent for over four hundred years. The flames shooting

8.18 Rigging to the furniture.

8.19 Lighting the Casa de Moneda.

out of the gold melting furnaces provided the obvious motivation for the lighting. Although they provided a great light and a center of interest, they weren't nearly enough for overall scene illumination, particularly against the

walls blackened by centuries of smoke and soot.

To carry the furnaces, a mighty (open-faced 2K) was rigged at the back wall out of frame camera right. One-half CTO and light gold gel gave it an appropriate flame gold color.

A baby 1K camera left provided the fill and an open-faced 1K camera left raked across the background equipment and gave some definition to the mid-background, just a little, though, as too much would have interfered with the smoky fires-of-hell look. In the far background, another openfaced 1K raked the backwall for a sense of depth for the scene.

8.20 The set-up is designed to preserve the feel of light coming from the gold melting furnaces.

8.21 Lighting plan for the Casa de Moneda.

8.22 High-intensity lighting for a large area.

Tennis Court

This tennis court had to be lit to a very high level for high-speed shooting: f/11 at ASA 400. Bringing a large area up to such a high level of brightness calls for the big guns: in this case, four 12K HMIs.

On the fill side two 6Ks hit 4 × 8-foot foamcore bounce boards and two 4Ks bounce directly into the ceiling for a little overall top fill. Two more 4Ks rake across the curtains at either end of the court.

The basic set-up was fine but there was a fundamental problem: the side of the court nearest the key was almost two stops hotter than the court near the fill lights. To bring up the intensity of the fill side would just make the whole scene bland, and in any case, as the players moved across the court they

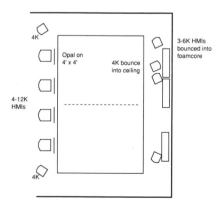

8.23 The tennis court plan.

would go from being hot on one side to hot on the other.

Open frames (4 × 4-foot) with 216 did little to smooth the imbalance and lowered the level down too much. The frames were changed to opal. Stacking grip nets under the units to hold down the near edge was not desirable because it reduced exposure too much.

The solution to the problem would not have been possible without an understanding of beam characteristics. Except with a truly ballistic light like a xenon (which has a highly polished parabolic reflector) most units have a definite fall off at the edge of the beam. Using this fall off by feathering this edge can be a delicate and subtle way to control exposure.

In this case it provided the answer. By aiming the 12Ks straight out at an almost 90° angle provided perfectly smooth exposure all the way across. Read directly toward the key, the exposure varied by less than one-quarter stops all the way across. With the key even from side to side, it was alright for the fill to vary, although being a bounce, it stayed within reasonable limits, 1/2 stop from side to side.

Japanese Commercial

This commercial involved some very large models against a muslin drop. The drop was lit by cyc lights along the bottom and five skypans along the top. The skypans were on dimmer.

The keylight was the big eye 10K camera left and the overall fill was two HMI PARs bounced into a 6 × 6-foot white griffolyn. Two 5Ks provided a sidelight for a closeup (Figure 8.24).

Boxing Arena

This boxing arena was a key location for a remake of a 1950s' boxing film. The look for the film was *noir* with lots of dark shadows.

The ring itself was covered by two types of light. Scoop lights were rigged over the ring but they were more props than lighting. They were chosen because they look like boxing ring lights,

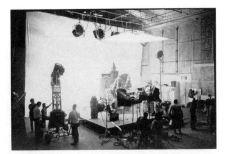

8.24 Lighting against a cyc.

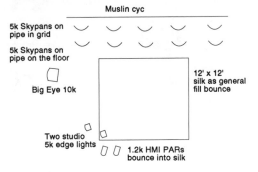

8.25 Overall plan for the Model City set.

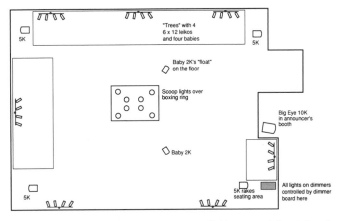

8.26 All the units in this arena scene were controlled by a central dimmer board.

8.27 Lighting the boxing arena took 3000 amps through dimmer boards.

8.28 The look was designed to have a fifties feel.

although they did add some soft presence.

The real light for the boxers was six studio deuces hidden in the rigging over the ring. Four of them covered areas of the ring and two of them covered the fighter's corners. The look was a hot, hard light in the ring. Some blending and slight fill were provided by bounce off the canvas, the scoops, and heavy smoke on the set.

For scenes in the corner areas, a pair of baby deuces float on stands ready for positioning in each shot.

The seating area where the key actors stay was covered by a big eye tenner above the announcer's booth. For the bleachers and the other seating areas, studio 5Ks raked directly across from behind opposite bleachers.

The ambiance of a darkly lit boxing arena was established by a number of trees in each bleacher area. On each tree were four 6 × 12-foot lekos to establish hot stabs of light through the smoke. Beneath the lekos were four babies that splashed down on the audience beneath the trees to silhouette them and give a sense of the people in the arena.

The 10 days of shooting in this location was greatly facilitated by having all the lights on dimmers. Running 3,000 amps through dimmers for a week will

inevitably lead to failures, and spare dimmer packs are a must.

Boxer in Hall

For the same boxing film, a long steadicam shot through the hallways beneath the arena was a real challenge in hiding lights. For this part of the shot the main source was three mightys hidden above the plumbing pipes on the left. They were splayed out to sprinkle down through the pipes (Figure 8.29).

Near the lens, a baby deuce was hidden up in the pipes. The exposed bulbs in the hall were replaced with ECAs that were then covered with small pieces of black wrap to cover the lens from the flaring hot spot. Enough of the bulb showed through to give a hot kick. In the door at the rear of the hall, a 5K raked through onto the wall.

Spokesman in Living Room

This shot for a big-budget black and white industrial film called for extreme contrast and very hot shafts of sunlight. For this effect, a 4K xenon was used, coming in through the window. Light smoke in the room softened it a bit and gave definition to the shaft of light.

Outside, a baby deuce was raked across the fireplace and another xenon and a tungsten PAR provided shafts of

A

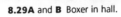

8.29A and **B** Boxer in hall.

5K

Three mightys
hidden in the
pipes

ECA in
wall socket

ECA in
wall socket

Baby 2K hidden
in the pipes

B

8.31 A 2.5K HMI, an HMI PAR and two mighty moles in the room behind the spokesman.

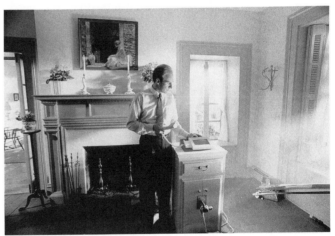

8.30 A living room set for a spokesman.

2.5K HMI on
background wall

HMI PAR as
backlight

Baby junior lights wall
seen through window

PAR on flowers
in window

1.2K HMI covers
door through
cucoloris

2K xenon

Baby junior for
splash on fireplace

PAR for foreground streak

8.33 Most of the lighting for this living room scene is brought in through the windows.

8.32 Xenons and PARs outside on the front lawn.

8.34 The hallway with smoke.

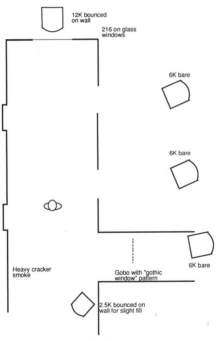

8.35 The hallway called for large units to cut through the heavy smoke.

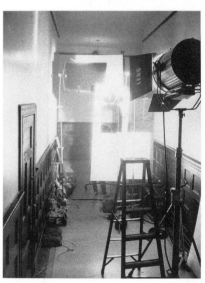

8.36 The gobo creates a shadow pattern for the actress to walk through.

light for the actor's walk past the camera. Some fill was provided by a piece of beadboard, but for the most part fill came from general room bounce and from the smoke.

For the window behind the actor, an HMI PAR zings through the window and a tungsten mighty warms up the plant. Another mighty hits the wall of the room visible through the window behind the actor and a 4K HMI illuminates the room visible to camera left.

Spooky Hallway
This commercial for higher education emphasized the stylized scariness of the empty hallway, so some exaggeration was called for. Bare 6Ks in the hallway

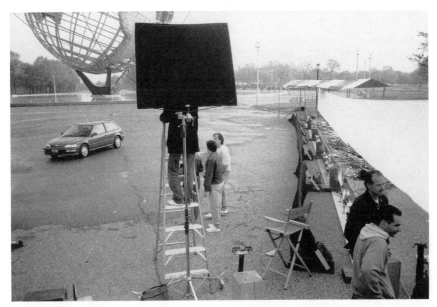

8.37 The rolling car rig.

doors sent strong, well-defined shafts into the hallway.

At the intersecting hallway, we needed some additional shafts for her to walk through, although the beam falling on the opposite wall would not be in frame. To provide this, a rough cookie is cut from foam core to simulate a gothic window. A 4K through this provides the hot shafts (Figure 8.36).

At the end of the hall a 6K on the floor hits a bounce card and fills the glass doors with hot glare. A 2.5K bounced into the wall from right next to the camera provides just a touch of fill, but most of the actual fill is from the large volume of cracker smoke in the hallway.

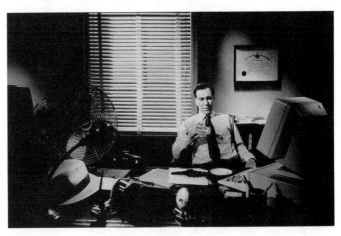

8.38 Set for a small industrial video with Bogie.

5K window light

1K on grid for
wall splash
and bookcase

1K pointed straight down
at desk lamp on file cabinet

Desk lamp

Studio 2K thru clear
transom above door
for far side of room

Studio 2K thru
translucent
glass door

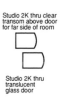

Baby soft for
slight fill

Studio 2K carries desk lamp
as actor's key light

8.40 Plan of the Bogie set.

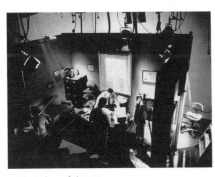
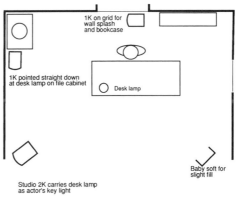

8.39 A view of the set.

8.42 This worker in the Casa de Moneda just needed simple, clean illumination, but with some character.

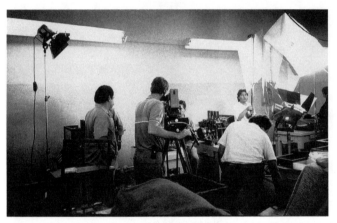

8.41 A basic frog light made from one mighty and foamcore, together with a 1K direct as a key, provided a quick, simple solution.

Sunrise Car Rig

Lighting for car shots often involves a lot of territory. Here the board called for the car to roll into the plaza as the sun rose camera right.

The overall lighting was, of course, morning magic hour, but some additional work was needed to give the car appropriate sparkle. First, a bleached muslin wall was rigged 9-foot high and 60-foot long. The muslin served two purposes. The sun would catch it from behind as it rose over the horizon, thus making it glow and putting a clean white line along the side of the car. This prevented a hot spot from the sun itself and a lot of visual noise as trees and shrubs are reflected.

The second use of the muslin was along the ground row. A row of 1K nook lights was rigged along the entire length of the wall and gelled half CTB. This gives a hot line along the bottom. The nooks are covered by a ground row of black duvyteen, which hides reflection in the car and also gives a black accent line along the lower edge of the car.

9. The Team

The workings of the lighting team are fairly standardized. The commonalties of technique and tools make it possible for a crew that has never worked together before to get the job done with a fair amount of efficiency, even when it includes members from other countries. In this chapter we will examine the duties of each member of the team and how they work together on and off the set.

The DP/LD

The person responsibile for the lighting team varies depending on the type of production. In feature films and commercials shot on film the team is run by a director of photography (DP). The DP works with the director and has authority over the electric crew, camera crew, and grip crew. He will also consult directly with the production designer.

Although directors differ in the amount of input they make concerning the frame (lens selection, camera position, angles, camera moves), it is the job of the DP to fulfill the director's vision of the scene. The DP implements this through the camera operator, the camera assistants, and the dolly grip.

The cinematographer's vision of the lighting is implemented by the gaffer and the key grip. Some DPs are very knowledgeable regarding the technical side of lighting and will issue very specific instructions concerning units, placement, gels, etc.. Others focus their full attention on camera and frame issues and discuss with the gaffer what it is they want to achieve and leave it to

9.1 Orson Welles and his team on *Citizen Kane*. *(Courtesy of the Museum of Modern Art Film Archives).*

his or her discretion how to achieve that look. There is, of course, a full range of working relationships in between. The general trend in film production has been for the DP to be more heavily involved with the director and the process of image making. This, together with a tendency toward more elaborate camera moves and more technically involved camera issues, has resulted in a tendency toward the gaffer sharing a greater responsibility for the actual lighting of the scene.

In video production, the responsibility is split. The camera operator deals strictly with the video camera and framing the shot, and a lighting director (LD) takes full responsibility for lighting the scene. This is not unlike the English system (also used in Japan) where the operator is responsible for working with the director on camera moves, placement and lens choice, and the lighting cameraman devotes his full attention to the lighting, often never even looking through the lens. There has been some movement toward working with the English system in film production here, where a cameraman who worked his way up as an assistant cameraman is well suited to handle camera issues, and a cinematographer who worked her way up as a lighting person is more suited to dealing with the lighting.

In commercials the trend is toward director/cameramen. With their attention devoted primarily toward directing the scene, dealing with the client, and operating the camera, they have come to depend heavily on *lighting gaffers* who light the scene based on a brief discussion of the board with the director. Many gaffers are still waiting for their day rates to catch up with their responsibilities.

The Gaffer

First let's clear up an ancient controversy. By now, you will likely have heard many fanciful stories about the origin of the term *gaffer*. Let's set the record straight—according to the *Oxford English Dictionary*, *gaffer* is a six-

teenth-century term meaning "one whose position entitled him to respect" or more directly, "the foreman or overman of a gang of workmen: a headman....a master, a governor."

The gaffer is, in traditional production, the DP's chief lieutenant for lighting. In the early days he was referred to as the chief electrician and director of the electric crew, although these terms are now seldom used. Recently the title has been changed to *chief lighting technician*. This more accurately reflects the job, since the gaffer rarely deals with electricity, which is the responsibility of the second electric.

The gaffer implements the DP's vision by issuing orders to the electricians and works in conjunction with the key grip.

Responsibilities include a wide range of duties. He or she

1. Scouts the location for lighting problems and opportunities and determines the availability of power, cable runs, etc.

2. After consultation with the DP and the production manager, prepares the lighting and electrical order.

3. Consults with the grip about rigging lights in the grid or ceiling, rigging lights on cars for running shots, silks or butterflies, diffusion frames, etc.

4. Gives orders to the electricians concerning what lights to place, and where and what diffusion or color correction they will need.

5. Meters the scene, directs the electricians in focusing and balancing the lighting, spot/flooding, adding or removing scrims or dimmers. Directs the grips in placing flags, nets, cutters, and diffusion frames.

6. Alerts the DP and/or director to any potential problems. For example, the lighting may look great for a certain position but the actor will *burn up* if he gets too close to a window.

7. Depending on the DP, may meter the scene to determine the camera aperture.

8. Consults with the DP, operator, and AC about special conditions such

as frame speed, practical monitors, HMI synch, filtration, etc.

9. During filming, monitors the scene for changing conditions, shifting sunlight, or clouds. Particularly where the DP is also operating the camera, the gaffer functions as the "eyes alert for trouble."

10. Most cinematographers have their gaffers attend dailies and video transfer so that the feedback process is more complete, although politics and vanity often prohibit this common sense practice.

The DP and gaffer's tools include
1. incident meter
2. spot meter
3. color temperature meter
4. Polaroid camera and film
5. gel books
6. HMI synch charts
7. 18% gray card and perhaps a gray scale and color chart
8. viewing filters
9. compass
10. flashlight
11. sun charts

The Best Boy

The electrical best boy is the NCO in charge of the electric crew. He is the gaffer's or lighting director's key assistant. Some people don't like the term *best boy* (particularly with many women fulfilling the function these days) and the position is also called *second electric* or *assistant chief lighting technician*. The job covers

1. Everything electrical: performing the tie-in or generator hook-up, cable runs, load balancing, and electrical equipment selection.

2. Direct supervision of the crew. On larger jobs the second will select and schedule electricians, see that their time sheets are filled out, and so on.

3. Equipment management. The second coordinates with production to ensure that all equipment requested is available and accounted for, and works out plans for swing trucks, rigging crews, and strike crews. The second should be ready at any time to tell the gaffer what lights are in use and what is still available.

4. Staging. The second should be ready to maneuver for a good staging area and then supervise off-loading the equipment and preparing it for use, and at the end of the day, is responsible for making sure it all gets back on the truck safely and efficiently.

On large feature productions, many of these functions (such as tie-ins) will be performed by the third or fourth electric and the second electric will generally stay on the truck, taking care of the paper work.

Third Electric and Electricians

The third electric is the corporal of the crew. On smaller jobs the third is the lowest on the totem pole, but on a large feature he may have some supervisory duties over the electricians and *day players*.

In the early days when open arcs were the only lights, there were no motors to advance the carbons as they burned down. Instead, an electrician tended each light, slowly turning a crank to keep the carbons in trim. This required considerable skill and these people earned the title *lamp operators*. Even today on the standard feature budget forms you will see the category, lamp operators.

Other Responsibilities

1. Equipment preparation. It is up to the third to make sure every piece of equipment is ready to go: every light has barndoor and scrims, every stage box has 301 1/2s, four-ways and singles standing by.

2. Placement. In general, when the gaffer calls for a light, it is the third who actually brings the light, while at the same time the second brings power to the position so that the light is hot as soon as it hits the stand.

A best boy/electrician should carry on the belt or in pockets

 cutter (usually a mat knife or razor
 knife; extra blades)

9.2 Standing by.

wooden clothespins
work gloves
crescent wrench 6"
flashlight
volt-ohm meter (both AC and DC)
continuity tester
amprobe
slotted screwdriver (shank wrapped
 with electrical tape)
slip-joint pliers 6"
marking pens

In the tool kit

vicegrips
channel-lock pliers
Phillips screwdrivers: #1, #2
set of hex wrenches
fuse puller
cube taps - heavy duty
current taps
3-to-2's
electrical tape (black)
colored plastic marking tape (red,
 blue, yellow, white, green)
spare fuses: household, stage box,
 barrel fuses
heavy duty staple gun
tape measure
wire nuts
zip cord

The Key Grip

The grips are an important part of the
lighting team. Their responsibilities in
regard to lighting include

1. Rigging all lights hanging from the
 grid or from the set (trapezes, trom-
 bones, set hangers, pipe clamps,
 wall claws, pigeons, etc.)
2. Rigging lights to vehicles for run-
 ning shots
3. Setting of flags, cutters, and nets
 and cookies
4. Rigging and adjusting silks, butter-
 flies, and overheads.
5. Seeing to any diffusion or gel not
 attached to the light, such as gel
 tacked to windows, on frames, or
 otherwise *tricked up*
6. Placing all sand bags, tieing-off tall
 stands with sash, grip chain, etc.

9.3 Household dimmer—a handy item for the toolkit.

7. Any hoisting or rigging of heavy
 equipment.
8. Helping out with heavy units or
 hard to reach situations
9. Providing ladders, lifts, cranes, scis-
 sor lifts, etc.
10. Providing rain protection for lights
11. Leveling all tall stands, molevators
 and crankovators with apple boxes,
 step-ups, and wedges

If there is no dolly grip, the key grip
usually tends to the dolly and the elec-
tricians deal with the second grip.

As described here, the responsibilities
of the grips are strictly according to the
American system as it was developed in
Hollywood in the first 50 years of this
century. To a certain extent it is the re-
sult of union rivalries between electrics,
grips, and prop people. In Europe and
Japan different systems are used; the
electricians handle all lighting tasks in-
cluding rigging, sand bagging, and set-
ting flags and cutters. Grips participate
when there is a heavy or complex rig-

9.4 The grips handle jobs like rigging this 6K out
of a window. Notice the strain relief that runs up
the next floor.

ging job, such as one involving cranes or pulleys.

This leaves the grips free to run the dolly, work with the set carpenters, attend to cranes, and other important duties. The division of labor under the American system can be a source of problems. It is possible for an electrician to set a light, focus, gel and scrim it, and then have to search for a grip to move the flag two inches. If it needs further adjustment, he has to find the grip again, explain with much discussion and hand waving what the flag is supposed to accomplish, and then stand by while the grip adjusts the flag.

A great grip crew can be an invaluable support, but for many grips, working with the electricians is low priority, and often they must wait while he sees to more pressing duties with the camera support, dolly, or crane. In the meantime, the electrician's job can grind to a halt while he stares at a piece of equipment that he knows perfectly well how to operate but is not allowed to touch.

Grips

The second grip works for the key grip just as the best boy electric does for the gaffer. On larger jobs the duties become largely administrative, but as with the key, the grips might be called on to perform a variety of duties in lighting control, rigging, leveling, camera support, cranes, and safety.

Most grips carry a large assortment of tools including

mat knife and extra blades
hammer
tape measure (25')
6' slip-joint pliers
channel-lock pliers
work gloves
slotted screwdrivers: 1/4", 3/16" and 1/8"
Phillips screwdrivers: #1, #2
flashlight
heavy-duty staple gun
portable drill and drywall screws: 1", 1-1/2", 2-1/2"

drill bits
Saw (a folding tree saw is handy; for big jobs, a circular saw)
bubble level
torpedo level
4' level
crescent wrenches: 6" and 8"
vice grips
chain vice grips
motorcycle straps (rachet straps)
socket wrench set
set of hex wrenches
small pry bar
s-hooks
speed square
WD-40 or silicone spray
marking pens
chalk for marking the floor
squeegee and spray bottle for applying gel to windows
bailing wire
washers, including fender washers
hacksaw
small c-clamps
camera wedges
chalk line
side cutters (dykes)
jig saw
nails: #16, #8
sunglasses (to watch cloud movements)
3/8"-16 bolts of various lengths (camera tie-downs)

Set Operations

The difference between a smoothly run set and a chaotic one can mean the difference of many hours in a production day. The DP or LD is in charge creatively, but it usually falls to the gaffer and second to run the lighting operation efficiently.

Load-In

One of the most crucial decisions on many locations can be where to park the truck. Try to keep it as close as you can and with sufficient room behind the loading gate. One of the most fundamental mistakes is to park the truck where it will appear in a shot later in the day. Moving the truck during the

shoot day can be a disaster. Pin down the AD on what is a safe location. If there is more than one truck try to keep them together.

Staging

Arrive early and stake out a good staging area before other departments take all the good ones. You will need room to line up all the hampers in an orderly fashion so they can be reached into quickly. You will need room to line up lights and stands so they can be grabbed quickly. Depending on how the day is expected to run, it may be efficient to leave some items on the truck, but every shoot is different.

Tie-In

The basic tie-in supplies, tie-in clips, some siameses, sash cord, gaffer's tape, and pieces of rubber mat should be kept in a best boy bag that is readily accessible without unloading anything. As soon as the crew arrives, the best boy is sent to begin the tie-in or hook up to the generator. Usually power is needed very quickly if only to test lights, set up video, or whatever. Equipment houses have a habit of putting the tie-in gear and feeder cable on the bottom of a hamper.

The Generator

Finding a parking place for the generator is even a more delicate operation than staging the trucks. A generator should be as close as possible in order to minimize time-consuming cable runs and voltage drop. On the other hand, even blimped generators make noise and if you are shooting sound you will want to keep the genny back far enough to minimize sound problems.

You will probably want to have the genny driver fire up the engine as soon as possible to allow time for warming up before applying a load. Voltage output and crystal synch must be checked at the beginning of the day and monitored periodically.

9.6 Don't let stands be placed over cable.

9.5 Checking the load with an Amprobe.

Cabling

A well thought-out cable run from the power source can make an enormous difference in the day. It should be as direct as possible, but it should not go any place where it might appear in a shot—this is critical.

Likewise, it should cross the path of traffic as little as possible, particularly in regard to the dolly, stands on wheels, and so on. It may be necessary to *fly it* to keep it out of the way of vehicles or dolly traffic. Sash cord is used to tie it off to beams, high boys, the truck, or whatever is available.

As the cable is run out, it is checked for proper color coding and adjusted if necessary. A quick visual check of connectors is a good idea. Then the neutrals are taped and stage boxes are plugged in.

The third visits each stage box and leaves 301 1/2s, a couple of four-ways, and a few single extensions. If necessary, she stages a few porcelains in strategic spots.

The second tests each box for proper voltage and marks the boxes if AC and DC are being mixed. Once he is satisfied that the power supply is safe and hot he informs the gaffer.

Rough-In

Based on previous plans the DP and gaffer will know some things about where they want the lights. As soon as they can, they start to rough-in a basic lighting.

As the gaffer calls for a light the procedure is generally this: an electrician goes to get the light and the best boy brings power to it with a single, porcelain, or whatever. If necessary one of the group passes on to the grips any required rigging, bagging, flagging, or ladders.

The most important part of this process is communication. As the crew is set in motion they announce what they are doing: for example the third calls out *deuce flying in* while the second says "bringing power to you." The reason for this is so that no task is duplicated (there is no more obvious example of an amateur crew than having three anxious-to-please electrics all run for the same light), and the gaffer and best boy know that all the bases are being covered.

When bringing a light to the set, it *must be complete*; never bring a light to the set without barndoor and scrims. Diffusion and clothespins should come with the light or be readily available—*anticipate*. If called for (or anticipated) bring snoots, gel frames, etc. If the gaffer calls for a single scrim, don't go up the ladder with just a single scrim, take the whole set with you; he may change his mind. The same goes for electrical equipment. If you need a four-way on the other side of the set, why not take two, to stay ahead of the game?

Scrims should stay with the light, with scrim clips or scrim boxes if possible. Time permitting, a piece of each standard diffusion and gel (usually 216, opal and color)) can be precut and attached to the light, folded up inside the doors. Cut the gel large enough to fit outside the doors; it can be trimmed down to fit inside.

Rehearsal
With rough-in complete, the lighting crew retires from the set and the DP and gaffer observe as the director blocks the action and rehearses the actors. This is probably the first time that they can see with finality the full scope of what they must do and any particular conditions that must be met.

Rehearsal complete, the director and actors leave and the fine tuning begins.

Fine Tuning after Rehearsal
It is critical that the lighting team have the real actors or good stand-ins for this phase. Lighting is fine tuned for a particular blocking and a particular facial shape and coloring. No stand-in or one that does not match in height, coloring, or depth of eye sockets will often mean delays later on, when the director and the high-priced talent will be even more impatient. It is the AD's responsibility to provide for this. Insist on it.

At this stage, any additional units are added. Scrims, nets, dimmers, or spotting and flooding are used to balance the lighting, and flags cast shadows where they are needed.

Where the set is noisy or the distances large, hand signals facilitate communication between the gaffer and the electrician or grip at each light that is being adjusted. The signals are
1. flood
2. spot
3. close (or open) the doors

Standing By
Time for coffee, right? Wrong. It is a rare set that doesn't need one more light once the actors are in. The lighting team must be alert and ready. This is when fuses are short and everyone is impatient. Some items are standard and should be standing by as close to the set as possible and completely ready to go: two or three each of inkies, tweenies and babies and usually at least one of each type of light that you are using. These should be on stands with barndoors, scrims, snoots and diffusion attached.

Shooting
While shooting, the gaffer and electricians stay alert for changing conditions, bulb burn-outs, etc..

9.7 Flood the light.

9.8 Spot the light.

9.9 Cover me —I'm leaving the set.

9.10 I'm going to the bathroom.

9.11 Tips for Grips (Drawings by Brent Hirn, Master of Gripology).

The camera is finally rolling and after six or seven takes the director is settling into his ritual chant "That was perfect, let's do one more." Now you have time to visit the craft services table for the first time, only to discover that the coffee is cold, all the really interesting do-nuts are gone, and there are flies in the cream cheese.

To top it off, a production assistant (PA) announces "I was trying to micro-wave a croissant for the producer and something popped and I smelled burning; could you check it out right away?"

10. Electricity

The set electrician need have only a rudimentary knowledge of electricity but must have a firm grasp of the fundamentals. For our purposes we must start with an understanding of the four basic measurements of electricity: volts, amps, watts, and ohms. From there we will look at the issues that confront a set electrician and briefly review standard set operating procedure for the electrical crew.

Electrical Fundamentals

To quickly review, a volt is a measure of the electrical *potential* of a circuit. It is like the pressure of water in a pipe. Water under high pressure has a high potential to do work regardless of other factors. *Resistance*, which is inherent in any circuit, is measured in ohms. Resistance can be thought of as the diameter of the water pipe. It is more difficult to push water through a small pipe than a large pipe.

Amperage is a measure of the actual amount of electricity flowing in the circuit (the total *current* flow). In our water analogy, amperage is the total amount of water that is flowing. Thus *pressure* times *pipe diameter* equals total *water flow*: *volts* times *amps* equals *watts*.

amps = watts / volts

watts = volts × amps

volts = watts / amps

ohms = volts / amps

If we want to push a large amount of water through a small pipe (high amperage through high resistance), we can do so with high voltage (water pressure). Conversely, a very large pipe (low resistance) can allow a large volume of water with little pressure. Low resistance allows greater amperage at low voltage.

Mains power, as local electrical supplies are called, is not as stable and permanent as we sometimes think; in fact, voltage varies from area to area and hour to hour. Some electric companies supply 110 volts and some supply 115, 120 volts or higher. In general we usually assume 120 and use it for calculations; the difference is minimal for our purposes. At 120 volts, 1000 watts equals 8.3 amps. Thus a 1K would draw 8.3 amps; a 2K, 16.6 amps; and a 10K, 84 amps; and so on.

If V × A = W, then W/V = A. For a 1K light, 1000/120 = 8.3 amps.

Types of Service

Electricity is supplied in one of two forms, single phase and three phase. Single phase is generally a three-wire service: two *hot* legs and one *neutral*. To oversimplify a bit, the hot legs carry the current flow *to* the unit and the neutral carries it back to the generator.

The *neutral* is not the same as the *ground* but the two are similar and, in some cases, interchangeable. The neutral is a part of the circuit. Think of it as the wire that leads from the light back to the generator. The ground is purely for emergency purposes. Its function is to give the electricity a safe path to follow.

10.1 Alternating current sine wave.

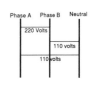

10.2 Single phase, 3-wire AC.

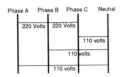

Phase A	Phase B	Phase C	Neutral
220 Volts	220 Volts		
		110 volts	
	110 volts		
110 volts			

10.3 Three phase, 4-wire AC.

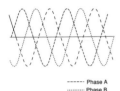

```
------- Phase A
......... Phase B
- - - · Phase C
```

10.4 Three Phase AC: the phases are out of synch 120° from each other.

All electricity needs someplace to go, if there is no complete circuit there can be no current flow. The earth is a primitive sort of conductor and all electricity will flow to it if given the chance. *A ground line* is not part of the circuit itself, that is, the circuit would function normally whether there was a ground or not. A conductor that runs from some part of the circuit to the earth or something connected to the earth, such as a water pipe or a metal stake in the ground is a ground. If your power is supplied by a generator, it can be a separate line that runs back to the chassis of the generator, and then the chassis may or may not be grounded to the actual earth, depending on the design of the generator.

If an electrical device is connected to a hot conductor and the other side is connected to either a neutral *or a* ground it will work equally well. It doesn't really matter which as long as the circuit is complete. In actual practice, the neutral is an integral part of the circuit and the ground is a safety precaution. The reason is simple—electricity always seeks the easiest path to ground. If a hot part of the circuit is exposed or loose it may come in contact with the metal frame of the light, a stand, or something else. If someone touches it, he is then a path for the electricity to take and the current will flow through him. If the metal frame of the light is also connected to a copper wire that leads to ground, it is a far better conductor than a human or animal and thus the current will flow through it.

Unfortunately, many film electrical systems (which are largely derived from older theatrical systems) are two-wire systems (a hot and a neutral) and are thus not grounded systems. Some states now require the use of grounded systems. While it means more equipment to pay for and handle (generally a five-wire distribution system) it is worth it for the safety it provides.

Three phase consists of three hot legs and a neutral. The three hot legs are wired to three separate sections of the same generator armature and are thus slightly out of phase with each other (we will discuss this characteristic later).

With either a three phase four-wire service or a single phase three-wire service, two voltages are possible. If you connect any hot leg to the neutral you will get the low voltage (110, 115, 120) and if you connect any two hot legs you will get high voltage: 220, 230, etc. In some industrial buildings you will find boxes that have no neutral. They are intended for high-voltage use only. If you need 120, you can connect to a hot leg and a ground (such as the box itself) and establish a standard voltage circuit.

In direct current, the higher voltage is always double the lower: 110/220, 120/240, etc. In alternating current the relationships depend on the wiring of the generator. There are two basic types of three-phase service, four-wire service: wye (*star*) and delta (*triangle*). In the wye or star system the nominal voltages are 120/208, 127/220, 220/380, and 230/400. The higher voltage is 1.732 (the square root of 3) times the lower voltage. In a delta or triangle system, the higher is always double the lower voltage: 110/220, 230/460, etc.

Power Sources

Power for film and video production usually comes from one of three sources: stage service, generators, and tie-ins.

Stage Service

Most studios and sound stages provide electrical service. Older stages will sometimes have DC (left over from the days of carbon arcs) and extreme caution must be used not to plug any AC only equipment into DC, which would severly damage drills and compressors. Smaller studios generally have at least 300 amps available, but be sure to ask. The most common situation is for a stage to have several hard-wired distribution points with fuse boxes and disconnect switches that terminate in either pin plug, Tweco, Cam-lock or similar connectors. You can then easily

plug in an appropriate amount of feeder cable and set a distribution box wherever you need it.

The only difficulty with a set up like this is that while it is easy to check the load balance at each box, there is usually no simple way to check the overall balance. It is generally sufficient to just try to distribute the load as evenly as possible. If you sense danger, check with the house manager; she may be able to take an electrician down to the main service for a balance and load check.

Generators

On location, generators provide the simplest and safest power source. Generators are available in all sizes: from portable 30 amp *put-puts* up to tractor-trailer rigs capable of providing several thousand amps of service.

Four issues are paramount when ordering a generator:

1. Capacity. Be sure to allow an extra margin of safety in calculating the total load. It is in most cases unhealthy for a generator to run at full load.

2. AC/DC. Gennys are available in AC, DC, or mixed AC and DC. It is vital to think about your needs and specify the correct service. If you are running Brute arcs you will need 225 amps of DC for each arc. If you are running HMIs or video, you must have AC.

3. Crystal sync. If you are using HMIs you must order a generator that has constant speed governed by a synchronizing crystal. Don't assume that all gennys are crystal. Specially modified portable gennys are available that are crystal. Always request a frequency meter. This is will allow you to monitor the frequency of the AC output to ensure that it is within acceptable limits. Under normal conditions with HMIs anything greater than a quarter of a cycle variation from 60 hertz (from 59.75 to 60.25) is cause for concern.

4. Sound proofing. Some gennys are sound-proofed to allow sync sound to be recorded without it sounding like "Mad Max" in the parking lot. If you can park the genny far enough away or it's a situation with high ambient noise, a sound-proofed genny may not be necessary.

Other things to remember:

1. Physical size. Consider where the genny will be driven and parked. Be sure it will fit and that your feeder cable can reach it.

2. Portability. There are five types of gennys: portable hand-carry units, portable put-puts that roll, towed units that can be hitched to a truck, piggyback units that sit behind the cab of an equipment truck, and independent units from van size to full tractor trailer size. Consider which will be appropriate for your needs.

10.5 A tow-away generator.

> Consider this problem: you are filming a commercial about a country and western band in their bus. You will need about 50 amps of power inside, the bus will be driven during the shots, and there will be sync sound. Clearly the power needs far exceed anything you could get from the bus's electrical system. You can't tie-in or run to a stationary genny because the bus is rolling. You can't put a genny in the back seat because of fumes and noise. What do you do?
>
> Solution: a 75-amp, sound-proofed tow-away hitched to the back of the bus with two double pocket porcelains snaked through the back windows.

3. Distance of runs. On very large exteriors, it may make more sense to rent two or three smaller gennys instead of doing monstrously long cable runs to a single large genny.

4. Fuel. Don't assume that the genny rental operation will provide fuel and lubricants. Usually they do, but always ask.

Generator Operation

If a generator operator is not provided, it will be the best boy's responsibility to

ensure the safe and efficient operation of the unit. Every genny is different, so be sure to ask the rental house if the genny has any particular needs or bad habits. Some general principles are

1. Set the generator as close to level as possible.
2. Check to make sure that the exhaust vents are open and clear before starting.
3. Check the oil, fuel, and antifreeze levels before starting.
4. *Always* warm a generator up for at least ten minutes before applying a load.
5. Make all connections before engaging the generator.
6. Always run a generator for ten minutes *after* the load is shut off before turning the engine off.

Always run a ground wire from the generator chassis to a rod stuck in the earth, a water pipe, or similar ground.

Generator efficiency is reduced by high altitude and high temperature. The reduction is roughly 3.5% for every 1000 feet over 500 feet above sea level. The reduction for high temperature is roughly 2% for every 10°F above 85°.

If you are working with foreign equipment, remember that a 50Hz genny is 20% more efficient when run at 60 Hz.

Some generators can run concurrent: producing both AC and DC at the same time. However, on most units, running concurrent means losing the three phase capability. For a typical 1000 amp genny, the following loads are the maximum when operating concurrent:

AC/DC concurrent
700 amp DC
200 amp AC 120 volt single phase
100 amp AC 220 volt

These are the maximums, any combination of these is possible, but the available AC depends on how much DC you are using: the greater the DC load, the greater the AC available. This is because autotransformers are used in operating concurrently.

Tie-Ins

The third common power source is the tie-in: tapping in to the power supply of a building. Tie-ins are cheap, convenient, and provide reliable power but in some areas they are strictly illegal and the electrician and production company can be subject to civil and criminal penalties. It is your responsibility to know the local laws and act appropriately. Even if a production company pressures you to save them money with a tie-in, keep in mind that you are taking responsibility for people's lives and the safety of valuable property. Any time you deal with electricity, it is not to be taken lightly.

Under no circumstances should anyone perform a tie-in until he or she has been *trained* and *checked out* by a senior film electrician. You can be killed while doing a tie-in. Don't take chances. Also, always tie-in after the electric meter, otherwise you will be guilty of stealing electricity. Many localities require that tie-ins be performed only by licensed electricians; some require that a fire marshal be present.

Tie-In Safety

Everyone should know the basic safety rules of tie-ins:

1. Two people should be present at a tie-in. There is a very real risk of electrocution in any tie-in. The second person must know CPR techniques, electrical rescue techniques, and be a level-headed type who won't panic. If at all possible the second person should be another film electrician.

2. Only one hand in the box at any time. The most dangerous situation is for current to run across the chest and heart from one hand to another.

3. Stand on a rubber mat or low wooden box (half or quarter apple box; a full apple box might make you a little wobbly). Wear rubber sole shoes if possible and long insulating lineman's gloves, as long as they don't make the operation dangerously awkward.

4. Wear safety glasses.

5. Have a fire extinguisher nearby.

6. Never stick anything metal in the box. Metal screwdrivers should be wrapped with electrical tape down the shank.

7. If the fuse box is behind a door, lock, sandbag or have a guard on it so that no one can swing the door open and slam you face first into the live connectors.

8. Always tie-in on the load side after the fuses or main circuit breakers.

9. Always meter the voltage of all legs and meter the case to determine that it is not hot. Check to see if it is AC or DC.

10. Use sash cord to tie the feeder cable up in a strain relief. Make sure there is no pressure on the tie-in clips that might pull them loose. Put the strain relief on before you make the connections. Ensure that the metal ends are not free to swing into the box or get in your way.

11. Use pieces of rubber mat or cardboard to *card off* the hot lugs and provide insulation anywhere that the tie-in clips might contact a hot lug and the case and arc.

12. Always clamp onto the neutral (white) first, then the hot legs. Always disconnect the neutral last when breaking the tie-in. If you have a case ground (green) connect it first, then the neutral.

13. Always use a *bull-switch* (disconnect and fuses) between your tie-in and the load.

14. Never leave a tie-in up overnight.

15. Always tape all neutrals so they can't come loose.

16. Color code all connections and lines.

17. Be sure you are using the appropriately sized connectors.

18. Tape or brace the door of the fuse box so it can't swing closed on the connectors.

19. Put rubber mat or show card over the open box so that no one can accidently touch it. If necessary cordon off the area.

20. Pray someone will invent some safe and easy-to-use tie-in connectors so we can stop using clumsy, dangerous, and unreliable Tricos, Anderson clamps, and alligator clips.

21. If you do so many tie-ins that you find yourself looking at the box and thinking it looks like some perfectly innocent metal parts, stop for a moment and remind yourself, "This is live electricity; it wants to kill me." Go slow and easy.

22. *If you are not a trained, tested, and certified electrician,* or if there is any doubt in your mind about your ability to perform the tie-in safely, DON'T DO IT.

23. If you feel the tie-in would not be safe or legal, DON'T DO IT. The gaffer is the absolute and final authority concerning electrical safety on the set. If he says no tie-in there will be no tie-in.

Determining KVA

In many industrial and commercial situations, the service is high voltage and a portion is stepped down by transformers for the 120-volt service. In these situations, it is not enough to look at the wire feeding the 120-volt box, you must also consider the capacity of the transformer, which is often only designed to run a few houselights and wall sockets. Transformers are rated in KVA, which means kilovolt amps. When we realize that a *volt amp* is really a watt (remember that volts times amps equals watts) the process becomes clear. Let's take a simple single phase example: a transformer is rated at 77 KVA. This is 77,000 watts.

$$\text{amps} = \frac{\text{KVA} \times 1000}{\text{volts}}$$

We divide by the voltage and get 640 amps. Thus we cannot exceed 640 amps per leg even if the feed wire and the fuses are rated higher.

$$\frac{77 \times 1000}{120} = 640$$

With two-phase, four-wire service, there is an additional factor.

$$amps = \frac{KVA \times 1000}{Volts \times 2}$$

In three-phase, given KVA and voltage, amperage is found by this formula:

$$Amps = \frac{KVA \times 1000}{Volts \times 1.73}$$

In order to understand these relationships, we must recall the following:
- Two-phase current = 2 × single-phase current.
- Three-phase current =1.73 × single-phase current.
- The current in the neutral of a two-phase, three-wire service is 141% greater than either of the other two conductors of that circuit.

Before transformers burn out they issue a very distinct and unmistakable burning odor. Learn to recognize that smell and add it to your mental list of things to check periodically when running a heavy load through a house transformer. If you detect it, reduce the load immediately, but don't panic. It usually isn't necessary to shut down the bull-switch and throw everybody into a tizzy. Just switch off as many lights as you can until you can rebalance.

Wall Plugging

For very small set-ups where only a small amount of light is needed (such as documentary and small unit video) it is possible to plug small units into the walls. In most areas, wall convenience outlets are usually 15-amp and occasionally 20-amp circuits. The standard two- or three-prong Edison plug duplex outlet that we are all familiar with is by convention rated at 15 amps. *If* there is nothing else on the circuit, they will usually hold a 2K light (16.6 amps). Some things to remember:

1. Check to see what's on the circuit. Switch off anything that isn't needed. The simplest technique is to station people throughout the house while someone switches each breaker on and off and labels it. It takes a few minutes but it's worth doing.

2. Have some spare fuses handy or if it's circuit breakers, be sure the fuse box is not behind a locked door.

3. *Never* plug into a circuit that serves computers, delicate electronics, any type of medical life-support equipment, or security systems.

4. Switch the lights off whenever you can.

5. Don't assume that each room has its own circuit. It is general practice in laying out household electrical to have circuits serve different areas to distribute the load. The same circuit might serve an outlet in the hallway and in an upstairs bathroom, while an outlet a few feet away is served by an entirely different circuit. If possible, try to get the architectural plans of the building to see the electrical layout.

6. *Never* bypass the fuses.

7. Let the lights burn for a few minutes after plugging. Better that the fuses blow now than when you are shooting.

Batteries

Battery rigs, consisting of ten 12 volt car batteries (for a total of 120 volts) can run a few film lights for an hour or less. Even large light such as 10Ks and brutes can be run off high-amperage battery rigs, but only for very short periods of time. They can be concealed in a car trunk, on a running rig, or other places where you can't get power.

One of the most useful applications of battery rigs is to power work lights for night wraps when the tie-in is taken down or the producer wants to get the generator off the clock.

Batteries fall into three basic categories: lead acid, heavy antimony, and nicad.

Lead acid

Lead acid batteries include ordinary automobile batteries. Typically they take an eight to ten hour charge. Batteries are rated in amp-hours. For example, a 100 amp-hour battery will deliver 5 amps for 20 hours. Anything less than 60 amp-hours is generally unacceptable;

80 amp hours is better for film use. If possible, order a battery with renewable cells and always request a hydrometer to test the state of charge.

Heavy antimony

Heavy antimony batteries are designed for heavy, continuous use, such as powering fork lifts. They are generally available in six-volt configurations and so you may have to hook up a series circuit. The disadvantage is that they tend to be extremely heavy.

Nicads

Batteries composed of nickel and cadmium are called nicads, they are the most commonly used power unit in film and video. The advantage of nicads is that they hold a charge much longer than other types of batteries and their output strength remains constant until they fail. Unfortunately they give very little warning when they fail. It is difficult to ascertain the charge state of a nicad battery, since most of them are sealed units. When using nicads to power video, film cameras, or sunguns, it is important to maintain a charge sheet to know when each battery gets charged and used.

Nicads require particular caution to preserve their full lifespan. Like all batteries they are happiest when being used, sitting on a shelf is detrimental to most batteries. Never store a nicad in a discharged state. Also never let it go to deep discharge where it is drained to the last volt.

On the other hand, it is not wise to repeatedly partially discharge then recharge a nicad battery. The reason for this is the memory effect, which will cause a nicad battery to fail to provide full output if it is repeatedly discharged part way. To avoid this it is important to periodically discharge a nicad fully and then recharge it to full capacity. When doing this don't forget to avoid deep discharge. Dischargers are available which will drain nicads safely and efficiently. If a nicad develops memory problems, discharge and recharge it four or five times.

Nicads must be treated with respect. Punctures, sharp blows, and othre shocks can cause internal shorts which can then be fatal to the battery. As with all batteries, they lose capacity when cooled and should be kept off the floor if it is cold.

Load Calculations

Lighting units are rated in terms of their wattage. A resistance unit (such as a tungsten filament) *draws* amperage based on its size (amps equals watts divided by volts); the larger the filament, the greater the draw. At 1,000 watts or more the term kilo (thousand) watts is used, hence, their common names 10K, 5K, etc..

For broad calculations we generally round off to 9 amps per thousand (or for real simplicity, 10 per thousand). This gives us a margin of safety and simplifies the arithmetic.

In planning and executing a power distribution system we have two jobs: to determine the amount of electricity needed and to order cable and connectors of the correct size to carry the load and get the power where we need it.

And don't forget the inevitable iron for the stylist, the hot curlers for the hairdresser and the *most* critical power need on the set, the coffeepot. These items draw surprisingly high amperages.

Determining the load is a simple matter. We merely add up the total wattage of the units we plan to use.

Ampacity

Cable and distribution equipment is rated in terms of their ability to carry electrical loads without overheating. This is called *ampacity*. The larger a cable or connector (and hence the lower its resistance) the greater the amount of current flow it can carry without overheating. If we push more amperage through a cable than it is rated for, it will overheat, then melt and possibly burn.

We must then select the cable that will safely carry that load. To do so we must look at the ampacity table. See Table 10.1.

Ampacities are not absolute; they vary according to situation, temperature, type of wire, type of usage, and courage. The conditions are generally related to heat buildup. For example, two individual cables lying next to each other on a cold concrete floor can handle a greater load than two cables run side by side in an enclosed metal conduit in a boiler room.

Wire size is designated by a number, the lower the number the larger the wire. Most household wiring is done with #12 wire. The power cords on a typical piece of home electronics might be #14 or #16. Speaker wire is usually #20. The largest cable we commonly use in film production is #0000 (pronounced *four ought*). Cable larger than #0000 is rated in MCM (mean circular mils), and is a measurement of the cross sectional area of the conductor. A *mil* is 1/1000th of a inch.

Table 10.1 Typical Ampacities for *Copper Wire*

Wire Size	Ampacity	SIZE (In²)	SIZE (MM²)	Diameter Inches
1000 MCM	545			
800 MCM	490			
750 MCM	475			
700 MCM	460			
600 MCM	420			
500 MCM	380			
400 MCM	335			
350 MCM	310			
300 MCM	285			
250 MCM	255			
#0000	230	.166	120.0	.460
#000	200	.132	95.0	.410
#00	175	.105	70.0	.365
#0	150	.083	50.0	.325
#1	130	.066	46.9	.289
#2	115	.052	35.0	.258
#3	100	.041	25.0	.229
#4	85	.033	23.3	.204
#6	65	.021	14.7	.162
#8	45	.013	9.2	.128
#10	30	.008	5.8	.102
#12	20	.005	3.7	.081
#14	15	.003	2.3	.064
#16	7	.002	1.5	.051
#18	3	.001	0.9	.040

For example: we are burning a 10K, 2 5Ks, 4 2Ks and 2 1Ks. This is a total of 30K watts. Multiplying by 9 gives us 270 amps. Of course we always allow more for unexpected additional units and to run the equipment at something less than its full rated load—usually a wise idea. This gives us 300 amps. If we are dealing with three-phase four-wire service we will assume that we will distribute the load as evenly as possible over

10.6 Actual wire sizes without insulation.

the three legs. This gives us 100 amps per leg.

Example
We see that #3 cable would carry the load, but #3 isn't generally available. Welding cable #2 is the industry workhorse for medium duty situations. So we order four-wire banded #2 welding cable. It is important to specify four-wire, because it is common to bundle #2 cable in three-wire bundles (correct for single phase). For a four-wire situation the rental house will send you a three-wire bundle and a fourth wire loose.

Color Coding
All service equipment must be color coded. In the U.S. the standard colors for 110- and 220-volt circuits are:
- neutral: white
- ground: green
- hot legs: red, blue and yellow, or black
Electricians should carry color coding tape with them and check that all circuits are correctly color coded.
The international colors are
- neutral: blue
- hot leg: red
- ground: yellow/green

The Neutral
The neutral is a very important part of the system. If the neutral were mistakenly plugged into a hot leg, creating 220 volts, serious equipment damage and injury could result. To prevent this many rental houses make it difficult to do this. Two strategies are common:
1. The neutral has a different size connector. For example, cable with #1 Tweco connectors might have a neutral with #2 Twecos.
2. Reversed neutral. In bundled cable, the neutral is run backwards so the male and females are at opposite ends from the hot legs.
Losing the neutral can also be very dangerous. Under certain conditions, losing the neutral can allow the voltage

to wander and rise to dangerous levels. The neutral should *never* be fused.

To prevent loss of neutral connections, the neutral lines must be taped with gaffer's tape to make sure they don't pull apart. Always connect the neutral first and disconnect it last. If there is a short or an arc, you want the current to have a better place to go than through you.

Distribution Equipment
Let's look at distribution equipment from the source all the way out to the light.

Tie-Ins
There are six main varieties of tie-in connectors: Tricos, Anderson clamps, Mueller or alligator clips, bus-bar lugs, and bare wires. Tricos are the most common. They come in 60-amp, 100-amp and 200-amp sizes, referred to as #1, #2, and #3. Anderson clamps are generally for larger jobs, are unwieldy and difficult to tighten, and won't fit in any tight space. They are all exposed metal that makes them more dangerous. Alligator clamps are only for extremely small jobs. They don't tighten down with sufficient pressure and are not recommended for this reason.

Bus-bar lugs are for connecting the feeder cable directly to a bus bar. They can be used for tie-ins and are used in *spider boxes,* which are bus-bar distribution boxes. Some large generators use bus bars and lugs for the primary connection. With the new five-wire grounded systems, the lugs are required to be keyed so that the neutral and ground lugs will only fit into the proper sections of the bus bar.

Bare wires are simply a piece of feeder cable that has the insulation stripped off at one end and terminate in a connector (Tweco, Caml-ock, pin plug, Twist-lock) at the other end. They are designed for use where there are large empty lugs available or for difficult situations where it is impossible to get clamps in.

10.7 Trico clips.

10.8 Pin plugs.

10.9 Tweco connector.

10.10 Cam-lock connector.

10.11 Bus-bar lug.

10.12 Stage plug.

10.13 Half stage plug.

10.14 Twist lock.

10.15 Edison connector (301).

10.16 Six- hole stage box.

Connectors

Connectors can be a nightmare, especially if the equipment comes from several different rental houses and adaptors are needed.

The simplest are *pin plugs*, copper cylinders that are split down the middle. They are also used to connect the head cables of many large tungsten lights (5K and above). They need frequent maintenance to ensure a solid connection. If the contact is loose, push a screw driver into the split to spread the connector and create better copper-to-copper contact.

On the East Coast, *Twecos* are still prevalent. Twecos are similar to pin plugs but have a small nipple that locks with a twist. Twecos may need to be spread or pinched like pin plugs and are prone to "freezing" together, which can make them extremely difficult to separate.

Cam-locks are similar to Twecos but are far superior in design. They are more positive in their locking and seldom freeze together. They also form a watertight and completely enclosed connection that is much safer.

Theatrical *three-pin connectors* are a fiber block with three pin-plug connectors.

Union connectors are more common in the theater and video studios. They are high-tech versions of three-pins and have a secure locking device.

Ordinary plugs such as you will find around the house (two parallel flat blades and a round ground pin) are referred to as *Edison* plugs, Hubble, U-ground, and household plugs. The adaptors that convert a 3-blade grounded Edison to a 2-blade ungrounded is called a *3-to-2*.

Twist locks have the pins arranged in a circle. One or more of the pins has a nib on the end that creates a positive lock when given a final twist. Twist locks are safe and easy to use and come in an enormous variety of arrangements.

As the name implies, *stage plugs* are old theater equipment. They are a fiber block with two copper plates on the sides. One copper plate is spring loaded. They fit into square plug holes that have copper plates at top and bottom. Stage plugs come in full and half sizes. Two half stage plugs will fit into one plug hole. Stage plugs have many disadvantages: they are difficult to ground, they slip out easily, and the holes are open invitations to electrocutions. Despite the disadvantages, the seniority and economy of the system ensures that they are still widely used.

Bull Switches

A bull switch is a portable disconnect switch with fuses for each hot leg. They come in 60-, 100-, and 300-amp sizes, most often with bladed cartridge fuses. A bull switch should be put in every distribution system, usually right after the tie-in or generator. In some cases you may want it near the set where it can be used as a master switch to shut everything down.

Feeder Cable

Feeder cable runs from the power source to the distribution boxes. The real workhorse of the business is #2 welding cable. Rated at 115 amps, it is compatible with the most common fuse boxes and distribution boxes (generally 100 amps per leg). It is flexible and easy to work with. On the East Coast it most often terminates in Tweco or Cam-lock connectors; on the West Coast pin plugs are common. For small jobs a popular size is #6/3 (a single cable with three conductors of #6).

For larger service #0 (*one ought*) and #00 are frequently used. For the really big jobs, such as a 225-amp brute arc, #0000 is the largest size most rental houses carry. These cables all come as individual wires, in 25-, 50- and 100-foot lengths. Picking up a 100-foot length of #0000 is not a one-person job.

Distribution Boxes

In the East, stage boxes are still the most used distribution box. There are

six square plug holes to accept six full or 12 half-stage plugs. Be sure you specify a three- or four-wire box, depending on whether you are running a single-phase or three-phase system. You may be able to get combo boxes which can be converted to either system by swinging one of the fuses to one of two tie-down screws inside the box. Combo boxes are essential if you don't know what type of system you will be working with. In order to provide for HMIs that require 220-volts, some stage boxes have twist-lock 220 volt outlets at the side or rear panels, which are usually color-coded so you know which legs you are loading.

Spider boxes are enclosed bus-bar systems that use bus-bar lugs to make the connections. Homemade boxes may have Camlock connectors, Edison connectors, stage plug pockets, or a combination of any of them. Unfused boxes with 2, 4, or 6 pockets are called Hollywood boxes. They have short leads that terminate in Tweco, slip-pin, or Camlock connectors. They are handy for running a line to an area that doesn't need a full box.

Whenever possible, distribution boxes should have fuses for each circuit. In stage boxes, flexible metal or lead fuses connect each pocket to the bus bar. Each leg may have a 60-amp or 100-amp fuse. It is wise to open each box and check each fuse. You should carry spare fuses, even though a good rental house will make sure each box has a spare fuse bolted in.

To plug Edison connectors into a stage box, 301 1/2s (pronounced *three-oh-one and a half*) are used. Rated at 20 amps, these are half-stage plugs connected to a single Edison connector. They are sometimes mistakenly referred to as *pigtails*.

Extensions

Lines that terminate in half- or full-stage plugs can be connected directly into the stage box. Large lights (5K and above) usually have a stage plug connector and

go right into the box. Smaller units are Edison and go into a 301-1/2.

If the head cable of the light doesn't reach to the box there are several options. To extend out to a stage plug equipped light or to run fairly large amounts of power (up to 100 amps) we can use porcelains. A porcelain has a half- or full-stage plug and a single- or double-stage plug pocket. Ratings are 60 and 100 amp. The 100 amps come in single or double pocket.

For lighter loads (up to 20 amps) we can use single extensions. A sturdier cousin of the household extension cord, it consists of a length of 12/3 (three conductors of #12) with Edison plugs at both ends. It is also called a *single*, a *stinger*, or a *12/3*.

A variant of the single is the four-way. Terminating in a #1900 box with four female Edison plugs, it is made from #10 wire (30 amp) and can have either a half-stage plug or male Edison. Shorty four-ways are also available, which allow four Edison plug devices in a single half-stage pocket. A standard electrical order will nearly always include some of each type.

For the oddball situations where we need to take power from an Edison plug and send it to a stage-plug device, we can use an Edison to stage-plug adaptor, usually called a *reverse polish adaptor*.

Planning a Distribution System

The primary challenge of planning is to get the power where you need it. The basic trick to get enough stage boxes (or whatever distribution boxes you are us-

10.17 Three pin to porcelain adaptor.

10.18 100-amp double pocket porcelain.

10.19 Four-way to half-stage plug.

ing) so that your final cabling to the lights is reasonable.

The most common ways in which people get into trouble with distribution are

1. Not enough stage boxes so that a huge web of porcelains, four-ways, and singles that cross and recross the set have to be run to get power to all the lights.
2. Not enough secondary distribution (porcelains).
3. Enough power but not enough *holes* (stage box pockets), so that everything can't be plugged in.

As much as any other part of lighting, planning a distribution system requires thinking ahead, anticipating variations, and allowing slack for the unexpected.

Balancing the Load

Once the power is up and running, one major responsibility remains, balancing the load. Simply put, keeping a balanced load means keeping a roughly equal amount of current flowing on all legs, whether it be a three-wire or a four-wire system.

If a system is rated at 100 amps per leg and the load is 100 amps, what is wrong with it all being on the same leg—after all, the fuses aren't going to blow? There are several problems. First, we have to remember that electricity travels in two directions. Remember Fudd's Law, "What goes in, must come out." To put it more mathematically, the current on the neutral is equal to the sum of the *difference* between the load on the hot legs. In other words, on a three-phase system, if there are 100 amps on each leg, the current on the neutral will be zero, the phases cancel each other out. On the other hand, if the same system has 100 amps on one leg and nothing on the other legs, the current on the neutral will be 100 amps.

This is dangerous for several reasons. First of all, we run the danger of overloading the neutral wire. Keep in mind that a neutral is never fused, so over-

loading it can have dire consequences. Secondly, even if our system can handle an overcurrent in the neutral, the transformer in the electric room or on the pole outside might fail as a result of the imbalance. In the realm of "things that will ensure you never get hired again by this company," melting down the transformer is near the top of the list.

The moral of the story is: balance your load. As you plug in or switch on, distribute the usage across all legs. Once everything is up and running, the load is checked with a clamp-on ammeter. Generrically called an *Amprobe* (after a major manufacturer of the devices), this type of meter is one of the most fundamental tools of the film electrician.

> A good trick is to always read a load in the same order, for example red, yellow, blue (RYB: "rib"). That way you only need to memorize a set of three numbers. This will help you remember which legs are high or low.

In some cases, it may be necessary to run a *ghost* load. For example, you have a 100-amp generator but are running only one light, a 10K. Since there is only one light, the load would be entirely on one leg, deadly to a small genny. Plug unused lights into the other legs and point them away so that they don't interfere with the set lights. Don't set them face down on the ground or cover them. This could cause them to overheat and create a fire hazard or blow the bulb.

In a tie-in situation don't forget that there may be other uses in the building. Check the load at the tie-in and on the building service itself. Even though your lights are in balance, there may be other heavy use in the building that is overloading the system or throwing it out of balance. This can be tricky—the worst offenders are, in fact, intermittent users: freezers, air conditioners, etc., which might be off when you scout the location and check the load, but kick in just as you are pulling your heaviest load.

Working with AC and DC

DC is used much less than it was a few years ago. This is the tail end of a battle that dates back to the earliest days of electricity. When electrical power was first being used outside of the laboratory and proposals were being made to wire up parts of cities, both types of power had their champions. Thomas Edison felt that DC was the preferred form of power. Nikola Tesla, the other great electrical innovator of the era, favored AC for its ability to be run over greater distances by stepping the voltage up and down—higher voltages will carry over longer distances with less loss of power. In the end, of course, AC prevailed and now AC power grids cover entire continents, while DC power transmission is limited to a few miles at best.

DC has other disadvantages. Since all the current flows in one direction it tends to eat the connectors by constantly eroding one side and depositing metal on the other. And, of course, modern electronics (such as those found in HMIs, xenons and even variacs) are not possible with DC.

Still, it has its uses. Until recently its major function on sets was for Brute arcs, which will run only on DC. Even today, if brutes are planned you must ensure that the generator or location is supplied with DC. Some generators will provide both AC and DC (some are switchable and will supply one at a time). This is a major consideration in ordering generators. Special ballasts are available that will run a DC arc on AC—most of them require three-phase.

Some older stages are still wired with DC. If you work on one, the first thing the electricians must do is clearly label all DC boxes (white camera tape is usually used). DC can be deadly. If an HMI, compressor, computer or any other AC device is plugged into DC, it will be cooked immediately. So, while tungsten lights (and most powered light stands, generically called *molevators*) will run on either AC or DC, few other devices are so indiscriminate. Extreme caution is always paramount.

Calculating Voltage Drop

A problem with long cable runs is that the resistance of the cable itself will cause the voltage to drop. This has always been a problem since each 10-volt drop creates a 100 K drop in color temperature in tungsten bulbs. Now with HMIs, voltage drop (VD) can be an even more serious problem. Many HMIs won't fire at all if the voltage is too low. Color temperature can be corrected with gels or in the lab, but a light that won't turn on can be fatal.

Voltage drop is a function of resistance. It can be cured in one of two ways: either shorten the cable run or reduce the resistance by increasing the size of the cable (and thereby decreasing resistance).

Voltage drop should be dealt with in the planning stage. This means that the calculations must be done beforehand. The formula for voltage drop is

$$VD = C \times R$$

where *VD* is voltage drop, *C* is current in amps, and *R* is resistance in ohms. If you call voltage drop *V*, you can remember it as

$$VCR$$

The current is the total amperage of your expected load. Resistance is the resistance per foot of the cable times the total run (the distance in *both* directions). For example, we expect a 100-amp load at 1000 feet from the genny. We try #2 welding cable. Its resistance per foot is .000162.

R is thus 1000 feet times 2 (the run *coming and going*) times .000194 times 100 amps:

$$1000' \times 2 \times .000194 \times 100 = 38.8$$

The voltage drop would be 38.8 volts. If we start with 120 volts we would end up with 120 - 38.8 = 81.2 volts, way below acceptable.

Let's try it with #00 cable. The resis-

Table 10.2 Calculating Voltage Drop

AWG	OHMS/FOOT
#12	0.0019800
#10	0.0012400
#8	0.0007780
#6	0.0004910
#4	0.0003080
#2	0.0001940
#1	0.0001540
#0	0.0001220
#00	0.0000967
#000	0.0000766
#0000	0.0000608

tance per foot of #00 is .0000967 ohms per foot.

$$1000' \times 2 \times .0000967 \times 100 = 19.34.$$

$$120 - 19.34 = 100.66.$$

Still not good enough. How about #0000?

$$1000' \times 2 \times .0000608 \times 100 = 12.16.$$

This means that with 120 volts we would end up with 107.84. Almost there. But the generator has a trim adjustment! We can crank the generator up to 130 volts. This leaves us with 117 volts. More than enough. That's why we get the big bucks.

Electrical Safety

Electrical safety must be taken seriously. We can't cover every aspect of this complex subject here, but the following is a list of the most fundamental rules to remember on a set:

1. Ground all systems whenever possible.
2. *Always* tape your neutrals and *never* fuse the neutral.
3. Keep distribution boxes away from water and off of wet ground. Use half-apples and rubber mats.
4. Always ground HMIs with substantial wire; zip cord is not sufficient.
5. No one but an electrician should ever plug in a light or provide power.
6. Always use a fused disconnect near the power supply.
7. Check voltage before plugging anything in.
8. Tape over any loose hot connectors or energized metal.
9. Never overload distribution equipment.
10. The fuse should always be the weakest link of the chain. The capacity of any fuse should always be *less* than the ampacity of any part of the system.
11. Never bypass the fuses.
12. Cables should be routed sensibly and taped down or bagged if necessary. Never lets loops of cable stick up to trip somebody. Use rubber mats over any cables where there is substantial traffic.
13. The head cable of a light on a stand should always hang vertically. It should never come off a light at an angle so as to put sideward force on the stand.
14. Keep your load balanced.
15. With large lights (5K and above in tungsten and some HMIs) the bulbs should be removed for transportation.
16. Hot lenses can shatter when water hits them. If rain or rain effects are a problem, provide rain hoods, plastic covered flag,s or other rain protection.
17. Warn people to look away when switching on a light.
18. Never touch two lights or light stands at the same time.
19. Don't assume it's AC. DC can be deadly. Check it.

Wet Work

Because water triples conductivity, working in or near water is probably the most hazardous situation a crew can face. Extra precautions and constant vigilance are required. Saltwater-soaked beaches are particularly hazardous.

Some things to keep in mind:

1. Keep all stage boxes and connectors dry by wrapping them in plastic and keep them on half-apple boxes. Remember that gaffer's tape is not resistant to water or cold; plastic electrical tape will work. Garbage bags are useful, but visqueen or heavy plastic is better.
2. Ground everything in sight.
3. Keep HMI ballasts out of water and off of damp sand.
4. Use waterproof shoes, rubber gloves, and waterproof suit if necessary. Place dry rubber mats liberally, wherever someone might be working with hot items such as HMI ballasts, distribution boxes, etc..
5. When equipment (including cable) has been around saltwater, wash it down if you can.

It is possible to run lights underwater. They must be immersed when turned on and cannot be taken out while hot or they will explode. If the connections are not completely sealed (with, for example, hot glue) the water will become electrically hot and may pose a danger. Freshwater is a poor conductor by itself but any salt will increase its conductivity dramatically. In fact, *saltwater dimmers* were a staple of low-budget theater for many years.

HMI Safety

Due to poor design and engineering, HMIs can be extremely hazardous. The startup voltage on an HMI can be 13,000 volts or more.

1. The ballast should always be grounded. The ground should be of substantial wire (at least #12 or larger) and attached to the ground metal with something that can take a large load such as a Trico, vice grips, Anderson clamp, etc. Incredibly, few ballasts provide an attachment point for a ground wire. Usually a screw must be slightly loosened or a bit of paint scrapped off.
2. Read voltage from the ballast to a ground and from the head to a ground.
3. Never operate the HMI with the lens off. The lens filters harmful ultraviolet radiation.
4. Never attempt to defeat the microswitch, which prevents the unit from firing if the lens is open.
5. Don't let anyone lean on the stand or sit on the ballast.

Grounding Safety

The concept of safety grounds is simple. We always want the electricity to have a path that is easier to follow than through us. In general, any metal object that is in some way connected to the earth will serve as a suitable ground. A metal rod buried in the ground is the most basic and perhaps most reliable ground. Most permanently installed electrical systems are grounded. Many building codes require that the neutral and ground be bonded together at the box and that a direct ground run from the box to the earth. This ground is then continued by the continuous metal contact of conduit and box to the metal housing of all devices.

Cold water pipes are a reliable ground since they have a continuous metal-to-metal circuit connected to the supply pipes that are buried in earth. Hot water pipes are less likely because the metal-to-metal contact may be broken at the hot water heater.

Sprinkler system pipes are grounded but it is considered unsafe (and in most cases illegal) to ground to them.

Most film electrical systems are two-wire (hot and neutral) and the cables we use are not metal sheathed; they are completely ungrounded systems. In California, grounded systems are now required. While this makes for a more cumbersome system, the added safety is worthwhile.

1. Always check for adequate ground with a voltage meter. Read the potential voltage between the ground and a hot source.
2. Remember that paint is an insulator. You will not get a good ground if you don't scrape down to bare metal.
3. A ground is not truly safe if it is not capable of carrying the entire load. A 200-amp load cannot be safely grounded with #20 wire.
4. When in doubt, ground it.

11. Lamps and Sockets

In this chapter we will look closely at the many different types of radiating sources that are available, and examine their potential and what techniques are necessary to successfully work with each of them.

Types of Radiating Sources
Carbon Arc

The oldest type of radiating source is the open arc. All carbon arc sources consist of a positive and a negative electrode. Current flows from the negative to the positive electrode. The high-current flow across the tip of the negative carbon gasifies the carbon/cerium metals electrode and creates a small flame that is an extremely hot plasma produced by the arc. The output is intense and can only be viewed through darkglass viewing ports in the side and back of the unit.

As the arc burns, the electrodes are consumed and must be moved forward to maintain optimal operating distance. In modern arcs this is performed by geared motors, but requires constant attention by an operator. In addition, the positives must be replaced roughly every half hour and the negatives last about twice as long.

Tungsten

The incandescent lamp was invented by Thomas Edison, and patented in 1879. It works on the principle of incandescence—The greater the current passing through the filament, the brighter the bulb will burn. Tungsten is used because it has the highest melting point of any material suitable for forming a filament. Even in the partial vacuum inside the

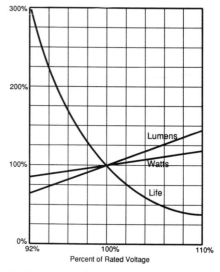

11.1 Incandescent lamp characteristics as affected by changes in voltage.

globe, the tungsten molecules boil off and accumulate on the relatively cooler glass envelope, where they form a sooty coating that gradually dims the bulb and affects its color temperature. To slow this evaporation, the globe is filled to about 80% atmospheric pressure with the inert gases nitrogen and argon.

Tungsten-Halogen

The accumulation of soot on the bulbs was solved by the introduction of the tungsten-halogen bulb. The idea for a tungsten-halogen bulb originated with Edison, but at the time there was no glass that could withstand the temperature. In general use, the term *tungsten* refers to any incandescent bulb. *Quartz* refers to tungsten-halogen bulbs.

Tungsten-halogen bulbs operate on a gas cycle that works to redeposit the

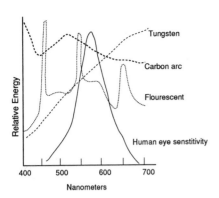

11.2 Various sources.

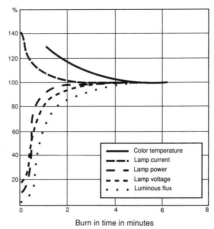

Burn in time in minutes

11.3 HMI startup.

evaporated metal back onto the filament. As the tungsten molecules leave the filament, they chemically combine with the iodine and bromine gases in the bulb. The resulting tungsten halide migrates back to the filament, where the very high temperature decomposes it back into tungsten, iodine, and bromine.

The halogen cycle will fail to operate if the lamp is operated below 250°C. If operated for a prolonged period with a bulb wall temperature of less than 250°, blackening may occur, with a loss of output and a reduction of lamp life. Obviously, dimming the light may result in an operating temperature lower than this limit, but if the lamp is dimmed to low levels, the evaporation of tungsten is also minimized and usually there is no problem.

In an incandescent lamp a 1% change in voltage results in a 3 1/2% change in output.

Enclosed Metal Arc: HMI

HMIs generate three to four times the light of tungsten-halogen, but consume up to 75% less energy for the same luminous flux. When a tungsten bulb is corrected to daylight, the advantage increases to seven times because they are more efficient in converting power to light, they give off less heat than a tungsten lamp.

The term HMI is an abbreviation for the basic components. "H" is from the Latin symbol for mercury (Hg), which is used primarily to create the lamp

voltage. "M" is for rare earth metals (such as sysporsium, thulium and homium) which control the color temperature of the output. "I" stands for iodine and bromine which are halogen compounds. The halogen serves much the same function as in a tungsten-halogen lamp and ensures that the rare earth metals remain concentrated in the hot zone of the arc.

HMI lamps are manufactured from high-temperature-tolerant quartz glass. They have two axial electrodes made from tungsten that project into a cylindrical or ellipsoidal discharge chamber. Power is supplied via molybdenum foils with a special surface profile. The foil is sealed in the quartz glass lamp shaft and provides the electrical connection between the base and the electrodes in the discharge chamber.

Color temperature as derived from a black body Planckian radiator does not directly apply to HMIs because they are not continuous spectrum radiators. HMI lamps produce a quasi-continuous spectrum that is very similar to that of the sun.

In an HMI lamp the basic mercury discharge spectrum is very discontinuous and concentrated in a few narrow bands. The output of the rare earths fill out the spectrum and produce an SED very close to daylight. For most HMIs the color rendering index is greater than 90, and thus above the minimum for film.

11.4 Xenon bulb.

When first developed, HMIs were not dimmable. Lamps have now been developed that can be dimmed to 40% of their rated output, which corresponds to 30% of their luminous flux. There is some slight shift of color temperature under these conditions.

All HMIs require a ballast. As with a carbon arc or an arc welder, the ballast includes a choke that acts as a current limiter. The reason for this is simple. An arc is basically a dead short. If the current were allowed to flow unimpeded, the circuit would overload and either trip the breaker or burn up. Original ballasts for HMIs were extremely heavy and bulky (200 pounds or more) and were universally hated by electricians. The invention of the smaller and lighter electronic ballast was a major improvement. They also allow the unit to operate on a squarewave, which solves the flicker problem as we will see elsewhere. The squarewave also increases light efficiency by 6% to 8%.

Voltages of 12,000 VAC or more are needed to start the arc, which is provided by a separate ignitor circuit in the ballast. The typical operating voltage is around 200V. When a lamp is already hot, much higher voltages are needed in order to ionize the pressurized gap between the electrodes. This can be 20 kV to more than 65 kV. For this reason, many HMIs cannot be restruck while hot. Hot restrike is a feature that has been added to many new designs.

Due to devitrification, which increases as the lamp ages, the color temperature falls by about 0.5K to 1K per hour burned, depending on the wattage. Bulbs should not be operated more than 25% past their rated life as they may explode.

Household and Projector Bulbs

Ordinary household bulbs and photographic bulbs also play a part in film and video lighting. They are used in these instances:

1. Special built rigs such as large soft boxes that use ordinary photographic or household bulbs as the source.

2. *Practicals* such as desk lamps, wall sconces, etc., that appear in the frame.

All bulbs have a coded letter designations known as ANSI codes, coordinated by the American National Standards Institute. These three-letter codes designate the basic bulb wattage, configuration, and socket of a bulb, and are used by all manufacturers. This ensures that bulbs from different makers are interchangeable.

For example, the ANSI code for a 2,000 watt tungsten-halogen bulb to fit in a studio baby is CYX. A 5K bulb is a DPY, and so on.

Practical Bulbs

Practical bulbs are needed for just about any desk lamp, floor lamp, wall sconce, or hanging light that appears in a scene. It is important to order a variety of sizes that will fit these units. Notice also that many modern lamps use specialized miniature bulbs that are not commonly available.

A practical bulb kit is a must on any production that involves on-camera practicals. It is common practice for any company to have a box of bulbs always available. A standard practical bulb kit would include the items shown in Figure 11.5.

(All of these bulbs are medium screw base, which is the most common socket in household lamps, sconces, and ceiling-mounted lamps, followed closely by the smaller candelabra base.)

One of the most important things to understand about household and photoflood bulbs is that they come in different sizes. The *fiddles* of many table or floor lamps may not be large enough to accommodate a large 200 watt household bulb, which is an A-23. A BBA, on the other hand, is an A-21 bulb and measures only 4 15/16, small enough to fit in most lamp housings.

Other popular bulbs include the 211, 212 series of enlarger bulbs. These feature a special bonded ceramic coating for even and soft light. The 211 is 75 watts medium base (A21) and the 212 is 150 watts medium base (A21).

DESIGNATION	WATT AGE	TYPE	SIZE	BASE	COLOR TEMP
25 watt	25 W	household bulb	A-19	medium screw	2600K
40 watt	40 W	household bulb	A-19	medium screw	2600K
60 watt	60 W	household bulb	A-19	medium screw	2600K
75 watt	75 W	household bulb	A-19	medium screw	2600K
100 watt	100 W	household bulb	A-19	medium screw	2600K
150 watt	150W	household bulb	A-21	medium screw	2800K
200 watt	200W	household bulb	A-23	medium screw	2800K
ECA	250W	photoflood bulb	A-23	medium screw	3200K
ECT	500W	photoflood bulb	PS-25	medium screw	3200K
BBA (#1 flood)	250 W	photoflood bulb	A-21	medium screw	3400K
EBV (#2 flood)	500 W	Blue photoflood	PS-25	medium screw	4800K
BCA (#B1 flood)	250 W	Blue photoflood	A-21	medium screw	4800K
EBW (#B2 flood)	500 W	Blue photoflood	PS-25	medium screw	4800K
211	75 W	Enlarger bulb	A-21	medium screw	2950K
212	150 W	Enlarger bulb	A-21	medium screw	2950K

11.5 Practical bulbs.

11.6 MR-16 in holder.

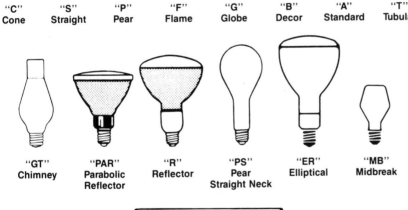

"C" Cone "S" Straight "P" Pear "F" Flame "G" Globe "B" Decor "A" Standard "T" Tubular

"GT" Chimney "PAR" Parabolic Reflector "R" Reflector "PS" Pear Straight Neck "ER" Elliptical "MB" Midbreak

"T" (Lumiline Type)

11.7 Incandescent lamp bulb shapes. (Courtesy General Electric.)

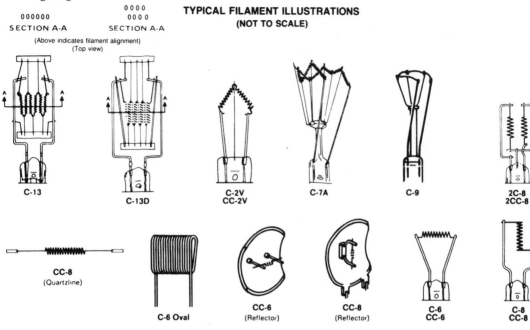

**TYPICAL FILAMENT ILLUSTRATIONS
(NOT TO SCALE)**

000000
SECTION A-A

0000
0000
SECTION A-A

(Above indicates filament alignment)
(Top view)

C-13

C-13D

C-2V
CC-2V

C-7A

C-9

2C-8
2CC-8

CC-8
(Quartzline)

C-6 Oval

CC-6
(Reflector)

CC-8
(Reflector)

C-6
CC-6

C-8
CC-8

11.8 Common incandescent filament forms. (Courtesy General Electric.)

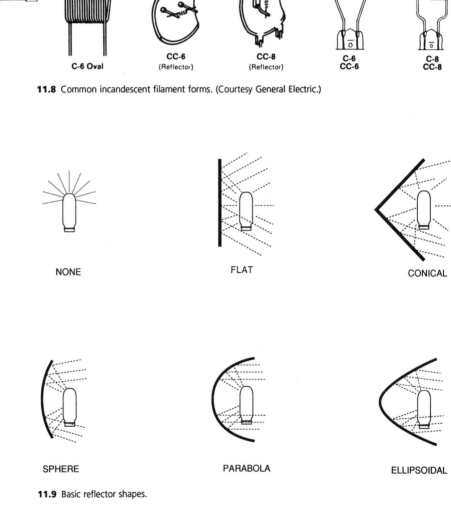

NONE

FLAT

CONICAL

SPHERE

PARABOLA

ELLIPSOIDAL

11.9 Basic reflector shapes.

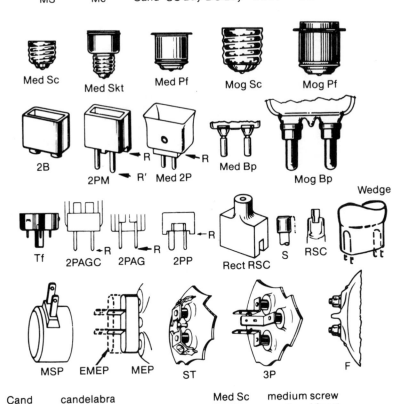

Cand	candelabra	
DC Bay	double-contact bayonet candelabra	
DC Pf	double-contact prefocus candelabra	
EMEP	extended mogul end prong	
F	ferrule contact	
Mc	minican	

Med Sc	medium screw
Med Bp	medium bipost
Med Pf	medium prefocus
Med Skt	medium skirted
Med 2P	medium two pin
MEP	mogul end prong (also: extended mogul end prong)

Mog Sc	mogul screw
Mog Bp	mogul bipost
Mog Pf	mogul prefocus
MS	miniature screw (with reference shoulder) (also: Tru-Loc miniature screw)
MSP	medium side prong
Rect RSC	rectangular recessed single contact
RM2P	rim mount two pin (see Fig. 10)
RSC	recessed single contact (also: single contact recessed)
S	metal sleeve
SC Bay	single-contact bayonet candelabra

SC Pf	single-contact prefocus
ST	screw terminal
TB2P	trubeam two pin (V2P*) (see Fig. 10)
Tf	trufocus (also: four pin)
TLMS	Tru-Loc miniature screw (also: miniature screw with reference shoulder)
Wedge	wedge
2B	two button
2PAG	two pin all glass (TP*)
2PAGC	two pin all glass (ceramic cover)
2PM	two pin miniature (trupin TrP*)
2PP	two pin prefocus
3P	three prong

Notes: R indicates special reference point for LCL.
 (RR – at 0.531 inch diameter)
 (R' indicates an obsolete reference.)
 *Obsolete Designation

11.10 Fresnel Operation.

Spot position

Flood position

11.11 Fresnel characteristics.

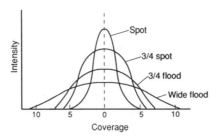

11.12 Common Incandescent Filament Forms.
(Courtesy General Electric.)

11.13 Specialized incandescent sockets. (Courtesy GTE-Sylvannia Lighting.)

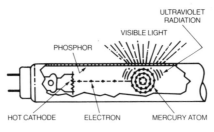

11.14 Fluorescent tube construction. (Courtesy GTE-Sylvannia Lighting.)

Fluorescent Tubes

Not surprisingly, fluorescent bulbs work on the principle of fluorescence, which was discovered by Sir George Stokes in 1852. Alexandre Bequerel used the principle to develop the first fluorescent tube that is not much different than those in use today, although low-voltage lamps were introduced by General Electric in 1938.

Fluorescent tubes have electrodes at each end of the tube. The electrodes propel electrons into the mercury vapor in the tube. The impact of an electron on a mercury atom dislodges an electron from its orbit. When it returns to its orbit, ultraviolet radiation is produced. The ultraviolet rays strike the phosphor coating around the interior of the tube causing it to fluorescence in the visible spectrum. The color of fluorescent tubes is a result of the chemical makeup of the phosphor coatings.

All fluorescents operate with a ballast that limits current flow and raises the voltage for initial firing. Ballasts may emit an audible hum that can interfere with sound filming.

Some bulb types have special phosphors added that change their spectral output. Bulbs have been developed that closely simulate daylight and tungsten-balanced light and have color rendering indexes high enough for reliable color filming. [See Chapter on color balance]

Continuous spectrum bulbs have few of the color rendition problems of standard fluorescents but have about 35% lower output.

Because a fluorescent is an AC gas discharge lamp, its output varies as the AC current rises and falls. With 60hz current the light pulses 120 times per second. Fortunately, the phosphor coating, which is what is producing the visible light output, decays more slowly. Once it is "excited" into producing light by the ultraviolet, it does not extinguish immediately when the current drops. This moderates the flicker effect, but does not eliminate it completely.

Fluorescents can cause flicker problems, just like HMIs. When using

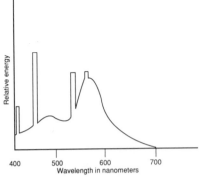

11.15 Cool white fluorescent-SED.

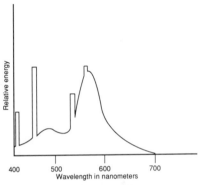

11.16 Warm white fluorescent-SED.

11.17 Design 50 fluorescent-SED.

11.18 Warm white deluxe fluorescent-SED.

SINGLE PIN

(T-6 SLIMLINE) (T-8 SLIMLINE) (T-12 SLIMLINE)

BI-PIN

(MINIATURE T-5 LAMP) (MEDIUM T-8 LAMP)

(MEDIUM T-12 LAMP)

(MOGUL T-17 LAMP)

RECESSED
DBL. CONTACT
(T-12 LAMP)

4-PIN
(CIRCLINE)

11.19 Bases for fluorescent lamps. (Courtesy GTE-Sylvannia Lighting.)

PAR 16

PAR 20

BIPIN LAMPS

MEDIUM
BUTT-ON

PAR 30

PUSH-PULL MEDIUM MOGUL

MINIATURE

SLIMLINE LAMPS HIGH OUTPUT LAMPS
 AND VERY HIGH OUTPUT LAMPS

PAR 38

HIGH LOW
VOLTAGE VOLTAGE RECESSED DOUBLE CONTACT
END END

11.21 Common PAR lamp shapes.

SLIMLINE LAMPS

HIGH VOLTAGE END LOW VOLTAGE END CIRCLINE LAMP
 "PLUNGER TYPE" CONNECTOR
 BUTT-ON MOUNTING

11.20 Typical lampholders for fluorescent lamps. (Courtesy GTE-Sylvannia Lighting.)

fluorescents as the sole source of lighting, it is best to put some of them on different legs so that the flicker effects of each phase of the AC cancel each other out.

Exposure time and, hence, shutter angle are an important factor in preventing flicker. It is wise to use the widest shutter angles you can (to achieve the longest exposure time) and to avoid, if possible, high-speed shooting, which dramatically increases the possibility of flicker.

Other precautions include using a crystal motor if at all feasible and using other types of lighting (such as appropriately filtered tungsten) as part of the set lighting.

Fluorescents can be dimmed, with the following caveats:
• Only autotransformer or solid-state dimmers will work on fluorescents.

- They cannot be dimmed all the way out. At a certain point they flicker and spiral inside the bulb.
- There is usually no color shift when fluorescents are dimmed, but lamps that have been dimmed will appear warmer.
- While being dimmed, the cathodes should remain heated at the standard current.

Bulb Handling and Safety

- Never touch a bulb with your bare fingers—to do so shortens its life.
- Don't move a light with the bulb on. Excessive vibration can damage the filament. Also avoid rapid flood-spotting or other sudden moves.
- Use extreme caution installing and re-moving bulbs, especially double-ended bulbs like the FCM and FHM that have very delicate and damage-prone porcelain ends.
- Note and follow the recommended operating positions of bulbs, particularly large bulbs like DTY and 6K/12K HMI bulbs, which are not only sensitive to position, but also extremely expensive.
- Never block the ventilation flow of a light.

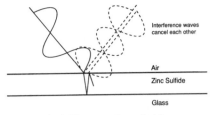

11.22 Dichroic Filter operating principles.

- Try to minimize on and off switching. Dimmers are an excellent way to control the light, reduce the heat level on the set, and reduce total energy consumption which helps save the planet.
- Make sure all lamps are securely seated in their sockets.
- Large bulbs (5K and above) must be removed from the light and placed in a foampadded box for shipment. This does not usually apply to HMI bulbs, which means that added caution is called for when handling HMIs.

Dichroics

Some bulbs have built-in conversion filters, primarily for converting tungsten to daylight balance. Generically called FAYs or faylights, they are a reliable old standby for daylight fill.

Technically, FAY is the ANSI code for a 650-watt PAR 36 with ferrule con-

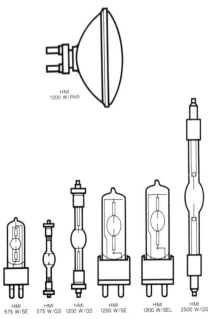

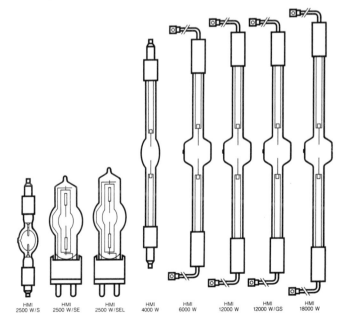

11.23 HMI Bulbs. (Courtesy of Osram.)

tact terminals and a color balance of 5,000K. This most commonly occurs in PAR clusters, such as the five-light and nine-light, although one- and two-lamp units are common for just a touch of fill on cloudy days or for hood-mounted rigs for running shots. Some units take a similar bulb that has screw terminals, the FBE/FGK. They may look quite similar from the outside, so check carefully before ordering bulbs.

Both of these bulbs have dichroic filters for conversion to approximate daylight color balance. Dichroic filters operate on the principle of *interference*. Glass is coated with a number of layers that are one quarter or one half the thickness of the wavelength of the color they are to filter. As that wavelength enters these layers, it creates a series of in-

terior reflections that cancel out the color. Dichroics have been developed to the point where they are very stable.

PAR 64 1000-watt dichroic bulbs are also available for maxi-brutes for high-intensity uses. They come in narrow spot (NSP), medium flood (MFL), and wide flood (WFL). Their rated life is only 200 hours, so be sure you have spares.

Although dichroics (often called *dykes*) are generally an integral part of the lamp, they are sometimes a separate filter that clips onto the lamp and can be swung in and out for instant changeover from daylight to tungsten balance. These rigs have become standard equipment for ENG video news crews. (Figure 11.22.)

12. Basic Gripology

Grip work is an important part of the lighting process. An understanding of basic grip procedure is essential for any lighting professional. This chapter will cover the tools and equipment of grip work, standard methods, and general set operating methods.

Definitions

Baby means a 5/8-inch stud on a light or pin on a piece of grip equipment or female receiver. *Junior* and *Senior* refers to 1 1/8-inch stud or female receiver. Other standard sizes are 1/4-, 3/8- and 1/2-inch. These plus the 5/8-inch are all found on most standard grip heads. The Matthews 4 1/2-inch grip head also has a junior hole.

Light Controls

Grip effects units modify the character or quantity of light—blocking, redirecting, feathering, and wrapping the light —in a word, *control*. The basic rule of thumb is that when the control is attached to a light, it is an electric department deal; if it is separate from the light (on a grip stand, for example) it becomes a grip effect and, for the most part, different equipment is used to deal with it.

Reflectors

Reflector boards or *shiny boards* are ancient and venerable film equipment. On "B westerns" of the 1940s and 1950s they were practically the only piece of lighting equipment used, those being the times of *day-for-night*, a now largely abandoned technique.

Traditionally, reflector boards are roughly 42 x 42-inch and are two-sided, a *hard side* and a *soft side*. The hard side is mirrorlike, smoothed, finish highly reflective material. The soft side is reflective material with just a bit of texture. This makes it a bit less specular and slightly softer. As a result the soft side has considerably less punch and throw than the hard side, which is sometimes referred to as a *bullet* for its ability to throw a hard, specular beam of reflected sunlight amazing distances.

The soft side (sometimes referred to as the *fill* side) is important for balancing daylight exteriors. Because the sun is so specular, daylight exteriors are extraordinarily high-contrast. The problem is that the sun is so intense, most film lights are insignificant in relation to it. Only an arc, 6K, or 12K means much against direct sun. The answer is to use the sun to balance itself. This is what makes reflector boards so useful: the intensity of the reflection rises and falls in direct proportion to the key source.

A variety of surfaces are available for reflector boards. The hardest is actual glass mirror, which provides tremendous punch and control, but of course is delicate to handle. Easier to transport but less regular is artificial mirror, which can be silvered plexiglass or silvered mylar (which can be stretched over a frame).

Hard reflector is one step below actual mirror. It is very smooth and specular silver paper and has very high reflectivity. In the old days, the reflective surfaces were actual silver leaf,

12.1 The Matthews popup casting, which combines a 2K receiver and a 1K stud.

12.2 Standard reflector.

which had to be carefully applied by the scenic artists; today's boards are easily recovered. Matthews also makes a line of lightweight and relatively low-cost expendable boards, which are much more durable than their name implies. They can be used as hand-held reflectors or held by brackets and C-stands.

The soft side is usually silverleaf, which is not as smooth and has the leafy edges that hang loose. The expendable boards have a dimpled silver paper as the soft side. Boards are also available in gold for matching warm light situations such as sunsets.

Beadboard is available which is white beadboard on one side (a very soft reflector) and silverized paper on the other. It makes a powerful reflector, but the beadboard is not rigid and seldom stays flat for very long. This is not a problem for the soft side, but it makes it very difficult to focus and maintain an even coverage on the hard side. Beadboard is a valuable bounce material, but keep in mind that a single sheet of beadboard is the equivalent of thousands of styrofoam cups.

Matthews also has *supersoft* and other reflector materials available in rolls. They can be stretched on frames and made into 6 × 6s, 12 × 12s, etc.

A good trick to to take a cheap glass mirror that is permanently mounted to a backing board (the kind of inexpensive full-length mirror available at a dime store, for example) and smash it with a hammer in several places. With a semi-soft light, it provides a dappled bounce with nice breakup. With a hard light, it makes a sparkly reflection that can simulate reflection off buildings.

Operating Reflectors

The key rule in relation to operating a reflector is of course the old physics rule:

angle of incidence = angle of reflection

This is the problem with reflectors. Because the sun is constantly moving, the boards require constant adjustment. For fast-moving work, it is necessary to station a grip or electrician at each board (one person can handle a couple of boards if they are together). Before each take, the command *shake 'em up* means to wiggle the boards to check that they are still focused where they should be.

Modern reflector boards are equipped with a brake in the yoke which is a tremendous convenience for keeping them properly focused. Other rules for using reflectors are:

1. Keep reflectors *flat* (parallel to the ground) when not in use. This keeps them from blinding people on the set and makes them less susceptible to being knocked over by the wind. It also serves as a reminder that they need refocusing.

2. If it's windy at all, lay the boards on the ground when not being attended by a crew member.

3. The reflection of direct sun is very intense. Try to keep it out of people's eyes.

4. Boards must be stabilized during the take. A moving reflection is very noticeable and obviously artificial.

Standard procedure for aiming a board is to tilt it down until the reflection of the sun is just in front of you. Once you have found the spot, it is easier to aim it where you want it to go.

Specialized stands known as reflector stands are usually used for shiny boards. Also called *combo* stands, they feature junior receivers, leg braces, no wheels, and a certain amount of heft to help keep things in place. They are called combo stands because they are also used as light stands.

Flags and Cutters

Flags and cutters are basic subtractive lighting. Coming in sizes from 12 × 18-inches to 24 × 72-inches, they are used to cast shadows, control spill, and shape the light. They are constructed with 3/8-inch wire and terminate in a 3/8-inch pin that fits in grip heads.

Flags are more squarish and come in the standard sizes 12 × 18, 18 × 24, 24 × 36, and 48 × 48-inch (four by four).

12.3 Flags and cutters.

Cutters are longer and narrower. Larger cutters are known as meat axes. Sizes include 10 × 42-, 18 × 48- and 24 × 72-inch.

The newest innovation in flag technology is the floppy flag. The floppy has two layers of duvetyne (the black cloth covering material), the standard sewn-on layer and a second layer that is sewn at one end only. The other end is held on with velcro and can be pulled out to create a double size flag.

Flag Tricks

The most basic rule about flags is that the farther away the flag is from the light source, the harder the cut will be, that is, the sharper the shadow will be. This is why flags are such an important adjunct to barndoors. Being attached to the light, barndoors can't be moved away from the light and there is a limit to how sharp a cut they can produce. The flag can be moved in as far as the frame will allow, making the cut almost infinitely adjustable.

The more flooded the light, the sharper the cut. For razor sharp control of light (and for harder shadows) the light must be at full flood. The more spotted a light is, the softer the shadows will be, and the harder it is to control with barndoors and flags.

very soft

Full Flood

12.4 The closer the flag is to the source, the softer the shadow.

hard cut

Full Flood

12.5 Flooding the light and moving the source back give a harder cut.

12.7 Fine tuning with nets. (Courtesy Matthews Studio Equipment.)

12.6 Flag on a short arm. (Courtesy Matthews Studio Equipment.)

For additional shaping, it is possible to clip small pieces of showcard onto the flag. Just position the spring clip so that it doesn't cast an unwanted shadow.

Except in rare circumstances, never mount a flag directly to the grip head on a C-stand. Always include at least a short arm so that the flag can be repositioned. As with any piece of equipment you set, always think ahead to the next step—that may be where you want it now, but what happens if it needs to move. Don't get yourself too locked in. Leave some slack!

Common terms are sider, topper, top chop, bottomer and bottom chop, all self-explanatory.

Nets

Nets are similar to flags, but instead of opaque black duvetyne, they are covered with bobbinet, a net material that reduces the amount of light without altering its quality.

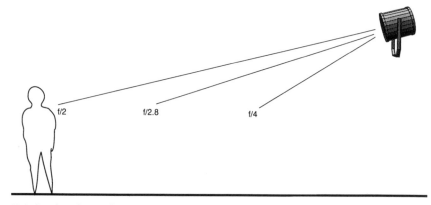

12.8 Covering a long walk presents exposure problems.

12.9 Netting the walk keeps the balance over the entire distance.

Nets come in two predominant flavors, single and double, (there is a third, called lavender, but it is rarely used). Double nets are usually just a double layer of bobbinet. Each layer is rotated 90° from the layer underneath it. Nets are color coded in the bindings that secure the scrim to the frame. Singles are white, doubles are red, and silk is color coded gold. Net material comes in black, white, and lavender, but black is predominately used.

A single net reduces light by a ½ stop, a double by 1 stop, and a triple, 1 ½ stops. A lavender reduces by ⅓ stop. The values are, of course, approximate—the actual reduction depends on the light sources, its distance from the net, and the angle of the net material relative to the direction of the light.

The main difference between a flag frame and a net frame is that net frames are open-ended: that is, they have one side open so that it, is possible to orient the net so that there is no shadow of the bar where it might show.

Net Tricks

If you tilt a net so that it is at an angle to the light, it becomes "thicker" and cuts the light even more. This is an easy way to fine tune the attenuation. As with a flag, the farther away the net is from the light source, the harder the cut will be.

To set a single source so that the f/stop stays constant over a long distance (to cover a walk, for example), nets can be stacked, overlapped so that the area nearest the light is covered by a single and a double, then a single only, then nothing. (Figures 12.8 and 12.9)

To fine tune very small areas, paper tape can be applied directly to a net.

When the gaffer calls for a single or double net on a light, don't just bring the one he asks for, bring them both, it might save a trip. This goes for just about anything that you offer to a light: diffusion, scrims, etc.

Dots and Fingers

Very small flags and nets are called *dots and fingers*. They are used for tabletop

12.10 Dots and fingers

12.11 30″ x 36″ flag and 4′ x 4′ open frame. (Courtesy Matthews Studio Equipment.)

work or for fine work where just a small shadow or shading is needed.

Dots are round and come in 3, 6, and 10 inches. Fingers are generally in the 2 × 12- and 4 × 14-inch range. Both terminate in 1/4-inch pin. All are available in single net, double net, solid and silk.

Matthews also has flex frames, which are small flags in 10 × 12- and 12 × 20-inch sizes. Flex frames have two 1/4-inch pins.

Open Frames

All size frames also come uncovered so that the grips can put on the diffusion of the day: whether it be opal frost, 216, or tracing paper. A couple of open frames in each size are a must in any grip order. Paper tape is usually used to apply gel to a frame, but double-stick tape is also useful. *Snot tape*, which is double sided transfer tape in a dispenser, is an extremely quick way to gel up a frame.

12.12 A cookie.

Cookies

Nobody really knows why it's called a *cucoloris*, but it is. *Cookies*, as they are commonly called, are random patterns designed to break up the light either subtly (if close to the light) or in a hard shadow pattern (if away from the light). Standard cookies come in two varieties: wood, made from 1/4-inch plywood and *celo*, which is a layer of wire net covered with plastic-like material which has a random pattern burned into it to create a varying pattern of transparency and semi-opacity. Celos are much more subtle than a wood cookie.

Any flat device designed to cast a patterned shadow is a cookie. Leaf patterns, blinds, and stained-glass windows are common cookie patterns. Cookies of this type are also known as *gobos*. Foamcore is easily cut, but rigid enough to be self-supporting. When actual branches and leaves are used as cookies they are called *dingles*. A small branch is a 1K dingle and larger ones are 2K or 5K dingles; another name is branchaloris. If they actually appear in the frame they are called *smilex* or *lettuce*.

As with flags, the farther away from the light, the sharper the cut. If a hard, sharp shadow pattern is needed, be sure to employ a light large enough to back way off and still get the stop. For maximum sharpness, take the lens off the light. This reduces the radiator to a point source which casts the sharpest possible pattern.

Grid

The use of grids came from still photographers, who used them to make nondirectional light directional. Honeycomb grids have very small openings and are one to two inches thick. They function in the same way as an eggcrate on a soft light. The Matthews version is called *Matthgrid*.

12.13 Flying a 20′ x 20′ silk.

Diffusers

Also known as silks, diffusers come in all the standard flag sizes and are covered with a white silk-like diffusion material. Originally, of course, it was real silk, and still is if you order *China silk*. More often, the silk is made of white nylon, which is easier to clean and doesn't turn yellow as readily.

Silks soften the light and reduce it by about 2 stops. Matthews has a new product called ¼ stop silk that reduces the light by about ¼ stop—go figure.

Butterflies and Overheads

Permanently mounted silks are seldom larger than the standard 4 × 4-foot. Six-by-sixes are called butterflies. They come in breakdown frames which are assembled on site and the covering is stretched and secured with ties.

Larger silks are called overheads and come in the standard sizes 12 × 12 and 20 × 20-foot, commonly called *12 by* and *20 by*. As with the 6 × 6-foot the frames are transported disassembled with the covering off. Also available are 9 × 12-foot and 20 × 30-foot and 30 × 30-foot. Butterflies (6 × 6-foot) can be flown on one stand (usually a highboy). A 12-by requires at least two highboys and a 20-by requires 4 stands unless it has a heavy duty frame designed for two stands.

The listed size of a rag is the size of the frame. The actual covering is smaller:

Table 12.1 Butterflies and Overheads

6 x 6 butterfly	5' 8" x 5' 8"
12 x 12 overhead	11' 8" x 11' 8"
20 x 20 overhead	19' 8" x 19' 8"

With all large silks, ordering it complete means that it includes the silk, a solid (black duvetyne), a single net and a double net, which gives you a wide variety of controls on the same frame. Bleached muslin (very white, about the consistency of a bedsheet) and unbleached muslin (yellowish white for a warmer look) can also be stretched on frames as a very heavy diffusion or bounce.

Twelve-by and twenty-by frames are flown on highboys. The critical factor in flying a 20-by is knowing that it is sufficient area to drive a sailboat at 12 knots; it can be powerful! Use extreme caution when a large silk is up. Don't fly a silk without an adequate size crew of *knowledgeable* grips and the proper ancillary supplies—lots of sandbags, tie-down points, and plenty of sash cord.

Overhead Rules

Never leave silks unattended when they are up in the air. One grip per stand is required at all times and two or three more when moving it in anything but dead calm conditions. These things can do some damage if they get away from you.

Bag liberally! Run your lines out at as shallow an angle as you can and secure properly. If possible, leave the top riser of the highboy unextended and leave it loose so it can take out any torsion that builds up in the system. Use a grip hitch on the anchor lines so they can be tensioned and readjusted.

Standard technique for the lines is to take a 100-foot hank of sash cord and find the center which is then secured to one of the top corners. The excess line is then coiled and left to hang far enough down so that it can be reached even if the frame is vertical.

Tying off to several heavy sand bags can make readjustment easier than tying off to something permanent. It is then possible to just drag the bags a bit, rather than having to adjust the knot.

Attach the rag to the frame using a shoelace knot. Set the frame up on apple boxes when attaching or removing the rag to keep it off the ground.

Griffs

One more type of covering that can go on overhead frames is *griffolyn* (pronounced griflon). Originally produced as a farm product (it's really just a high-

tech tarpaulin), griffolyn is a reinforced plastic material. Its advantage is that the white side is extremely reflective and the whole unit is highly durable and waterproof.

Griff comes in all sizes from 4 × 4-foot to 20 × 20-foot and also can be had in rolls for custom application. Matthews markets special tape, which can fuse sections together, and *duck feet* griff clips, which provide attachment points so that a custom-made piece can be quickly flown in a variety of situations—with or without a frame.

Matthews offers griff in black-and-white, white-and-white and clear configurations. See Table 12.2.

Table 12.2 Griffolyn Types

Type	Designation	Surface	Thickness
Black & white or			
White & white	T-55	glossy	5 mils
Clear	T-75	dull	8 mils
Black & white	T-85	dull	10 mils

Griff is versatile. Its most frequent use is as a large reflector, either for sun or for a large HMI as a bounce fill. A 12 × 12-foot or 20 × 20-foot white griff with a 6K bounced into it is also a popular combination for night exteriors. It's soft enough to appear *sourceless*, but reflective enough to provide a good stop.

A griff on a frame can also be used by turning the black side to the subject as a solid cutter or as negative fill. If it rains the griff is waterproof so it can be an excellent rain tent. With the white side down it even provides a bit of sky ambiance.

Also available is *grifflector,* which is griff in silver, gold, or checkerboard silver and gold sewn onto a white griff.

Holding
Grip Heads
Much of grip hardware is just for that purpose—gripping stuff. A good deal of the grip's job is getting things to stay where you want them. Over the years a number of ingenious and efficient devices have become part of the grip's rep-

12.14 The right hand rule.

ertoire for getting just about anything to stay just about anywhere.

Holding stuff is the essence of gripping. The grip box is full of things that are designed only to hold something somewhere, *firmly* but *adjustably*.

The grip head or gobo head is one of the most important inventions of the twentieth century. Versatile, powerful and stable, the grip head has been called upon to perform a mind-boggling array of tasks.

It is a connector with two pressure plates and holes for ⅝-, ½-, ⅜- and ¼-inch. It can also accept slotted flat plates (such as on the ears of an overhead mount) and foam core, show card, plywood, etc. In place, it can hold a grip arm, a ⅝-inch stud for a light, a baby plate, a small tree branch, armature wire, pencils and just about anything else you can imagine.

A *gobo arm* is the same device but permanently mounted on a steel rod, which is 40 inches standard. *Short arms* are usually around 20 inches and are an important part of any order. A short arm with a grip head attached is known as a *short arm assembly*. Always order at least a few of them, they are invaluable.

Grip Stand Rules
As any grip will tell you, one of the most basic rules of gripology is the *right hand rule*. The rule is, always set a grip head so that gravity wants to tighten it. It's simple when you think about it. Grip heads are friction devices. By tightening the screw in a clockwise direction you are putting pressure on the arm (or whatever you are holding) and friction is what is both holding the arm in <u>and</u> preventing the pressure from releasing. If the item being held extends out from the stand, it exerts rotational force in the direction of gravity. If this rotational force turns the screw in a counterclockwise direction, it will release the pressure.

Make sure that the force of the load is trying to turn the head in the same direction that you did to tighten it. One

way to do this is to always keep the knuckle on the right from your point of view behind the stand.

Clamps
Studded C-Clamps
Studded clamps come in a range of sizes from 4 to 10 inches and with either baby (⅝-inch) studs or junior (1-⅛") receivers. They are used for rigging lights, grips heads, tie off points, and other items to beams, walls, trees, and anything else they can be fitted on.

C-Clamp Tips
- A properly mounted studded C can hold a substantial load securely. It is not good at resisting the turning load perpendicular to its axis, so don't try to make it do that.
- A C-clamp will definitely leave marks on just about anything. Standard procedure is to *card it*: put a small piece of showcard underneath the feet to protect the surface.
- ALWAYS put a safety line around the item being mounted and the C-clamp itself.
- Choose the appropriate size C-clamp. A clamp that is large for the job will have to be extended too far. When this happens the threaded bar can wobble and twist because it is too far from its support. This is an unsafe condition and should be avoided.
- If you are clamping to a pipe you must use a C-clamp that has channel iron mounted to it (U-shaped steel feet). A flat C-clamp will not safely grab a pipe.

Bar Clamps
A variation on the studded C-clamp is the bar clamp, which is a furniture clamp with a 1K stud attached to it. Bar clamps can be extremely wide (up to several feet) and so can fit around items that would be impossible for a C-clamp.

Pipe Clamps
Pipe clamps are specialty items for mounting directly to pipes and grids. They are a theatrical item and get their most frequent use in studio work. If you are likely to be working in a studio or an industrial situation with a pipe grid, pipe clamps can free lights from stands.

Studded Chain Vise Grips
This is a grip's grip tool. Chain vise grips are carried in the personal kits of many grips, because they are oddball items not carried by many rental companies. Studded versions can mount lights to vertical pipes, beams, bumpers, and other odd places. Nonstudded chain vise grips are often used to secure two pipes together or to mount a light stand on a crane or a fire escape. They provide the kind of bite and stability that you just can't get from sash cord or clamps.

Mafer Clamps
Pronounced *may-fer*, these clamps are indispensable: don't leave home without them. They can bite anything up to the size of a 2 × 4-inch, and have interchangeable studs that can do anything from rigging a baby spot to holding a glass plate. They have dozens of other uses:
- Grips often clamp one onto the end of the dolly track so that they don't accidently let the dolly run off the end.
- With the baby stud clamped into a grip head, they can hold up a 6 × 6-foot frame.
- With a baby plate mounted in it, the mafer can be attached to pipe or board to hold a small reflector card....the uses are endless.

Quacker
Studded vise grip with 5 × 6-inch plates for grabbing beadboard and foamcore with minimal breakage.

Wall Plates, Baby Plates, and Pigeons
Although technically different things, the names are used interchangeably. They are all basically baby studs with a flat plate attached. The plate always has screw holes. With a pigeon, some drywall screws and a portable drill, a grip

12.15 Studded C-clamp.

12.16 Adjustable hanger.

12.17 Bar clamp.

12.18 Studded chain vise-grip.

12.19 Mafer.

12.20 1K pigeon.

12.21 2K pigeon.

12.22 Crowder hanger.

12.25 T-bone are used for low mounts of large lights.

can attach small lights, grip arms, cutters, reflectors, and props to any wood surface.

A particularly popular combination is a baby plate mounted on a half-apple box. This is the standard low mounting position for small lights. When you need even lower, a pancake (the slimmest form of apple box) should be used, although the depth of the screws is limited. When a half-apple is not enough, other apple boxes can be placed beneath for some degree of adjustability.

2K Pigeons

Same deal with a 2K female receiver. A variation on the 2K pigeon is the *turtle* , which is a three-legged low mount for any 2K studded light. The advantage of the turtle is that it is self-supporting with a sandbag or two. The *T-bone* is similar. It is a "T" made of two flat steel bars with a 2K receiver. It will mount the light lower than a turtle and can also be screwed to a wall. T-bones all have safety chains attached. The chains are constantly in the way and always seem to get under the T-bone or apple box when you try to get it to sit flat. They have no conceivable application, and yet they are permanently mounted. We can all hope that manufacturers will wake up and make T-bones without the chains.

Several manufacturers now make C-stands with a detachable base. When the vertical riser is removed the legs are an independent unit with a junior hole. This makes an instant turtle. The riser can be clamped to a fire escape or mounted in other hard to get to places as an extendable mount.

Side Arms and Offset Arms

Side arms (both 1K and 2K varieties) serve two functions:
1. They arm the light out a bit for that little extra stretch.
2. Because they can clamp onto the stand at any level, they are useful for mounting a light low but still on a stand.

Offset arms (both sizes) are similar

12.23 Sidearm.

12.24 Offset arm.

12.26 Triple header.

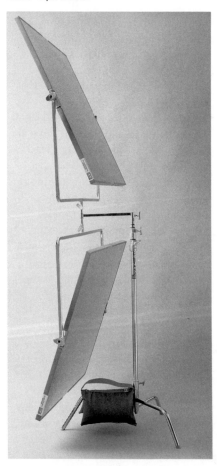

12.27 Using an offset arm to mount two lightweight reflectors. (Courtesy Matthews Studio Equipment)

but mount only to the top of the stand. They are very helpful in getting a light to stretch those few extra inches over the side of a table, over a wall, or anywhere when the stand keeps you from getting the light where you want.

Offset arms are also important in allowing you to underhang a light. Most lights are impossible to point straight down (or even near it) when mounted on top of the stand. With an offset arm you have much greater freedom in directing the light.

- When setting a light on an offset or side arm always place it over a leg .
- Be sure to put a bag on the opposite side and always rig a safety line.

When underhanging a 2K studded light there is usually a hole through the stud that can be aligned with a hole in the receiver. A nail or cotter pin is placed through the hole and bent. This safetys the light but allows it to spin for focusing.

Scissor Clamp
The scissor clamp is a specialized device that clips onto the metal frame pieces of a drop-ceiling system. Also called drop ceiling clamps, they can be time savers in tight situations.

Rigging
An important part of gripping is *rigging*, which, loosely defined, means anything that is supported in the air (other than just directly attached to a stand), *flown*, (suspended by cables or rope) or supported by special built scaffolding or rigs. In addition to the normal requirements of stability, adjustability and quickness, rigging requires a special burden of absolute safety. In most cases, rigged items will be over the heads of actors or technicians

Wall Stretcherss
Wall stretchers are screw-mount pressure plates that compress 2 × 4-inch or 2 × 6-inch dimensional lumber to support them in a wall-to-wall mounting position. Properly rigged, wall stretch-

ers can support a number of lights over fairly long spans.

When rigging wall stretchers *check your surface.* Make sure you are placing the stretcher on a solid, load-bearing surface, not just sheet rock. Always safety with nails, drywall screws, or sash cord. Don't depend on friction alone.

Related to wall stretchers are *pogo sticks,* also known as *Math poles* or *pole-cats.* These are spring-loaded aluminum tubes that come in a range of sizes. Each size is adjustable over a range of several feet and the spring-loading device also self-adjusts to a certain extent.

In use, the pole is adjusted to the width of the span and then the spring is compressed. A twist of the pole locks the spring in. When it is in position, another twist releases the spring, which presses rubber cups at each end of the pole into the wall. They won't support nearly as much load as a wall stretcher, but they are much quicker to install and cheaper (no lumber is cut).

Standard sizes are: 30 to 53, 52 to 96, and 95 to 178-inch.

Parallels
Parallels are scaffolding, which are frequently used to get large lights up high or for camera positions. They come

12.28 Scissor clamp.

12.29 Using wall stretchers for rigging.

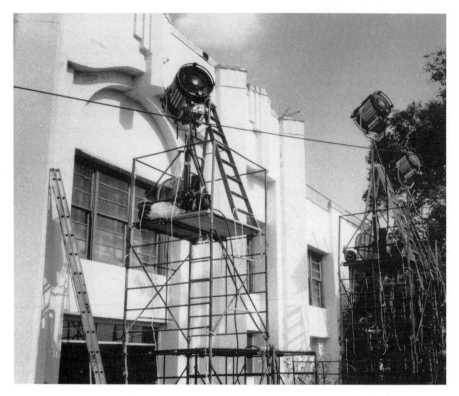

12.30 12Ks on parallels.

12.31 Parallels.

12.32 Condor crane.

with leveling legs (don't forget to order them) and wheels. Standard sections are 6 × 6-foot and are easily stackable. They should not be stacked more than three high, on wheels. For more than three sections, don't use wheels and tie off to a building or other solid support at every other level. When going more than two sections, parallels should be grouped. Don't go high with just one section When going up next to a building, use spacer pipe that extend out from the parallels and makes contact with the wall. For larger sections use outriggers for additional stability. Bag liberally and be sure to order hand rails for the top section.

When building parallels on soft ground, order plywood pads (minimum ¾ inch) to place under the wheels.

Support
Support equipment is the basic nuts and bolts of the set—stands and high-boys.

C-Stands
Century stands also known as *grip stands,* are one of the most crucial items on a set. They hold nets and flags, reflectors, position props, support small video monitors, steady hand models, elbows, and so on. It is incredible how many get used on even the simplest of shots.

C-stands are different from light stands in two ways.
1. They don't have wheels.
2. They always have at least one *high leg* The purpose of the high leg is to provide a support for the sand bag which will put the full weight of the bag on the stand, not on the floor. Always put the bag on the high leg. Also, always put the extended arm out over the high leg.

Highboys
Highboys are maxi-stands. They carry the loads that are too heavy or un-

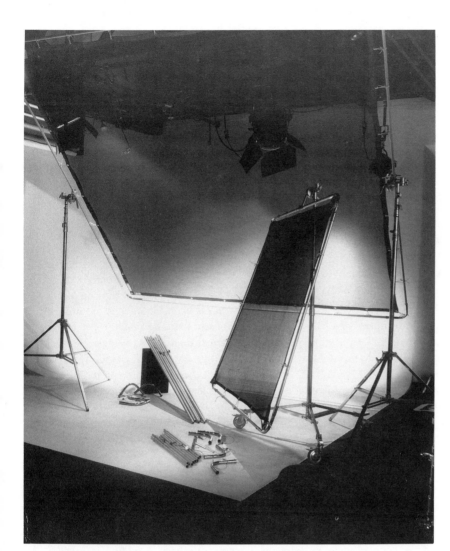

12.35 Highboys supporting a 12′ x 12′ net and a single highboy holding a 6′ x 6′ net.

12.33 C-stand supporting a beadboard bounce. A 1K pigeon is taped to the back of the beadboard, grabbing it from the side would rip the board and punching something through would put a stray reflection in glassware, etc. This double arm arrangement allows for full mobility in all axes.

12.34 Highboy.

12.36 Using a short arm to support a snoot box.

wieldy for C-stands, light stands, and combo stands. For example, overheads are always flown from highboys.

In addition, highboys extend much further than any other type of stand. A high-high roller will go up to 18 feet 6 inches. This facility can be enormously useful. Although at this height it won't carry heavy loads, it can loft an HMI PAR high enough to get in the second story window of an ordinary house. This can provide shafts of sunlight in a matter of minutes where the normal method of building scaffolding and mounting 6Ks would take hours.

Highboys terminate in a *combo head* which is a 4 ½-inch jumbo grip head

(holes for ⅜ inch and ⅝ inch) and a junior receiver on the side. They can be either permanently mounted or separate units, in which case they have a junior stud mount on the bottom.

Combo Stand

Combo stands are both a grip and an electric item. Also known as *reflector stands*, they are heavier and sturdier than a 2K stand and they don't have wheels. Designed to hold reflectors, which are subject to more wind force than a light, they make a solid base for a variety of items. One good trick is to use a combo stand with a 4 ½-inch grip head as a heavy duty grip stand, espe-

cially for windy exteriors. They also come with a rocky mountain leg (adjustable leveling) that makes them especially handy outdoors.

Stud Adaptor

Also known as a *frisco pin*, this adapts a 2K receiver to hold a light with a ⅝ inch receiver.

Apple Boxes

full = 12 × 8 × 20-inch

half = 12 × 4 × 20-inch

¼ = 12 × 2 × 20-inch

⅛ = 12 × 1 × 20-inch (usually called a pancake)

Matthews has Basso blocks, which are basically open-sided half-apples and quarter-apples. They stack more compactly and will do most of the jobs of the full boxes.

An apple box lying down on its broadside is at its lowest position called #1. When it is up on its side it is #2, and on its end for highest position is #3.

Sandbags

Sandbags are simple deadweight. They are canvas or plasticized canvas bags filled with lead shot, sand or kitty litter. They are made of two compartments which make it convenient to drape them over a leg or wrap around a stand. They always have a strap handle and often a steel ring for hanging off a nail or for running a rope through. Butterfly bags have their handle running from edge-to-edge, which means that the two compartments separate and lift easily off a stand leg. Sandbags come in 15, 25, 35 and 50-pound sizes.

Proper Bagging Procedure

On a C-stand, always put the bag on the highest leg so its full weight is on the stand, not on the ground. On a light stand, wrap it around the center post just above the leg so its weight is centered. For heavy bagging (on highboys supporting a 20-by for example), put one or more bags on each leg, as far out as possible.

12.37 Sandbag.

12.38 Step-up.

12.39 Wedge.

On wheeled light stands that have no locks, bags can be draped over the wheels to lock the light in place. This keeps the light from becoming unfocused by a kick.

Step-Up Blocks

Also called *stair blocks*, they are deceptively simple in concept, just three pieces of 2 × 4-inch nailed together, they are remarkably handy for raising, propping, and wedging.

Wedges and Shingles

Wedges are invaluable for leveling and stabilizing. A box is absolutely essential if any sort of rigging or laying of dolly track is planned. Shingles are ordinary household siding shingles and are much thinner than regular wedges. They are used primarily for laying dolly track where there are small variations in the floor level and where wedges would be too large.

Expendables
Black Wrap

Black wrap is black anodized heavy aluminum foil. It is used as foldable, crushable flags, cutters, light spill blockers and as a heat reflector. Don't use black wrap tight against a flag to prevent it from burning; because it is black it collects heat and will burn the flag. Also, don't wrap a light so completely that the cooling ventilation is blocked off.

Bailing Wire

Bailing wire is indispensable for safeties on barndoors, snoots, and other items rigged in the air.

Beadboard

Beadboard is formed from polystyrene beads. Originally used as housing insulation, it is favored as a bounce material for the soft, diffuse quality of its bounce light. Some beadboard comes backed in silver foil, which creates a hard bounce side. Beadboard cannot take much heat and a PAR or mighty placed too close will melt it.

Dulling Spray

Dulling spray is a matte finish that is used to tone down reflective surfaces to reduce flares and glares. Dulling spray washes off easily. A good trick for applying dulling spray to very small objects is to spray some on a cotton swab and then apply it.

Duvetyne

Duvetyne is solid black cloth that has been sprayed with fire retardant. It is the material that flags and cutters are made of; it comes in rolls 48" wide. Duvetyne is essential for blacking out windows, controlling large light spills and other miscellaneous uses.

Foamcore

Foamcore is a graphic arts material that is used as bounce board, building snoots and teasers, and hundreds of other uses. It is ³⁄₁₆", ¼" or ½" and comes in either white on both sides, or black on one side and white on the other. Black and white is very useful for general purpose duty, the white side can be a reflector and the black side will work as negative fill, teasers, etc. It is rigid, self-supporting and easily cut.

G-Tape, Paper Tape

Gaffer tape is sometimes called duct tape, but the two are different. The secret of gaffer tape is that it is on a base of good quality cloth. This gives the adhesive something to adhere to so a higher level of "stick" is possible. Two-inch gray is the most commonly used, but it comes in many colors. One-inch white is called camera tape. Don't leave gaffer tape on lights or stands for long periods, as it will leave them sticky. Don't use gaffer or camera tape to hold a used roll of gel together. Use paper tape instead—it won't leave the sticky residue.

Paper tape is what we call masking tape. One-inch and 2-inch black is important on any set. Although multi-purposed, it has three fundamental uses. Paper tape used on hot lights, or applied directly to the barn doors, won't melt and burn. For this reason, gaffer tape should never be used for this purpose. Paper tape is also used for taping off the camera mattebox to catch little flares that can't be reached with flags or the french flag, and for covering shiny surfaces that are creating a hot spot or flare in the lens.

For uses that will appear in the frame it is important to have photo-black tape which has a very dull matte finish that eliminates all glares and reflections.

Grip Chain

Grip chain is called sash chain in the hardware store. It is a lightweight chain used for securing stands to platforms, safetying pipe, and dozens of other uses.

Magic Tape

Scotch brand Magic tape can be used to splice two pieces of gel together. It will make a clean invisible splice (important for gel that will appear on camera, such as neutral density windows.) Two-inch transparent *J-lar* tape, which is highly heat resistant, is also used for splicing gel together.

Sash Cord

Sash cord is the basic rope that we use on the set. Two sizes are used, #8 and #10 (the heavier line). Sash is used for

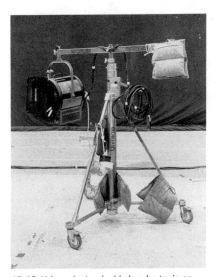

12.40 Using a junior double header to rig an offset baby 5K.

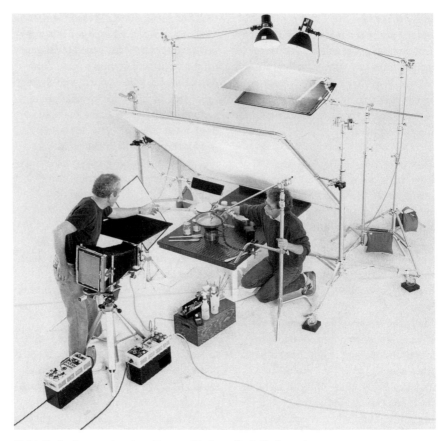

12.41 Rigging for a product shot. (Courtesy Matthews Studio Equipment)

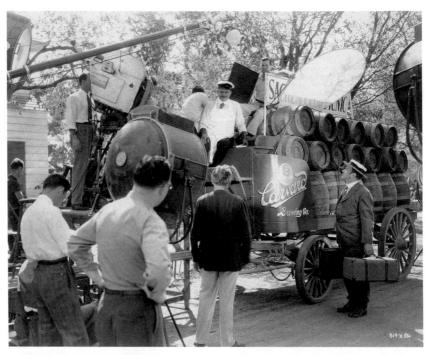

12.42 Gripping in 30's Hollywood.

tieing off silks, safety lines and rigging of every type and scope. For heavier jobs such as rigging block and tackle, regular hemp rope is used.

Show Card

Show card is a graphics arts board, about $\frac{1}{16}$-inch thick, 32 × 40 inches, black on one side and white on the other. The fact that it is not as rigid as foamcore is an advantage. It can be coved (curved) for a more directional bounce, cut up for cookies, used to custom build dots and fingers and taped, stapled and glued to just about anything. It is heat resistant enough to be used as a barndoor extension when the regular barndoors don't cut enough.

Streaks 'N Tips

Streaks 'N Tips is a brand name hair coloring. It is the only product that can be sprayed onto operating practical bulbs and will not melt off. It can tone down a practical that is too hot in the frame. Do not spray it on a hot bulb; let the bulb cool first. It comes in a variety of colors, but black, white and brown are the most commonly used on the set.

Trick Line

Trick line is much lighter than sash cord—about twice as heavy as shoe laces. It is used for safety lines on lightweight items, tieing up cable bundles and other small jobs.

Visqueen

Visqueen is heavy duty plastic (.006 mil) used to cover equipment and sets when it rains.

Clothespins

Ordinary household clothespins are probably the most indispensible item on a set. They are the only practical means of attaching gel and diffusion to hot lights. They also serve as mini-clamps for show card and as tiny wedges. They are also known as C-47s and #2 wood clamps.

13. Video Lighting

The differences between lighting for film and video are not as great as sometimes imagined. All of what we have discussed about basic lighting applies equally to film and video.

There are several differences between film and video as imaging mediums, the most fundamental of which is the ability to handle contrast. While film negative can handle ranges of seven to eight stops (128:1, 256:1) and even more, most video systems cannot reproduce more than five stops (32:1).

The second difference is separation in the shadows and highlights. Video has trouble seeing detail in the shadows, and large areas of darkness will usually translate to murkiness. Overall, film has a smoother transition in both the shoulder and knee of the D-Log E curve.

Depending on the type of video tube used, highlights can cause comet-tailing, streaking, blooming, and bleeding. Peaking out (signal areas greater than 100%) can introduce video noise.

This does not mean that less is more. In fact, a video picture that is very low in contrast can be a problem as well. This is due to what is called *DC restoration.* The DC component of a video signal regulates relative brightness in the scene in relation to the blanking level. Without good DC restoration, a scene that does not have a full range of brightness levels will "drift" towards medium gray. For example, a scene that has lots of dark shadows but no maximum white will tend to "pull-up" the dark tones. Since there is little detail in the shadows, the result will be a mushy gray. This indicates an important consideration for video lighting—every scene should include some very dark and some very light areas.

Taken all together these considerations lead us to three simple rules for lighting video:

- Accommodate lighting ratio to the video limits.
- Avoid areas of extreme overexposure (hot spots).
- Include reference black and reference white in every scene.

The Video Engineer

Between the video camera and the video tape recorder there is an important link—the video engineer. She is the chief technician responsible for making sure all equipment is properly set up and operating. She monitors the signal and constantly checks on the quality of the recording. On larger jobs she will be assisted by an assistant engineer and a tape operator. The video engineer's tools include the waveform monitor, the vectorscope, and the paintbox.

The Waveform Monitor

While video lighting is fundamentally the same as film lighting it is important to accommodate its limitations. The key instrument in accomplishing this goal is the waveform monitor.

The waveform monitor is the light meter of video. You must learn to use it for video as you learn to use meters in lighting for film.

The waveform monitor is basically an oscilloscope that displays the video signal. Using the waveform monitor as

a technical and creative tool depends on an understanding of the video signal.

Let's review the basics. The video picture is formed by a scanning beam of electrons. When the scanning beam reaches the edge of the screen, it goes blank (turns off) and flies back to the opposite edge where it starts across again. This continues for 262½ lines, followed by the longer vertical blanking interval, during which the scan returns to the top left of the screen and begins again, this time in the spaces in between the scan lines it just did.

This is not a new frame however; it is the same frame again. Each frame is painted twice, and each half is called a field. The reason for this two-field system (which is called *interlaced video*) is that if a scan line painted a frame for 525 lines from top left to bottom right there would be too long a time lag between the beginning and the end. The screen would appear to be dark in the upper left while the lower right was being painted. It would be similar to a film projected at 12 frames a second—not fast enough to establish the illusion.

Each of these fields is scanned in 1/60 of second, making a frame 1/30 of a second.

On a waveform monitor, the screen is divided into 140 IEEE (Institute of Electrical and Electronic Engineers) units (also called IRE units; it was formerly the Institute of Radio Engineers). A video signal ranges from 0 to 100 IEE units. The actual minimum black level is 7.5 IEE units, while maximum white is 100 units. During the blanking interval (the time when the scan line is moving back across the screen) the signal goes to 0 units, which is important in keeping it invisible as it moves back to the other side of the screen.

The sync pulse, which is a trigger that signals the beam to begin to move back across, actually dips below 0, to -40 IEE units. These blanking and sync pulses occur outside the picture area, in the so-called overscan areas.

The waveform monitor is a trace of one scan line of the picture (in actuality

13.1 Each video field consists of 262½ scan lines.

13.2 Waveform monitor display.

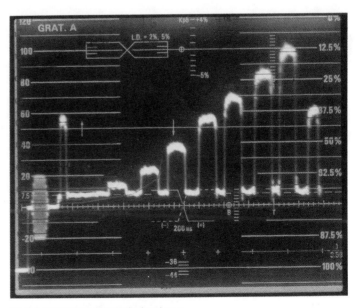

13.3 A typical step chart as displayed on a waveform monitor. (Reprinted courtesy of Eastman Kodak.)

Table 13.1 Zone system/
IEE Units

Zone	IEE Units
I	Below 7.5 IEE
II	15 IEE
III	20 IEE
IV	40 IEE
V	55 IEE
VI	80 IEE
VII	100 IEE
VIII	120 IEE

most waveform monitors can display all 525 lines, but for clarity we will discuss single-line display). As this single trace moves across the screen it records the relative brightness of the picture information. It is exactly the same as a series of spot meter readings across the set from left to right in a straight line. Totally black areas in the picture will show up on the monitor as 7.5 units. Bright areas will record as 90 or 100 units or more. Where the picture exceeds 100 IEE units, the video signal is overloaded. Video engineers will always try to keep the signal well under 100 units.

To return to the zone system as discussed in the chapter on exposure, we can relate specific signal levels in IEE units to specific zones. See Table 13.1.

The waveform monitor is an invaluable tool in lighting a scene. It can be used to set the overall brightness level, the contrast ratios, the iris setting, and to watch for any hot spots. The pitfall is in being a slave to it. As a general rule, the lighting of the scene must accommodate the parameters of video. Don't forget that your creative instincts may sometimes conflict with these rules; in that case you must use your judgment

and the video monitor. Remember that even in video what you see is not always what you get. Scenes that look good on the studio reference monitor may still not process well on down the line if Ultimatte or other effects are planned.

The Vector Scope
The waveform monitor tells us little about the color content and balance of a scene—for that we need a vectorscope. The color signal of video is defined by two basic elements, hue and saturation, displayed by a vector scope in a circular display. Hue is represented by degrees of rotations from the reference point and saturation is represented by distance from the center of the circle.

For most NTSC vectorscopes 0° is at 3 o'clock. The six basic colors are positioned as follows:

magenta, 61°
red, 104°
yellow, 167°
green, 241°
cyan, 284°
blue, 347°

Square brackets mark the position of each pure hue on the face of the vectorscope. These act as targets when setting up with color bars.

Iris Control
Video cameras vary in sensitivity, but in general, run around 100 to 125 ASA. This translates to a light level of 200 footcandles to achieve an f/4. Control of the iris (f/stop setting of the lens) may selectively be at the camera or at the video engineer's station. Like film, it determines the overall exposure of the scene. Because highlight areas are so much more problematical than shadow areas, the general practice in videography is to set the exposure for the highlights and deal with the shadows in another way. Many video lenses are not marked for f/stops and so reading with a light meter would be irrelevant in any case.

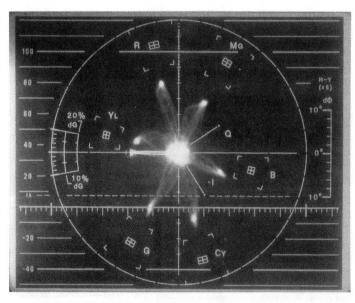

13.4 The vectorscope displays color distribution in the scene. (Reprinted courtesy of Eastman Kodak.)

As a rule, face tones are set at about 80% of peak brightness. If there is a bright white object in the scene (for example, a white shirt) which is registering on the waveform monitor at 120%, the video engineer would be forced to close down the iris in order to keep the shirt under 100%. This would also lower the level of the face 20 units, which would make it appear darker than normal. Since we are assuming that the face is important, not the shirt, this would be unacceptable. The shirt has to be dealt with somehow, and here there is no difference between film and video; the tricks are the same. We can set a net to keep light off the shirt, change the shirt to a darker one, soak the shirt in tea to tone it down, or add a little light to the face.

Electronic Pushing

Another factor that affects overall exposure is electronic pushing. This is the electronic equivalent of forced development for film. It raises the sensitivity of the tube, allowing the camera to form an image at a lower exposure level. The boost is rated in decibels (db) and each 6-db boost is the equivalent of one stop. As with film, there is a penalty to pay. In this case it is increased electronic noise in the picture, not unlike the increased grain in pushed film.

The Paintbox

We have already met the waveform monitor; now the paintbox deserves an introduction. The paintbox is an electronic control with which the video engineer can alter pedestal, color balance, overall scene gamma, and the gamma and intensity of each component color.

Pedestal is another term for the black level, which, normally set at 7.5 IEE units, can be altered. Raising the pedestal is similar to flashing the film. It increases the average overall brightness of the image without raising the peak of the signal; that is, it affects the dark and mid-tones more than the highlights. It is similar in effect to turning up the

brightness level on a monitor. *Stretching the blacks* is a method of showing more detail in the shadow area without affecting the pedestal.

White Balance

As with film, video must be balanced to the overall color temperature of the lighting. This is achieved electronically by white balancing. A relatively quick and simple process, white balancing is necessary only at the beginning of the day or when a major change occurs in the lighting, such as going from indoors to exterior, or using a different setup with color gel on the lights.

White balancing can be accomplished either automatically by the camera itself or manually by the video engineer. In either case it consists of focusing the camera on a white or neutral gray target (such as a white showcard) and either pushing the auto white balance button or manually adjusting the paint controls. Many advanced cameras have the ability to memorize more than one white balance which can then be selected later. Most also include some preset balances such as tungsten lighting and daylight which can be selected when there is no time for a white balance.

The key concept to remember when white balancing is to know what your reference is. Let's consider two situations.

1. You are shooting in a remote location that has very low voltage. The tungsten lights are burning very yellow as a result of the voltage drop. You want to be sure you get good clean color.

2. You have lit a set for late afternoon. The lights have all been gelled with 1/2 85 and the "sunlight" coming through the window has full 85 and No-Color Straw to simulate golden hour.

Your response would be different for each of these situations. In the case of the low voltage, you want to get rid of the yellow in the lights. In this case you

would expose the white card with the yellow light from the set lighting units. White balancing would then *remove* the yellow, just like a filter or color timing at the lab would remove unwanted color.

In the second case, the color is an effect that you want. If you exposed the white card to the light with the CTO or No-Color Straw gel, the white balance would remove the color and negate the effect you are trying to build. In this case it is necessary to have a neutral light available to white balance. It should be a light without any gel added, straight 3,200K or 5,500K, depending on the type of lights you are using.

Transferring Film to Video: Compression

The question is often asked, "If all television programs and commercials and nearly all motion pictures eventually end up on video anyway, why not just accept the limitations and shoot them on video to begin with?" The answer is that even if the final product is the same, how you get there is important—just as an Ansel Adams photograph of Yosemite taken with an 8 × 10 camera will be fundamentally different from a tourist shot of the same subject taken with a 35mm autofocus camera. The fact that both end up as 8 × 10 enlargements does not negate the fact that the intermediate steps are key determinants of picture quality.

While it is true that the telecine and video recording of a film transfer is limited by the same 30:1 contrast ratio as video originated material, the key factor is compression—the compression that takes place up in the toe and shoulder of the H & D curve when we take the original shot on film negative. While the live scene may have a contrast ratio that even exceeds 128:1, the highlights are not reproduced at a 1:1 equivalence when it is recorded on film. Because they fall in the shoulder of the film curve they are compacted. There is still separation from one area of tone to the

next higher area, but the difference is not as extreme as it was in real life.

No matter how bright an object is in real life it can only reach D-max. It can't be any more dense than the film emulsion maximum. All this means that while the film may still exceed the limits of the video, it is a lot closer than was the live scene. The video transfer benefits from this intermediate step.

Lighting for Multiple Camera

Video image quality has a generally bad reputation in regard to film. Part of this is due to limited brightness range and resolution and part of it is due to historically poor lighting. The bad reputation of video lighting is based on two historical factors:

1. Video is frequently the lower cost alternative. A production company that is saving money by shooting video is unlikely to splurge on the lighting crew, equipment, and time.

2. Video production is often multi-camera shooting.

Lighting for multi-camera, whether video or film, almost always involves compromises. What looks great from one viewpoint is often a disaster from another position. With some care and skill, however, it can be almost as good as single camera lighting. There are two basic approaches.

1. Find lighting solutions that work as well as possible for all camera positions. This often involves broad sources and a more general lighting.

2. Use dimmers to alter the lighting balance as the *take* shifts from camera to camera. In practice, this approach is most often applied to multi-camera film shoots for television. For example, the sitcom "Cheers" is shot this way and is widely recognized as a well done lighting job.

"Cheers" may work well this way because, even though there is a good deal of movement, the actors often work highly localized positions, which makes it possible to tailor the lighting for certain actors in these positions.

For a more generalized situation, an X approach is often used. For each position, there is a front left and front right unit and a back left and back right unit. This means that no matter what the camera position and the actor's direction, there is a light that can act as a key, one that can be a fill and one or more that can be a backlight or kicker. The dimmer operator is in control of the balances and which lights serve what purpose for each shot. It takes a good crew and a thorough rehearsal, but it can work well.

14. Image Control

The art of lighting is similar to the art of image making—it takes far more than just plugging in a few lights to create the visual image. It is essential to understand the entire process from start to finish in order to fully utilize all parts of the system. In this chapter we will look at how methods of image control other than lighting play a part in the process and what the gaffer and cinematographer must understand in order to integrate the entire image-making system.

Filters

First of all, let's remember what it is that makes a filter a filter. A blue filter appears blue because it allows most of the blue light to pass through, but absorbs other colors.

Filters in B and W
Contrast Filters

This characteristic of transmitting some colors and absorbing others makes color filters valuable in controlling black and white images. Most scenes contain a variety of colors, and to a certain extent scenes are *color coded* according to image content. In other words, the sky may be the only blue area in an image, a field of grass may be the only green element in a scene.

For a more subtle example, let's assume we are to shoot a scene that consists of brownish stone cliffs in full sunlight while on the other side of the scene are cliffs in shadow. Instead of being illuminated by the orange/yellow of full sunlight, these shadowed cliffs are lit largely by skylight, which is much bluer than direct sun.

If we use a yellow filter, light reflected off the sunlit cliffs will be transmitted through the filter, while the blue light reflected off of the shadowed cliffs will be absorbed. The black and white film will "see" the much greater amount of light off the sunlit cliffs and be blinded to the blue light absorbed by the filter. The result will be a black and white image that shows the sunlit cliffs as brightly illuminated and the shadowed cliffs as much darker than they appear to the eye. We have effectively raised the contrast of the scene.

The opposite is equally true, of course—a blue filter will transmit the blue light reflected from the shadowed cliffs and absorb much of the yellow. This would lower the contrast and the film would see much more of the shadowed side. We have effectively substituted filtration for the difficult or impossible task of increasing the illumination of the shadowed cliffs with lighting.

This is the basic principle of contrast control filtration in black-and-white cinematography. A filter lightens colors in its own area of the spectrum

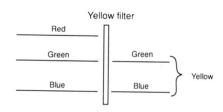

14.1 Yellow filter.

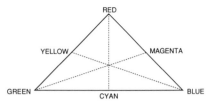

14.2 Primary and secondary colors.

and darkens the complementary colors.

How strong an effect it has is the result of two factors: how strong the color differences of the original subject are and how strong the filter is. The subject scene is, of course, the result of the colors of the objects themselves and the colors of the light that falls on them.

Keep in mind that color filters only increase or decrease contrast on black-and-white film when there is color difference in the scene. In a scene composed of only black, white, and gray objects a color filter would only reduce exposure—it would not alter the contrast.

Exposure compensation

Anytime we use a filter to absorb certain colors we are reducing the total amount of light reaching the film. We must compensate by allowing more overall exposure. The exposure compensation necessary for each filter is expressed as the *filter factor*.

Filter factors and resulting exposure compensation in stops are shown in Table 14.1.

It is important to notice that in Figure 19.3, different filter factors are given for daylight and tungsten light. This is a reminder that the effect of a color filter depends to a great extent on the color of light falling on the scene.

Notice that in the warm colors (red, orange, yellow) the daylight filter factors are greater than the tungsten filter factors. In the violet and blue range, the daylight factors are less than the tungsten, but for the cyan/green range of the spectrum the daylight and tungsten filter factors are nearly all equal. The same is true for magenta, which is equally red and blue.

Harrison and Harrison in their book, *The Mystery of Filters*, provide a simple rule for black-and-white filters: expose for the darkest subject in the scene which is substantially the same color as the filter, and let the filter take care of the highlights.

Kodak Wratten Filters

With color compensating filters (CC series), the definition of the color value of the filter is quite simple. A CC-10Y has a peak density of 10 yellow. For other filters that are not pure color (that is, not restricted to a narrow band of the spectrum), it is not as simple to affix a designation. There are many systems for naming filters; indeed there are roughly as many as there are filter manufacturers. The most widely accepted is the system used to designate Kodak Wratten filters; most other manufacturers provide an equivalence expressed in the Wratten system.

Combining Filters

In *The Negative,* Ansel Adams notes that combining contrast filters for black-and-white does not have the cumulative effect that we might expect. For example, combining a #8 and #15 filter gives the same visual effect as a #15 filter alone (although the filter factor is changed by the combination of the two). Combining two filters of dif-

Table 14.1 Filter Factors and Resulting Exposure Compensation in Stops

Filter Factor	Stop Increase	Filter Factor	Stop Increase	Filter Factor	Stop Increase
1.25	+1/3	4	+2	12	+3 2/3
1.5	+2/3	5	+2 1/3	40	+5 1/3
2	+1	6	+2 2/3	100	+6 2/3
2.5	+1 1/3	8	+3	1000	+10
3	+1 1/3	10	+3 1/3		

Table 14.2 The most commonly used Kodak Wratten gelatin filters

#	Color	Use
1A	Pale pink	Absorbs ultraviolet. Reduces excess bluishness in open shade scenes
2A	Pale yellow	Absorbs ultraviolet. Reduces atmospheric haze.
2B	Pale yellow	Absorbs ultraviolet. Stronger haze reduction than 2C.
8	Yellow	Darkens sky and shadows lit by blue skylight. Lightens foliage. Formerly known as K2. Considered to give a "normal" rendition of day scenes with pan film.
11	Yellow-green	Corrects color response of Type B panchromatic emulsions to match response of the eye to objects exposed to tungsten illumination. Formerly known as X1. Better flesh tones in portraits against sky.
12	Deep yellow	Minus blue. Haze penetration in aerial work.
15	Deep yellow	Darkens sky more dramatically than #8 or #9. Used with black-and-white infrared film. Absorbs some green. Formerly known as G.
16	Yellow-orange	Even greater correction of sky than #15. Absorbs small amount of green. Sometimes used to check blue screen backgrounds.
21	Orange	Contrast filter for blue and blue-green absorption.
23A	Light red	Contrast filter with greater green absorption than #21 or #22. Used for color separation work. Darken blue sky and sky-lit shadows producing strong contrast effects.
25	Red tricolor	For color separation work. Haze penetration in aerial work. Darken sky and sky-lit shadows. Formerly known as A.
29	Deep red	Deep red tricolor. Maximum contrast with landscape situations. Formerly known as F.
34A	Violet	For minus-green and plus-blue separation.
44A	Light blue-green	Minus-red. (#12 is minus-blue and #32 is minus-green). Used with panchromatic emulsion, simulates the effect of an orthochromatic film, emphasizing blue and green.
47	Blue	Lightens the sky and darkens green foliage and reds. Exaggerates atmospheric effects. Formerly known as C5.
47B	Deep blue	Color separation blue. Used with #25 (red) and #58 (green). Used for polaroid check of blue screen illumination.
58	Green	Separation tricolor green. Produces very light foliage.

(Reprinted Courtesy Eastman Kodak Co.)

Table 14.3 Exposure compensation for Panchromatic films

#	Name	Stop loss Daylight	Stop loss Tungsten
1A	UV	-	-
2A	Haze	-	-
6	Yellow 1	2/3	2/3
8	Yellow 2	1	2/3
11	Green 1	2	1-2/3
12	Yellow	1	2/3
13	Green 2	2-1/3	2
15	Deep yellow	1-2/3	1
16	Orange	1-2/3	1-2/3
21	Orange	2-1/3	2
23A	Light red	2-2/3	1-2/3
25A	Red 1	3	2-2/3
29	Dark red	4-1/3	2
47	Dark blue	2-1/3	3
47B	Dark blue	3	4
58	Dark green	3	3

ferent groups is seldom necessary, since there is almost always a single filter that will accomplish the same effect.

Polarizers

Natural light vibrates in all directions around its path of travel. A polarizer transmits the light that is vibrating in one direction only. Polarizers are extremely versatile filters and serve a variety of functions.

Glare on a polished surface or on a glass window is, to a certain extent, polarized as it is reflected. By rotating a polarizer to eliminate that particular direction of polarization, we can reduce or eliminate the glare and surface reflection. Brewster's angle, 56° from normal, or 34° from the surface, is the zone of maximum polarization.

In copy work or in product photography with reflective surfaces, the lighting units can be polarized with

14.3 Polarization angles.

polascreens, and then a polarizer on the lens can be used to dial in the desired amount of reflection. As with glare on water and windows, it is seldom desirable to eliminate all reflections as this creates an unnatural effect.

The polarizer can be used with color film to darken the sky. Maximum polarization occurs at about 90° from the sun. This works well for static shots, but care must be taken if a pan or tilt is called for as the degree of polarization may change as the camera moves. If the sky is overcast, the polarizer won't help much.

Polarizers carry a heavy penalty in terms of light loss, generally at least 1-2/3 to 2 stops as a filter factor. The filter factor does *not* change as you rotate the polarizer.

Neutral Density

Neutral density (ND) filters are used to reduce overall exposure without affecting color rendition. They can be used in extremely high-illumination situations (such as a sunlit snow scene or a beach scene), where the exposure would be too great or where reduced exposure is desired to crush depth of field.

Table 14.4 Neutral density filters

Neutral density	Percent transmission	Filter factor	Exposure increase
.1	80	1 1/4	1/3
.2	63	1 1/2	2/3
.3	50	2	1
.4	40	2 1/2	1 1/3
.5	32	3	1 2/3
.6	25	4	2
.7	20	5	2 1/3
.8	16	6	2 2/3
.9	13	8	3
1.0	10	10	3 1/3
2.0	1	100	6 2/3
3.0	.1	1000	10
4.0	.01	10000	13 1/3

Neutral density filters combined with 85 correction filters (85N3, 85N6 and 85N9) are a standard order with any camera package for exterior work.

Also known as Wratten #96, the opacity of ND filters is given in density units so that .3 equals one stop, .6 equals two stops, and .9 equals three stops.

In gelatin filters, NDs are available in .1 increments (one-third a stop). If you combine ND filters, the density values are *added*. If you are using the arithmetic exposure factors, don't forget to *multiply* the exposure factor.

Film Manipulation
Flashing

Flashing film, both before and after exposure, is a method of reducing contrast or adding a color cast to the film. It gives the film a uniform exposure to light either in the camera or at the lab.

Flashing of the film has a seemingly mystical reputation that is undeserved; it's actually a quite simple process. Recall that exposure of film is simply a matter of allowing enough light to fall on the emulsion to produce a proportional chemical change. If the scene is underexposed (or the shadows too dark), the silver halide crystals don't get

Table 14.5 Filter sizes

Series size	US	Metric	Adaptation range
IV	13/16"	22 mm	14.2 mm to 23 mm
V	1-3/16"	30 mm	23.4 mm to 34.6 mm
VI	1-5/8"	41 mm	34.8 mm to 44 mm
VII	2"	51 mm	44.4 mm to 55 mm
VIII	2-1/2"	63.5 mm	55.2 mm to 65.7 mm
IX	3-1/4"	82.5 mm	66.7 mm to 85.2 mm
X	4 1/2"	115 mm	
XI	5 7/16"	138 mm	

Table 14.6 Square/rectangular filters

Series	Inches	Millimeters
Series 5	2 x 2	50 x 50
Series 6	3 x 3	76 x 76
Series 7	4 x 4	102 x 102
Series 8	4 x 5.65	102 x 143
Series 8 1/2	6.6 x 6.6	167 x 167
Series 9	6 x 4	152 x 102

Table 14.7

Zones	I	II	III	IV	V	VI	VII	VIII	IX
Exposure Units	1	2	4	8	16	32	64	128	256

Table 14.8

Zones	I	II	III	IV	V	VI	VII	VIII	IX
Exposure Units	1	2	4	8	16	32	64	128	256
Added Exposure	2	2	2	2	2	2	2	2	2
Total Exposure	3	4	6	10	18	34	68	130	258

enough light to create the proper chemical change, particularly in the shadows. Flashing is a way of "jump starting" the shadow areas to bring them up to a more suitable relationship with the highlights.

The most logical question to ask about flashing is, "If we are exposing the film to uniform light, aren't we pre-exposing the highlight areas in exactly the same way as the shadows?" Good question, but the answer is no.

Remember that exposure is basically geometric. One stop (and hence, one zone) more exposure is *twice* as much light. Table 14.7 shows the exposure units for a basic nine-zone exposure.

Now say we are going to expose the film to a uniform Zone II: 2 units of exposure.

The effect is intuitively obvious. We have made a substantial difference in the lower zones (Table 14.8). For example, we have raised Zone II an entire stop of exposure, making it a Zone III, but at the other end of the scale, the effect is negligible. The difference between 256 units of exposure and 258 units would not be detectable even with scientific instruments. We have effectively reduced the contrast range of the negative.

Overdone flashing can lead to a veiling effect or a false tonality. The mere suggestion of exposing valuable, undeveloped footage to light is enough to give some producers and directors apoplexy and may be useful in getting them to approve an additional lighting order as an alternative.

The problem with preflashing is that there is no uniform terminology or method among motion picture labs. If you plan to preflash or postflash a film, extensive discussion with the lab and testing beforehand is essential. The most common method is to specify a density above base density plus fog (the basic density of unexposed film).

Varicon

There is an alternative to flashing that does the same job but more predictably and in a more controlled manner.

Devices are available that work by flashing the image, rather than the film. Both devices place optical glass in front of the lens (partially silvered mirror in one and clear in the other) and introduce a limited and controlled amount of veiling glare on the glass. This has the same effect as flashing the film.

The Arriflex Varicon represents a real advance over the bulky Lightflex, which formerly did the job. A simple device that mounts on the matte box rods, the Varicon is compact and simple to use. In design it is a clear glass plate that sits in front of the lens, with eight 6-volt halogen bulbs around the edge of the glass. The unit is powered by two 12-volt batteries or by a 12-volt AC/DC power supply, which is recommended for any lengthy use, as the Varicon eats up batteries very quickly.

The bulbs inject light into the optical

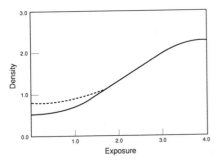

14.4 Exposure modified by Varicon.

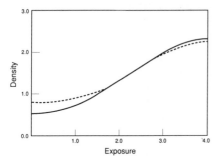

14.5 Exposure modified by low contrast filter.

14.6 The Arriflex Varicon. (Courtesy Arriflex.)

flat (which is called the emitter plate) and it glows evenly. It adds light to the image in amounts small enough that they affect only the low-exposure areas. It works in exactly the same way as pre- or postflashing, except that it flashes the film at the same time that the image is being recorded.

Adjustment of contrast reduction is by means of a simple mechanical handle on top of the unit. The dimming is mechanical so that there is no color change, and the effect is visible in the viewfinder.

Using the Varicon has two distinct advantages over using low-contrast (LC) filters. The first is that it decreases contrast without degrading the image.

It does not produce halations and double images that are common around bright sources when seen through LC filters. The second advantage is that the Varicon affects only the low exposure areas of the image in normal use.

These systems, as well as flashing, can be used to introduce an overall tone to the image, which is more visible in the shadows and therefore perhaps more subtle than an overall tone from a color filter.

In color work, it is possible to selectively color the shadow areas without affecting the highlights. For example, the shadow areas can be warmed while a blue sky would remain unaffected. Using a warming filter would, of course, affect the entire image.

Varicon has advantages over flashing as well. Flashing can be somewhat unpredictable and cannot be viewed at the time of shooting. No cameraman in the world can rest easy as his *exposed* footage, representing days of work and hundreds of thousands of dollars, is taken out of the can and purposely exposed to light. With Varicon, the effect can be viewed through the lens and can be adjusted from shot to shot and even during the shot. Other filters can be used at the same time as the Varicon.

Degree of flashing is controlled mechanically, but the unit has a meter that registers the amount of light reaching the emitter plate. The meter is marked in f/stops from f/1.4 to f/11. With the unit are cards for various film ASAs. The cards are calibrated in terms of equivalence to low-contrast filters, which are effects that should be familiar to most camera people.

To use the charts you first select the ASA you are using, for example, ASA 100. You then read the f/stop at the lens (example, f/2.8). Then find the row corresponding to the low-contrast effect that you want, say LC 1. Read across to the column for the lens f/stop. Immediately underneath is the correct setting for the Varicon. In our example the result would be f/4. You then adjust the handle till the Varicon meter reads f/4

and you have a contrast reduction of LC 1.

For low-light situations you can put neutral density material in the gel holders, and for very bright situations you can use two emitter plates (the second one is standard with the rig).

Caution is needed when using the unit as it does become hot enough to burn and will certainly melt the gel and use up the batteries if left on for long periods of time. Turn it off whenever possible. The Varicon is currently shipped with a small gel pack including some combination gels from Rosco.

Other Methods

Value Control: Set Design and Painting

Never shrink from any aspect of image control. Remember that set and costume design, the painting of the set, location selection, time of day, and even placement of the action are all part of making the image. It is your responsibility to diplomatically input where you feel it will be useful.

Scrims and Smoke

Not all *diffusion filters* are fitted directly on the lens. Theatrical scrim and bobbinet are sometimes used to create an atmospheric haze, reduce contrast, and create a sense of distance. They can be placed at any depth in the set. For example, a white scrim placed behind the main action will make the background seem distant and hazy.

Smoke can serve the same purpose in addition to its more direct content functions. It serves as a diffusion for the lights and as a diffusion for the image reaching the lens, reducing contrast.

Video: Adjusting the Gamma

For projects finished on video there is an enormous range of image control available, from simple adjustments of the gamma to complex Paintbox, Harry, and DaVinci image manipulations. For adjusting gamma and enlarging the image, it is generally best to do so at the time of transfer.

Prints: Low-Contrast Print for Transfer

It is difficult to shoot film that will look good in projection and also transfer well to video. One solution is to have the film printed on special low-contrast print stock before transferring. Consultation with the lab and with the person who will do the video transfer is essential.

Dealing with the Lab

In shooting film, a gray card is usually shot at the beginning of each roll (or at each change in lighting set-up) to give the timer guidance for the exposure and color balance of the scene. The idea behind this is that the timer may not know what you are trying to do. If the scene is lit dark and shadowy for a dramatic purpose, the timer has no way of knowing that it is not merely underexposed. She may compensate by making the print light and bland.

The same applies to color. You may have bathed the scene in intense blue, for example, and the timer can only assume that he must take all the blue out to make the color balance normal. The ideal set-up for shooting a gray card is to place it so that the scene behind it is still visible, and light the gray scale to the same exposure as you have lit the scene. This way the timer knows what the scene is supposed to look like.

Additive Color Control

Printer timing values are usually given on a scale of 0 to 50 for each of the color layers, normally in the sequence, red-green-blue (RGB). These numbers represent the color of light in the printer, *not* the effect on the print. In color negative, each color controls the amount of the complementary color in the final print. Increasing blue will make the print more yellow.

Because of this reverse effect, some labs list printer values in the complementary colors: yellow-magenta-cyan (YMC).

For timing color prints from color negatives the changes in value are

Printer value	Print value
+ B	more yellow
- B	less yellow
+ G	more magenta
- G	less magenta
+ R	more cyan
- R	less cyan
+ BG	more red
+ GR	more blue
+ RB	more green

Image Control in Video Transfer

Video systems are inherently less able to handle as wide a range of contrast as photographic emulsion. This is primarily an issue when film is transferred to video. Theatrical print densities range from around 0.10 to 2.80, which in projection results in a brightness range of 50:1 to 100:1. A video monitor cannot generally exceed a brightness range of about 20:1. Video signals that exceed this range will produce images with unbalanced gray scale reproduction and a great deal of electronic noise.

All this means that some accommodation must be made for the limitations of video. There are three basic methods:
- Limit the contrast ratio of the original scene.
- Make a print from the original negative on low-contrast print stock for transfer to video.
- Make adjustments on the video controls of the telecine machine.

Of these methods the first is the safest, particularly when film is being shot solely for transfer to video, an extremely common situation. Shoot on film, finish on video is the most widely accepted method for obtaining high-quality images for commercials, industrials, and other types of nontheatrical film.

For theatrical features, a compromise must be struck. For most films today, a great portion of their income is from the film's life on video: rental, television, and cable. On the other hand, powerful cinematography has become important to a film's success in the theatrical circuit. Here the most widely accepted solution is to light the film for theatrical projection and then make a print on low-contrast print stock that compresses the brightness range sufficiently for a successful video transfer.

Another part of this process is for the cinematographer to supervise the video transfer just as he has traditionally supervised the timing of the print. The video transfer is an important part of the production of the final image. Although there are many talented and sensitive colorists (as video transfer operators are known), the video transfer is a part of the creative process of filmmaking. If the final vision of the cinematographer is to be realized, then being present at the transfer is imperative. In many cases cinematographers have insisted that it be included in their contracts. Many a brilliantly shot film has been utterly ruined by insensitive producers who make cut-rate deals on the transfer. Many cinematographers have fought to ensure that sufficient time is allowed for a quality transfer. In the case of *Empire of the Sun*, Allen Daviau spent three weeks creating the video version of the film.

Running Film Tests

A proper film test is the most effective way of isolating the variables of a new emulsion and understanding what you can do with it. Traditionally, a human face is used for the film and video tests.

The model should wear black, which will give good contrast against the white background. The other way around would lose the model against black and

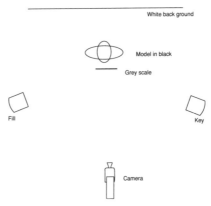

14.7 Film test set-up.

we would be tempted to add hair lights and backlights that would confuse the issue. Always include a gray scale and a color chart in the scene for reference.

The first part of the test is key/fill balance ratios. Although you may want to try others, the standard is to shoot with the fill 1, 2, 3, and 4 stops lower than the key.

The next part of the test is over- and underexposure. Start with correct exposure according to the meter, using your own favorite metering technique. Then go in a half-stop increments to three stops overexposed and three stops underexposed. Slate the steps carefully and make sure your camera notes are complete.

At this point you will want to consult with your timer or video colorist. Whether in film or video, you will want two prints. One should be a *one-light* print, set for a normal print on the basis of the correct first exposure of the gray scale. In this print you will see the effect of over- and underexposure under nominal conditions and on a nominal print.

In the second print, the timer or colorist will attempt to make a normal print from the negative. From this you will learn how far you can go and still be saved by the timer, and will learn how over and underexposure affect the negative's ability to give the result you want. The printer's numbers on this part of the test will be particularly instructive and will assist you in future communications with the timer.

If you are viewing the results in a screening room be sure to ask the projectionist to check the screen brightness, which should be 16-foot lamberts at the center. Any professional projectionist will be equipped to make this measurement, but if you need to check it yourself you can do so with an ordinary light meter.

Set the meter at ASA 100 and 1/50 of a second. The projector should be running, but with no film in the gate. See Table 14.9.

Table 14.9 Projection screen illumination

F/stop	EV	Footlamberts
F/1.5	EV7	4
F/2.2	EV8	8
F/2.5	EV8.5	10
F/2.8	EV 8.75	12
F/3.2	EV9	16
F/4.8	EV10	32

15. Technical Issues

As more high-tech equipment becomes available, lighting becomes more complex. A solid grounding in the theory and practice of using tools for lighting is essential to not only complete the day successfully, but also to avoid disaster in the screening room.

In this chapter we will examine these issues and review basic operating techniques associated with them.

Shooting with HMIs

Shooting with HMIs (as well as fluorescents and other AC powered nontungsten lights) always presents the danger of *flicker*. Flicker appears on film as a rhythmic change in exposure. It is caused by uneven exposure from frame to frame as a result of a mismatch in the output waveform of the light and the framing rate of the camera. Flicker can be serious enough to render an entire shooting unusable.

To understand the reason for flicker, we must look at how an HMI generates light. Except for brute arcs and studio

situations in which tungsten lamps are run on DC, most filming situations utilize alternating current. The fundamental nature of alternating current is, of course, that it alternates. The output of an AC generator varies constantly as a sine wave. When the current flow is at the maximum (top of the peak) or minimum (bottom of the trough), the output of the light will be maximum. The light doesn't care whether the flow is positive or negative. At the moment when the sine wave crosses the axis, however, the current flow is zero. At that instant the

15.1 AC power cycle.

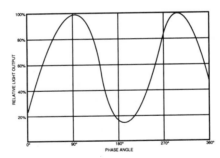

15.2 HMI light modulation.

With 60 hertz A.C. and a camera exposure of 1/24th of a second, each frame "sees" five light pulses

When the camera speed is not stabilized, each frame sees a slightly different number of pulses, which creates unequal exposure

15.3 Synchronization of exposure with HMIs.

electron flow is static—the light can generate no output. Since the light is on for both the positive and negative side of the sine wave, it reaches its maximum at twice the rate of the AC: 120 cycles per second (cps) for 60-Hz current and 100 cps for 50-Hz current.

This applies to any source powered by AC, but with tungsten filament lamps the result is negligible because the tungsten stays glowing hot even when the current is momentarily zero. There is some loss of output, but it is minimal, usually only about 10% to 20%.

With enclosed arc lamps (HMIs as well as CSI and CID lamps which are not commonly used in video or film production in the U.S.) the variation is greater. For an HMI with a standard reactance ballast, the minimum output may be as low as 17% of total output. At first glance it would seem that we might just average the maximum and minimum output (58%) and take this as the total average output of the light.

In a crude sort of way this is exactly what does happen. In film, however, there is another complication. The shutter is opening and closing at a rate which may be different than the rate at that the light output is fluctuating.

As illustrated in Figure 15.3, when the relationship of the shutter and the light output varies in relation to each other, each film frame sees different amounts of the cycle. The result is unequal exposure. This problem can occur in three ways:

1. The frame rate of the camera varies unevenly.
2. The frequency of the electrical supply varies unevenly.
3. The frame rate of the shutter creates a mismatch in the synchronization of the shutter and the light output.

The first two are intuitively obvious. If either the shutter rate or the light output is random, it is clear that there will be different amounts of exposure for each frame. The third is a bit more complex. Through experimentation, engineers have found that only certain combinations of shutter speed and power supply frequency can be considered acceptably safe. Deviations from these combinations always embody the risk of noticeable flicker.

The danger of HMI flicker will always be greatest when there are no other non-flicker sources (tungsten, DC arcs, daylight) and when all HMIs are being run on the same electrical phase. The risk will be reduced by combining other sources or by powering the HMIs on all three electrical phases. None of these, however, completely eliminates the risk of at least a small amount of noticeable exposure variation.

To prevent flicker four conditions are absolutely essential:
1. constant frequency in the AC power supply
2. constant framing rate in the camera
3. compatible shutter angle
4. compatible frame rate

In practice the first two conditions are met with either crystal controls on the generator and camera or by running one or both of them from the local AC mains, which in most countries are considered reliable in frequency.

The shutter angle and frame rate are determined by consulting the accompanying charts. The relationship of AC frequency to shutter is generally only crucial in high-speed cinematography and is usually not a factor in most filming situations.

At 24 fps camera speed, if a stable power supply is assured, shutter angle can be varied from 90° to 200° with relatively little risk. Theoretically, the ideal shutter angle is 144° since this results in an exposure time of 1/60th of a second and thus matches the frequency of the power supply. In practice, there is little risk in using a 180° shutter if the camera is crystal controlled and the power supply is regulated. At 144°, the camera is exposing 2 1/2 pulses per frame (rather than the exactly 2 pulses per frame as you would get with 144°) and so exposure can theoretically vary by as much as 9%.

Table 15.1 Safe Frame Rates for Any Shutter Angle

60 Hertz FPS	50 Hertz FPS
120.000	100.000
60.000	50.000
40.000	33.333
30.00	25.000
24.000	20.000
20.000	16.666
17.143	14.285
15.000	12.500
13.333	11.111
12.000	10.000
10.909	9.090
10.000	8.333
9.231	7.692
8.571	7.142
8.000	6.666
7.500	6.250
7.508	5.882
6.666	5.555
6.315	5.263
6.000	5.000
5.714	7.461
5.454	4.545
5.217	4.347
5.000	4.166
4.800	4.000
4.000	3.333
3.750	3.125
3.000	2.500
2.500	2.000
2.000	1.250
1.875	1.000
1.500	
1.000	

Table 15.2 Safe Frame Rates for Specific Shutter Angles

60 Hertz		50 Hertz			
FPS	Shutter	FPS	Shutter		
71.667	215	59.722	215		
70.000	210	58.333	210		
66.667	200	55.556	200		
65.000	195	54.167	195		
63.333	190	52.778	190		
57.600	172.8	48.000	172.8		
56.667	170	47.222	170		
55.000	165	45.833	165		
53.333	160	44.444	160		
50.000	150	41.667	150		
48.000	144	40.000	144		
46.667	140	38.889	140		
45.000	135	37.500	135		
43.333	130	36.111	130		
36.667	110	30.556	110		
35.000	105	210	29.167	105	
33.333	100	200	27.778	100	
26.667	80	160	24.000	86.4	172.8
25.000	75	150	22.222	80	160



60 Hertz FPS	Shutter	Shutter 2	50 Hertz FPS	Shutter	Shutter 2
35.000	105	210	29.167	105	
33.333	100	200	27.778	100	
26.667	80	160	24.000	86.4	172.8
25.000	75	150	22.222	80	160

Table 15.5

Power supply	Fluctuation cycle
60 Hz +/- 0.0025	200 seconds
60 Hz +/- 0.005	100 seconds
60 Hz +/- 0.01	50 seconds
60 Hz +/- 0.02	25 seconds
60 Hz +/- 0.05	10 seconds

Table 15.3 60 Hertz Any shutter angle

120
60
40
30
24
20
15
12
10
8
6
5
4
2
1

Table 15.4 50 Hertz Any shutter angle

100
50
25
20
10
5
4
2
1

The ideal shutter angle for shooting at 24 fps with 50Hz per supply is 172.8°.

Tables 15.1 and 15.2 list the acceptable safe frame rates for shooting at any shutter angle (with either 50Hz or 60Hz electrical supplies) and the acceptable safe frame rates for specific shutter speeds.

A simplified series is shown in Table 15.3.

A simple way to think about it is to divide 120 by a whole number, e.g.

$$120/4 = 30, 120/8 = 15.$$

For 50 Hz power systems, divide 100 by a whole number. This results in the simplified series are shown Table15.4.

The Power Supply

Any variation in the frequency of the power supply will result in an exposure fluctuation of approximately .4 f/stop. The time for one cycle of fluctuation to occur will depend on how far off is the power supply. (See table 15.5.)

When working with a generator it is essential that it be crystal controlled. Governor controls are never sufficient for the accuracy demanded. Even with a crystal controlled generator, a frequency meter should be used and constantly monitored. As a general rule, plus or minus one-quarter of a cycle is considered acceptable.

Flicker-Free HMIs

The newest generation of HMIs use flicker-free ballasts, which minimize the danger of exposure fluctuation.

Flicker-free units use electronic ballasts instead of the older iron-core reac-

Square wave

1 Cycle

15.4 The square AC wave reduces the time when output is less than maximum.

tance ballasts. They utilize two basic principles:

- square-wave output
- high frequency

Square wave ballasts operate by modifying the waveform of the power supply. They *square* it so that instead of the normal sinusoidal pattern, the output is angular. The result is that the rising and falling sections of the wave occupy a much smaller portion of the total. As a result the light output is off for a much shorter time. This method is used in most battery-powered HMI sunguns and as a result, flicker is seldom a problem with them.

The other method is increased frequency. The operating principle is that with 200 or 250 cycles per second there

is less likelihood of a mismatch from frame to frame. The major disadvantage of this method is an increase in the noise level of the light. Some flicker-free units are switchable from normal to flicker-free operation. Flicker-free units are now available in every size of HMI, including the largest units.

Some caution is required when using flicker-free ballasts. Because they convert the normal sine-wave of AC current to a series of sharp peaks, the load on different phases does not cancel out. This means that you cannot balance the load in the normal manner: whatever comes out on the hot legs goes back on the neutral. For this reason, it is essential that you use an oversize neutral when running large loads at near capacity. Because it is not a normal sinewave, the load can only be read with a true root mean square (RMS) amp meter, such as the Fluke 87 with a clamp-on accessory.

Flicker-free ballasts made by Lightmaker have the advantage of being able to run on either AC or DC; they are also less susceptible to variation in frequency and can operate effectively from 47 to 63 Hertz on AC. They will generally fire on from 100 to 132 volts. They have a color temperature adjustment which will vary the output roughly plus or minus 500K.

Because they generate less firing voltage, flicker-free ballasts may sometimes fail to fire heads that are not well maintained or that have the ignitor box spark gap set improperly. With properly maintained heads, there should be no problem.

Filming Practical Monitors

First, a word of caution: because a monitor is a scanned image, most spot meters *do not* give accurate readings of video monitors. They tend to underestimate the luminance, often by a stop or more. Calibrate your own meter with tests and check with Polaroid.

Working monitors or televisions in a scene will exhibit a disturbing *roll bar* unless precautions are taken to prevent

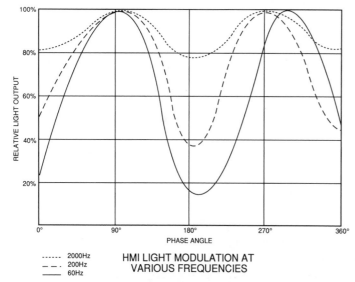

HMI LIGHT MODULATION AT
VARIOUS FREQUENCIES

······ 2000Hz
— —. 200Hz
—— 60Hz

15.5 HMI light modulation at various frequencies.

it. The solution will depend on the nature of the monitor and the requirements of the scene being filmed.

The source video falls into one of three categories:

1. NTSC (the U.S. video standard), PAL(European video), or SECAM (Eastern Europe) video from broadcast television, cable, or prerecorded videotape on the set
2. A computer monitor, graphics workstation, video game or other nonstandard CRT display
3. Specially prepared 24 fps video signal

The final output can be one of four types:

1. Film shot to be transferred directly to videotape, either with or without sync sound
2. Film shot for theatrical projection at 24 fps without sync sound
3. Film shot for theatrical projection with sync sound
4. Film that will be edited as a film workprint using conventional postproduction methods and then transferred to video. While film editors and video transfer houses can accommodate film shot at nonstandard frame rates (even with lip-sync dialogue) the inconvenience may prove undesirable in certain circumstances.

NTSC video (the American broadcast standard for all television and video recording) is based on a 3.58 Mhz subcarrier that results in a frame rate of 29.97. Thus each video field is on for approximately 1/60 of a second (actually 1/59.94). The frame rate of a motion picture camera with a 180° shutter is 1/48 of a second. It is the discrepancy between these two frame rates that results in the roll bar effect.

Unfortunately, it is impossible to lock a roll bar off the screen at the standard 24 fps camera speed. There are several methods available to achieve the desired result.

Transfer of Film Directly to Video

This is the simplest condition in which to work. Use crystal control to run the camera at 29.97 fps at 180° shutter. This method works only with a shutter angle of 180° or more and works for both MOS and sync sound filming.

Theatrical Projection

For theatrical projection that must be shot at sound sync speed (24 fps), use a 144° shutter and crystal controlled camera at 23.976 fps. This works because a 144° shutter equals 1/60 of a second exposure, which approximates the video exposure time.

The roll bar will still be visible but can be minimized and can be locked in place on the screen.

There is a one-third stop loss in closing down to 144°, which must be compensated in your exposure calculations.

Of course, this is only possible when using cameras that have adjustable shutters. Always inform the rental house when you are going to be dealing with practical monitors so that they can ensure that all equipment is compatible.

Theatrical Projection for Synch Sound

If the filming is without sync sound, shooting can be at 29.97 fps with 180° shutter or at 23.976 with 144° shutter.

At 29.97, there will be noticeable slowing of the action when projected at 24 fps. If this is not acceptable, the 23.976 fps method should be used. If the film is to be transferred to video, either method may be used, but be sure to slate the film clearly and log the variation onto the camera reports so that the video transfer house will know how to deal with it.

Video Conversion

There is an alternative that eliminates all problems associated with this type of filming. Many video houses and location video operators are capable of transferring the video source material to 24 fps video, which may then be filmed at normal camera speeds without roll bar. This must be used in conjunction with a camera capable of supplying a framing pulse as output.

Filming Nonstandard CRTs

CRTs other than standard video, such as computer screens or video games, have widely varying frame rates. In many cases it is necessary to determine the frame rate either from the manufacturer's specifications, with a frequency checker or by observing the image through the viewfinder or gate while varying the frame rate of the camera with a crystal speed control.

The most reliable method is to take a portion of the video signal and use it to drive the camera. This is accomplished with a synchronizer unit.

Shooting Video of Computer Monitors

Videography of computer monitors can be just as difficult as filming them. Because computer monitor frame rates usually differ from standard NTSC video the screen will seem to flicker, which may be unacceptable for some applications. In practice, it may be necessary to alter the scan rate of the computer monitor to conform to video standard.

Synchronizers are available that will alter the scan rate of some monitors. For MS-DOS computers, software patches can be used to adjust the scan rates. As a last resort, it is possible to replace the video tube in the monitor with a similar tube that has long persistent phosphors. If the decay rate of the phosphor is longer than the scan rate, the flicker will be eliminated, but some smearing of the image may result.

When shooting computer monitors, two pieces of information are essential, the *filming scan rate* of the monitor and the *shutter ratio* of the camera.

Shutter Ratio

Shutter ratio is the relationship between the shutter angle (also known as exposure angle) of the camera and the reflex viewing mirror. For example, in a camera such as the Arri BL2, both the shutter and the mirror are 180°. 180/180 = 1. This makes the shutter ratio 1. If the shutter is 144° and the mirror is 180°, the ratio is 144/180 = 0.8.

When the shutter ratio is one, the image in the eyepiece exactly matches what reaches the film. When the shutter ratio is not one, there will be a slight mismatch between what is shown in the eyepiece and what exposes the film. Since the eyepiece sees the image slightly longer (180° versus 144° in our example), the eyepiece will see some areas of the monitor as overexposed, because they are double scanned during the time the mirror is in position. Because of the reduced shutter, the film exposure will be correct.

Filming Scan Rate

The filming scan rate is half the rate at which the computer scans. A monitor with a scan rate of 59.94 will have a filming scan rate of 29.97. Most computers have a filming scan rate between 27 Hz and 32 Hz.

Filming Speed

Filming speed (in frames per second) is determined by multiplying *shutter ratio* by *filming scan rate*.

fps = shutter ratio × filming scan rate

For example, if the shutter ratio is one, then the filming speed will be the same as the filming scan rate:

Table 15.6 Shutter ratios for commonly available cameras

Camera	Exposure angle	Mirror angle	Shutter ratio	Minimum
Aaton 7 LTR	180	180	1	1.0
Aaton LTR 54	180	180	1	1.0
Aaton XTR	180	180	1	1.0
Arriflex 16SR 1 and HS	180*	180	1	1.5
Arriflex 16SR 2 and HS	180*	180	1	1.5
Arriflex 35-3	Adjustable	180	-	2.0
Arriflex 35 BL 1 and BL 2	180	180	1	1.5
Arriflex 35 BL 3 and BL 4	Adjustable	180	-	1.0
Cinema Products GSMO	180*	180	1	5.0
Mitchell with Fries Motor	Focal Pl	-	-	10.0
Panaflex (10° increments)	Adjustable 180	-	6.0	

(Courtesy Cinematography Electronics)

* CAUTION: Some cameras of these models with 144° shutters and 180° mirrors do exist.

shutter angle	180°
mirror angle	180°
filming scan rate	31.25

Therefore:

Shutter ratio = 1.

Filming speed (fps) = 31.25 × 1 = 31.25

For a shutter ratio other than 1:

shutter angle	144°
mirror angle	180°
filming scan rate	31.25

Therefore:

shutter ratio = 144/180 = 0.8

and filming speed is

31.25 × 0.8 = 32.05

If the scan rate of the monitor is not known, and no measuring equipment is available to check it, it will be necessary to find the correct speed by trial and error. Start at 30 fps and adjust the speed control by one-frame increments until the scan line is slowed down. Then adjust by 0.1 increments to further reduce rolling and so on until the bar is stationary. Differences of .001 fps may take a minute to show movement. Obviously, this part of the process is done without film.

Once the speed has been determined, you can load film, start the camera, and observe the roll bar. Pushing the phase button will roll the bar off the screen. This process must be repeated every time the camera is started.

Working With Specific Equipment
Panavision

There are two different devices made by Panavision:

1. The Field-to-Frame Synchronizer. This device "slaves" the camera motor to a composite video source (it will not work with a radio frequency [RF] signal) and automatically phases the roll bar off the screen when the phasing button is depressed. The red light will turn green when the phasing is complete. The Field-to-Frame Synchronizer is designed to work when there is a difference between the camera speed and the video frame rate. Therefore, it is necessary to set the camera speed control to a slightly different frame rate, such as 29.3. The frame rate should be slower than the video rate but very close to it.

2. The Video/Film Synchronizer (VFS) also uses the composite video signal to drive the camera. In conjunction with a 144° shutter on the camera, the VFS will drive the camera motor at 23.976. The unit also has a *line position* adjust which allows the operator to change the position of the roll bar on the screen, which must be done with the camera running. The green light indicates that sync has been achieved.

Other Cameras
Cinematography Electronics manufactures three units that are suitable to syncing cameras to video:

HMI and TV Crystal Control. Has crystal control at the following speeds: 7.5, 15, 23.976, 24, 29.97, 30, 40, 60, and 120 fps. The roll bar is phased by flipping the switch from "TV" to "24" and back while observing the monitor through the camera viewfinder. For sound recording, a sync cable may be run from the unit to the recorder.

Precision Speed Control. This unit is not limited to a preset range of speeds and is thus useful in a wider range of situations, such as with computer monitors. It offers crystal-locked speed control to three decimal places and a range from 1 to 50 fps. It is compatible with Arriflex BL 3 and 4, 35-3, and SR cameras. It has a phase button to adjust the position of the roll bar. To use it with nonstandard and unknown video frame rates, observe the monitor through the viewfinder with the camera running and adjust the camera speed

until the roll bar freezes. Then use the phase button to adjust its position.

The *Cine Check,* from the same company, is a device that reads and displays the frame rate of a video monitor. It is, however, a four-digit display and will usually be only a rough guide.

Film/Video Synchronizing Control. Also made by Cinematography Electronics, this unit includes a signal pickup that is attached to the side of the video monitor to sense its frame rate. Its speed range is 8 to 65 fps and it is compatible with the Arriflex BL 3 & 4, 35-3, the SR, Panavision, and Aaton cameras. It includes automatic phasing.

There are five switches that must be set before using this unit:

1. Function Select Switch.
 - Projector/Camera position is for 1:1 filming conditions, to lock a camera to a projected image, or to lock two camera shutters together.
 - Computer/Video position is for filming standard NTSC, PAL monitors, or computer terminals.
 - 2 Field-Comp/Video position is for filming double video or computer fields when required. The film speed will be half of what is achieved in the computer/video (one field) position but with twice the resolution and brightness on film.
2. Phase Thumbwheel Knob. For adjusting the phase relationship between the camera shutter and the source. After initial phasing, the same phase relationship will be achieved each time the camera is started.
3. 144/180 Shutter Switch. Must be set to match the camera shutter angle. The unit will automatically adjust the camera speed to compensate for the change. To maintain automatic phasing, the power and the source input must not be interrupted.
4. 75 Ohm Switch. For terminating the BNC coax input. "On" switches the

75 ohms in. "Off" switches the 75 ohm load off. The 75-ohm termination will only affect the video monitor.

5. 26/60 Audio 25/50 Switch. Controls the pilot-tone frequency at the audio connector. When in the 24/60 position, the output will be proportional to the ratio of 24:60 (1:2.5) or 25:50 (1:2). Output voltage is 2 volts, peak to peak.

Filming speed is determined automatically by the combination of scan rate or speed of source and the setting of the 144/180 shutter switch. When the camera is turned on, the red Search LED will light. As synchronization is achieved, the Search LED will go out and the green Sync LED will light, indicating that the camera and source are locked.

Moviecam Super. As an integral part of the Moviecam system, the variable speed module allows for a full range of crystal speed control.

Lighting for Process Photography
Chroma Key

Chroma key, also known as *blue screen* or *process* photography, is a method of producing mattes for compositing. The

Chroma key floor lighting

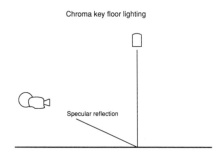

Specular reflection

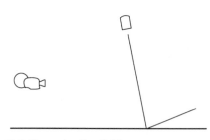

15.6 Chroma key floor lighting.

blue background is generally made of a translucent blue or green backing back-lit by either PAR-40 bulbs evenly spaced or flicker-free blue fluorescent lamps. A few basic principles apply in lighting for blue screen:

- The background lighting must be uniform.
- Variations in the background surface must be eliminated with fill light.
- The foreground subject should be as far away from the background as is practicable to prevent blue light from splashing back onto the subject.
- Incident light level at the background should match incident light level at the subject.
- Use a polarizer to eliminate floor glare.

Although blue and green are widely used colors, any color can be used. The only requirement is that it be a color that is not present in the foreground subject.

Ultimatte

Ultimatte is a sophisticated form of chroma key video developed by Peter Vlahos.

According to *Ultimatte Technical Bulletin #3*, "There are several reasons why it may be advantageous to shoot Ultimatte foregrounds on film rather than video. The most obvious advantage is the possibility of non-realtime photography. Film currently offers greater flexibility than video for high-speed slow-motion photography or stop motion, animation, and motion control photography."

As with chroma key, blue and green are the most widely used colors, but any color that is different from the foreground object may be used.

Other recommendations:

- Do not use 16mm.
- Use a pin-registered camera such as Panaflex, Arri BL, Arri III, or Mitchell.
- Use the lowest grain film possible. Grain introduces noise into the image.
- Do not use diffusion over the lens. Do not use heavy smoke effects.

- Always shoot a gray scale lit with neutral light (3,200K or 5,500K) at the beginning of each roll. Shoot the gray scale (or chip chart for video) in a place where they will not be contaminated by splashback from the background or floor.
- Whenever possible use a polarizing filter to eliminate specular glare.
- With a video camera avoid shooting with the lens wide open. The reason for this is that many video camera lenses "vignette" very slightly when wide open, which can create problems with the mat.
- In video, never compensate for low-light levels by boosting the gain. Never push film.
- The video camera should be color balanced for the foreground subject.
- To match the depth of focus of the foreground, shoot the background plate with the focus set at where it would be if the foreground object was actually there.
- Carefully plan the screen direction and perspective of the background plates. It is essential that it match the foreground. Take note, for example, that there is a slight difference in perspective between a 1/2-inch video tube and a 2/3-inch camera. Consult

Table 15.7

Tangent of 1/2 Angle of View = 1/2 Image Size/Focal Length					
Lens Angle of View = 2 x ARC TANGENT (Image Size/(2 x Focal Length)					
Format	1/2″	2/3″	1″	1 1/4″	35mm film · 16mm film
			IMAGE SIZE		
Width	6.4 mm	8.8 mm	12.8 mm	17.1 mm	22.05 mm · 10.3 mm
Height	4.8 mm	6.6 mm	9.6 mm	12.8 mm	16.03 mm · 7.5 mm
ANGLE			FOCAL LENGTH (mm)		
52°	6.6	9.0	13.1	17.5	22.6 · 10.6
40°	8.8	12.1	17.6	23.5	30.3 · 14.1
30°	11.9	16.4	23.9	31.9	41.0 · 19.22
20°	18.1	25.0	36.3	40.5	62.5 · 29.2
15°	24.3	33.4	48.6	64.9	83.7 · 39.1
5°	73.3	100.8	146.6	195.8	252.5 · 118.0
3°	122.2	168.0	244.4	326.5	421.0 · 196.7

To convert a 1/2″ video focal length to its equivalent 2/3″ focal length, multiply by 1.375.
To convert a 2/3″ video focal length to its equivalent 1/2″ focal length, multiply by 0.727.
The equivalent focal lengths of any two formats are directly proportional to the respective image widths.

Table 15.7 for shooting plates in two different formats.

Lighting

Ideal exposure levels for Ultimatte would theoretically be those that give you the greatest difference between the density of the blue layer and the densities of the green and red layers. With a blue background lit with blue light separately from the foreground subject, it is possible to achieve RGB levels of 80 to 90 IRE units of blue with less than 10 units of green or red. "Theoretically this is a signal an Ultimatte should love. The problem is that the noise in the Rank [telecine] when the blue channel has 90 units is so much greater than when the blue channel is 60 units. It turns out that reducing the exposure level of the backing results in a quieter final composite event though the Ultimatte has to do more amplification of the matte signal it creates." (*Ultimatte Technical Bulletin #3.*)

Optimal exposure levels depend on the nature of the subject and the set-up. Ultimatte needs at least 30 IRE units of separation between the background color (blue or green) and the higher of the other two colors. Ultimatte recommends exposing the blue backing to produce 50 to 60 units of blue with a maximum of 15 or 25 units of green or red. They recommend that this can be achieved with "Gothic Ultra Blue" paint for the background and lighting it with 3,200K to the same level as the foreground subject.

This configuration permits using the same lighting for the background and the foreground subject, which has the added advantage of allowing the subject to cast shadows that will be reproduced in the final composite. This allows additional creative possibilities and makes it easier to achieve realistic effects. According to *Bulletin #3* "A 1:1 lighting ratio between the foreground subject and the backing is a safe choice, even if it is not the ideal one."

When a green background can be lit separately from the foreground, it is advisable to reduce the light on the background to one stop below the foreground. Ultimatte does not advise using blue light on a blue background, which they have found can produce certain transitional anomalies.

Set pieces (such as tables, boxes to sit on, etc) that are painted blue to give the actor something to walk behind or interact with present problems. The top of the piece will almost always be hotter than the shadow side. This will definitely cause problems with the composite. Lighting can help but it may create problems of its own. One trick is to use different blue paints for the top and sides. Ultimatte recommends "Gothic Ultra Blue" on the top surface and "Ultimatte Blue" on the shadowed surfaces. The Gothic Ultra has less luminance than the Ultimatte Blue.

Nothing will undermine the believability of a composite more than a mismatch of lighting in the foreground and background. Careful attention must be paid to recreating the look, direction, and quality of the lighting in the background plate.

Ultimatte Tips

- Guard against backsplash.
- Block off any blue screen not in use.
- Don't use a complementary color as a backlight, although this is acceptable in chroma key.
- Ask if they need to see the floor, as you will need to deal with the shadows if they do, and plan accordingly.
- Don't use diffusion.
- Don't use smoke.
- Don't include the matte color in the scene.
- Try not to have anybody lying on the floor or on a table. Sometimes a mirror on the floor will help by eliminating shadows.
- Use black-and-white Polaroid and a blue filter (47B) to check the uniformity of the background lighting and meter with spot meter and incident meter

Luminance Key

Luminance key is the same concept as chroma key except that the difference between light and dark objects is used as the key for producing a different matte. If the subject is primarily light colored, then the background and all parts of the scene that you want to become transparent (so that the composited background plate will show through) should be black. The opposite is true if the subject is predominantly dark.

Luminance key is fairly simple to create but the inherent problem is that any shadow areas in the foreground subject will become transparent to the background matte. This creates severe limitations on lighting. For a good key, the foreground objects should be about 20 to 25 IRE units above black.

Dimmers

There are a number of ways we control the intensity of light output at the unit itself:

- flood-spot
- wire scrims
- grip nets
- diffusion
- neutral density filters
- aim (spilling the beam)
- switching off bulbs in multi-bulb units (soft lights)

The alternative is to control the power input to the light with dimmers. The advantages are

- fine degree of control
- ability to control inaccessible units
- ability to quickly look at several different combinations
- ability to do *cues*
- ability to preset scene combinations
- ability to save energy and heat buildup by cooling down between takes

The disadvantages are

- lights change color as they dim
- some lights cannot be dimmed, particularly HMIs
- necessity of additional cabling
- cost

15.7 Typical dimmer set-up.

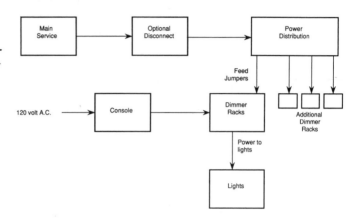

15.8 Diagram of a simple electronic dimmer system.

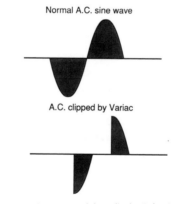

15.9 SCR dimmers work by "clipping" the AC waveform.

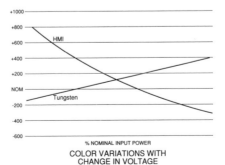

COLOR VARIATIONS WITH CHANGE IN VOLTAGE

15.10 Color variation with change In voltage.

15.11 2K variac.

15.12 Dimmer board.

The first dimmers invented were resistance units. They operate by placing a variable resistance in the power line. The excess energy is burned off as heat. Resistance dimmers are still available up to 10K, are heavy and clumsy, but cheap. The major problem with resistance dimmers is that they must be loaded to at least 80% of their capacity in order to operate. If you put a 5K on a 10K dimmer, for example, the dimmer will only reduce a small amount of the output. You won't be able to dim all the way down—a dummy load may be necessary to operate.

The next generation of dimmers were autotransformers. They operate as variable transformers and alter the voltage. They do not have to be loaded to capacity and they don't generate excess heat but they do operate only on AC. Known as *variacs* (for variable AC) they are still standard equipment, particularly in the 1K and 2K sizes.

For larger applications, silicon-controlled rectifiers are used. Known as *SCRs*, these are electronic devices that are small in size, quiet, and relatively low-cost. They can be controlled remotely by dimmer boards, which means that the dimmer packs can be near the lights. This saves cabling, since only a small control cable needs to run from the board to the dimmer packs. The remote cable carries a control voltage of 0 to 10 volts and can be run up to 200 feet. The signal is multiplex and can run up to 192 dimmers.

SCR dimmers do not alter the voltage. They work by *clipping* the waveform so that the voltage is heating the filament for a shorter period of time. The result is that the output of this type of dimmer cannot be read with an ordinary voltage meter. Only a VOM that reads root mean square voltage (RMS), such as the high-end Fluke meters, will work—there must be a load to read the output. The shorter rise time can sometimes cause filament sing and create RF (radio frequency) and AF (audio frequency) noise. The RF interference can be transmitted back along the powerline and cause problems, particularly for unbalanced high-impedance type sound systems. In most cases, with properly grounded audio systems, there should be no problem, but a portable radio can be used to test.

When using an SCR dimmer with a generator, the genny must be frequency controlled—the loss of sync will cause flicker. Also, since most dimmers are voltage regulated, raising the voltage of the generator will not increase the output. An anomaly of these systems is that the neutral load can, in some cases, be higher than the hot leg.

SCR dimmers are basically theatrical equipment so their connectors will often not be compatible with the rest of your equipment. As a rule, the outputs will be theatrical three-pin connectors, either 60 amp or 100 amp. It is important to order adaptors compatible with your plugging system.

The input side of most dimmer packs are Cam-lok connectors. Frequently the neutral is reversed (male instead of female), which can cause problems with dimmer orders if you forget to order feeder cable with the neutral reversed or *turnarounds*, female-to-female connectors.

Control panels vary in sophistication. Some are simply sets of slider switches, one for each circuit; others include masters and submasters and may have sepa-

Table15.8

Type	Lamp color shift	CCT direction	Degree of shift
Incandescent / Tungsten Halogen	Orange-red	Lower	Marked
Fluorescent	Not discernible	Negligible	Negligible
Metal Halide	Blue	Higher	Drastic
Mercury	Not discernible	Negligible	Negligible

rate banks for X and Y scenes, making it possible to do a cue from one preset to another. The next level is *soft patching*, which allows for electronic routing of each line to a dimming circuit. The most sophisticated feature is computer controlled timed cues. Most control panels will run any set of dimmers.

The effect of dimming on color temperature varies with the source a is shown in Table 15.8.

Working with Strobes

There are several types of strobe lighting for cinematography, the most widely known being Unilux. The Unilux package consists of a power supply and from one to three strobe heads. Several units can be controlled together for a greater number of heads. Frame rates of up to 500 fps are possible. The strobes are fired by a pulse from the camera which signals when the shutter is open. Any camera that provides such a pulse is compatible with the system. In some cases, a pulse contact is added to a moving part of the camera and this provides the synch signal.

Strobe lighting in film is used for several reasons:

1. To light cooler (strobes produce substantially less heat than tungsten heads), which can be a tremendous advantage when shooting ice cream, for example.

2. To produce sharper images. The exposure duration for each flash can be as short as 1/100,000 of a second. As a result, the image is frozen and appears sharper than if photographed on moving film at standard exposures.

3. To provide sufficient exposure for high-speed photography with a small power input.

It is often used in spray shots of soft drink cans being opened: the strobe effect captures each droplet of spray crisply. In fact, it can be too sharp for some people. In shower scenes for shampoo commercials, the shower can appear as a series of razor sharp drops rather than a soft spray.

As a result, for beauty applications,

it is common practice to combine Unilux with tungsten lighting. In most cases, the Unilux light is balanced with an equal amount of tungsten within a range of plus or minus one stop. This presents an interesting exposure problem.

Like most strobes, Unilux is blue, about 6,000° Kelvin. When combining Unilux with other sources, appropriate filtration is required. When mixing with tungsten use an 85 to obtain 3,400K and an 85B to reach 3,200K. To maximize the Unilux, use 80A or CTB on the tungsten lights. Most people prefer to light only the moving object with strobe and the rest of the scene with tungsten.

Strobes are fan cooled and so are not useful for synch-sound shooting.

Strobe Exposure

Consider this situation: you are shooting at 96 fps and equal amounts of tungsten and strobe lights are desired. Everytime you increase the frame rate of the motion picture camera, you are decreasing the amount of time the shutter stays open—you are decreasing exposure. Ninety-six fps is four times faster than normal, therefore, the shutter speed is 1/200 of a second instead of the normal 1/50. This is an exposure loss of two stops. This is simple enough. To achieve a f/5.6, for example, you light to an f/11.

But the same is not true of the strobe lighting. The strobe is instantaneous. It fires for only a few thousandths of a second at some time while the shutter is open. As a result, it is completely independent of the frame rate. It doesn't matter whether the film is moving at six frames a second or 600, the exposure will be the same.

Here's the problem. We read the tungsten and have to compensate. We then read the Unilux with a strobe meter and we *don't* have to compensate—clearly we can't read them at the same time. How do we arrive at a setting for the lens?

The answer is intuitively obvious, but mathematically a bit complex. We read them separately and then add the two

Table 15.9 Unilux H3000 typical readings at 3' (400 ASA)

Speed	Spot				Flood			
	1 ft	2 ft	3 ft	4 ft	1 ft	2 ft	3 ft	4 ft
10-120	32	223	162	115	22	16	111	8.03
120-240	228	22	16	112	168	118	11	8.02
240-360	168	119	11	8.04	116	8.05	5.68	5.63
360-500	16	11	8.02	5.68	8.08	5.67	5.62	4.08

Table 15.10 Unilux H3000 output at 400 ASA

Max speed	Spot			Flood		
	2 ft	3 ft	4 ft	2 ft	3 ft	4 ft
120	225	169	162	163	112	8.06
130	223	166	16	161	111	8.02
150	221	163	117	119	8.08	8.0
160	168	161	115	116	8.05	5.67
200	166	119	113	113	114	5.66
210	164	117	111	112	8.01	5.63
230	161	114	8.07	8.09	5.68	5.61
240	118	111	8.05	8.06	5.65	4.08
290	117	11	8.04	8.05	5.64	4.06
320	114	8.08	8.01	8.02	5.62	4.06
340	112	8.05	5.68	8.0	4.09	4.02
360	8.09	8.02	5.66	5.67	4.06	2.89
560	8.0	5.63	4.07	4.08	2.87	2.8
580	5.68	5.61	4.05	4.06	2.85	2.08
640	5.65	4.08	4.02	4.03	2.82	2.05
650	5.62	4.05	2.89	4.0	2.09	2.02

exposures. As it turns out, adding an f/stop is not especially simple.

Let's take the simplest case first. We read the Unilux by itself (and it is very important to turn off all tungsten lights when we do this) and find that it is f/5.6. We have to balance the tungsten to that. As we know, at 96 fps, we have to set the tungsten lights for f/11, which will be f/5.6 at 96 fps.

The logical temptation might be to average them, which would result in a very incorrect exposure—therefore we must add them.

What is f/5.6 plus f/5.6? In effect we are doubling the amount of light. The tungsten is providing f/5.6 and the Unilux is supplying an entirely different illumination that is also f/5.6. Twice as much light as f/5.6 is f/8. Recall that each f/stop represents a doubling of the amount of light.

Now it gets a bit stickier. Let's say that the the Unilux is f/8 and the tungsten is f/5.6. Think of it this way: if f/8 is a base of 100%, then the tungsten light is 50% (one stop less equals one-half the amount of light). We then have 150% of the base light. One hundred fifty percent of f/8 is one-half stop hotter than f/8, f/8 and one-half.

If one of the sources is f/8 and the other is f/4, the correct exposure is f/8 and 1/4. F/4 is only 25% the amount of light of f/8, 125%.

Although a flashmeter is the preferred method (supplied by the rental), many ordinary electronic light meters can read high-speed strobes. The reason is that at 60 flashes per second, it is perceived as continuous by many meters—not really much different from fluorescents, for example.

Typical Exposures

Unilux is switchable for four intensity levels. The Unilux H3000 system is switchable to 16 speed ranges, which gives one-fourth stop level control. The levels are determined by the speeds at which the lights are flashing. Typical readings based on ASA 400 film at a subject distance of 3 feet are shown in Table 15.9.

Remember that the *flash rate is twice the camera speed because there is one flash for the shutter and one for the viewfinder.*

The lights only come up to full intensity when the camera goes to speed. If you want to take a reading, the lights must be running at speed.

Other Considerations

1. Shutter angle should be opened to the maximum.

2. Check the synchronization frequently. This is done by removing the lens and looking at the shutter with camera running and strobes operating. It is the same effect as using a timing light on a car. The shutter will appear frozen and it should appear open.

3. For reflex viewing, the strobes can be run in *split synch* mode. In this case there are two flashes for each rotation of the shutter, one for the exposure and one for the viewfinder.

4. Unilux usually comes with a technician, so don't forget to budget for this. Some types of strobes are rented without operator.

5. Unilux requires 208v–240v *3-phase* and a ground. It cannot be run through a stage box because there is no ground. Standard Unilux consumes 5 amps per light. The Unilux H3000 system requires 220-volt *single-phase* and 10 amps per light. Tie-in equipment and cables are supplied with the equipment.

6. Some cameras (such as the Photosonics Actionmaster 16) must be fitted with an additional pickup for synchronization.

Macrophotography

Regular prime lenses can seldom focus closer than nine or ten inches; zooms generally have a minimum of around two feet.

Extreme closeup photography has a set of problems all its own. The most critical aspect of macro work is the degree of magnification. A magnification of 1:1 means that the object will be reproduced on film actual size, that is, an object that is 1/2 inch in reality will produce an image on the negative (or video tube) of 1/2 inch. 1:2 will be 1/2 size, 1:3 will be 1/3 size, and so on.

In film, the 35mm academy frame is 16mm high and 22mm wide. In 1:1 reproduction a 22mm object will fill the entire frame. Most lenses of ordinary design can focus no closer than a ratio of 1:8 or 1:10.

When a small image is being spread over a large piece of film, it naturally produces less exposure. With reproduction ratios greater than 1:10, exposure compensation is necessary. The formula is

$$\text{Shooting } f/\text{stop} = \frac{f/\text{stop determined by meter}}{1 + \text{magnification ratio}}$$

Example: Meter reading is f/8. Your reproduction ratio is 1:2 or 1/2 size. The calculation is 8/(1+.5) = 5.3. See Table 15.11.

Depth-of-Field in Closeup Work

There are many misconceptions associated with macrophotography; perhaps the most basic is that wide-angle lenses have more depth-of-field. Frequently this prompts the DP who is having a depth-of-field problem to ask for a wider lens. Sorry, it doesn't help.

Depth-of-field is a function of image size, not focal length. Yes, it is true that wide-angle lenses have more depth-of-field—a look at any depth-of-field chart confirms this. The problem is that once you have put a wider lens on, you still want the same image you had before, and in order to accomplish this, you must move the camera closer to the subject. Once you do this, the depth-of-field is exactly the same as it was before, since focus distance is also an important determinant of depth-of-field.

The important aspects of closeup photography are:

- Depth-of-field decreases as magnification increases.
- Depth-of-field decreases as focus distance decreases.
- Depth-of-field is doubled by closing down the lens two stops.

Table 15.11

Magnification ratio	Exposure increase in stops
1:10	1/3
1:6	1/2
1:4	2/3
1:3	1
1:2	1 1/3
1:1.4	1 1/2
1:1.2	1 2/3
1:1	2

Closeup Tools

Extreme closeup photography can be be accomplished with a variety of tools.

Diopters

Commonly referred to as *proxars*, these are simple meniscus lenses that are placed in front of the camera lens and reduce the minimum focusing distance of the lens. The lenses are measured in diopters, which is the reciprocal of the focal length as measured in meters. A +1 diopter has a focal length of 1 meter, a + 2 is 1/2 meter, etc.. Minimum focusing distance with the lens set at infinity is determined by dividing the diopter number into 100 cm. For example, a +2 diopter is 100/2 = 50 cm. This equals 19.68 inches. You will actually be able to focus a bit closer by changing the focus of the lens itself. See Table 15.12.

Closer focusing is possible by setting the lens to its minimum focus.

Diopter recommendations include

- Use the lowest power diopter you can, combined with a longer focal length lens, if necessary.
- Stop down as much as possible.
- There is no need for exposure compensation with diopters.
- When using two diopters together, add the diopter factors and always place the highest power closest to the lens.

Extension Tubes or Bellows

The advantage of extension tubes or bellows is that they do not alter the optics at all; thus there is no degradation of the image. Extension tubes are simple rigid tubes that hold the lens farther away from the film plane than it normally sits, thus reducing the minimum focus distance.

A bellows unit is the same idea but is continuously variable with a rack and pinion. Either will give good results down to about 1:2.

Extension tubes are generally incompatible with wide-angle or zoom lenses. Lenses with larger minimum apertures generally give better results than high-speed lenses.

Optically, the best results at very high magnifications are obtained by reversing the lens (so that the back of the lens faces the subject) and mounting on a bellows unit.

The simple rule to achieve 1:1 reproduction is that the extension must equal the focal length of the lens. For 1:1 with a 50mm, for example, you would need a 50mm extension.

Macrolenses

Macrolenses are actually specially designed optics, optimized for closeup work. They are good in the 1:2 to 1:1 range. Some macros have barrel markings for magnification ratio as well as focus distance. This facilitates calculating the exposure compensation.

Close Focus Lenses

Close focus lenses differ from macros in that they are no different in design from ordinary prime lenses. For the most part, close focus lenses are primes that have had the *stop* pins removed so that the focus barrel can rotate more than a full rotation and thus focus closer than normal.

Extenders

A similar situation exists with extenders that increase focal length. When using an extender, aperture as well as focal length is increased by the power of the extender. A 2× extender used with a 25–250mm f/4 zoom yields a 50–500mm f/8 zoom. A 1.5× extender transforms the same lens into a 37.5–375mm f/6 and a 3× extender changes the lens to a 75–750mm f/12.

Table 15.12

Diopter	Millimeters	Min focus Inches (Lens at ∞)
1/4 D	4000.00	157.48
+1/2 D	2000.00	78.74
+1 D	1000.00	39.37
+1 1/2 D	666.00	26.22
2 D	500.00	19.69
3 D	333.33	13.12

Innovision

Several types of *snorkle* lenses are available that are like periscopes. They generally allow for extremely close focus and for getting the lens into incredibly small spaces. Century Precision Optics, Cine Photo Tech and other companies make some excellent units. Some units require exposure compensation and some have the compensation built in. Be sure to check which type you are using.

Innovision is a snorkle-type lens that can be fitted on both video and motion picture cameras for extreme closeup work. It has the advantage of an extremely narrow barrel, which can reach inside very small areas, even inside flowers.

The f/stop is fixed and is very high, around f/32 to f/45, depending on the application; however, a high f/stop is generally needed for extreme closeup work in any case. Innovision has its own light source, which is a small ring around the front element of the lens. It is a fiber optics rig and is remotely lit from a separate unit. It is approximately daylight balanced and can be gelled inside the power unit.

Lighting for Extreme Closeup

There are two basic considerations in lighting for extreme closeup. The first is that due to extremely small depth of field (which is inherent in close focusing), and the need to stop down for improved optical performance, very high light levels are needed. Particularly in conjunction with high-speed photography, an uncorrected stop of f/64 and higher is often called for. Since the area being lit is usually very small, there is generally no problem with this, although in dealing with large units (such as 10Ks) it can be quite a job just to get them close together and all focused on a small subject.

The other problem is caused by the lens being so close to the subject. In some cases the front of the lens may be no more than an inch away from the subject. This makes it difficult to achieve any kind of front lighting or fill, as the lens and the camera are in the way. A further difficulty is introduced when the subject is reflective. In this case no matter how much light is poured on the subject, what you will see in the reflective surface is a mirror image of the lens itself, which will appear as a large black circle.

There are two solutions. One is to cut a hole in a reflector card just large enough for the lens. Sometimes it is not even necessary for the hole to cover the entire front optic. You will find by experimenting that the actual working area is smaller and that the hole can be smaller without interfering with the image. This is a form of ring light and a number of subtleties are possible with a little imagination. Black strips of tape can put some modulation into the reflective surface, and slightly bending the card can create a pattern of highlights and shadows.

The other solution is a half silver mirror. The mirror is placed between the lens and the object and angled slightly to reflect the image of the light source onto the subject in axis with the lens. Don't forget that the mirror has an exposure factor that you can measure with a spot or incident meter.

Ring lights, which are any type of unit that fits around the lens, may be useful in lighting for extreme closeup, if they are small enough.

Underwater Filming

Water—even fresh water—acts as a filter, absorbing the red wavelengths first, on down the spectrum, until all frequencies are absorbed. This is why there is no light at all below a certain depth, which varies according to the clarity of the water.

There are several underwater lighting units available. Most of them are small-er *sungun*, battery operated units. Observe the manufacturers rated maximum depth carefully, as exceeding it may lead to an implosion and short circuit.

15.13 The SeaPAR.

SeaPARs

The SeaPar® by HydroImage is built around a 1,200-watt Sylvannia HMI par bulb, encased in a watertight container, which can withstand depths of up to 220 feet in salt water (110 pound per square inch). The fresnel is permanently bonded to the front of the bulb to reduce the amount of glass, so instead of changing lenses, it is necessary to change lights. This is made easier by the inclusion of an underwater pluggable connector that can be detached underwater. It includes an aluminum re-

tainer ring for gels and accessories and a bonded grounded return line back to the ballast, which operates above water and is equipped with a 20-amp grounded fault interrupter. A flicker-free ballast is also available.

LTM makes the AQUAPAR, which is bulkier and somewhat less sophisticaated.

Tungsten-halogen PAR 64s (1000 watt) and PAR 36s (650 watt) are also available in watertight housings. The PAR 36 can be configured for use with an underwater battery pack that can run two lights for an hour. In the tungsten units, the bulbs can be changed to alter the beam from wide-flood to narrow-spot and for daylight or tungsten balance.

Measures of Image Quality

No matter what medium we are dealing with—video, film, still photos, computer monitors—we need ways to describe their ability to reproduce an image accurately. What we subjectively call "sharpness"—whether in lenses, emulsions, or video tubes—is actually a combination of factors.

Modulation-Transfer Function

The modulation-transfer function (MTF) is a measure of an imaging system's ability to reproduce fine detail. Physically, the measurement evaluates the effect of the image of light diffusion within the emulsion. It is sometimes called the *contrast-transfer function*. Modulation is an expression of the difference between the lightest and darkest areas of a test pattern.

The film is exposed to a test pattern that consists of alternating black and white lines which become smaller and closer together. After development, the image is read with a microdensitometer. Where the lines are large and far apart, the image system will have no trouble reproducing them as completely black or white, which is a modulation factor of one (the modulation of the reproduced image exactly matches the modulation of the test target). Where the lines

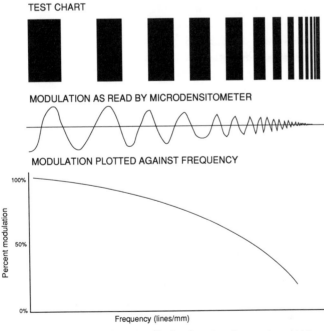

15.14 Measuring the modulation transfer function. Top: the test chart, middle: the reading of the microdensitometer; bottom: modulation plotted against spatial frequency.

are smaller and closer together, the image system will begin to blur them together until they eventually are reproduced as a uniform gray. The graph of the modulation transfer function shows the system's ability to accurately reproduce at all spatial frequencies (line pairs or cycles per millimeter).

The measurement shows the degree of loss in image contrast as the detail becomes finer (that is, a higher frequency of modulation). The rate of modulation is defined by the formula

$$M = \frac{E\ max - E\ min}{E\ max + E\ min} \qquad E\ is\ exposure$$

The result is the ratio of modulation of the developed image to the modulation of the exposing pattern.

$$\frac{Mi}{Mo}$$

The ratio is plotted on the vertical axis as a percentage of response. The spatial frequency of the patterns is plotted on the horizontal axis as cycles per millimeter.

When the detail is large, the film reproduces it accurately, as in the left hand part of the curve. As the detail is finer and the lines closer together (the right hand part of the curve) the film is less able to reproduce it accurately. For most of us, modulation-transfer functions are only useful in comparison to each other, but they can be useful in judging films, lenses, or imaging systems. The MTFs of each component of a system (lens, emulsion, print stock or lens, video tube, tape, monitor) can be multiplied to arrive at an MTF for the entire system. As we see in Figure 15.15, film still has clear superiority as a total imaging system over even high-definition television.

Effects
Rain

Rain is the province of the prop department, but it does have implications for lighting. To be visible, rain must be backlit. Frontlighting will not work

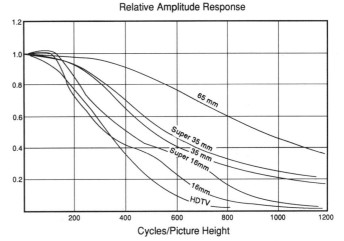

15.15 Comparison of modulation transfer functions of various mediums.

with anything but the most intense downpours, and even then the result will be anemic.

Even with the most carefully controlled rain effect, water gets everywhere. Several precautions are necessary:

- Raise all connectors, especially distribution connectors, off the ground on apple boxes. Wrap them in plastic and seal with tape. Use electrical tape as gaffers' tape won't withstand water.
- Ground everything you can.
- Put rain hats on all lights. Protect the lenses of all large lights; water on a hot lens will shatter it, with the possibility of glass flying out.
- Cover hampers and other spare equipment with heavy plastic.
- Crew members should wear insulating shoes and stand on rubber mats whenever working with hot equipment.
- Observe all electrical safety rules religiously.

Smoke

Many types of smoke are available for use on sets: incense in bee-smokers, smoke cookies, smoke powder, and oth-

ers. They have all been found to be hazardous to health except for cracker smoke. Cracker smoke is atomized oil such as baby oil, cooking oil and other types of lightweight oil. The oil is atomized by forcing compressed air or nitrogen through extremely small holes. Cracker smoke is very white, and fills an area with thick billowing smoke very quickly. The smoke has the added advantage of hanging for an extremely long time, which can be a tremendous time-saver in production. Other types of smoke required "smoking it up" before every take, followed by wafting it around, then waiting for it to settle—a laborious, boring process.

Smoke crackers are available in all sizes, from small hand carry units up to big industrial size crackers with compressors that are moved on dollies.

Fire
Fire is established by a low-key orange flickering effect. CTO can be used to warm the light and the flicker can be accomplished in a variety of ways. Silver foil, waving hands, and rotating mirror drums are used, but the simplest and most convincing effect is usually to place the source light on a dimmer and have an electrician with an "eye" operate it.

A more high-tech method is the use of a flicker generator. Two kinds are available. One is a random generator that can be programmed for various rates of random flicker. The other uses an optical sensor to read the light of a candle or fire and drives a dimmer in synch with it. This is particularly effective for scenes where the dimmer or fire is the primary source and is visible in the scene. McIntire Enterprises makes several *Magic boxes,* which can drive up to 10K dimmers and a smaller unit that directly controls up to a 2K.

Small hand-held candles or oil lamps can be executed with an inky socket and a small bulb. They can be AC powered with a wire running up the actor's sleeve or DC powered with a battery hidden on the actor's body. In a pinch,

flashlight bulbs can be used, although the socket will be a bit more difficult to rig.

TV and Projector Effects
Like fire effects, the look of a flickering TV is best accomplished with dimmers. The source, which might be a fresnel or practical bulbs in porcelain sockets with some diffusion, is usually placed in a snoot box to confine the light in a realistic pattern. In general, one half or full CTB cools the light to simulate the blue look of black-and-white television. This is a convention even though most people watch color TV, which projects a variety of colors. Here again, it is important that the person operating the effect have some sensitivity to the mood of the scene and keep it random. Actual television flickers considerably less than is usually portrayed, but the activity helps sell the effect.

Projection effects can be accomplished the same way with the addition of bouncing the light for a softer look. Film projection is bounced off a large screen, while television is a smaller direct source.

Projection can also be simulated by running actual film through a projector and aiming it at the audience. Obviously it is necessary to defocus the projector or remove the lens so the image won't appear on the faces.

Day-for-Night
With the advent of high-speed film and electronic boost for video cameras, speed lenses, high-efficiency HMIs, and sunguns, day-for-night is hardly ever done anymore. In the early days of black-and-white infrared film was used for night effects, generally in conjunction with a filter such as a Wratten #25. Traditionally, day-for-night is done around noon since long shadows would give away the fact that it is day. Of course, showing the sky is strictly forbidden.

In color (both film and video), it is possible to achieve a reasonably convincing effect by underexposing from 1

1/2 to 2 1/2 stops. Moonlight blue can be simulated by removing the 85 filter with tungsten-balanced film or white balancing the video camera for tungsten. Subtleties of color balance can be achieved with color correcting filters depending on the feel that is desired.

If reflectors are used, gold reflectors are a better choice to preserve the correct color balance. Silver reflectors without an 85 will probably be cold. Harrison and Harrison make a series of day-for-night filters. The #1 is blue-red; the blue gives the night effect while the red component helps hold the skin tones in balance. The #2 is the same color but also lowers the contrast, which can help maintain the night illusion. The #3 filter offers a greater degree of contrast control. They all have an exposure factor of 2 stops.

Moonlight Effect

As you recall from our discussion of the Purkinje effect, it is a widely accepted convention that moonlight is blue. The use of blue for moonlight is controversial and many purists insist on using no more than 1/2 CTB for the effect. More common is full CTB or double blue. Of course, these are all in addition to whatever blue is used to establish basic color balance.

Water Effects

The dapple of light reflected on water can be a beautiful and subtle effect. It can be achieved in a number of ways. Some people use broken mirrors or crumpled aluminum foil to reflect a strong directional light (usually a fresnel or a PAR). These tend to be somewhat stilted and artificial. The best effect is always achieved by actually using water. In a shallow pan with

15.16 Lightning machine.

a black backing (black visqueen or a garbage bag is effective) water itself can be highly reflective if you use a strong enough unit. Sometimes it is useful to float a sheet of silvered mylar to increase the bounce.

Lightning

Because lightning must be extremely powerful to be effective, it generally calls for a specially built rig. Most lightning rigs are based on carbon arc technology. They consist of an arc ballast and a set of carbons, which can be pushed together, then rapidly withdrawn with a levered handle. The resulting arc produces a powerful and momentary blast of light that is very convincing.

A brute arc can be used by reversing the polarity of the DC so that it is "wrong" and then throwing the striking lever. The carbons will produce a brief, powerful arc but won't strike because the polarity is wrong. Understandably, these effects can be very hard on a generator, so be sure you have plenty of headroom before attempting these effects.

Sometimes flashbulb rigs are used for the effect. M-type flashbulbs, which have a long burn time, are most effective for this purpose. Regular flashbulbs fire very quickly, and they might burn while the shutter is closed.

Glossary

Abby Singer shot The Abby Singer shot is the next-to-last shot of the day. The martini shot is the last shot before camera wrap is called.

Accent light A special unit that emphasizes one subject. Can be a key, a kicker, or backlight.

Ambient light General room light. Non-directional.

Aperture A variable opening inside the lens that regulates the amount of light reaching the image plane. Also known as the iris.

Apple box A box solidly built of 3/4-inch plywood. A full apple is 12 × 8 × 20-inch. A half apple is 12 × 4 × 20-inch, a quarter apple is 12 × 2 × 20-inch, and an eighth apple is 12 × 1 × 20-inch. The term *eighth apple* is hardly ever used; it is usually called a *pancake*. If an apple box is lying down on its lowest dimension, it is a *#1 apple* (or half-apple); if its on its second largest dimension, it is a *#2 apple*, if its on end, it is a *#3 apple*.

Arc Unit that generates light from the electrical arc between two carbon electrodes.

ASA The rated speed of film, from the old American Standards Association. Now technically known as ISO (International Standards Organization) or EI (Exposure Index).

Baby (1)Anything with a 5/8-inch stud; i.e., baby plate. (2)A 1K light. (3) Any light smaller than the standard model: baby 1K, baby 2K, baby 5K, etc..

Baby legs Short tripod.

Baby plate A steel plate with a baby pin welded on. Used for mounting lights or grip heads on a wall, an apple box, etc.. Has holes for nails or screws in the steel plate.

Backlight Also known as a hair light or separation light. A true backlight is behind and above the subject and illuminates the hair and shoulders. It should not be so high that it shines over the top of the head and onto the nose (this is referred to as being too *toppy*).

Barndoors Folding doors attached to the front of a light for control.

Bazooka Like a 2K stand, with no legs. It has a junior hole at one end and a junior stud at the other. A sliding riser modifies the length.

Beadboard Beadboard is formed from polystyrene beads. Originally used as housing insulation, it is favored as a bounce material for the soft, diffuse quality of its bounce light. Some beadboard comes backed in silver foil, which creates a hard bounce side. Beadboard cannot take much heat and a PAR or mighty placed too close will melt it.

Beaver board A 2K pigeon on an apple box.

Beef Output of a light. As in "beef it up."

Beefy baby Heavy-duty 1K stand without wheels.

Best boy Second electric, the assistant chief lighting technician or assistant to the key grip. Note that there is no such thing as a "first electric."

Black wrap Black anodized aluminum foil. Used for wrapping lights to control spill, making small flags, etc..

Blocking The pre-arranged movement of the actors in a scene.

Blonde Open faced 2K, also called a mighty.

Bobbinet Black mesh cloth used for grip scrims. Also comes in rolls for darkening windows.

Bottom chop Flag or cutter keeping light off the floor or lower part of the scene. Also *bottomer, bottom cut.*

Branch holder A pipe-like section with a locking nut used to hold branches, wooden poles, etc.

Breast line A guide line attached to anything being hauled up on a crane, pulley, or freehand.

Broad A rectangular open-faced light, used for general fill or cyc illumination. From the old term *broadside,* which was originally a burning arc for photoengraving plates, adapted for film use in 1912.

Broom back Sweep back. To clear lights and stands off a set once it is time for a *new deal.*

Brute A brute arc, 225 amps DC.

California scrim set Scrim set with two doubles.

Camera wedge Small wooden wedges, 4 inches long by ½ inch at the big end.

Cam-lok A feeder cable connector. Similar to a Tweco, but more positive locking, easier to disconnect, and watertight.

Candela Unit of light intensity, a standard candle.

Celo A type of cookie made from wire mesh coated with plastic. An irregular pattern is burned into the plastic. Makes a more subtle breakup than a wooden or foamcore cookie. Slightly reduces and diffuses the light. Actually pronounced *selo,* but most people call it a *chelo.*

Century stand A grip stand, also known as a *C-stand.*

Chain vise grip A vise grip with a chain for the the clamping action. Used for securing pipe, attaching a stand to a fire escape, etc..

Circle of confusion A measurement of focus: the diameter of a point of light as focused on the film plane. The more the lens is out of focus , the bigger the circle of confusion.

Clothespins Ordinary clothespins. Used for securing gel to barndoors and other locations subjected to high heat. You can't make a film without them. Also known as C-47 or #1 wood clamp.

Combo box A six-pocket stage box that can be converted from three-phase four-wire to single-phase three-wire operation.

Combo stand A heavy-duty 2K stand with no wheels. Called a combo stand because it is used for reflectors and lights.

Contrast Brightness ratio of a scene.

Cookie See *cuculoris.*

Cover me I'm leaving the set, take over.

Cribbing Short pieces of lumber. Usually $1 \times 3 \times 10$-inch or $2 \times 4 \times 10$-inch.

Crowder clamp Clamps onto a 2×4-inch or 2×6-inch and can suspend a baby or junior studded light. The safest method for attaching a light to lumber.

Cucoloris Perforated material used to break up a light or create a shadow pattern. Also called a *cookie.* A related device is the celo.

Cup blocks $5½ \times 5½$-inch blocks with a dish in the middle. Light stand wheels are placed in the cups to prevent them from rolling or sliding. Particularly important when a wheeled stand is on a high platform or scaffolding.

Cyc lights Row lights for evenly illuminating a cyclorama or other background.

Cyclorama Permanent background built in a studio, nearly always coved (curved) at the floor line to create a shadowless *infinity* backdrop.

Dailies Also known as rushes. The first prints of the previous day's shooting.

Dance floor A floor built of 3/4-inch plywood, usually covered with masonite to provide a smooth surface for free-form dollying.

Densitometer Device for reading the density of a film negative or print. Used in densitometry, the science of evaluating exposure and film response.

Density The degree to which a negative or print is opaque. Maximum density is called *D-max*, minimum is *D-min*.

Depth of field The range of distance at which objects are in acceptable focus.

Depth of focus Essentially, a depth of field at the film plane, the plane of acceptable sharpness at the film gate.

Dimmer Device for varying power to the light. Strictly defined, a dimmer is a variable resistance device. See *variac* and *SCR dimmer*.

Dingle Branches placed in front of a light as a cookie. A small branch is a 1K dingle, a larger branch is a 2K dingle, and so on. Sometimes called a *branch-a-loris*. See *smilex*.

Doorway dolly Plywood dolly with four soft tires, two of them steerable. Narrow enough to fit through a door. Used for camera on tripod, also great for transporting heavy lights, cable, etc..

Dots and fingers Small nets and flags. Dots are round (3, 6, 10 inches), fingers are rectangular, typically 2 × 12-inch and 4 × 14-inch.

Drop ceiling hanger A scissor clip that attaches to the metal frame of drop ceiling. Has a baby stud. Very handy, but don't get too enthusiastic.

Duvetyne Duvetyne is a heavy black cloth, treated with fire resistant chemicals. It comes in 48-inch rolls and is used for blacking out windows, making teasers, hiding cables, and hundreds of other uses.

Edison plug Ordinary household plug with two parallel flat blades and a round ground pin.

Empty frames The same sizes as nets and flags but with no covering, so you can custom make your own diffusions, gel packs, etc.. Can also be made from lumber (1 × 3-inches) or from pre-fabbed artist's canvas stretchers.

Emulsion Light sensitive coating on the film. Film stock is often referred to as the emulsion.

Eyelight A small light designed to fill in eye sockets. If it's right over the lens, it's an *obie*.

F/stop A measure of a lens' transmission of light. As the number get smaller, more light is passed.

FAST The camera assistant's chant: focus, aperture, shutter, tachometer. All the things the assistant must remember to do before each shot, working from the front to the back of the camera.

FAY A 650-watt PAR 36 with daylight-balanced dichroic filter. Also refers to a cluster light (5-light or 9-light) used for daylight-balanced fill or broad wash.

Finger Small, rectangular flag or net.

Flood The widest beam spread on a lensed light.

Foamcore Polystyrene sandwiched between paper. Can be white on both sides or black and white. Used for building reflectors, soft-boxes, etc., because it is self-stable and rigid, but can be easily cut.

Focal length Measurement of the distance between the effective optical center of the lens and the film plane when the lens is focused at infinity.

Footcandle Luminous flux falling on a sphere placed one foot away from a standard candle. Also known as a *candela*. Standard unit of illumination.

Footlambert The uniform brightness of a perfectly diffused surface emitting or reflecting light at the rate of one lumen per square foot. Standard unit of brightness.

Fresnel A stepped convex lens. Also a colloquial expression for tungsten-incandescent lamps from inky to 10K.

Frisco pin See *stud adaptor*.

Gaffer The chief lighting technician or lighting designer.

Gamma Degree of contrast in a negative or print. A measure of the

angle of the straight light portion of the D-log E curve.

Golden hour The fifteen minutes immediately before the sun goes down. Dying sun plus reflected skylight results in soft, gentle, golden glow. Not really an hour by any means, it varies according to the time of year, cloud conditions, and topography.

Greens Studio catwalks around the set.

Grip A film technician who handles camera support, rigging, leveling, and some lighting control devices not attached to lights such as nets, flags, cutters, silks, and large reflectors.

Halation Ghost image caused by internal reflection in the film emulsion base.

Halogen Class of elements including iodine, bromine, chlorine, fluorine, and astatine. Used as the gas in tungsten-halogen bulbs.

Headroom Space above the subject in the frame.

Hertz A unit of frequency equal to one cycle per second. Abbreviated Hz, 1000 Hertz is 1 KHz.

Highkey Overall brightly lit scene with relatively few shadows.

Highboy Heavy-duty rolling stand, usually with a combo head that has a junior receiver and a large grip head. Also called *overhead stands.*

HMI An enclosed, AC mercury arc lamp.

Hollywood box A stage plug-type box with no fuses.

Incandescent Standard light bulb: glowing tungsten filament.

Incident The light falling on the subject before it is reflected off the subject. Light meter technique that measures the light that is falling on the subject (as opposed to the light reflected by the subject).

Inkie Small 250-watt fresnel light.

Iris Variable aperture that controls exposure on the camera or video assist. Variable circular opening on leko lights. A special effect used in the silent era where the frame closed down to a circle around the subject.

J-lar Transparent tape used for splicing gels together.

Japanese lantern A paper-covered wire frame globe in which a socket and bulb can be placed. An *omni* soft light.

Junior (1) A 2K fresnel (see also *deuce*). (2) Any 1 1/8-inch spud or mounting pin or any 1 1/8-inch female receiver (such as a junior stand).

Kelvin Kelvin temperature scale, used to describe *Correlated Color Temperature* (see color temperature).

Keylight The main light on a subject.

Kicker A three-quarter backlight that brushes along the cheek.

Kiss A light that just gently brushes a subject.

Lamp Refers to the bulb inside the unit or the whole lighting unit.

Latitude Latitude is the range between overexposure and underexposure within which a film will still produce usable images.

Leko An ellipsoidal reflector spot. A theatrical instrument with highly controllable leaf shutters at the focal point of the optics. Comes in various focal lengths and front diameters from 3 to 8 inches.

Limbo Shadowless black, white, or pure color background, generally done on seamless set paper or a coved cyc.

Low boy A low version of a highboy.

Lowkey High-contrast lighting with lots of shadows, large areas of darkness.

Lumen A unit of light flux equal to 1 candela falling on one square unit of surface, one unit of distance from the radiating source.

Lux Standard unit of lighting intensity. One lux is the illumination of a surface, all points of which are 1 meter distant from a point source of 1 candela (essentially, a meter-candle). One footcandle = 10.764 lux.

MOS Silent filming. The traditional explanation is that it stands for *mit out sound*, or *motion omit sound* .

Macro Shooting in extreme closeup, so that the subject appears near lifesize on the film.

Mafer A small adjustable clamp with a baby stud which can be interchanged with a variety of accessories, J-hooks, glass holders, etc..

Magic hour Should really be called *magic quarter-hour*. The fifteen minutes immediately after the sun goes down when the sky is still light and suffuses the landscape with a beautiful golden/magenta glow, and the incident level approximately balances the glow of building lights, streetlights, etc..

Maxi-brute A 9-lite with 1000-watt PAR 64s. An extremely powerful source.

Motivated lighting Light that imitates existing sources such as lamps, windows, etc..

Musco lite An array of permanently crane mounted HMIs.

Nets A grip item: bobbinet on a frame. Like scrims, they come in single and double variety for half-stop or full-stop light reduction.

Neutral density Colorless filters that reduce the amount of light in controlled degrees. *ND* for short.

Newton rings Ring-like patterns caused by contact of two optical surfaces.

Noir Refers to the classic black and white *film noir* detective mystery genre (*Maltese Falcon, Kiss Me Deadly, Murder, My Sweet*, etc.), which typically employed hard shadows and a dark, low key lighting.

Noseroom Space in front of a head in the frame (in the direction they are looking, right or left).

Obie An eyelight mounted on the camera. Named after Merle Oberon, for whom it was invented. Also known as a *basher* or a *camera light*.

Opacity Ratio of amount of light falling on a surface to the amount transmitted. The log of opacity equals density.

Orthochromatic Black-and-white film sensitive only to blue and green.

Pan Horizontal rotation of the camera. It is not correct to say "pan up." Technically, you tilt up.

Panchromatic Black-and-white film sensitive to all colors of the visible spectrum.

Parallels Temporary scaffolding, used as platform for camera, lighting, rigging, etc..

Perms Studio catwalks. Fitted with junior holes every few feet for bazookas and other mounting equipment.

Photoflood Light bulb designed for photographic use. The filament is run at overvoltage to increase light output and color temperature.

Plate Background for any type of process shot.

Polarity The direction of current in DC, defined as positive and negative.

Polecats Adjustable spring-loaded aluminum tubes with rubber suction-cup feet which can be used vertically as background holders or horizontally spanning from wall to wall as a portable, temporary grid.

Porcelain A heavy-duty extension that terminates in a single- or double-pocket stage plug hole. Generally rated either 60 or 100 amps.

Practical Any light that appears in the scene (such as a desklight) or any prop that works in a scene, such as a television that must be on, or a microwave that must operate. For the lighting crews *make this practical for me* means provide electricity for it.

Process shot A shot that will be composited from two other shots. The background shot is referred to as a *plate*.

Punch Amount of light, but generally refers to the specular collimation of a light, hence its ability to throw light. A

xenon is far more punchy than a softlight.

Quartz lights Tungsten-halogen. Name comes from the quartz glass used to resist the intense heat and pressure.

Rectifier Converts AC to DC power.

Redhead An open-faced 1K, also known as a mickey.

Reflector Any shiny surface that reflects light in a more or less specular manner. Reflectors mounted on stands are standard lighting equipment in daylight situation. Also called *shiny boards*.

Rim A little more backlight than a kicker. Gives a hard rim on the subject but doesn't brush along the cheek. Can be thought of as a backlight that is on the same level as the subject, (a backlight is generally above the subject).

Riser (1) A cylindrical metal device placed between the dolly head and the camera base to raise the camera. (2) Prebuilt platforms used to raise the set, the camera, or lights.

Rolling shot Any shot done on a vehicle that is driving or mounted on a moving platform. Also known as a car rig shot.

Rough-in Approximate placement of the lights.

SCR dimmer Silicon-controlled rectifier. A type of electronic dimmer.

Scrim Metal window screen that can be placed in the gel holder slot of light, a mechanical dimmer. Comes in two main varieties, single and double. A single reduces the light by one-half stop, a double by one full stop. Each are available in half size, which only covers half the light. These four are considered a full set and every light should have a full set. Also referred to as *metal* or *wire*, as in "what metal do we have in that light?"

Second unit Another photographic team that shoots scenes not involving the main cast members such as sunsets, car chases, stunts, etc..

Senior A 5K fresnel.

Senior stand A braced junior stand sufficiently rugged for large lights such as 5K, 10K, or Big Eye.

Sensitometer See *Densitometer*.

Shake 'em up Command to re-aim the reflectors just before every shot.

Shiny boards A grip reflector. Usually hard on one side and soft on the other.

Shotmaker A sophisticated camera car.

Showcard Black-and-white artist's board used for small reflectors, making special rigs, etc.. Easily cut and shaped, a must on every set.

Siamese A splitter that divides a power line into two parts. Used for distributing power to more than one location.

Sider Side cut with a flag or cutter.

Silk A diffusion material. Used to be real silk, now it's nylon.

Single (1) A single extension (#12 cable with hubble plugs). (2) A single scrim. (3) A single net. To avoid confusion, can be called a *single net* or a *grip single*. (4) 12/3 or 12/2 elec-trical cable, also known as a stinger.

Skypan A large bowl-shaped open-faced light for either a 2K or 5K bulb. Used for illuminating large areas. Also known as a skylite.

Slip pin A type of high ampacity connector used for feeder cable (on the West Coast) and the power connector of large lights.

Smilex A dingle. Leaf effects outside a window. If it's shrubbery in the frame, it's also know as *lettuce*.

SMPTE Society of Motion Picture and Television Engineers.

Specular Technically, a hard, mirror-like surface that reflects light in accordance with the *angle of incidence / angle of reflection* principle. Also used to describe highly directional, focused light: *hard* light, as in the opposite of *soft* light.

Speed (1) The lowest t/stop of a lens: a lens with a lower t/stop is a "fast" lens. (2) Light sensitivity of a film emulsion or video tube as rated in EI, ASA, or ISO. (3) The frame rate of a camera.

Spill Light that escapes from the sides of light or that is falling where you don't want it.

Spot On a lensed light, the smallest beam spread.

Stage box A distribution box with six pockets for stage-plug connectors. May be a three-wire, four-wire, or a combo (convertible to three- or four-wire).

Staging A location for temporary storage of the working equipment.

Stinger A single extension. Most often used to refer to a single that is hot, but left lying around for occasional use, such as to pump up the dolly hydraulics.

Stud adaptor A 2K (1 1/8-inch) pin at one end and a baby (5/8-inch) pin at the other. An adaptor that allows something with a baby hole to fit on a junior stand. Also known as a *frisco pin*.

Suicide Distribution wiring connector with male plugs at both ends. Used for reversing the connectors and for tempting fate.

T/stop A true f/stop as opposed to one derived mathematically. The actual light transmission of a lens as measured on an optical bench.

Ted Lewis Crushable and formable light metal snoot. Named for the hat of the 1940s entertainer, Ted Lewis.

Telecine Film chain device for transferring film positive or negative to video.

Tenner A standard studio 10K, as opposed to a baby 10 or a Big Eye, which are also 10's.

Tie-in Power feed obtained by temporarily clipping on to the main service of a location. Illegal in many areas.

Tilt Rotation of the camera on the vertical axis.

Timing A corrected print in which each shot is balanced for color and exposure. The technician who does this is a *timer*. The record of what exposures and color balances he used is called the *printer lights*

Top chop A cutter or flag that comes in from the top. Also known as a *topper* or *top cut*.

Toplight A top light is almost straight down, generally an overall base illumination. One rarely puts a hard toplight on a subject because of the nose and eye socket shadows, but of course this effect can work well for horror, villains, mystery, etc..

Translucent Technically, a semi-transparent object or diffuser. In reference to light quality it means a clean, gentle-wrapping glow as from a large, highly diffuse source, such as a *Mr. Big* unit.

Trim Final focusing of the lights.

Trombone A tubular, extending device for suspending lights from set walls, the perms, etc..

Tungsten The metal used in incandescent lights. Term also refers to 3200K color temperature, as in tungsten film.

Turnaround (1) The reverse angle shots of a scene, usually involving a relight. (2) A double ended connector, for reversing the direction of connectors on a power line. (3) The amount of time between wrap and call-time next day; usually a ten-hour minimum to allow for eight hours of sleep and two hours of travel time and real life.

Turtle A flat on the floor mount for large lights with junior receiver.

Tweco Similar to a slip pin connector. Used on feeder cable, it has a positive lock twist connection.

Ultraviolet UV light beyond the violet end of the visible spectrum. Invisible to the eye but will affect the exposure of many emulsions. Harmful to human skin and eyes.

Union connector More sophisticated version of a three-pin theatrical connector.

Variac Dimmer that reduces the voltage. Stands for VARIable AC.

Wedges Wood wedges cut from 2 × 4-inch lumber, used for leveling and stabilizing.

Western dolly Plywood dolly with four

large soft tires, two of them steerable, pull-handled and push-barred. Used as a camera dolly on smooth floor or on plywood. Also used to transport equipment.

Whip A section of feeder cable siamesed off the main line and to a secondary location (such as the grid or outside the set). Differs from a siamese main feeder line in that it is often just one hot leg and a neutral.

Woof That's it. Perfect. Lock it in.

Xenon A high-intensity, gas-discharged light with a polished parabolic reflector.

Bibliography

Adams, A. 1983. *The Negative.* Boston:Little, Brown & Co.

Beacham, R. 1987. *Adolphe Appia.* Cambridge:Cambridge University Press.

Bureau of Naval Personnel. 1970. *Basic Electricity.* New York:Dover Publications.

Campbell, R. 1974. *Photographic Theory for the Motion Picture Cameraman.* New York: A.S. Barnes & Co..

Campbell, R. 1979. *Practical Motion Picture Photography.* New York: A.S. Barnes & Co..

Carlson, V. & S. 1985. *Professional Lighting Handbook.* Boston:Focal Press.

Case, D. 1990. *Motion Picture Film Processing.* Boston:Focal Press.

Cook, D. A. 1981. *A History of Narrative Film.* New York: W.W. Norton & Co..

Davis, P. 1981.*Beyond The Zone System.* New York: Van Nostrand Reinhold Co.

Eastman Kodak Co. 1981.*Kodak Filters For Scientific and Technical Uses.* Rochester: Eastman Kodak Co..

Eastman Kodak Co. 1982. *Professional Motion Picture Films.* Rochester: Eastman Kodak Co.

Fauer, J. 1989. *The Arri 35 Book.* Blauveldt, NY: Arriflex Corp..

G.E. Lighting 1989. *Stage and Studio Lamp Catalog.* Cleveland, Ohio: General Electric.

Grob, B. 1984. *Basic Television and Video Systems.* New York:McGraw-Hill.

Happe, L. B. 1989. *Your Film and the Lab.* Boston:Focal Press.

Harrison, H.K. 1981. *The Mystery of Filters.* Hollywood: Harrison and Harrison.

Hart, G. and S. 1978. *Ugly's Electrical References.* Houston: United Printing Arts.

Higham, C. 1986. *Hollywood Cameramen: Sources of Light.* New York: Garland Publishing.

Hyypia, J. 1981. *The Complete Tiffen Filter Manual.* New York: Amphoto.

Maltin, L. 1978. *The Art of The Cinematographer.* New York:Dover Publications.

McClain, J. 1990. "The Influence of Stage Lighting on Early Cinema" *International Photographer.*

Millerson, G. 1983, *Lighting For Television and Motion Pictures.* Boston:Focal Press

Ray, S. 1976. *The Lens In Action.* Boston:Focal Press.

Shipman, D. 1984. *The Story of Cinema.* New York: St. Martin's Press.

Sterling, A-K. 1987. *Cinematographers on the Art and Craft of Cinematography* Metuchen, NY: Scarecrow Press.

Stroebel, L. 1974. *Photographic Filters.* Dobbs Ferry, NY: Morgan & Morgan.

Sylvannia Corporation/Sylvannia Lighting Center. 1989. *Lighting Handbook 8th Edition.* Danvers, MA: GTE Products.

Ultimatte Corporation.

"Shooting Film For Ultimatte."
Ultimatte Technical Bulletin #3 .
Reseda, CA: Ultimatte Corp..

Ultimatte Corp.
"Lighting For Ultimatte." *Ultimatte
Technical Bulletin #4*

Reseda, CA:Ultimatte Corp..

Wilson, A. 1983. *Cinema Workshop.*
Los Angeles: American Society of
Cinematographers.

Index